THE MAN

NOBODY

KILLED

ALSO BY ELON GREEN

*Last Call: A True Story of Love,
Lust, and Murder in Queer New York*

LIFE, DEATH, AND ART IN MICHAEL STEWART'S NEW YORK

THE MAN

ELON

NOBODY

GREEN

KILLED

CELADON BOOKS NEW YORK

www.celadonbooks.com

Library of Congress Cataloging-in-Publication Data (TK)

ISBN 978-1-250-89822-7 (hardcover)

ISBN 978-1-250-89823-4 (ebook)

Our books may be purchased in bulk for promotional, educational, or business use. Please contact your local bookseller or the Macmillan Corporate and Premium Sales Department at 800-221-7945, extension 5442, or by email at MacmillanSpecialMarkets@macmillan.com.

First Edition: 2025

10 9 8 7 6 5 4 3 2 1

FOR MY PARENTS, WHO TAUGHT ME ABOUT INJUSTICE

CONTENTS

Prologue 1

1. The Park 5

2. The Fab 500 15

3. Glasgow 23

4. Berserk 27

5. The Talk of the Day 37

6. 10–85 49

7. The Eyes of Michael Stewart 55

8. Pressman 63

9. Madonna 71

10. Stop Protecting Killer Cops 77

11. Radiant Children 85

12. Mr. Morgenthau Declines to Meet 91

13. The Gross Report 97

14. New York City Pigs 101

15. Private Detective 111

16. Absolute Secrecy 119

17. An Unsworn Witness 129

18. Eleanor Bumpurs 137

19. Simultaneous Probes 147

20. Here's Another 155

21. Failure to Protect 161

22. Ricochet 171

23. The Students 181

24. Rested 191

25. No Evidence of Racism 201

26. Remember Michael Stewart 205

Acknowledgments 221

Notes 225

Index 263

What you did was awful
Not what I did
It's what I was
If I was white
I'd be alive

—TONI MORRISON

Call it what it is.

—BEN HARPER,
"CALL IT WHAT IT IS"

THE MAN
NOBODY
KILLED

Prologue

Not long after midnight on September 15, 1983, Michael Stewart telephoned Patricia Pesce. He didn't know her all that well, as they'd spent only a few hours together a couple of weeks before, at Lucky Strike, a bar in the East Village where her sister was deejaying.

Michael was twenty-five, four years younger than Patricia. A slender man nearly six feet tall, he was Black and unusually handsome, with wide-spaced eyes and a palpable air of thoughtfulness. His short locs often carried a scent of the coconut oil he used to style them. When he spoke, it was only after careful deliberation. His quiet and unassuming way of moving through the world was in crisp contrast to the loud, brash circus of early '80s Manhattan, with its mélange of assertive personalities, each striving to be the most colorful in the room. Ironically, what might have made Michael recede elsewhere, here in New York made him stand out. When you saw him, his quietness drew you in. With his friends, he was sweet and playful, knowledgeable about fashion, art, and especially music—all pursuits that made his particular corner of New York City tick.

Michael rented a studio in Lower Manhattan where he made art, but he also did some deejaying and modeling, and a little dancing for the odd video project, while working less glamorous gigs on the side—a cobbled-together life very common for the early '80s downtown scene. During that first hangout at Lucky Strike, Michael had shown Patricia his latest art project, which involved pages and pages of black-and-white contact sheets on which he'd

drawn with marker. Years later, she'd recall that as they walked a few blocks near St. Mark's Place, snow had unexpectedly fallen on the city.

Pesce hadn't expected ever to see Michael again. But when he called her on what would turn out to be his final good night, she agreed to meet him at the Pyramid Club. When she arrived, he had already been there for a while, after a failed attempt to crash a party at the home of Keith Haring—the artist, skinny and bespectacled and also twenty-five, had spent the past years dotting the city's walls and subway cars with chalked and painted works faster than they could be erased.

Pesce arrived at the loud, grimy, eclectic, electric East Village club and snaked her way through the crowd to order a drink. A slight woman dressed that night all in black, she followed Michael to the basement, the domain of staff and regulars. The first night they'd hung out, Michael had been quiet. Conversation with sweet Michael, Pesce would observe, meant that "you did most of the talking." Tonight, as they sat together on a couch, he was unusually chatty.

Michael took a sip from Pesce's drink of rum and orange juice, and shared his excitement. He'd gotten a spot deejaying at Lucky Strike, and he'd just modeled on a shoot for a magazine. As the two talked, he found a cowrie shell on the couch and gave it to Pesce. She'd later think of this as an omen.

All told, they were together in the club for about an hour and fifteen minutes.

After leaving the Pyramid, the two walked a block west and then perched on a tenement stoop to talk further. The night was chilly. Noticing Pesce's discomfort, Michael offered her his top layer. "I'm going to show you my shirt," he told her. The shirt underneath was designed by Peter Kea, an up-and-comer in the fashion world. "Everybody has been trying to see it all day."

They sat for a while longer and smoked. Michael said he was going to have his own show. If you were an aspiring artist then, the solo show was the landmark event you aimed for. Just the year before, Keith Haring had had one at the Tony Shafrazi Gallery, and it had vaulted him forward toward fame—and fame, as much as money, was the hungry aim of this time. As Haring put it during a characteristically clear-eyed interview, about where he wanted to go and what it would take to get there, "When you go to the top of the Empire

State Building and look around at how many lights there are, I think I could work my ass off my whole life and never make a dent. I would like to get in everybody's house." Jean-Michel Basquiat, a friend of Haring's and an acquaintance of Michael's, had also been gaining fame since Rene Ricard's bombshell essay about him in *Artforum*. Michael was young, too—he was born nearly two years before Basquiat and five days after Haring. There was still time to catch up.

The pair walked a few more blocks. Michael debated going to a club on West Broadway, but it was late. He had recently moved back into his parents' house in Brooklyn, and it was time to get home.

At First Avenue, he and Pesce hailed a taxi.

Pesce, who lived on Eighty-Second Street in the Upper East Side, offered to drop Michael off at the LL, the train he'd take out of Manhattan. Once they reached the station at Fourteenth Street and First Avenue, Michael tried to give Pesce some money for the cab. Before he got out of the car, Pesce kissed him on the cheek and said, "Speak to you tomorrow."

It wasn't yet 3 a.m. when Michael exited the taxi. He waved, then disappeared down the subway steps. This would be the last time anyone who cared about Michael would see him alive and well.

1 The Park

In 1982, not long into his first term, Ronald Reagan visited the Waldorf Astoria in Manhattan. Leading a country in the teeth of a recession, the president stood in the hotel's ballroom and praised the business leaders assembled there for pulling New York City out of near ruin. As Reagan saw it, this achievement was a victory for private enterprise and a blueprint for the future, for both the city and the country. If the president had had his druthers, there'd have been no funds earmarked for making life sustainable for people who didn't already have money. "We've made our choice and turned a historic corner," he said. "We're not going back to the glory days of big government."

Reagan's words were sunny nonsense, but ones that accidentally prefigured a metropolis in decline. New York had once been a land of inexhaustible promise, and this had allowed the city to attract some of the greatest artists, writers, and filmmakers of the twentieth century. Even if you weren't rich, you could eke out a good life there. But the civic amenities that made it all possible had been under threat for a while and were being systematically stripped away. The city's future as an increasingly unaffordable, sanitized playground for the white and the wealthy was much closer to its present than anyone knew.

New York City's government had for decades spent generously and, with great deliberation, to the benefit of its citizens. Much of the work had been under the watch of two administrations. The Great Depression–era mayor, Fiorello La Guardia, transformed the subway system and kept it affordable,

created new parks, and founded the country's first agency to provide publicly funded housing. In 1954, nearly a decade after La Guardia's tenure ended, Robert Wagner Jr. assumed office and oversaw the construction of hundreds of public schools, libraries, playgrounds, and the tuition-free City University of New York system. These projects, noted a historian, "embodied the connection between government and the citizenry."

To many, these decades were a golden age. The 1940s, hurtling toward the Eisenhower years, had been typified by "a sense of sturdiness and serenity," writer Cynthia Ozick recalled. Still, many white New Yorkers, resentful of high taxes and, oftentimes, their Black neighbors, fled to the suburbs. Many of those who left were middle-class families, from all five boroughs, and they took with them a substantial bounty in tax revenue. This coincided with the loss of manufacturing companies, which decamped for less expensive precincts, and of shipping companies, which migrated across the Hudson to the Port of New Jersey. Once-stable New York industries, such as printing and garment production, were limping.

This was a city with grand visions that could no longer afford them.

So, when Abraham Beame, a former accountant and the city's first observant Jewish mayor, took over in 1974, he inherited a dire financial situation. The city was in crisis, with over $1.5 billion in debt. In June 1975, in an attempt to meet debt obligations and avert bankruptcy, 15,000 city employees (including thousands of police and 11 percent of the firefighters) were dismissed. Tens of thousands of other additional workers were fired within months.

These measures still weren't enough, and in the paunch of October 1975, the city of New York came within hours of bankruptcy. Beame appealed to President Gerald Ford for bailout help and was turned down, a decision famously summed up by a *Daily News* headline: "Ford to City: Drop Dead."

Ultimately, the city staved off bankruptcy with $150 million from the teachers' union pension fund and some federal support. But over the long haul, things continued to look grim, and nearly every inch of the five boroughs felt the cuts: Transit workers' wages were frozen as inflation soared; subway cars descended into filth, and the system lost millions in ridership. Maintenance of the dilapidated parks, crippled by budget cuts, was assumed by locals, who

took on the responsibility of picking up trash, repairing swings, and planting flowers. No police were hired from July 1975 to November 1979. In time, as one resident later put it, the police "had become almost invisible."

New York was hobbled for years.

In 1977, Ed Koch, a fiscal conservative—"a liberal with sanity" was his preferred descriptive—defeated Beame in the primary and then Mario Cuomo in the general election to become the 105th mayor of New York City. The Bronx-born attorney, balding and penguin-like in appearance, had gone to City College and then to New York University for law school. He was a product of a city that had been flush, but his inaugural address was about the center of the universe on the brink of collapse. "If we who live in this great urban center are to survive, we must give more than we ask," he said. "Living in the heightened reality and splendor of this city demands a price from every one of us—and it is a price worth paying."

By 1983, Union Square Park had fallen apart. Its six and a half acres just north of Greenwich Village were no longer landscaped, its poorly lit overgrowth providing cover to a generation of drug dealers. The ubiquity of marijuana, heroin, and pills was such that, on any given day, the park seemed better stocked than a Genovese. Saturday's Greenmarket aside, New Yorkers learned to keep their distance.

It hadn't always been this way. At the turn of the twentieth century, Union Square was a desirable address—home to the Academy of Music, theater spaces, and Tiffany and Company, and encompassed in the Ladies' Mile shopping district. While the elegant moneyed shopped along its perimeter, the park itself was an epicenter for activism, a gathering place for people who strove for a more just society. There was the inaugural Labor Day parade in 1882, attended by ten thousand workers. There was, in 1914, the mass of union men in bowler hats supporting the Industrial Workers of the World. In the summer of 1927, thousands of supporters of Nicola Sacco and Bartolomeo Vanzetti gathered there to protest the anarchists' imminent execution, as men with machine guns reportedly eyed the protestors from a roof on the east side of the park. The progressive atmosphere never stopped, and in 1970, the park played host to the maiden Earth Day. The square was,

wrote one chronicler, "the most important space for political expression in New York City."

The radicalism remained, but eventually, the center of business in Manhattan moved both downtown and uptown, leaving Union Square imperiled. The decline accelerated in the 1950s, with the departure of two vital department stores, Hearn's and Ohrbach's. In the minds of New Yorkers, though, it was the closing in 1975 of S. Klein, a beloved department store between Fourteenth and Fifteenth Streets that had been operating in the red for years, that sounded the true death knell for the neighborhood.

The streets where Diamond Jim Brady and other Gilded Age bigwigs had once shopped for their jewels had become a dumping ground for the city's indigent. By the time of New York's near bankruptcy, most of the shops bordering the park were gone and the buildings abandoned. "Statues have been damaged and what is left of them has been covered with graffiti. Benches and street lights have been ripped out," observed a reporter in 1982. The next year, the *Times* deemed Union Square "the shabby domain of drug dealers and derelicts." Indeed, the parks commissioner told a reporter that a planned renovation of the park had been canceled because it made no sense to "build a palace for junkies."

Not every building was abandoned, though, and the exceptions were notable: 860 Broadway held the penultimate iteration of Andy Warhol's Factory and the Underground, a basement club where, on any given night, one might see Warhol himself along with figures like Richard Gere, Patti LaBelle, and Farrah Fawcett.

Thirty-One Union Square West, too, was a proud holdout, a rollicking sixteen-story outlier that vibrated with culture and boasted a varied tenant list. In 1983, the bottom floor was occupied by Zippers, a recently opened private club that hosted concerts, movie screenings, and a children's theater. The upper floors were residential, and occupants included the heavily bearded sci-fi great Thomas Disch and fashion illustrator Antonio Lopez, with his wishbone mustache. Lopez kept his doors open to a stream of famous friends and to a dedicated set of the building's younger residents, with whom he would party on the roof. The kids were obligated to shout warnings

when luminaries were on the way up: *MIIIICCCCCKKKK JAAAGGGG-GERRRRRR's in the building!*

The Lopez devotees were mostly freshmen at Parsons School of Design, the renowned institution founded in 1896 whose alumni over the decades had included Edward Hopper, Jasper Johns, Bill Blass, and Donna Karan. Parsons attracted art-minded students from around the world; in 1983, the incoming class had 589 students representing 34 countries.

The dorm at 31 Union Square West was for freshmen, who occupied several of the lower floors. By policy, the residents weren't students who lived nearby: home had to be at least 150 miles from New York City. That September, the freshman there didn't really know each other yet. Courses hadn't started, and most of the students had been in Manhattan for only a few days. It was a busy, overwhelming time, an ice bath introduction to their new home.

The artist Ai Weiwei, who'd lived in the dorm the year before, recalled his time there: "The room I shared with two other students was on the top floor of the building[,] facing the park. Coming from China, I was eager to be accepted in this new environment, which felt like a monstrous machine—indifferent, its frenetic energy fueled by ambition." Like so many young people finding their way at a new college, Ai was unsure about his future. "I did not know what my passions or imagination would lead to. I tried to focus on my art. My sense of time was completely distorted. I had no reason to stay awake or to fall asleep. I slept when I was exhausted and awoke when I was refreshed. I existed like a soldier preparing for combat. But where was the battlefield?"

This was the sort of thoughtful, ambitious student who turned up at Parsons—eager to make their mark on the world, but also to make sense of the city around them, which seemed filled with both giddy possibility and lurking danger. Nineteen eighty-three's enrolling class was warned by administrators, *Avoid unnecessary risks, and especially steer clear of the park across the street.* A resident advisor even encouraged the students to travel to the East Village to buy their drugs. In reality, Union Square Park wasn't terribly dangerous, but it was rat-infested, and its landscaping was unkempt. It seemed like a forest.

On the edge of that forest was the entrance to the District 4 police precinct.

Over the coming months, approximately thirty residents of 31 Union Square West would provide accounts of what they saw and heard in the early hours of September 15, 1983. They were uniquely positioned to do so because their side of Union Square was dotted with buildings at least a dozen stories high. With the exception of the grass, every surface was hardscape that reflected sound right up to their apartments. This was particularly so for the frequency range of the human voice. With this canyon effect, sound bounced off and up the skyscrapers, allowing street-level noise to be heard with startling clarity.

Around 3 a.m., Timothy Jeffs was jerked out of his sleep by the sound of someone screaming. The Parsons freshman hurried to the common room in his seventh-floor suite. Sitting by the six-foot-tall window—so massive that one could comfortably sit *in* it—he was joined by several suitemates, including Chris Seyster, a blond-haired transplant from Middletown, Rhode Island. Below, there were police cars. A Black man was on the ground, an officer kneeling on his back. Other officers were beating the man with nightsticks. Seyster saw one officer hold a club under the man's neck. "The man with the club was to the left of the individual on the ground," he'd later recall. "He was down on one knee, both hands on the ends of the club, with the other knee in the man's back, and he was pulling on the stick, upward."

A poster of Peter Max's psychedelic portrait of Bob Dylan hung on the wall of the common room. This was the property of one of the other suitemates, Robert Cummings, an aspiring musician. He was there, too, peering out the window with Seyster and Jeffs. (Cummings would later, under the moniker "Rob Zombie," find fame as a musician and film director.) For a while, the group took in the horror down below. Then all returned to their bedrooms.

John Gunderson, a floor below, had also been drawn to the window. Gunderson saw a man on the ground, surrounded by three or four uniformed officers holding nightsticks. "God, please help me!" the man yelled. The man's arms were bound behind his back. At least three more officers stood by and

did not intervene. From his vantage, Gunderson could see their caps but not their faces. Given the amount of force being used, he assumed they'd caught a murderer.

Down the hall, Curtis Lipscomb was having a party in his suite's common area. Detroit-born, out of the closet since the age of fifteen, he was one of the few Black members of the Parsons class, a point of difference the white students never let him forget. Lipscomb was standing by the window when he heard the noises from outside. Looking out, he saw a man running and police in pursuit. Then the man was face down on the sidewalk, pinned by an officer, whose knee was on the man's back. Lipscomb and his classmates yelled out the window at the police, "Look, look! Stop doing that!"

Lipscomb wanted to be a fashion designer. In his everyday life, he studied human anatomy—fingers, feet, hair—and was attuned to movement. On one of the officers, he noticed the motion of a blonde ponytail. Then it registered: *That's a woman.*

Martin Cooper, one of the incoming class's other Black students, lived over in 5C; he and his suitemates were at their windows, too. For Cooper, New York seemed a city of magic, full of energy and opportunity—far removed from the Deep South, with its Confederate flags everywhere. Back home in Columbia, South Carolina, Cooper had been called all sorts of names to remind him of his Blackness, but he'd never seen physical brutality like this—certainly not at the hands of police. Before Cooper left for Parsons, his father, a locally prominent dentist, had given him the Talk—but it was about how to avoid impregnating a date, not how to conduct himself as a Black youth around police. "If you get in trouble with the law, I can probably help you with that," his father had said. "You get a girl pregnant, I can't help you with that."

Cooper poked his head out the window, and as he looked up and down, left and right, he saw the heads of his other classmates at adjacent windows. It was a surreal, out-of-body experience. He estimated that there were ten officers converged around the man on the ground, who screamed, "Please don't kill me." Cooper thought, *What could this guy have done?* His suitemate Daniel Baxter was also watching, and as he recounted the episode years later, he formed the impression that maybe the officers were trying to calm the

man down. But then other police had come over, and "they were tussling with him." Baxter approximated that there were six officers present.

On another corner of the fifth floor, Rebecca Reiss entered her bedroom and went to the window to investigate the noises she was hearing from outside. Looking out onto the building's Sixteenth Street side, she saw a commotion at the north end of the park. She heard a yell: "What did I do? What did I do?" Police had a man pinned against a car, chest forward, hands behind his back. It appeared they were trying to handcuff him. Reiss could see the man push the police, who responded by shoving him to the ground. An officer kicked him. "Oh, my God, someone help me," the man yelled. "Someone help me."

Another fifth-floor resident, Heidi Posner, had just returned from a night-club. Enrolled at the New School's Lang College, Posner was clearheaded that early morning, having had only one drink. Hearing a cry of "Help me," she'd gone to her window and seen a man on the ground, surrounded by officers. As she watched, more police showed up. Posner felt the man was making things worse for himself by resisting arrest, she recalled years later.

Candice Baker, a petite freshman who'd moved to New York from a steel town in Pennsylvania, began the night on the sixth floor. She and some new friends were celebrating a birthday and had tried baking a cake in the dorm kitchen. They were eating it, all agreeing that it was a failed experiment that tasted like Play-Doh, when they first heard the yelling. But looking out the windows, they couldn't see much; the suite was on the west side of the dorm, far from the park. So, they ran down two flights of stairs to 4A. Three of the four bedrooms there had windows overlooking the park, and the common space had a view of Seventeenth Street. What Baker saw on the poorly lit sidewalk—the kicking, the nightsticks—would radicalize her (as it would, to varying degrees, other witnesses from the dorm). Specific visual memories from the evening would eventually fade, but the sounds would haunt her: "I have never heard screams like that in my life, and I hope to never hear screams like that again."

What happened next was remembered with virtual unanimity by all who witnessed the event, even as their recollections diverged in such particulars as the number of police officers present. The man on the ground had stopped

moving. He was clearly unconscious, or maybe in a condition even more serious. Baker and others watched as two policemen picked him up, still bound, and carried him to a paddy wagon idling directly in front of the dorm. Then, in a swinging motion, the officers launched the man into the back of the van. It was the nonchalance of the movement that would stay with Baker: "It was just like you would throw a bag of mulch onto a truck."

In the weeks to come, there was much discussion among the residents of 31 Union Square West about why no one—not a single student—called the police. In 1983, few had phones in their suites. There was one pay phone on each floor, on the west side of the dorm. Some students had heard that such violence was common in New York City. Despite the brutality of what they'd seen, they had on some level interpreted it as maybe not uncommon—part of their new city lives. Others presumed the man was guilty of something serious, that he was a criminal who might very well have required extreme measures to subdue. Mostly, they were willing to give the police the benefit of the doubt. After all, the police were the good guys, weren't they? For Baker, though, the violence presented a question to which she didn't know the answer: Could you call the police on the police?

In hindsight, the paralysis of the freshmen was unsurprising. For, while they would soon enough leave a significant footprint in the fields of art and design, book publishing, and music, in the moment, in those hazy early morning hours, these teenagers were keenly conscious of what they were *not*: hardened, knowledgeable, streetwise New Yorkers. As one of them said nearly forty years later, "We were babies."

Eventually, residents lost interest in what was happening down below. Some began closing their windows. Of the many freshmen who watched the events unfold that night, only a few were still present to witness what happened as the unconscious man lay in the back of the police van—which was, in a word: nothing. That is, the vehicle didn't speed off to a hospital. Not right away. Instead, one witness recalled, the police "stood around for the next twenty minutes, all talking to one another."

2 The Fab 500

In the early years of the 1980s, the East Village, a neighborhood on the east side of lower Manhattan, had a population of roughly sixty thousand. But the worlds of art, music, and literature operating east of the Bowery and Third, south of Fourteenth, and north of Houston felt far smaller. The neighborhood of low buildings and crooked streets, a place so hollowed out and reduced to rubble that it resembled postwar Vienna, was intimate. Everyone seemed to be only one degree of separation from Madonna, from Jean-Michel Basquiat, from Keith Haring—from people on the cusp of changing the world but who were still, for the time being, well known only in New York.

The community was so small that a gallerist estimated that 3,500 members of the art world lived in the neighborhood. Another number discussed was 500. The "Fabulous 500" was the coinage of fashion designer Dianne Brill to describe "the conceptual movers and shakers of everything" who made up the Village. Brill, with her big, bleached blonde hair and a heart-shaped smile, was herself one of the 500. In his 1988 work *Andy Warhol's Party Book*, the wigged-up artist would observe, "Dianne Brill . . . was the first young girl in decades to really play up a big body with big curves and big cleavage. [She] operated full tilt all night all over New York as the ultimate Party Girl and earned herself the title 'Queen of the Night.'"

Michael Jerome Stewart wasn't among the Fab 500. Still, he was very much a part of their world. The modeling job he'd told Patricia Pesce about had been for a spread in Mexican *Vogue* featuring Brill's fashion. Michael hadn't taken a single bad shot, the designer later said. "He always gave gorgeous faces."

Michael was also tightly connected to the Pyramid Club, the nightclub on Avenue A, just off Tompkins Square Park, where he'd met up with Pesce that night. Once a Ukrainian haunt frequented by local babushkas, the club fell on hard times until, in the early 1980s, new managers decided to dramatically alter the joint's appeal. They left the tiles embedded in the pyramid shape of the floor that had given the club its name, but changed pretty much everything else.

At the Pyramid's grand reopening in 1981, the reconceptualized establishment on the Village's perimeter announced itself as *the* place to be for the pansexual, the punk, the queer, those in drag, and anyone else comfortable in the milieu—anti-hierarchy; no velvet ropes; an alternative, coiled energy. On opening night, a classically trained dancer in a bustier, a red wig, and black-painted eye sockets performed *The Martyrdom of Saint Sebastian* as a nod to the gay icon. For the finale, he flipped himself over a railing and pretended to die—all while made up in, as he later put it, "glamorous gender-fuck punk drag."

The celebration was titled *On the Range*, a nod to the "frontier" that was Avenues A through D. Depending on whom you asked, it was also variously called Alphabet City, Loisaida, or just "the neighborhood." Incredibly, real estate vultures had already begun to circle, but back then, it was still a mostly rundown, desolate area that was so quiet, one tabloid claimed, that "you can hear a rat crossing the street." The neglect stretched from one end of the neighborhood to the other: Avenue A was dotted with empty storefronts, while there were lines around the block on Avenue D to buy heroin. A local poet, seeking solace, observed that such conditions would ward off gentrification, at least for a while: ". . . keep it looking messed up / Maybe the gentry can't set up shop."

The Pyramid, thoroughly impervious, was printing money. Future indie rock royalty like Sonic Youth's Thurston Moore was among the many willing to pay the ten-dollar cover to enter what he viewed as "the most significant spot in the East Village." Night after night, a scrum of bodies rubbed up against one another, figuratively and literally. And what bodies! The patrons, observed one attendee, were "the right mix of lunatics, friends, drunks, and intellectuals." It was a largely white and often queer crowd, but Pyramid regu-

lars were intensely accepting. It was an odd oasis in which gender, sexuality, and race didn't determine whether you got through the door.

Michael, hired as a busboy, was welcomed there with open arms.

Michael Stewart was born on May 9, 1958, to Millard and Carrie Stewart of Fort Greene, Brooklyn. The Stewarts had left Kentucky three years earlier, during the Second Great Migration. Mrs. Stewart, a short woman with a thin smile, worked as a public school teacher. Mr. Stewart, whose tall, thin frame his son would inherit, was a veteran of World War II and Korea and now worked for the Transit Authority. Michael was the eldest of four children, all raised in a two-story home on a block of old brownstones within arm's reach of the Brooklyn-Queens Expressway.

What Michael loved, from the time he was a little boy, was to draw. In elementary school his passion was obvious. "He would write imaginary stories and illustrate them," his mother said years later. "He started sketching on paper napkins or drawing on top of photographs, or doing strange kinds of things that maybe you wouldn't really call painting—or even artistic—but he started making things that seemed strange to other people but made sense to him."

Michael wasn't academically minded, but he gave higher learning a try. After a year at City College, he enrolled in a summer program at Pratt Institute, a four-year university in Brooklyn that had graduated many eminences in the worlds of music, film, and fashion. There, he further developed an interest in art, working backstage on sets. Even after the program was over, Michael continued to orbit Pratt's campus, which wasn't far from the Stewart home. Sometimes he'd come straight from his job at the phone company, still clad in a dark blue jumpsuit and gear, his locs tucked under a hat.

On an October night in 1981, a pair of Pratt students were at the Mudd Club in Manhattan to see the band Liquid Liquid. One gestured to Michael, who was wearing a Joy Division T-shirt. It was easy to notice Michael, who stood out in predominantly white spaces. The student knew him as the deep and sotto voce host of a show on the campus radio station, WPIR.

Located on the first floor of the Willoughby dorm, WPIR had become a home away from home for Michael. Its deejays were divided into two

camps: the art students, who played punk, rockabilly, and the like; and the engineering students, who preferred disco. Michael aligned himself with the art students. Allergic to the chart-toppers, his crowd gravitated toward the abstruse. Michael fit right in, collecting albums from labels like England's Rough Trade Records, which distributed the Raincoats and a Certain Ratio. His musical tastes, said an awed deejay, "were pretty reaching at that point." It didn't bother anyone that Michael had a radio show despite no longer being a Pratt student.

After his show was over, Michael would hang around the station, dancing along to music in the listening room adjacent to the studio, or making faces at whoever was on the air. Late at night, after the security guard stopped checking up on them, the deejays would gather to drink, play records, and make out.

In those years, Michael would leave home, portfolio in hand, to return in the early morning hours after a night of drinking and dancing. Dancing was an activity he particularly loved. He and Cheryl Ricelyn "Rice" Jackson, a close friend of several years, entered contests around Manhattan: at the Ritz, the Peppermint Lounge, Save the Robots. Wearing fashionable clothes they made themselves with scraps found in SoHo dumpsters, they would do spins and dips in sync to Blondie and Talking Heads. No matter how hard they tried, the pair always finished second. "Every little beat, every little intonation of a song, of a record—even if we'd never heard it before—he could hit that beat, he could hit that note," Jackson said. "The music was just inside of him." (She and Michael would watch *Looney Tunes* with contemporary music on, so the escapades of Bugs and Elmer Fudd would sync in funny ways.)

To his friends, it was obvious that Michael loved music, but the pull of art had intensified in his life. By 1982, he was developing his own style, creating murals at street level and drawing on Polaroids that he would then glue to Manhattan subway walls—a sort of public installation. And he began entertaining visions of making art on a larger and larger scale, with the idea of blowing up photos and painting on them.

Artists at the time considered New York as one colossal canvas. Michael, too, engaged in more traditional tagging in the subway stations. On at least a dozen occasions, after finishing work at the Pyramid, he and Arthur "Chino" Ludwig, who was in charge of the club's security, went out on the town with

cans of spray paint. Michael favored green, yellow, and black. "We would go all over the place," Ludwig recalled. Union Square, Forty-Second Street, to Second Avenue and Eighteenth Street on the F line. Sometimes they'd venture as far as Fulton Street in Brooklyn.

During these outings, while Michael worked, Ludwig stood guard. It was well known that police targeted taggers. Still, despite taking precautions, Michael and Ludwig had the occasional close call. One night, they went to 138th Street in the Bronx, not far from where Ludwig's mother lived in the projects. At Third Avenue, flashlight in hand, they walked along the tracks for about a quarter of a mile, until they reached an old station. It was lit up and covered with graffiti. Other taggers were there, too, and they knew Michael. All was well—until the police arrived. Everyone scattered. But not fast enough, and several of their number were arrested.

On these nights, as Michael sprayed, he and Ludwig would talk about family, girls, the crazy Pyramid patrons, drugs, and their life aspirations. As Ludwig remembered it, "He wanted to go on and be real famous. He wanted to do *giant* murals across the country. He wanted to travel to Germany. He wanted to go to Prague. I mean, he spoke about the world and how he wanted to just travel and become famous and do *that*. That was his goal. He really wanted to be worldwide.

"That was his end game."

If Michael wasn't yet one of the Fab 500, he planned to be.

September 14, 1983, a Wednesday, had been a typical day for Michael. That afternoon, he biked across the Brooklyn Bridge.* He spent time at the studio he rented. Later, he met up with his sometime girlfriend Suzanne Mallouk, for drinks at Lucky Strike. He was special to Mallouk, an intense twenty-three-year-old, stylish in her oversize clothes, with short dark hair and bangs clipped just above the eyes. She tended bar at the Berlin, where Michael visited her on many nights to play tic-tac-toe and eat olives and cherries from the bartenders' supply. They had known each other for over a year, having

* That's the recollection of Patricia Pesce. However, in a 1988 interview with an attorney, Millard Stewart said he last saw Michael at 8 p.m., which suggests that Michael would not have been in Manhattan so early in the day.

met the summer before, at the Pyramid. At the time, Mallouk was broken up with Basquiat, who was just emerging into fame. Mallouk and the artist had had an on-again, off-again relationship, and after one of their breakups, she began to date Michael, even as she continued to have deep feelings for Basquiat.

Mallouk thought Michael was handsome and caring, but mostly he reminded her of her younger brother. She had real affection for him, but she didn't love him. Meanwhile, Michael adored her and was awed by her proximity to Basquiat. The year before, when Mallouk had been hospitalized over the holidays for pelvic inflammatory disease and confined to bed with an antibiotic IV drip, Michael visited her every day. On New Year's Eve, he kept her company in the hospital room, and the two rang in the New Year together.

Michael had lived with Mallouk for a while in her apartment on the Lower East Side, but then she asked him to move out, as she realized that her love for Basquiat made it impossible for her to be "fully present" in their relationship. So, Michael left, moving back in with his parents in Brooklyn. But the two stayed close. That night at Lucky Strike, Suzanne apologized for how she kept flitting between the two men. "Yes, yes," Michael had said, stroking her arm. He was understanding, unfussed.

After leaving Lucky Strike, Michael had met up with George Condo, a visual artist, and a friend of Condo's named Freddie. The trio tried to get into a party at Haring's Broome Street loft, which had become something of a quasi nightclub in the neighborhood. Haring, known for his vibrant white-chalk-and-ink drawings of faceless people and barking dogs, was a big deal, having been anointed by Rene Ricard, pursued by Warhol, and exhibited at Patti Astor's Fun Gallery, *the* new locus of the city's contemporary art. The artist, acting as the evening's doorman as well as its host, had bounded down from the third floor when they arrived. Haring knew Michael from around the Pyramid, and well enough for a greeting and a salutation hug. Condo and Haring eventually would become close, but at the time, they hardly knew each other. It was Freddie who was the real obstacle to the group's gaining entry—he'd swindled Haring out of a thousand dollars, and the painter was still angry. Haring refused to let the group in.

So, the three men had moved along to the Pyramid Club instead. When they

arrived, Basquiat was standing outside. Condo asked if he could borrow some money, and with the painter's ten dollars, Condo and the group went inside.

Michael seemed to enjoy the show, listening to music and drinking with his friends. While he appeared relaxed, his financial situation at the time was fraught, and a source of anxiety. Two months earlier, he'd been fired from his thirty-five-dollar-a-night gig as a busboy at Pyramid. He had lacked the aggression necessary to ruthlessly wade through a crowd to empty a table or ferry a tub of glasses held high above his head. Michael wept when he got the news. He liked his colleagues, after all. One coworker had brought him back to her house for home-cooked meals. Another partied with him at Danceteria. She had vivid memories of their trips home on the A Train and had been immensely bothered that, in a crowded subway car, Transit Authority police always, somehow, ended up standing next to Michael. "It's all right," he'd tell her. "Don't worry about it." And he'd been close also with the Pyramid's regulars, with whom he would dance until daybreak. Sometimes he'd go straight home afterward, but sometimes he'd head into the subway, can of spray paint in hand.

In the two months since being fired, Michael had drifted. Still, despite his precarious finances, he expected brighter days ahead. Aside from modeling jobs, like the one he'd done for Dianne Brill, he was deejaying, too, and that might prove a source of steady income. Just a month before, he'd spun records at a party thrown by Maripol, who'd earned acclaim as a fashion designer and photographer—capturing intimate Polaroid portraits of Warhol, Grace Jones, and Basquiat. Michael had also deejayed occasionally at the Pyramid, and as he told Pesce, he was set to play at Lucky Strike in a few days.

Whatever pressures or optimism he may have felt, he'd stayed at the club long enough to watch the night's featured performer, Tanya Ransom, a progenitor of punk drag. Afterward, in an unusually garrulous mood, Michael had sat talking with former coworkers. "He seemed to be all bubbling," one of them later said. He'd then stopped by the dressing room to see Ransom. Michael may have had a few beers, but to the performer, he seemed "fairly lucid."

Afterward, Michael called Patricia Pesce.

3 Glasgow

Bellevue Hospital may have had a storied history of storied patients, including Saul Bellow, Charles Mingus, and Lead Belly. But the leviathan of Kips Bay, hugging the river on Manhattan's East Side, was just as famously known as a hospital of last resort.

As a publicly funded hospital, and in sharp contrast to its private counterparts, Bellevue would not—could not—turn anyone away. For this reason, it was the destination for all manner of "undesirable" cases. In 1980, a man walked into the hospital with what turned out to be Kaposi sarcoma, a type of cancer associated with a little-known (or -understood) disease eventually termed acquired immune deficiency syndrome. By 1983, AIDS was still mysterious, and its sufferers (mostly young gay men) often cloistered on Bellevue's sixteenth floor. This was a period of intense fear in the medical profession over the virus that caused AIDS, a fear born in part of ignorance about viral transmission. Despite their stature, Bellevue physicians weren't immune to showing prejudice themselves, and sometimes they refused to treat patients who tested positive.

Bellevue was also the terminus for police who were injured on the job, and for the victims of the violence police inflicted. This was how, around three in the morning on September 15, Michael Stewart ended up being wheeled into Bellevue Hospital on a gurney, surrounded by men in uniform. A Bellevue policeman stationed near the entrance was struck by the situation, as he'd never seen so many police at one time. It was obvious as soon as the patient reached the emergency room that he wasn't breathing. His chest didn't rise or fall.

A nurse later wrote in her notes:

> This black male present at the triage desk in company of transit police restrained X4c̄ [arms and legs with] handcuffs in prone position face down on stretcher padding. Obvious head trauma noted-cyanosis of face and both hands; bilateral hematomas above temporal areas c̄ [with] bilateral battle signs. Unresponsive to verbal and tactile stimuli. Taken to rm. 6 via stretcher.

Michael's face was swollen, and had blue splotches. The nurse put an oxygen mask over his mouth, called a code, and screamed for physicians. The doctors' attempts to resuscitate Michael were delayed, however. The handcuffs impeded the removal of his clothing, and the police officers who'd brought him in couldn't find the key. This meant that, for the time being, Michael was left on his stomach hog-tied, the air from the oxygen mask unable to reach his lungs. After some minutes, the Bellevue policeman stepped in to "manipulate the handcuffs," as he put it. This freed the patient.

Michael was repositioned onto his back, and emergency treatment could begin. David Pizzuti, the doctor directing the response, was a third-year resident at New York University Medical School who moonlighted in the Bellevue ER.* He was startled by the unconscious patient's youth and what appeared to be previously good health. Patients that age tended to be overdose victims. Having no idea how long Michael had been unconscious, Pizzuti was somewhat optimistic that the team could revive him, even though a check of his vital signs revealed neither a heartbeat nor a pulse. The team immediately intubated Michael, put him on an IV, and over the course of the code, administered oxygen, drugs, and electric shocks. The task at hand was saving his life; what had imperiled it in the first place was not their proximate concern, and they knew that an autopsy, if it came to that, would reveal all. In any case, Pizzuti observed blood in Michael's ear, suggestive of head trauma, and a bruise over his left eye.

The environment was controlled chaos, but the ER team adhered to proto-

* Dr. Pizzuti transitioned in 2015 and is now named Dana. She requested that she be referred to as David in the text, to preserve the consistency of the historical record.

col. Eventually, the physicians managed to revive and stabilize Michael's heart functions. But he still could not breathe on his own. Once admitted to the intensive care unit, he was placed on a ventilator.

Around 4 a.m., a resident checked on Michael, now stripped to the waist. In addition to bruises around the eyes and behind the ears, the resident observed horizontal bruising on the neck. An accompanying nurse examined Michael as well. She, like others on the floor, had heard stories about the events of earlier that morning—that the patient had been restrained by police, that he'd fallen down some stairs. But in her experience as an ER nurse, that scenario was not consistent with the patient's injuries. There were bruises all over: the face, the neck, and on the arms. And there were, in her opinion, bilateral "Battle signs"—bruising behind the ears at the base of the skull, indicative of a skull fracture.

Once a CT scan of Michael's head was taken, he was examined by neurosurgery resident Duncan McBride. It was, by then, 6 a.m.

The neurologist on call had reviewed the CT scan and decided it was essentially normal. However, he'd wanted a second opinion, to be certain that Michael didn't have a head injury or require surgery. That was when McBride was called in. Only a couple of years out of medical school, he was already used to providing care in the maelstrom of the emergency room. If a patient had a neurological issue, McBride treated them. Police brutality, he recalled, was not a rare occurrence: "People would get the baton to the head and have to have a neurosurgeon."

McBride agreed with the on-call neurologist's assessment of the scan: there were no blood clots or lesions. The scan also revealed neither trauma to the brain itself nor (in apparent contradiction to what the nurse had seen) a fractured skull. However, McBride did observe considerable swelling on the left side of Michael's head, severe impairment of the brain stem, and an absence of neurological function. The swelling suggested that Michael had banged his head hard on something, but evidently not hard enough to crack the bone. McBride administered a series of tests that indicated Michael's reflexes weren't working. On the Glasgow Coma Scale, on which 3 indicates the severest lack of response and 15 the mildest, Michael scored a 3.

McBride removed the respirator for thirty seconds to see if Michael could breathe on his own. He could not.

Hours later, William Cole, the chief medical resident, came by. He'd examined Michael earlier. Upon removing the cervical collar, he found black-and-blue marks on both sides of his neck, each mark the size of a fat pencil eraser.

Cole had never seen bruises like this on a patient. "You moonlight a million hours in the emergency room, but you often don't come in with strangle patients with billy club marks across their neck," he recalled.

The chief medical resident also saw bruises above Michael's right eye, behind his ear, and along his right shoulder and the right side of his torso.

At three o'clock that afternoon, McBride examined Michael again. Now that the cervical collar was gone, the neurosurgery resident could more clearly see the pattern of swelling around the young man's head and neck, which suggested to him an anoxic brain injury. This type of injury is caused by a lack of oxygen to the brain rather than, say, a blow to the head or the use of physical restraints. In McBride's opinion, Michael's condition could be explained by pressure applied to his neck, which would have deprived him of blood flow or air flow.

McBride was quite certain that his patient had been strangled, and he discussed this possibility with Cole. The senior doctor was less sure. "We all *thought* that there was some problem with his airway," Cole would say. It seemed unlikely, however, that if Michael had been strangled and consequently suffered a cardiac arrest—either before he was put in an emergency transport vehicle or while en route to Bellevue—that resuscitation would have been possible.

When he revisited the case decades later, what stood out to Cole was how much about Michael's condition was simply unknowable. "It's all conjecture," he lamented. "You don't have a smoking gun."

McBride, too, was aware of the uncertainty, which would only be exacerbated in the weeks to come. Michael was going to be at Bellevue for an extended stay, and that would further complicate the question of his injuries, as some might begin to heal, fade, or become obscured by interventions during his hospitalization.

This would, soon enough, be a major problem.

4 Berserk

Suzanne Mallouk, Michael's intermittent girlfriend, got a phone call from Michael's mother early on the morning of September 15 asking her to come to the Bellevue Hospital emergency room. Her son was under arrest. Mallouk asked why he was in Bellevue, then, if he'd been arrested. Mrs. Stewart didn't know.

The sun had barely risen over Fort Greene when two Transit Authority officers arrived at the Stewarts' door to inform them that their son had been hospitalized and was in critical condition. This was not the first time Michael's parents had had to suffer through intense fear and panic over one of their children. Seven years earlier, shortly before Michael's eighteenth birthday, his younger brother David had gone missing. Two weeks later, his body was found in the East River, near Pier 5 in Brooklyn Heights. According to an autopsy, the teenager had drowned; there were no signs of foul play.

At the hospital, Mallouk found that the Stewarts still had not been told much about Michael's condition or the circumstances of his arrest. The lack of specifics was perhaps not a surprise, given that Michael had been misidentified by the hospital upon his arrival as an "unknown white male."

Frustrated, Mallouk approached the emergency room visitors' desk and insisted that, as Michael's fiancée (which she was not), she had the right to see him and to know what had happened to him. Just after being informed that she wasn't entitled to such information, she was approached by a plainclothes detective. *Did Michael do drugs?* No. *Was he known to be violent?* Certainly not. Mallouk was upset by this line of inquiry and asked the detective

questions of her own; he professed to know nothing. She was suspicious and asked why Michael was under arrest and if he was going to die.

In a whisper, the detective said, *Yes.*

Returning to Michael's parents, Mallouk asked Mrs. Stewart if they were acquainted with any civil rights attorneys. It turned out they were: Louis Clayton Jones, whom the Stewarts knew from back in Kentucky, was now in practice with a lawyer named Michael Warren. (Attorney Alton Maddox Jr. was later added to complete the legal team.) The attorneys showed up at the hospital within hours. They retained Dr. Robert Wolf, a Mount Sinai internist, to consult. As Mallouk and the Stewarts were escorted to a private room, the lawyers and the internist were taken to see Michael.

Wolf reviewed Michael's chart and X-rays, then examined him under the cervical collar supporting his neck. Michael's spine, he saw, was intact, but there was a two-and-a-half-centimeter-long contusion in the front of his neck and bruises all over his body; pads had been placed over the young man's closed eyes.

When Wolf returned, he sat with Michael's parents.

"There are so many things wrong with your son. You should hope he dies," he said. The doctor confirmed that Michael was brain-dead, that he'd incurred a cerebral hemorrhage caused, it appeared, by strangulation, perhaps from a choke hold or a nightstick. Furthermore, there were markings all over his body, over his wrists and ankles in particular, indicating that he had been handcuffed and shackled.

Word of Michael Stewart's arrest and assault began to surface in the tabloids. The following morning, September 16, *Newsday* published an Associated Press dispatch on page 35. Rife with misinformation, the story would set the tone for coverage of the incident and its aftermath.

> A Brooklyn man who apparently went berserk while Transit Authority
> officers tried to arrest him for writing graffiti on a subway wall had to be
> rushed to a nearby hospital after he lapsed into what is believed to be a
> drug-induced coma, a TA spokesman said.

Michael Stewart, 25, lapsed into a coma while the officers were transporting him to Bellevue Hospital for psychiatric observation, TA spokesman Ed Silberfarb said.

Although they did not know what caused Stewart to begin kicking the doors, windows and police when they arrested him, Silberfarb said the officers later found cocaine in his possession.

The *Daily News* picked up Michael's story as well. Rev. Benjamin Chavis said that Michael had been "beaten ruthlessly" and that the Manhattan District Attorney's Office had been briefed. The paper quoted an unnamed Transit Authority spokesman—almost certainly Silberfarb—who claimed that five officers had had to "subdue" Michael after he became violent. The spokesman pointedly declined to divulge how Michael was subdued or why he was comatose.

During this time, Suzanne Mallouk was doing some work for the artist and stylist Maripol, who had been pulled in to craft Madonna's signature look for her debut album. Mallouk also worked at Fiorucci, a "daytime Studio 54," as it was often called, that counted among its regulars Warhol, Calvin Klein, and Truman Capote. Later that morning, though, she cut her own hair, bought a plain-looking blouse and skirt and a cheap string of pearls at a thrift shop, and borrowed a friend's camera. Then she returned to Bellevue.

Mallouk went to the sixteenth floor. The prison ward apparently lacked facilities sufficient for a patient in Michael's condition, so he was being housed on the same floor as many of the city's AIDS patients. Michael, fingerprinted and handcuffed, had a bed among the afflicted.

He had been charged with a slew of misdemeanors: criminal mischief, obstructing governmental administration, resisting arrest, attempted escape in the third degree, and possession of marijuana. These were curiously innocuous charges, considering that hours before, the Transit Authority spokesman had publicly accused him of possessing cocaine and assaulting a police officer, both felonies.

Mallouk, in her "disguise," encountered a policeman waiting outside

Michael's room. "Sir, mister, he is my boyfriend," she said. "Sir, mister, please let me in for two minutes. Please, sir, please, mister." Her entreaty, and the conservative outfit, proved persuasive, and he let her by.

When she stepped into the room, she was greeted by the smell of decay. She pulled back the sheets covering Michael and snapped photographs, keeping her camera obscured by a coat. She documented each mark, each little trauma. Her friend's gauzed head. The cuts on his swollen face, the bits of glass. His red eyes rimmed with black. The bruised chest and legs. The wounds on his ankles and wrists. The respirator in his mouth and the tubes coming from his nose.

The situation was unfathomable to Mallouk, a Canadian who had never even seen a homeless person before coming to New York. She was from a country where, so far as she knew, "the government and the police would protect you." As she looked at her friend, her understanding of America shifted.

Later, Mallouk gave the photographs she'd taken under the shield of her coat to the Stewarts' attorneys. They'd prove useful. No one else had thought to document Michael's wounds in this way.

Capt. Leonard Pezzillo had gone on duty at 11 p.m. on September 14. He'd entered the precinct, District 4, through a set of double doors on the mezzanine level of the Union Square subway station. As the tour commander, and the highest-ranking person on shift, Pezzillo was expected to respond to emergencies. About five hours into his shift, he was notified that an emotionally disturbed person had been arrested for graffiti by his officers, who had transported the prisoner to Bellevue Hospital.

Pezzillo called District 4 for an update around 5 a.m. and then went to Bellevue. There, he met with hospital personnel and John Dempsey, a Transit Authority detective who'd been on night watch in Brooklyn when he got the call about a prisoner in cardiac arrest en route to the ER. At the hospital, Dempsey interviewed Michael's parents, who'd arrived from Brooklyn. He also interviewed doctors, one of whom told the officer he believed Michael had been beaten and that the police were already covering it up.

Dempsey reported all this to Pezzillo, who then contacted District 4 and demanded that the officers involved in Stewart's arrest remain at the station;

if they were out, they should return. As the captain saw it, he'd explain, this would "kind of freeze the incident so I could determine which path to go."

Back at District 4, around 5:50 a.m., Pezzillo called the Transit Authority Police Department's Inspectional Services. The division, distinct from the NYPD's own, much larger operation, consisted of four units: Civilian Complaint, Field Investigative, Inspection and Review, and Internal Affairs—the last of which was responsible for investigating all allegations of Transit police misconduct.

The Transit captain spoke to the night duty officer there about what he'd heard so far. Ten minutes later, the two spoke again. During this time, Pezzillo also spoke to Capt. Jerome Donnelly, his counterpart in Inspectional Services, who reported directly to the Transit Police chief. Pezzillo told Donnelly that the prisoner was in a coma and that Transit Authority detectives and patrol were on-site at Bellevue. This didn't persuade Donnelly, who said that, absent a civilian complaint, Inspectional Services couldn't take action. Investigating the arrest and handling of prisoners was, he said, the responsibility of the Transit Police. In effect, the people closest to the incident would be responsible for investigating it, but Pezzillo was assured that Inspectional Services would monitor the case.

Shortly after 7 a.m., Pezzillo received a call from Sgt. Thomas Dunn, the duty officer from Inspectional Services. Dunn informed the captain that the Detective Division, rather than Inspectional Services, would conduct an investigation along with the Manhattan district attorney. Which was, frankly, odd. This seemed the very definition of a police misconduct allegation. But Dunn, echoing Donnelly, believed Inspectional Services should not involve itself in the matter absent "definite information that a person had made a complaint against a police officer."

The rationale for Inspectional Services' inaction didn't satisfy Carolyn Burke, who came on duty at 7:25 a.m. Burke was a sergeant in the Detective Division. She was an experienced officer, one who'd worked robberies and dealt with the city's steady stream of pickpockets and "dicky-wavers." She once worked out of District 4, where women were still sufficiently scarce that a ladies' room and designated locker room were novelties. Dunn tasked Burke with heading the investigation and asked that she keep him apprised.

Burke believed that giving the case to the Detective Division was a mistake—not because she thought the Transit officers had caused Michael Stewart's coma. Far from it. As she saw it, if the investigation weren't handled properly, there would always be cause for doubt in the mind of the public. That was reason enough to perform an investigation quickly and by the book. This meant Inspectional Services taking the lead. It was their job—by statute, in fact—to handle accusations of police misconduct.

Meanwhile, Dempsey, the detective over at the hospital, reported back to Burke. She'd learned that the young man at Bellevue had been arrested for graffiti, had an altercation with officers, and that his medical condition was dire. Burke knew that even absent a civilian complaint, this was sufficient for Inspectional Services—and not the Detective Division—to handle the investigation. Burke called Dunn.

As Dunn recounted in the Inspectional Services call logbook: "She advised me that Det. Dempsey advised her that the male is "brain dead"; but apparently this condition was not caused by any beating. However, the male has apparent choke marks on his neck. The male's family is at the hospital." Dunn underlined "not" in his notes because, in his view, this was exculpatory. Still, even with the news about the choke marks, Inspectional Services wanted no part in the investigation.

In Burke's experience, the situation was unprecedented. Never had she known Inspectional Services to refuse to investigate a case. Sometimes she wouldn't even have to call them; they'd show up on their own initiative. Decades later, she theorized as to why this case was different. "I'd put it off, at first, to being lazy," she mused. "The people who went on to that side [Inspectional Services]—what cops called 'the dark side'—were usually people who didn't want to be cops. They wanted something easy." It wasn't sinister, in her view; just an average workplace passing of the buck.

Still, this inaction had significant repercussions for the Michael Stewart case. By late morning on September 15, Inspectional Services knew that Michael had suffered brain death while in police custody; that Bellevue staff alleged he'd been beaten; and that there were possible choke marks on his neck. Despite being asked by Pezzillo and Burke, separately, to take the case over from the Detective Division, the department had refused. This decision carried the

authority of James Meehan, the Transit Police chief, who signed off on it that very same day. As a consequence, no effort was made to expeditiously interview the participants in the immediate aftermath of Michael's arrest.

An investigation was, however, under way. At 11:30 a.m., about eight hours after Michael was hospitalized, assistant district attorneys Stephen Saracco and Peter Kougasian arrived at District 4. The New York City Transit Police, aware that Inspectional Services had refused to get involved, had been calling the Manhattan District Attorney's Office for hours.

Saracco and Kougasian talked to some of the officers, who were joined by their representatives from the union, the Patrolmen's Benevolent Association. The involvement of the DA's Office in the investigation unnerved the PBA's president.

One of the PBA representatives on the scene was District 4's Peter Marsala. In his decade as a Transit officer, Marsala had been the subject of nearly two dozen civilian complaints, the large majority for acts of physical brutality. Indeed, he'd been indicted on charges of striking five men over a three-and-a-half-year period. The charges stemmed from assaults committed during arrests for minor violations or misdemeanors. A Queens man smoking in the Broadway-Nassau station had received a blackjack to the head that left him with permanent brain damage. In another case, a Manhattan data processor who had the temerity to question some minor traffic infractions with which he was being charged was handcuffed and taken down into the District 4 restroom. When the man declined to cooperate with a strip search, Marsala, in the words of a judge, "flew into a rage, took out a blackjack which, incidentally, is a prohibited weapon for an officer to carry, and proceeded to hit the victim with it several times on the face and head. In addition, [Marsala] pulled out some clumps of hair from the victim's scalp, kneed [him] in the groin, and grabbed him by the tie which caused a choking sensation." Marsala's fellow officer, Charles App, reportedly pulled him off each victim. Rather than disclose Marsala's actions, App falsified memo books. The violence was then covered up by District 4 sergeants as well, who, according to a prosecutor, "winked at [Marsala's] conduct." As a consequence, Marsala lost thirty days' pay and was on modified duty as he awaited trial.

The ADAs' questioning of the officers involved was of limited use: at no

point since Michael was admitted to Bellevue were the officers separated so that their accounts could be taken. Instead, they had been left alone, which gave them the opportunity to confer with one another. As a consequence, a rather obvious question would be left open: In the hours prior to the arrival of the ADAs, did the Transit officers discuss what had happened in Union Square and collude on a story? In subsequent years, several officers averred that they had done nothing of the sort—that, upon the advice of Marsala, they had remained silent until they could be interviewed. Marsala, however, could not recall imparting such guidance.

But the very fact that the step was never taken to separate the officers meant that, even with the involvement of the District Attorney's Office, a thorough, accurate investigation into the events of that morning was now impossible.

Four days into Michael's coma, a congressional hearing on police brutality was held in Harlem. Chaired by Rep. John Conyers, the Democrat from Detroit, the hearing was staged at the 369th Regiment Armory on Fifth Avenue. Among the attendees was Mallouk, accompanied by a group of artists.

The timing was, of course, a morbid coincidence. In June of that year, a delegation of Black community leaders had met with Conyers in Washington, D.C., presenting the congressman with a list of nearly four hundred incidents involving New York City police over a two-year period. They explained that tensions between Black New Yorkers and the NYPD were threatening to boil over. Attempts to address the issue had not worked. The community leaders decided that federal intervention was the only solution; a public airing of the issues was, they thought, the first step toward fixing the problem.

A hearing was scheduled for July in Harlem, but on the very first morning, it had imploded. Just as congressman Major Owens of Brooklyn was launching into his opening remarks about the violence of the police regime in Philadelphia, fostered under the city's notorious mayor, Frank Rizzo, a woman began to scream from the audience: "They killed my son! Eight bullets! They killed my son!" This was the voice of Shirley Roper, a Black woman whose son had been shot to death by three officers after allegedly attacking the police with a knife. The hearing was canceled after Roper's

outburst. Rep. Charles Rangel of Manhattan accused Roper of being "a professional who was deliberately attempting to disrupt the hearing."

New York City mayor Ed Koch had been scheduled to testify at the thwarted July hearing, but he refused to participate once it was rescheduled. During his tenure, the mayor had thus far pointedly declined even to acknowledge systemic police brutality, and he called the September hearing "a circus" that was "aimed" at him. New York City's police commissioner, Robert McGuire, evinced a similar antagonism, suggesting that Conyers "could well have started the hearings in his own hometown of Detroit."

The opening witness at the second hearing was Donald Shriver, who served as the president of Union Theological Seminary in Manhattan's Morningside Heights. That April, a graduate student from the seminary, a Black man named Lee Johnson, had been driving with friends on Lenox Avenue when two white officers stopped his car and asked for his driver's license, insurance, and registration. When Johnson asked why he had been stopped, the police responded with profanity. After Johnson identified himself as a member of clergy, an officer opened the car door and hit Johnson in the face and leg, then pulled him from the car. He was handcuffed, struck with a nightstick, thrown against the vehicle, then taken under arrest to the Twenty-Eighth Precinct. There, police called him "nigger" and mocked his religion. "I don't believe in that shit anyway, Reverend," they told Johnson. "You don't pay no taxes anyway." In a station stairwell, still handcuffed, Johnson was choked and kicked by the arresting officers. "I am going to teach you a lesson, nigger," one said. "When you open your mouth, nigger, you had better say Sir."

That night, Johnson was released. No charges were filed.

The beating of the seminary student received days of coverage in the New York newspapers and was a catalyst for the hearings. As Shriver told the congressional committee, the coverage of Johnson's assault inspired other victims to come forward and recount their own brutalization at the hands of police. The violence Johnson had endured was clearly not an isolated incident. "This very phenomenon should be of great interest to this committee," Shriver said. "If Mr. Johnson's problem with the police were a rarity, would all this public interest have stirred?"

After Shriver concluded, Representative Rangel, in reference to Mayor

Koch, said that the seminary president's testimony should shatter "any myth that anyone may have that this was a circus."

The audience was packed with hundreds of Black New Yorkers. Over the course of the day, they watched as dozens of witnesses testified to act after act of violence. A woman wept as she recounted the beating of her cousin by Transit police and presented the subcommittee with the bloody blouse her cousin had been wearing. A mother of three recalled how she and a friend were accosted by police, with no provocation: "The guns were in our heads and our backs." A Brooklyn man testified how, after losing his wife in a terrible accident, he'd been kicked by an officer in the stomach.

Rev. Herbert Daughtry, chairperson of National Black United Front, was one of the hearing's organizers. During Daughtry's testimony, he shared a litany of cases that had occurred in New York City: Randolph Evans, a teenager shot and killed by police in front of a Brooklyn housing development; Arthur Miller, choked to death during a traffic stop; Luis Baez, shot by five officers twenty-one times after he allegedly lunged toward them with a pair of scissors. Then Daughtry told the members of the subcommittee of a recent case. "Just this past Thursday," he said, "Michael Stewart was severely beaten by New York Transit police officers after he was handcuffed." The reverend continued: "Here was a young 25-year-old handcuffed, scars up and down his legs, his neck is out this big, his head is bloated out, on his body are scars. You have to ask if the man was handcuffed, why did he need to be beaten? If he was beaten, why did he need to be handcuffed?"

After seven hours, the hearing concluded.

For his part, Koch remained unapologetic about his refusal to attend the hearing. "When you are polarizing the city on a racial basis, then you are doing damage to the very fabric of the city and you have to be condemned," he told reporters the next day. "This"—by which he meant police brutality—"is a phony, false issue."

5 The Talk of the Day

By the early 1980s, Andy Warhol's days as the silk-screening enfant terrible of the New York art world were two decades in the past. Now he was a father figure (a "culture parent," as Rene Ricard put it) to younger artists voraciously seeking his approval. Indeed, Warhol was often the reason they'd moved to the city in the first place. Simply being in his presence meant that life had handed you pocket aces. As one New Yorker observed of the era, "If you were at the right party, the party you were supposed to be at, then Andy Warhol was there."

Warhol was there, often, because of his acute radar for younger talent willing to be nurtured by him. It was a mutually beneficial relationship, of course. As he'd note more than once to his young admirers, "I'm living my life through you." One artist rewarded with Warhol's attention was Keith Haring, who'd idolized the older man since his days in art school. The two had met at Fun Gallery in February 1983. Warhol had been impressed with Haring's ability to promote his work and, therefore, himself, and he subsequently introduced the wiry go-getter to a leading art dealer.

Warhol wasn't as quick to recognize the genius of Jean-Michel Basquiat, who, at nineteen, approached Warhol while he was dining with curator Henry Geldzahler at a SoHo bar. Basquiat was carrying postcard-size works. "Show it to the Commissioner," Warhol had said. Geldzahler returned the postcards, pronouncing Basquiat "too young," but Warhol bought one anyway, for a dollar. It would be several years before he'd take Basquiat on as a protégé.

Toward the end of August 1983, Warhol rented his East Village carriage

house to Basquiat, hoping the pricey arrangement (four thousand dollars a month) would induce productivity. Otherwise, Warhol wrote in his diary, his tenant wouldn't have the money for rent and would be subject to eviction.

Warhol needn't have doubted. Basquiat was ascendant and had been for a while. The prior March, the twenty-two-year-old had a solo show in SoHo and another the following month, at Larry Gagosian's gallery in Los Angeles. In a matter of months, Basquiat would return to L.A. in preparation for another show, and stay at the Venice home of Gagosian, still several years away from opening a gallery in New York. His then girlfriend, Madonna, visited as well, so Gagosian took the pair to his mother's house for Christmas Day. Then the trio spent New Year's Eve together.

The Gagosian show was a success. "He piles up rich palimpsests of paint over black grounds or snazzy oranges that are structured with architectronic [sic] solidity," the Los Angeles Times raved. "There is never any sense that Basquiat is faking. We are simultaneously convinced that he is a tough street-voodoo artist and a painter of astonishing precosity [sic]."

Basquiat finished out 1982 with his work exhibited in galleries abroad and at home. Then, a landmark: the next year, his paintings would be on display at the Whitney Biennial. The famed exhibition (which had been staged annually until the early 1970s) had introduced to the world a half century of new artists: Jackson Pollock, Georgia O'Keeffe, Edward Hopper, Ben Shahn. It was a format that inevitably favored youth, but even among the new cohort, which included Keith Haring, David Salle, and Cindy Sherman, Basquiat was the youngest. By summer, his gallerist Mary Boone was pricing his work in the low six figures—an almost unimaginable development from only two years earlier, when Debbie Harry, lead singer of Blondie, bought a painting of his for two hundred dollars.

It was far beyond the work Basquiat had produced as a teenager with Al Díaz, a pal he'd made at the City-as-School, an alternative high school in Brooklyn Heights, and with whom he roamed the Lower East Side. Díaz was from Manhattan, while Basquiat was Brooklyn born, though he and his family had spent a couple of years in Puerto Rico, too. One night, as the two smoked marijuana, Basquiat mused that the drug was "the same old shit."

"Imagine this," he said to Díaz: "selling packs of SAMO!" The tag was

road-tested in the school newspaper, but quickly migrated to buildings, rest-rooms, and across SoHo and both sides of the Village. SAMO became a fixture, and a mystery, to the extent that the *SoHo News* ran photos of the graffiti tag, inviting readers to unmask the artist. Basquiat and Díaz sold their story to the *Village Voice* for one hundred dollars instead, and in a December 1978 profile, the paper captured some of the hundreds of SAMO aphorisms: "SAMO© AS AN ALTERNATIVE TO GOD, STAR-TREK, AND RED DYE NO. 2"; "SAMO© AS AN END TO MINDWASH RELIGION, NOWHERE POLITICS, AND BOGUS PHILOSOPHY"; "SAMO© AS AN ALTERNATIVE TO JOE NORMAL BOOSH-WAH-ZEE FANTA-SIES"; "SAMO© SAVES IDIOTS."

Michael Stewart and Jean-Michel Basquiat were both handsome Brooklyn-born Black men who wore their hair in short locs, made art, and dabbled in graffiti. They moved in the same circles, and both appeared in music videos. They'd both been in love with Suzanne Mallouk. The resemblances were in some ways superficial, in other ways deep. The circumstances of Michael's hospitalization, happening a month after Basquiat had moved into Warhol's carriage house, came as a terrible shock to the artist. For the rest of his short life, whenever the subject of Michael arose, Basquiat would say, "It could have been me."

Even before word got out in the papers, news of Michael's condition began to circulate in the East Village. It jolted everyone who knew him; the vio-lence of the assault felt exponentially more shocking when contrasted with Michael's gentleness and exponentially disproportionate, given the alleged offense. Shock quickly turned to anger at the injustice. The outrage spread from Michael's friends and coworkers at the Pyramid into the wider Manhat-tan art world. He was one of their own. They had to do *something*.

A group of art world luminaries converged on the Wooster Street loft of powerhouse critic Edit DeAk. Born in Budapest, DeAk managed to escape communist Hungary and make her way to New York. She had luminous eyes, red hair with a curtain of bangs, and wore her clothes in such a way that, as the writer Janet Malcolm put it, they seemed to "have a sense of quotation marks around them." Her influence seemed to be felt everywhere: DeAk had a hand

in the creation of Artists Space, the Kitchen, Printed Matter, and most notably, *Art-Rite*, the underground magazine that lovingly chronicled work beyond the mainstream. Her eye for the new was exceptionally sharp; DeAk was an early appreciator of Kathy Acker and Laurie Anderson and among the first critics to champion the work of Basquiat before it was shown in galleries.

Guests that day at her loft—the walls of which were dotted with paintings and graffiti tags—included Rene Ricard, the writer and Warhol protégé; Diego Cortez, who curated 1981's *New York/New Wave* show, featuring work by Warhol, Haring, and Basquiat; and the writer Duncan Smith, a close friend of Basquiat's. The group was rounded out by Mallouk and the gallerist Patrick Fox, who rented Michael Stewart his studio space. Fox brought three of Michael's drawings to the meeting, in order "to illustrate that this guy was not a graffiti artist, as the news reports were saying."

To the attendees, a few of whom didn't know Michael, the drawings were illuminating. His work had become increasingly sophisticated. He'd recently done a multicolored work of shapes and explosions titled *cacotechny*, a word, borrowed from the Greek, meaning "bad art." The Basquiat influence—the inclusion of funny phrases such as "DANSE LITTL JUDY" playfully scrawled in a drawing—was evident. The art also demonstrated Michael's interest in numerology, with 6, 11, 13, 14, and 17 appearing in a separate work. (He would often carry a notebook filled with numbers and astrological figures.)

Michael, despite dabbling, wasn't actually a true graffiti artist, as his friends well knew. Artists active in the medium couldn't recall seeing him taking part. "I don't remember him tagging with us, or talking about it," said the painter Kenny Scharf. "He was an artist," said Haring, "but wasn't known at all as a graffiti artist." The descriptor being used in the press was a way to flatten a complex young man. In the eyes of New Yorkers, a graffiti artist might *deserve* to be assaulted by police, while it was, perhaps, somewhat less acceptable to beat up a painter or a sculptor.

Graffiti wasn't a recent phenomenon in the five boroughs. After all, the famed long-nosed Kilroy cropped up on subway advertisements as early as World War II. But in the late 1960s and early '70s, the art form was deemed a problem, and its cleanup cost New York City, the Transit Authority esti-

mated, three hundred thousand dollars for a single year. The city's "war on graffiti," as Mayor John Lindsay called it, began in the summer of 1972, when the spitting-mad Lindsay demanded that the City Council pass a bill to make it illegal to carry an open can of spray paint in public. Lindsay's successor, Beame, took up the cause, spending millions to clean the trains. Koch, though, adopted an even more punitive approach, installing razor wire and guard dogs to protect the subway yards—though, he joked that perhaps wolves would be preferable.

Still, graffiti was a medium in which one could be a star outside the galleries. Was it a scourge? Yes, for many New Yorkers, who were only too happy to see the work wiped out. But the art could also be seen as a desperate flip of the bird at the stratified art world, the mayor, the governor, and the entire suppressive system of white hegemony. "It was a scream; it was a yell," said Fred Brathwaite, known as Fab 5 Freddy. "It was just our response to the bias—to the inequality in the city against Black and brown people."

To the extent that Michael was described as a *graffiti* artist, the label magnified the psychic impact of the Transit officers' assault. The actual artists understood the message sent by the City of New York: they were on notice. This was doubly true for Black artists like Brathwaite, who read between the lines of the graffiti characterization. "It was like a chill going through you, realizing that it could be me—it could be any number of people I knew," he'd recall.

The decision to portray Michael as a graffiti artist to reporters and to people in the art world had been a strategic one on Mallouk's part. As she acknowledged decades later, "Because graffiti art was being shown [in galleries] all over SoHo—and it was just when hip-hop was coming into the white East Village culture—I said the way I can raise money is I can call him a graffiti artist. He was killed by doing graffiti, and I'll go to all the galleries and get money. And that's what I did."

The meeting at DeAk's loft was a bust. "We didn't really come up with anything concrete," Fox recalled. "There wasn't even a second meeting."

About those paintings of Michael Stewart's that Fox brought to the meeting: He hadn't had to borrow them. He owned the works, having received them

from Michael in lieu of rent. Fox was in the process of opening the Anderson Theatre Gallery, at 66 Second Avenue, on the Bowery. It would become a way station for emerging artists in the ascendant. But for now, the Anderson Theatre was a home for Fox and a studio for others.

The Anderson's historical trajectory could have happened only in a city like New York. In the 1920s, it had been a Yiddish performance space. Decades later, and only for a matter of months, it hosted rock-and-roll shows, featuring such performers as Janis Joplin, Procol Harum, and the Yardbirds. The shows stopped after the Fillmore East opened, until Hilly Kristal of CBGB fame ran the place for a few years as CBGB Second Avenue Theatre.

By 1983, the Anderson was in its less glamorous iteration, with three floors occupied by artists and aspiring artists toiling above, as Fox put it, "an 1,800-seat theater, with a huge chandelier, a balcony, box seats, and giant proscenium." The building lacked running water, so men had the option of urinating in water bottles, and women in a fishbowl.

Michael's studio was on the marquee level. He was supposed to pay twenty-five dollars a month, but he never had enough money for rent, so he gave Fox, the de facto landlord, artwork instead. Michael's space was in the front; painter Jo Shane's was in the back. Michael's drawings, said Fox, were marked by "slashes of a color"—one from earlier in the year was stark red and black on yellow—as if "he was trying to leave proof of his own existence."

Fox had seen Michael at the Anderson Theatre on the artist's last good day. He was arriving just as Michael was on his way out. Together they had raised the heavy security gate at the front of the building. As Fox remembered it, Michael was in an irritable mood, which was out of character for him.

While the organizational meeting at DeAk's may have gone nowhere, all was not lost. Soon, protests for Michael would gain traction—and through the efforts of someone who hadn't even been at the loft that day.

You could call Howard "Haoui" Montaug, then thirty-one years old, a doorman. But that wouldn't really describe who he was, or *what* he was. Not exactly. Montaug had been raised on Brooklyn's Flatbush Avenue, the son of a stay-at-home mother and a union man who marched against the Vietnam War. At the age of thirteen or so, he was caught trying on his mother's

nightgowns. She was devastated, while her husband wondered if the child's presumed homosexuality was the result of something *he*'d done. Montaug was taken to therapy.

During the summers, the Montaugs rented a Catskills bungalow, and the teenager took roles in every local theater production he could. Even then, his sister would recall, "he always looked like he was ready, not to play ball, but to go onstage."

Montaug went to Boston University for college, where he studied early childhood education; he graduated in 1973. After a spell, he decamped for Europe, was briefly married to an Englishwoman, then returned to New York City.

Montaug had become the hidden hand of the Manhattan art and music world. The curly-haired, brown-eyed man seemed to be everywhere and to know everyone. He had been hired by Danceteria's manager, Jim Fouratt, who later described Montaug as unemployable. Fouratt was convinced that when he hired him as a doorman, he'd given him "the only job he could actually really do." But Montaug did it with gusto. There he was, waving the Beastie Boys into Danceteria when they were still teenagers. There he was, if only for a few months, managing the Lounge Lizards. There he was, according to legend, making Mick Jagger pay six dollars to get into Studio 54.

It was Montaug's decision if a clubgoer was allowed past the velvet rope or spent the night on the sidewalk, and he had strict rules of conduct for would-be entrants. *Don't attempt to bribe the doorman. No public displays of affection. Don't whine.* As one obituary put it, "He maintained order through sheer force of personality and a few choice retorts." Or, in the words of Michael Musto, the longtime *Village Voice* writer, "He didn't take any bull-shit. You couldn't tell him you were somebody or you deserved to get in if you really *didn't* deserve to get in."

Montaug was best known for *No Entiendes*, a cabaret he'd founded in 1981 at Danceteria that had become a monthly showcase for acts ranging from jugglers and fire-eaters to the coolest underground musicians.

The cabaret's production on October 13, 1982, was especially memorable. Soon after the show had begun, Montaug took to the stage in a top hat, bow-tie, and tails and asked, "Now, is everybody ready?" When the crowd of three

hundred yelled in the affirmative, he asked, "Can I hear everybody say 'Everybody'?" The response was insufficiently enthusiastic. "Oh, come on," he said, shifting from side to side. "Wake your fucking selves *up*! Pinch yourselves! Pinch the person next to you in the ass. I don't care what it takes. Just get it done."

After getting the crowd wound up, Montaug introduced the night's featured performer: "*No Entiendes* is proud to present the world premiere of Sire recording artist . . . Madonna!"

Madonna, all of twenty-four, took the stage, backed up by Erika Belle, Bags Rilez, and her best friend, Martin Burgoyne. The four had practiced endlessly, wrote a biographer, with "Madonna always the first to arrive, the last to leave." Her dedication showed, and the performance was effective; the six minutes she performed in *No Entiendes* convinced Sire Records executives that it was worth paying to shoot a video for the artist's debut single.

The evening at Danceteria altered the music landscape, and that was thanks, at least in part, to Montaug. And now, drawing on his familiarity with the demonstrations of the 1960s, he decided to organize a protest of his own. It would be held on the site of Michael's beating, in Union Square.

The afternoon of September 26 was chilly and overcast. On the cusp of sunset, several hundred people, most of them white, were milling around the limestone pavilion on the park's north side. Montaug, that legendary doorman with the soul of an activist, had indeed drawn a crowd. Many had come because of David Wojnarowicz's eye-catching flyer, which had been plastered on lampposts in the East Village: it depicted skeleton policemen beating a handcuffed Black man. Even Madonna showed up. "Everyone from the neighborhood was there," recalled Kenny Scharf, who attended the protest with Keith Haring.

The assault on Michael Stewart particularly resonated for the two artists, both of whom had had multiple altercations with law enforcement while creating graffiti art. That summer, near Ninth Street and First Avenue, Scharf had been accosted by a pair of police: One knocked him to the ground and then pinned his arm behind his back. The other shoved a gun down his throat, mimicking a blowjob. As for Haring, he had been arrested numerous times,

famously so—a year before, footage of him being led away by police, hands cuffed behind his back, had aired on *CBS Evening News*.

A large yellow banner was draped in front of the Union Square pavilion, serving as a backdrop to the afternoon's speakers. On it was written WHY? MURDERED!, in red, and toward the bottom, in black letters, STOP KILLER COPS.

National Black United Front's Michael Amon-Ra, bearded and bespectacled, was the first speaker. He took the mic from Montaug, who was acting as emcee. To Amon-Ra's right, clad in black and with her arms crossed, stood Suzanne Mallouk.

"Friends, brothers, and sisters," Amon-Ra began, speaking without notes:

> Unfortunately, we are gathered here on this occasion not to celebrate, but to again underscore what is *not* a figment of our imagination. To underscore what is *not* abnormal paranoia on our parts. To underscore what is *not* just some *grand* illusions about those that we wish to call inhuman. But is, again, to reaffirm the fact that we are presently a people in this city too often the victims, targets—the actual ones who have to confront the reality of very real police brutality, killings, and other forms of non-peace officer behavior.

Noting the police presence at the protest, Amon-Ra observed that law enforcement engaged in actions that were often "at best" criminal and at worst "vicious and savage."

"Right!" cried a voice in the crowd. There was sustained applause.

Amon-Ra acknowledged the commuters entering the Union Square subway station, then expressed gratitude for the presence of the protesters. (Among media outlets, only a solitary reporter, from WBAI, the progressive radio station in Brooklyn, had shown up.) "If you did not come out on this day and stand here to testify by your presence that Michael Stewart had friends, had neighbors, comrades . . . Michael Stewart would be written down as another statistic to be filed away, to be filed away and forgot." Michael was not, in short, "someone who could just be taken off the planet."

Amon-Ra continued, labeling Mayor Koch a "bald head creature in City

Hall," and calling for police reform. As Montaug, hands on hips, watched him sermonize, Amon-Ra—with something approaching a yell—told the crowd that police lie. They plant evidence. They dehumanize so you're easier to kill. Steps, he said, must be taken to halt the bloodshed. Make the cops live in the communities they police; they must not be occupying forces.

Amon-Ra proceeded to recite names of the dead, including Luis Baez, Arthur Miller, and Claude Reese Jr., a fourteen-year-old Black child from Brooklyn shot by a white officer in 1974. He reminded the attendees that, unless something were done about police brutality, such protests would remain necessary and commonplace. "The struggle must be one that we wage relentlessly, every day of our lives, until New York City is a place where anybody can walk safely, where everybody can walk in peace." He continued: "Until that day comes, there should be no peace in New York City. There *will* be no peace in New York City. We cannot let business go on as usual."

If circumstances did not substantially change, he said, mass civil disobedience—a takeover of the subway, maybe, or a disruption of the airports or an intentional blackout—would be necessary. What mattered was the end result: Grind the city to a halt.

Montaug reclaimed the mic to announce that there would be an "art parade" the next day, starting at 104th Street, to be led by Koch and Bess Myerson, a former beauty queen who acted as the mayor's girlfriend for public appearances. Montaug was not appeased by the prospect of the mayor's participation, and he hissed after he said Koch's name. (Ultimately, 1,300 artists participated in the parade, including members of the "Michael Stewart Friends Committee," founded by two employees of the Pyramid.)

Jeff Weiss, the second speaker, knew Michael from the Pyramid and identified himself as a dear friend. Surveying the crowd, he estimated that two thirds of the attendees were, too. Weiss told the story of Michael's last good night in brief: Patricia Pesce dropping him off at the subway; the altercation with the police; the difficulties with removing his handcuffs after his arrival at Bellevue. There was also the matter of Michael's legal trouble. At his arraignment, said Weiss, the felony charges, such as cocaine possession, had been dropped, and only the misdemeanors remained. The intention, he speculated, was to shield

the arresting officers from an increased level of scrutiny that a felony arrest would have brought. "We just want to find out what happened."

When Montaug worked at the Palladium, he'd been known to calm a rowdy crowd by reciting his own poetry.* Now, on the protest stage, he paraphrased "Reggae Fi Peach," a song written by the Black British poet Linton Kwesi Johnson about a New Zealand teacher killed by police:

> *Everywhere you go it's the talk of the day*
> *Everywhere you go you hear people say*
> *That the Transit police them are murderer, murderer*
> *We can't make them get much furtherer, furtherer*
> *Them killed Michael Stewart, the dirty bleeders.*

Over applause, Montaug exhorted the crowd to make Michael's assault "the talk of the day."

The concluding speaker was Mallouk. She'd been working tirelessly to advocate for justice in Michael's beating, and she looked emotionally spent as she stepped forward. Still, she read with confidence from papers in her hand. "He now rests in a deep, hopefully peaceful state of coma, suspended between life and death," she said. "But as a close friend, I feel his soul has already departed from us and will move among us, making us better and stronger individuals. All we can hope for is that Michael dies with a dignity that he deserves."

Montaug then led the crowd in a chant: *No more murders! No more murders! No more murders!* "Let 'em hear you in Gracie Mansion!" he yelled.

* Montaug's "Doorman Poem" is the lament of a clubgoer who isn't allowed past the velvet rope: "Excuse me excuse me / Who is in charge here / I mean who has the guest list / I must be on it."

I t had been eleven days since a Transit Authority patrolman named John Wolf Kostick, twenty-four, concluded the night's assignment of riding the Lexington Avenue IRT local.

Like all Transit police, Kostick patrolled solo. If he'd gotten the job he wanted, as a City officer, he would have had a partner. But he failed a psychological exam given by the New York City Police Department. "We have in Mr. Kostick a young man who appears very anxious, very unsure of himself," the psychologist wrote. He believed the aspiring City policeman "would have a great deal of difficulty with the pressures involved with police work."

Since 1955, the New York City Transit Police and the NYPD had served separate masters—the 3,200 officers patrolling the subways and buses were under the auspices of a public benefit corporation called the Transit Authority, while the latter force of 23,000 was led by a commissioner answering only to the mayor himself.

Oftentimes being a Transit officer was the fallback, as it was, in many ways, a comparatively unenviable job. For one, the equipment was inferior to the NYPD's: radios often didn't work, which meant officers couldn't reliably request backup. Sometimes, the police didn't even have their own radios; they were given batteries that powered shared radios that were passed from officer to officer. The pay was at parity with their City brethren, but Transit didn't command commensurate respect from either the public or the City police themselves.

Kostick became a Transit officer in January 1982. As he and his colleagues were well aware, the eight-hour shift could be exceedingly dangerous. Three years before, in 1980, a patrolman named Seraphin Calabrese had been fatally

shot in the back and head with his own gun. Nearly four months later, Joseph Keegan suffered a similar fate, at the same subway station as Calabrese. The next year, a man with an extensive arrest record assaulted patrolman William Martin with his own nightstick. Martin would go on to spend the next seven years at Bellevue and suffered the effects of the assault until his death in 2011. "Those things, I think, were always on your mind when you had an interaction with a person," recalled William McKechnie, a former Transit Police Benevolent Association president and a patrolman from 1965 to 1980.

At 1 a.m. on September 15, 1983, Kostick notified his precinct, District 4, headquartered in Union Square, that he was leaving the train. His lieutenant sent the officer to the Canarsie-bound First and Third Avenue stops on the LL Train line, which ran along Fourteenth Street. When Kostick walked through the gate and strode down to the platform, he witnessed an infraction of utter banality: a young Black man was defacing the subway wall with a marker. In all, the alleged graffiti consisted of three three-foot-high letters, either "RAS" or "RQS." (There's some confusion over which it was, and the discrepancy can't be resolved because the alleged graffiti doesn't appear to have been photographed.)

Kostick asked the man what he was doing.

"You got me," Michael Stewart replied.

"Put your hands behind your back," the officer instructed, then handcuffed Michael and placed him under arrest. According to Kostick, he guided Michael up the stairs to the token booth and asked for his name and address.

Michael asked Kostick not to contact his home, as he didn't want his parents to be woken up in the middle of the night. He also told the officer there was an existing warrant for his arrest. This wasn't true and was, perhaps, Michael's way of saying he was already in enough trouble. As Michael stood handcuffed by the token booth, Kostick requested a car to transport them to District 4 headquarters.

KOSTICK: 1st Ave. on the "LL" holding one (1) at booth Harry-8 request RMP. K Shield 2688.

CONSOLE: 10–4.

KOSTICK: 10–4 Central.

According to the token booth clerk, Michael walked quickly up the stairs leading to the street. Here, Kostick's and the token booth clerk's versions of events diverge. Kostick would later claim that Michael *ran* up the stairs in an attempt to escape. Upon reaching the top, he fell face-forward onto the southeast corner of Fourteenth Street and First Avenue. There was then a struggle, during which the officer sat on Michael's legs and, in an effort to subdue him, put a nightstick lengthwise across his back and pushed on it.

However, another interpretation of these events would eventually be offered up: Michael didn't simply fall unhindered. Rather, Kostick chased him up the stairs, caught him by the entrance to the street, and wrestled him to the ground. Once Michael was face down, the officer sat on him.

At 2:57 a.m., Kostick sent a "10–85" call, asking for assistance.

KOSTICK: Central request at 10–85 at 14th and 1st re: holding one (1).

CONSOLE: This is 14th and 1st or 14th and 3rd? Unit where do you want the 85 at 3rd or at 1st? Unit requesting the 10–85 are you at 14th and 3rd or 14th and 1st?

UNIDENTIFIED: 10–5 Central.

CONSOLE: Give me a 10–85 at 14th and 1st at booth H-8 10–85.

UNIDENTIFIED: What line Central is that 10–85?

CONSOLE: On the double "L." Unit at 14th and 1st. 1st Ave on the double "L." Unit with 10–5 come in. Unit with 10–5 come in.

KOSTICK: 14th and 1st Central. I still need that backup.

Within minutes, four Transit Authority officers responded. Anthony Piscola and Henry Boerner arrived first, in RMP 442, a GMC Suburban, followed by an emergency service vehicle containing Richard Locke and Richard Costa. In the officers' telling, the four men got out and two helped

Kostick pull Michael to his feet. The call for assistance was canceled. Once Michael was off the ground, he was walked to the rear side door of Piscola and Boerner's car to sit in the back seat. Kostick sat next to him.

There is yet another version of the events of that early morning, reported by an auxiliary police officer who was on shift at a Blimpie sandwich shop at the northwest corner of Fourteenth Street and First Avenue. Less than a day after the incident, the witness filed a complaint with a detective at a nearby precinct: "He observes a uniformed P.O. come out of the subway with a (male black) who was apparently handcuffed behind his back, the officer was holding by the arm," wrote the detective. "[A] suffel [sic] ensued the officer was assisted by two other officers from a police van, the officers through [sic] the male to the floor and sat on top of him."

Farther into the complaint, it was noted that "the witness changed his statement, this time he stated that a uniform cop came up from the subway with a (black hisp) threw him to the ground, to [sic] other officers got out of a van walked over and sat on top of him, while the other officer handcuffed him. Then he was placed in a van and they drove off."

Locke and Costa drove the emergency rescue vehicle south toward Lower Manhattan. Meanwhile, the GMC Suburban carrying Michael barreled west along Fourteenth Street, toward Union Square. Piscola was at the wheel, with Boerner beside him in the front seat and Kostick in the back with Michael. In a radio dispatch at 3 a.m., the officers notified headquarters that they were en route to District 4.

Before long, according to the police, Michael attempted to kick the two officers in the front seat. Boerner turned around and pushed his legs away. From his seat next to Michael, Kostick seized him, and in the struggle, their upper bodies tipped into the cargo storage area at the vehicle's back. Kostick held Michael down until they arrived at Union Square, where the officers intended to book him for criminal mischief and defacing public property. Piscola parked the vehicle by the stairs on Union Square West and Sixteenth Street, the entrance to District 4.

Boerner exited the front seat and opened the passenger-side door for Michael

and Kostick. Michael got out and, according to the officers, attempted to run south on Union Square West.

The officers would claim that Michael, who at 5'11" weighed only 143 pounds, ran into Piscola and knocked him to the ground. Now caught between a parked car and a stanchion on the curb, Michael was detained by Kostick and Boerner. They held him against the hood of the Suburban. He struggled and fell to the pavement. The officers placed themselves on top of him. Boerner tried to call for assistance on his police radio, while Piscola did likewise with the radio in the car. "Send somebody up forthwith," he said.

It was at this point that Michael began to scream, which was what drew all the observers at 31 Union Square West to their windows.

Officers Susan Techky, James McCarron, and Sgts. James Barry and Henry Hassler were on duty at District 4. Upon getting the call, they ran up the stairs to Union Square. According to Techky, when they got to the scene, Michael was on his stomach, thrashing on the ground. She took the place of Boerner, who had been restraining Michael's upper body.

Barry then threaded his nightstick through the link between Michael's handcuffs, while Hassler and McCarron attempted to cuff Michael's legs together. The officers were able to cuff only the left leg. McCarron went downstairs into the precinct. Officers would disagree over whether he'd gone to retrieve tape or a "stair chair," a piece of equipment used to transport the sick or injured. In any case, McCarron told Lt. Francis Harte about what was transpiring on the street. Harte said that rather than bring Michael to District 4, the prisoner should be taken to Bellevue Hospital and admitted as an EDP, police shorthand for "emotionally disturbed person."

Meanwhile, in response to the call for assistance, two additional cars pulled up to Union Square, carrying, respectively, Officers Noreen Devine and Richard McCready and Locke and Costa. The latter two officers had responded to Kostick's original 10–85 and then driven back uptown.

There were now eleven Transit Authority officers on scene.

Locke put a nightstick across Michael's shins to keep him from kicking, while Costa returned from his and Locke's car with a roll of stretch bandage. Locke wrapped it around Michael's legs, then threaded it through the link in

the handcuffs. Michael's ankles and wrists were now bound together. Four officers then carried him face down to the GMC Suburban. Piscola opened the rear doors, and the officers put Michael into the cargo area behind the back seat. Later, nearly every officer who testified about the incident used the word *placed* to describe how Michael was put into the vehicle.

Piscola drove, with Boerner in the passenger seat and Kostick in the back. Michael was unaccompanied in the cargo area—a contravention of procedure. Kostick would argue that he was able to monitor Michael from his position in the back seat. He'd also claim that, during the ride to Bellevue, the prisoner was breathing. Nearly three years later, in a deposition, Kostick was asked about this:

Q: When you were glancing at him, could you see his face?

A: His face was to the side.

Q: Away from you?

A: No. I saw his face. I'm sure I saw his face, yes.

Q: Were his eyes open?

A: I believe his eyes were closed.

Q: Could you tell whether or not he was breathing?

A: I heard him breathing.

Michael never regained consciousness, and his condition deteriorated precipitously. He suffered multiple arrhythmias and cardiac arrests and had to be shocked back to life. "He just kept trying to die on us," one of his doctors recalled. "This was going on for days. We just kept bringing him back, bringing him back, bringing him back."

There was nothing to be done.

At 5:20 a.m. on September 28, 1983, after thirteen days at Bellevue, Michael Stewart died.

7 The Eyes of Michael Stewart

The work of the chief medical examiner to conduct an independent investigation into a suspicious or unusual death is righteous work. Indeed, it is indispensable to the criminal justice system. The position is prestigious, but one with inherently unpleasant features. For the reward of a public servant's middling salary, the chief medical examiner can become the object of public scorn and the target of reporters' slings and arrows. A despairing Tennessean once characterized it (in language as eternal as it was universal) as a "thankless" twenty-four-hour-a-day calling. "I'd be most pleased," the doctor told the *Knoxville News-Sentinel*, "for anyone to take over the job who wants to."

In New York City, where savaging boldface names was, and remains, a time-honored pursuit, the perils of the position were magnified. How strange, then, that in August 1979, a rumpled, laconic man, comfortable in the chill of an autopsy room but palpably ill at ease with the press, took a six-thousand-dollar pay cut to become the most high-profile chief medical examiner in the country.

For a New Yorker to the marrow, Elliot M. Gross's appointment was a homecoming. Gross, born in Manhattan in 1934, was a graduate of the Horace Mann School, Columbia College, and the New York University School of Medicine. He had aspirations to be a journalist and had written for Max Frankel, future executive editor of the *New York Times*, at his college paper. But given that he was the son of a police surgeon, his interest in forensic medicine was practically congenital. After a detour in the air force, Gross served for several years as an associate medical examiner under Milton Helpern—the famous chief medical examiner whose daughter Gross would

later marry—and personally determined the cause of death in approximately eight hundred homicides, suicides, and accidents. But before he could rise through the ranks of the city Office of Chief Medical Examiner, he needed executive experience.

In 1970, Gross left New York to become Connecticut's inaugural chief medical examiner. For nearly a decade, he built up the office's forensic capabilities and oversaw Nutmeg State autopsies—ranging from a dead jogger to a suicidal cop to the Kennedy-adjacent murder of Greenwich high-schooler Martha Moxley. There was the occasional hiccup, as when Gross forgot to analyze a bite mark on the shoulder blade of a murder victim, an oversight that left investigators with only a photo of the mark once the body had been cremated.

After nine years in Connecticut, Gross came home. He was appointed by Mayor Ed Koch to succeed Michael Baden as New York City's chief medical examiner, which made him the sixth since the creation of the office in 1918. Baden, who'd been classmates with Gross at New York University, had been sacked for poor recordkeeping and judgment—or maybe, as Baden himself believed, because the Manhattan district attorney believed he wasn't "a team player."

Gross, who worked for the commissioner of health, now oversaw a staff of more than 150 and a budget of $3.5 million. The workload was exorbitant, with the office annually conducting inquiries into the death of thousands. It was a period in which the staff was swamped by the dawn of twin epidemics: AIDS and crack. Most of the dead were of little renown, and their autopsies uncontroversial: the Bay Ridge family who succumbed to natural causes; the man who killed himself by swallowing an M-80 firecracker; the hospital patients who died due to a staffing shortage.

Occasionally, a death made news, and by extension, Gross did, too—for better and worse. The medical examiner's work on the case of Helen Hagnes, a violinist who'd been found dead at the bottom of an elevator shaft at the Metropolitan Opera House, helped burnish the office's tarnished reputation. (The perpetrator was an employee at the Met.) Then, in December 1980, Gross was confronted with a case that would change his relationship with the press.

Gross wasn't quick to talk to reporters. The line about coroners—that all that's required to discredit them is to "let them talk in public"—is true, and the same could be said for medical examiners. But after the murder of John Lennon in 1980, a press officer for Koch advised Gross to hold a press conference. This wasn't a task that could be delegated, as the office didn't have a designated spokesperson. The medical examiner was especially reluctant, as the secondary aspects of the former Beatle's autopsy were incomplete: Gross had neither finished dictating the report nor sent samples off to various laboratories. However, the Koch adviser wanted the press conference to be done in time for the six o'clock news. Gross recalled decades later, "I wasn't going to argue with her." Not one to waste words, he told reporters that Lennon was "essentially pulseless" upon his arrival at Roosevelt Hospital.

In February 1983, less than four years into the job, Gross was confronted with a similarly momentous case when Tennessee Williams was found dead at the Hotel Elysée. Gross's preliminary diagnosis was that the playwright had fatally choked on a bottle cap for nasal spray or eye drops. Nearly six months later, the medical examiner—so concerned about foul play, he'd sent Williams's tissue samples to the lab under another name—announced that the cause of death was an overdose of barbiturates. The months between the preliminary and final diagnoses gave Gross the time to discern what had killed Williams, but there was a downside: the unusually long interregnum had bred uncertainty and doubt and allowed Williams's brother to peddle the falsehood that the *Glass Menagerie* playwright had been murdered.

In these two cases can be seen the outlines of Gross's dilemma when faced with high-profile deaths. A quiet man forced to act in public, he found his cautious way of proceeding subject to disruption by sometimes ill-advised, premature communication with the press.

It surely had not helped that the Office of Chief Medical Examiner, like the rest of the city departments, lacked the funds to do its job at an optimal level. The year before Michael Stewart's arrest, several dozen medical investigators were dispatched to assess approximately 10,000 crimes, while a mere fourteen pathologists carried out 6,900 autopsies. This meant that the medical

examiners had about 280 cases each, and the pathologists were on pace to do about 500 cases a year.

The examinations were conducted at 520 First Avenue, in the neighborhood of Kips Bay. On the marble lobby wall was a Latin inscription that, in translation, suggested grim purpose: "Let conversation cease, let laughter flee. This is the place where death delights to help the living."

In the basement, spread across an entire floor, were 126 refrigerated compartments for bodies, a separate room for deceased infants, a storage room for the clothing of homicide victims, and the autopsy room itself. Far from pristine, the space featured broken floor tiles, rusted implements, dust-coated light fixtures, and walls damaged by years of collisions with gurneys.

It was here, in this dilapidated sanctum unbefitting the importance of the labor, that Gross performed the solemn task of autopsies.

In his role as chief, much of Gross's time was filled with administrative duties, which left the large majority of autopsies to be conducted by associates. But the case of Michael Stewart was noteworthy. Because a spotlight would inevitably be shone on the results, Gross chose to conduct the examination himself. To prepare, he requested all pertinent hospital records. Despite the heightened scrutiny, or maybe because of it, he abided by standard protocol: he spent thirty minutes reviewing the doctors' notes, but did not consult the nurses' notes—which contained further information about the damage done to Michael's body. He also examined photographs of Michael at Bellevue, presumably those taken by Suzanne Mallouk. The photos were poorly lit, but Gross thought he saw evidence of injuries caused by blunt force trauma.

Gross took the unusual step of asking Bellevue if William Cole, the hospital's chief resident in medicine, could attend the autopsy. Cole had supervised Michael's care, and Gross wanted him on hand to help him distinguish which injuries were present when Michael arrived at Bellevue and which were likely the result of procedures he'd undergone at the hospital.

Additional supplementary information arrived from a pair of Transit Authority detectives who stopped by Gross's office. Gross neither reviewed the

case file they brought him nor asked the detectives questions about the incident, depriving himself of potentially useful information about what had happened to Michael in Union Square.

It was understood, well before the end, that Michael would die, and the Stewarts were concerned that the autopsy would be a means to a cover-up. To that end, their attorneys asked Gross if the doctors they'd retained, Robert Wolf and John Grauerholz, could attend the autopsy. Wolf was the internist at Mount Sinai who'd been at Bellevue within hours of Michael's hospitalization. Grauerholz was a board-certified forensic pathologist in New Jersey. He was referred to the family by Baden, who had declined the Stewarts' request to consult on the case, citing a conflict of interest.

On September 22, a week into Michael's hospitalization, Grauerholz visited Bellevue to review medical records, meet with floor residents, and examine his patient. He knew that Wolf believed that his coma was the result of blows to the head. Grauerholz was also aware that the day Michael was admitted to Bellevue, nurses had seen Battle signs—hemorrhaging often indicative of a fracture at the base of the skull. But none of the X-rays or CT scans showed a basal skull fracture, and Grauerholz suspected that the presumed Battle signs behind Michael's ear were, in fact, bruises.

Grauerholz decided that blows to the head could *not* account for Michael's comatose state. He also saw no signs of a spinal injury, nor conclusive evidence of trauma or asphyxiation on the neck. The pathologist did, however, see indications in the hospital records that Michael's neck had been "compressed," which would have caused a lack of oxygen. As far as the pathologist was concerned, this could account for Michael's condition even absent a significant head injury.

Neither Grauerholz nor Wolf before him chose to examine Michael's patched eyes. This would prove to be a consequential lapse.

The Chief Medical Examiner's Office took possession of the body shortly after Michael's death was pronounced.

At the last minute, the Stewarts' attorneys had asked if they could attend

along with the doctors they'd retained. Gross called the Office of the Corporation Counsel, which provides legal advice to New York City officials, and was told to follow standard procedure: allow the doctors to attend, but not the lawyers.

As it happened, the autopsy arena was crowded enough at 1:30 p.m. on September 29. In addition to Gross and Grauerholz, Gross's deputy chief medical examiner, Josette Montas, was present, as were detectives Burke and Dempsey. A medical stenographer, Siegfried Oppenheim, was on hand to take dictation from Gross. In the end, the Stewarts' second retained doctor, Wolf, wasn't able to attend because of a scheduling conflict. William Cole, the supervising doctor from Bellevue, wasn't present at the start, as he'd been delayed.

At the outset, Gross looked for the Battle signs noted in the hospital records, but he didn't find the telltale fracture.

Cole arrived an hour and a half in, nervous with regard to the weight his statements would carry. He found a tense atmosphere. As the doctors hovered over the table, Cole pointed out marks on Michael's body. He traced the discolorations made by the intravenous lines used in Michael's treatment at Bellevue. He also documented where on the body he'd seen bruising upon Michael's admission, blemishes that had faded over the weeks of hospitalization. These included bruises around his neck. Grauerholz asked Cole if the marks he'd observed indicated strangulation. Cole said he had no way of ascertaining what had caused the marks, only that they had been present.

As Cole stepped back from Michael's body, Gross admonished him. "You answer *my* questions only," he said. "What you say can come back to you."

Gross would later claim that he had no memory of Cole's pointing out where the black-and-blue marks had been, any talk of strangulation, or his scolding of the young doctor. Nevertheless, it likely happened. Gross would have been acutely aware that, because Michael's injuries were possibly the result of a criminal act, any record of conversations in the room would surely end up in the hands of Manhattan's district attorney.

Grauerholz drew the medical examiner's attention to something he'd spotted about Michael's eyes: reddish-brown splintering called petechial hemorrhages. These were important, as they can be evidence of strangulation or neck compression. Gross photographed the petechiae.

At 8:15 that evening, the autopsy concluded. The examination had lasted six hours and forty-five minutes, far longer than was typical.

There were a few notable occurrences in the aftermath of the autopsy.

After Cole returned home that evening, he repeatedly called the Chief Medical Examiner's Office. He had information for Gross that he'd held back during the autopsy. Gross, back at his office preparing a statement on the day's findings for city officials and the press, didn't return Cole's call for several hours. When they did speak, the young physician told Gross that on September 15, the day Michael was admitted to Bellevue, two emergency room nurses saw Michael raise his head and look around. Cole believed this hadn't happened, that perhaps the nurses misinterpreted something they'd seen, and the incident was not reflected in the hospital records. Cole felt it would have been inappropriate to mention this during the autopsy.

Gross was upset that Cole hadn't disclosed this earlier, and he told him to put the information in the records. Gross planned to notify the New York County district attorney of the incident.

In the meantime, the Stewarts' consulting physicians were seemingly at odds with each other. Grauerholz told the family's attorneys that, as yet, there was no evidence that Michael had died as a result of a beating. When he was left at Bellevue by the police, he appeared to be in good health, the coma notwithstanding. (In other words, he had no underlying conditions.) There *was* evidence of an altercation. But rather than a beating, Grauerholz told the lawyers they should consider, absent other causes, that Michael's death was the result of neck compression. Crucially, this wasn't to discount the possibility that Michael had been beaten, but as the pathologist saw it, the beating was separate from the neck compression—and the latter was the proximate cause of death. In Wolf's view, though, the petechiae on Michael's eye were evidence of strangulation, and he wasn't shy about saying exactly this to reporters. Wolf's eagerness to go public with this opinion so soon after the autopsy led Gross to make a contentious decision that would become forever linked to the case.

Two days after Michael's death, the Stewarts were, in addition to heartbroken, increasingly anxious. Gross had promised they would have possession

of Michael's body no later than the morning after the autopsy. That time had passed. There was one more procedure the medical examiner wanted to perform. He tried to reach the Stewarts' pathologist so that he could be present for it, but failed.[*]

Gross's decision to keep the body a bit longer was made out of impatience to preserve evidence, which became imperative, he believed, once Wolf went public with his opinions on hemorrhaging. Furthermore, he needed an insurance policy if something happened to the as-yet-undeveloped photographs he'd taken at the autopsy.

And so, on September 30, at approximately 12:45 p.m., Gross removed Michael's eyes. He'd performed such a procedure before, notably after a boxer named Willie Classen died after a fight at the Felt Forum a few years prior. The chief medical examiner did not tell his deputy, Josette Montas, why this was necessary, but she understood that her boss was doing it to look for hemorrhages—signs of strangulation. The deputy had seen other pathologists remove the eyes to preserve evidence. It wasn't exactly common, but Montas recalled its being done by Baden, Gross's predecessor, too.

As was protocol, Michael's eyes were placed in a preservative solution called formalin. Gross then sent them off to be processed by an ophthalmologist at Montefiore Medical Center.

It never crossed Gross's mind that there might be fallout from this decision.

[*] In 1985, Grauerholz denied that Gross attempted to contact him.

8 Pressman

The first-floor reception area of the Medical Examiner's Office was buzzing with reporters as wires were run and questions were prepped. Michael's assault had at first received only minimal coverage, but attention to the case was ballooning. A lot of the interest had been stirred up by a bulldog news correspondent prowling the room, silver hair plastered against his head, a sheaf of papers in hand. The man with the striped tie and poorly fitted pants, holding a microphone emblazoned with the logo for Channel 4, was Gabriel "Gabe" Pressman.

Pressman had been at it for years, covering everything from the sinking of the SS *Andrea Doria* to President John Kennedy's assassination to the arrival of the Beatles. He was as woven into the city's fabric as anyone he covered, and New Yorkers loved him for it. "On the rounds for WNBC-TV," a competitor wrote, "Gabe was greeted by every cabdriver, ward healer, mafia don, and call girl from Bronx to Staten Island." This was only a slight exaggeration.

Pressman was born in the Bronx in 1924. Even as a child, he was a reporter, writing and printing the family newspaper on a hectograph he'd been given by his father. After earning a master's from Columbia University's journalism program, Pressman began writing for the *Newark Evening News*. Then it was on to the *New York World-Telegram*, where he was assigned to City Hall and covered a succession of mayoral administrations. By the mid-1950s, after a couple of years in radio, he decamped for yet another ascendent mode of communication: television. He was a local television reporter for WNBC at a time when such a position was just coming

into existence, which made him, at first, something of a curiosity. "Here comes Gabe with his little gray box," Mayor Robert Wagner would say whenever Pressman showed up at Wagner's office, tape recorder always in hand. It would be years before Pressman's competition, WABC and WCBS, could emulate him. But until then, as one profiler noted, "Gabe had the entire city to himself, and he loved it."

Now nearing sixty, Pressman was something of a bellwether; if he cared about a story, every other reporter in New York City would, too. He'd started covering Michael's case a few days after the assault, and he would go on to file dozens of reports before the year's end. At the outset, his competition was mostly the local Black press—the *Daily Challenge*, the *New York Carib News*, and Black-owned radio stations. Pressman's persistence ensured that the rest of the press corps eventually followed suit.

Pressman's career was varied, but one constant was an instinctive distrust of power and those who wielded it. He would say that politicians were guilty until proven innocent. There was little surprise that he'd been drawn to Michael's story and then pursued it obsessively. From the start, Pressman was sure that *somebody* was lying. Recalled his wife, Vera, "He smelled that something was wrong."

The night before the autopsy, Pressman looked into the studio's camera and asked, "Why did Michael Stewart die?" He told viewers about how Michael was beaten and that evidence of this was all over his body. He said that the Transit Authority denied culpability and that the agency maintained that Michael had suffered a mere cut over one eye. But, Pressman told viewers, the medical evidence didn't support the police's preferred version of events.

Pressman had an innate love for public servants, which in his universe meant police, firemen, and even cabbies. That the police were culpable in Michael's death was surely a painful conclusion for someone who truly admired the lawmen in blue, who had even gone so far as to accuse the chief counsel to the Knapp Commission—a mayor-ordered investigation into corruption within the NYPD—of McCarthyism on live television.

"This is not another case of Black activists and the TA police trading

charges," Pressman said of Michael Stewart's death. "It would seem there's prima facie evidence here that someone is *not* telling the truth."

Reporters had been calling the Chief Medical Examiner's Office throughout the day of the autopsy. Gross, reluctantly, decided to release a statement regarding preliminary results. After John Lennon's death, a Koch adviser had suggested that, from then on, the medical examiner hold a press conference whenever his office was getting a lot of media inquiries about a case. Michael's was such a case. The press was out in full force with questions. "There was no way I was going to get out of the building," Gross recalled decades later of the reporters cluttering the first-floor reception area. "They were *camped*."[*]

That evening, after the autopsy, Gross retreated to his office and drafted a statement about his findings for city officials, including the mayor's spokesman. Afterward, the medical examiner showed the statement to Grauerholz, who nodded, and to the Transit detectives John Dempsey and his boss, Carolyn Burke, who had tried to convince Inspectional Services to conduct the investigation in the hours following Michael's hospitalization.

During the autopsy, Grauerholz had provided the detectives with updates on its progress and had answered questions. When, toward the end of the day, Burke asked Grauerholz's opinion on the cause of death, the pathologist replied that Michael had been put into a choke hold. On account of intoxication, he lacked the normal reflex to breathe or even attempt to breathe. Grauerholz's opinion, though, wasn't the one that mattered.

Hours later, in Gross's office, the two detectives read the medical examiner's statement in silence. Gross explained his findings to the detectives so they could notify the Transit Authority police as soon as possible. The medical examiner didn't go into detail, saying only that Michael had become comatose, suffered cardiac arrest, endured pneumonia in the lungs, and that further tests would be necessary.

[*] An adviser to Governor Mario Cuomo was less charitable: "He *allowed* himself to be pressured by the Mayor's Office."

Burke asked, "Is this it, cardiac arrest?"

Gross said it was, pending the examination of the spinal cord and brain tissue.

The detectives left Gross's office. They both felt that the evidence so far suggested that Michael had not died as a result of a beating. As Burke recalled, she and Dempsey hadn't seen the telltale signs—a broken arm, crushed ribs, a skull fracture. Had the cause of the cardiac arrest been drugs? They didn't know.

Pressman had seen the detectives enter Gross's office. Now, upon their exit, he was among the phalanx of reporters who approached them. He asked if they knew what the medical examiner was going to say at the press conference. Dempsey, sleepy-eyed in his checkered blazer, said he didn't—even though he'd just reviewed the statement.

Pressman queried Burke as well: "You spoke about the autopsy? But he is about to come out here to *talk* to us! *Obviously*, he talked to you about the autopsy a few moments before he came out here to talk to us. You think there's anything irregular about that?"

"Not that I can see," said Burke, shaking her head. She was furious at the reporter for finding something inappropriate in her meeting with the medical examiner.

"Well, he's supposed to be the umpire in this," Pressman pushed. "He's not supposed to take *your* side or the family's side. He's supposed to be impartial! And he had *you* in just before he came out to see us. Isn't that strange?"

Another reporter asked Dempsey if he'd seen the press release.

"No, I have not," the detective said.

"You have no idea what the medical examiner is going to say?"

"No idea," Dempsey said.

A photograph of Michael had been taped to the front of the lectern, but by the time Gross stepped up to the bank of microphones, it was gone. The medical examiner had expressed concern to Koch's press aide that reporters might ask questions he couldn't answer, and the aide advised him to simply read the cause of death and then leave.

"An autopsy was performed upon the body of Michael J. Stewart beginning at 1:30 p.m. and concluding at 8:15 p.m.," Gross began.

The cause of death is "Cardiac arrest with survival for thirteen days. Bronchopneumonia. Pending further study."

The autopsy disclosed findings consistent with the hospital course of coma, following a cardiac arrest. While there *was* evidence of healing injuries on the body, the autopsy demonstrated no evidence of physical injury resulting or contributing to death. Further tests, including examination of the brain and spinal cord and microscopic tests, will be performed.

As in all cases where a death occurs in Manhattan after an individual has been in custody, the records and the findings are being forwarded to the Office of the New York County District Attorney, Robert Morgenthau.

Dr. John Grauerholz, who represented the parents of the deceased, Mr. and Mrs. Millard Stewart, was present throughout the autopsy procedure.

"That is the extent of my statement," Gross said.

Then the questions began. Gross did not heed the advice of the mayor's aide.

A reporter pounced on the phrase "healing injuries." What were these, he asked, and what did the medical examiner think had caused them? In his answer, Gross alluded to some "resolving injuries" around the face and some "superficial scrapes, abrasions" around Michael's wrists. His answer was hesitant, awkward, dotted with "uhs." The scrapes on the wrists "would come from, uh, the uh, bindings that may have been on the deceased."

This didn't satisfy the reporters, who wanted to know what had *caused* the injuries to the face.

"Blunt force trauma," Gross replied.

The reporter asked what that meant.

"Injuries from, uh, blunt force," said Gross, who, perhaps noticing the tautology, elaborated: "Exactly how they occurred, the details of the, uh, injuries, uh, of the extent of them, uh, which were not, uh, as I indicated, uh, in my record—in my statement—uh, did not contribute or cause death."

Questions from reporters picked up their pace. Answers were given, but the answers did not illuminate. Pressman methodically tried to pin Gross down.

"Dr. Gross, the ultimate cause of death was cardiac arrest, is that correct?"

"The ultimate cause of death *is* cardiac arrest," Gross replied.

Pressman talked over Gross's answer. "There are *proximate* causes that led to the ultimate cause, isn't that right?"

Gross wouldn't take the bait. "The ultimate cause of death is cardiac arrest, pending further study."

Pressman tried again. "Could the cardiac arrest have been precipitated by strangulation, by force being applied to the patient's neck?"

"Cardiac arrest can occur in a number of different conditions," Gross said. "With regards to this particular case, there was no evidence of injury reflecting a strangulation."

"What caused the patient to fall into the coma?" Pressman asked, monopolizing Gross's attention.

"Coma occurred incident to the cardiac arrest."

Other reporters muscled in, but they, too, were getting little from the medical examiner. The questions piled up. Did the cardiac arrest occur as a result of applied force from the outside? When are the other tests going to be conducted? And so on. After reminding them that he was constrained in what he could say, as he would eventually be testifying in front of a grand jury, Gross pursed his lips and gave them nothing. But the newsmen had column inches to fill. Leonard Levitt, *Newsday*'s dogged police reporter, asked Gross what had caused the cardiac arrest.

"I answered that, Mr. Levitt," Gross replied, "in that cardiac arrest in this particular incident—cardiac arrest can occur under a number of different conditions. I cannot, at this point in time, comment on all those possibilities."

Pressman tried again. "You're not shutting the door on the possibility that his contact with the police, in the thirty minutes that they say they had him in their custody, could have precipitated the cardiac arrest?"

"I am, at this point, not giving an opinion until such time as all of the tests are completed."

Then Pressman asked, "Doctor, was there something unusual in the fact that, just before you came out here to report to us, you met with the Transit police officers?".

"Not at all," said Gross.

"You don't think that's unusual, since you're supposed to be impartial? They obviously have a vested interest, just as the family does."

"The family had a representative present throughout the autopsy, *Mr. Pressman*," the medical examiner said, emphasizing the veteran reporter's name as if he were a misbehaving child or a pocket-size dog.

And then, soon enough, it was over.

The takeaway from Gross's statement and press conference was that there was "no evidence of physical injury resulting [*sic*] or contributing to death," a line that made Levitt's lede the next day.

William Cole, the chief medical resident from Bellevue who assisted with the autopsy, was surprised by Gross's conclusion, that there was no evidence that Michael's physical injuries—which is to say, the injuries inflicted by police—had caused his death.

Decades later, he was blunt: "*Of course* they did something to cause his death!"

More than anyone involved in the Michael Stewart case, Elliot Gross, whose conclusions would determine the trajectory of an investigation and any subsequent prosecution, was subject to criticism—more than the lawyers, more than the district attorney, more even than the police. This was, in part, a matter of visibility. If the Manhattan DA wanted to take questions from the press—to let Pressman treat him like a chew toy—that was his prerogative. As for the police, well, their identities were still a mystery. Gross, then, was left to bear the collective burden.

Not that the chief medical examiner was without fault. Gross was hardly an agile communicator—a key component of the job—and he seemed to believe that the science spoke for itself. His preliminary finding, which appeared to exonerate the police, elicited understandable skepticism of his judgment. And yes, he'd made mistakes before and would make them again.

In a sense, Gross was the scapegoat and would remain so. But the failures in Michael's case were systemic, the result of a starved city with clogged courts and morgues and an embittered police force overwhelmed by daily violence. The situation was well beyond the control of any single person to steer the story in a righteous and just direction.

9 **Madonna**

In 1975, a *Charlotte Observer* reporter on assignment at a dance festival approached one of the participants, a sophomore at the University of Michigan. He sat next to her on a bench, and they talked. She was unusually self-possessed and made the lede of his below-the-fold dispatch for the Sunday paper: "Her name is Madonna Ciccone, and her face matches her name." No mention was made of any musical aspirations, or any hint that she was about to drop out of college and would be in New York City by autumn.

New York City was a fast place; if you slowed down, you risked being trampled. Madonna had just the metabolism, and her intervening years were busy. She studied dance with Martha Graham, ditched her surname, and started performing around town with her band, Emmy. She'd gotten a photo spread in the *Village Voice*, black-and-whites in which, clad in a fedora, she bore a passing resemblance to Ingrid Bergman in *Casablanca*. But it wasn't a glamorous existence. There was the time her nightgown went up in flames, lit up by a Garment District space heater; the dates she went on with "idiots" so she could use their bathrooms; the meals salvaged from garbage cans. The precarity was worth it, though, because she had nothing to lose by making music that pleased only *her*. "That's an important thing," she'd recall, "because it allowed me to develop as an artist and to be pure, without any influences."

Madonna wasn't famous yet, but she'd taken steps to render her eventual celebrity an inevitability rather than a fluke. This relentless focus, this drive, wasn't hidden; just about anyone in the East Village who paid the slightest attention could see that Madonna was too big for that little world, in part because the singer herself evinced a belief in her own wattage. As Michael

Musto later said, "She acted every bit the star even then—even though she was nothing."

In early 1982, subsisting on a diet of mostly popcorn, Madonna would sneak into the studio with her ex-boyfriend from Michigan, Stephen Bray, to make a demo. It consisted of four tracks, written over several weeks: "Stay," "Don't You Know," "Ain't No Big Deal," and "Everybody."

Madonna, every bit as confident as that reporter from North Carolina had observed, was certain they could be hits, given the right audience. That meant the crowd at Danceteria—the Midtown Manhattan club that attracted Warhol, Blondie, Betsey Johnson, and Basquiat. She'd spent many a Saturday night there since moving to New York. Even in that rarified crowd, the platinum blonde stood out. "It was very sudden," Madonna's friend Erika Belle once said. "Everybody asked us, 'Who is this girl?'"

At twenty-four, Madonna had an unusually developed understanding of New York City's tastemakers. In the music scene, few were as influential as Mark Kamins, Danceteria's curly-haired deejay, who considered the club "an experimental melting pot" for music. (It was also a magnet for talent, with the Beastie Boys, LL Cool J, and Keith Haring on staff.) Depending on who's telling the tale, Madonna either seduced Kamins over the course of several days before springing the demo on him or simply handed him the tape and he listened to it right there in the club. In any case, the Danceteria crowd loved it.

Buoyed by the response, Kamins took the demo to Chris Blackwell, the founder of Island Records, who turned it down because, as he later wrote, "I couldn't work out what on earth I could do for her." Then Kamins called upon Warner Bros.' Sire Records and asked the exec to meet Madonna. Michael Rosenblatt, who had signed the B-52's, showed up at Danceteria with Wham!'s singer George Michael in tow. The music exec invited Madonna to stop by his office.

Within days, Kamins and Madonna were playing the demo in Rosenblatt's office at Rockefeller Center. The first track was the thumping but unpolished "Everybody," for which she'd written the lyrics. It's a rhythmic exhortation to party, with a maddeningly repetitive chorus:

Everybody come on, dance and sing
Everybody get up and do your thing
Everybody come on, dance and sing
Everybody get up and do your thing

The three promptly came to terms on a deal—blessed, according to legend, by Seymour Stein, the head of the label, from his bed at Lenox Hill Hospital, where he was recovering from chest pains. The song was rerecorded in a Manhattan studio, released on October 6, 1982, and sprinted up the dance charts.

This set the stage for two pivotal events in the young life of Madonna: the first was an appearance shortly thereafter at *No Entiendes*, Haoui Montaug's popular cabaret; the second was the filming of her debut music video. The label had allocated $1,500 for the production—an amount that was, even then, a pittance. The shoot was at Paradise Garage, a sprawling West Village discotheque, where Madonna had recently performed. After the show, Jordan Levin, a Mudd Club and Pyramid celebutante who'd been invited by Madonna, found herself in a limousine with the singer, Martin Burgoyne, and, by chance, Michael Stewart. As Levin wrote in 2019:

> A limo—she had a limo! She dropped us off at the Pyramid around 3am—we were too hyped to go home. We danced to *Dollar Bill Y'all*, the bass throbbing through the roll in our hips and our smoky, giddy brains, swimming in the dark—the Pyramid was so black, an inky pool whose blackness made it seem bigger than it was. The song thrummed in our veins "dollar bill y'all, dollar bill y'all, dollar dollar dollar dollar dollar bill y'all." Which we didn't have but so what? We had the song. We'd been to the show, ridden to the club in a limo and were rolling in the dark. The night was perfect.

The shoot for the "Everybody" video was a few days later. Given the minuscule budget, it was left to Madonna's friend Debi Mazar to do makeup, while East Village club kids, including Levin and Michael, were brought in to populate the floor in front of the stage.

The twentysomethings received little direction, as the focus was predominantly trained on Madonna and her dancers. Just once, the camera operator descended to the dance floor, giving the club kids visions of stardom. Michael was filmed for just a moment, his arms waving slowly, face set in deep concentration. Fleeting, but impossible to miss.

Nearly a year after the video shoot, within days of Michael's death, Madonna agreed to headline a benefit concert at Danceteria to raise money for the Stewarts.

In the meantime, she'd gotten a bit more famous.

A second single, "Burning Up," was released in March 1983. After that, too, became a *Billboard* hit, Madonna went into the studio to record an album. Reggie Lucas was hired to produce. He'd worked with everyone from Miles Davis to Lou Rawls and with female vocalists such as Roberta Flack and Stephanie Mills.

Lucas took a quick shine to Madonna. Others might have been taken aback by her bohemianism, the producer later told a reporter, but "after hanging out with the Heliocentric Worlds of Sun Ra, Madonna didn't seem particularly avant-garde." When they met to discuss the album, he noticed that, despite the successful singles, Madonna was not yet living a life of luxury. She was staying in Basquiat's painting-cluttered apartment. (She'd dumped the artist several months earlier after finding him at Larry Gagosian's house with an immoderate number of women and cocaine.)

Madonna recorded eight tracks. Most were her own compositions. In the studio, she was disciplined but also had, according to Lucas, a knack for improvisation: "On the tags—you know, the ends of the records—and on 'Burning Up' when she's like 'I'm burning up, *Unh! Unh! Unh!*' me and the engineer were like 'This is great, man!' So we're just like, 'Madonna, do it one more time!' So we kept making her do it over and over."

"Everybody" was the closing track. The rawness of the *No Entiendes* performance had been sanded away and replaced by the finesse of a slew of top session musicians and backup singers.

In April, while Madonna was still working on the album, *Newsday* published a short profile. "I like to stay in the street—if you stay there, you never

get too removed," she told the reporter, who seemed reluctant to believe that "Madonna" was the singer's real name.

The eponymous debut album was released several months later, introducing listeners to "Lucky Star" and the Lucas-penned "Borderline." *Madonna* marched slowly up the charts, cracking the Top 200 in *Billboard* early that September, just a couple weeks before Michael Stewart was brought to Bellevue without a heartbeat. Over the next year, the album would sell nearly three million copies in the United States alone.

Meanwhile, the Stewarts' expenses were mounting, and members of the art world stepped in to reduce the financial burden. Julian Schnabel, Kenny Scharf, and Keith Haring, among others, agreed to donate proceeds from earmarked gallery sales.* "Keith was ranting and raving about this black graffiti artist that's in the papers now because the police killed him," Warhol wrote in his diary. "And Keith said that he's been arrested by the police four times, but that because he looks normal they just sort of call him a fairy and let him *go*. But this kid that was killed, he had the Jean Michel look—dreadlocks."

Haoui Montaug, the man who'd helped launch Madonna's career, stepped in with yet more help. He'd already organized the protest in Union Square. Now he planned a benefit concert at Danceteria and asked Madonna to perform. Despite her presence, not much is remembered about the show except that Madonna was there. She had little or nothing in common with the rest of the acts on the bill, which included performance artist Kembra Pfahler, Cha Cha of Cha Cha Fernandez and the Slumlords, and 3 Teens Kill 4.

The last act, frequently shortened to "3TK4," was founded in the summer of 1980, their name taken from a *New York Post* headline. The original members—Brian Butterick, Julie Hair, Jesse Hultberg, and David Wojnarowicz—were artists who worked at Danceteria, the Pyramid, or both. It was an unorthodox, post-punk group. Wojnarowicz, who'd left the band by the time of the Danceteria benefit, would say he played the tape recorder. As for Hair, she joined the band as a drummer, despite having no experience

* Decades later, neither Scharf nor Schnabel could recall what the earmarked work would have been. The former was somewhat incredulous, telling the author, "My work wasn't selling for very much back then."

on the drums. There was no lead singer, no lead guitarist. "Nobody was allowed to stay with one instrument," remembered Doug Bressler, who was soon added to the band. "We traded instruments off, passed them around onstage. I tried, more than anyone, to hang on to the guitar." Hultberg gravitated toward the bass, and Butterick, who managed the Pyramid, where he performed in drag as Hattie Hathaway, to the drum machine.

The band's music is a boisterous mélange of the Velvet Underground and Talking Heads. Its most accessible recording was probably a cover of Chaka Khan and Rufus's "Tell Me Something Good," which interwove newscast audio about the failed attempt to assassinate Ronald Reagan in 1981. Cultural critic Carlo McCormick likened 3TK4 to "a stripped-down, jagged, art-damaged minimalism that unspooled like the deranged version of Pop you might expect from a talent show in a kindergarten run by sociopaths."

None of the musicians at the benefit played for a packed house, not even its headliner. Madonna's music had not been universally embraced in the East Village, where a number of residents (who were, predictably, a little envious of her success) had rechristened her first Top 10 hit as "Boredomline." The evening's only lasting memory was created offstage, in Danceteria's aggressively unappointed basement dressing room: Madonna stopped by as the members of 3TK4 were relaxing and, depending on who's telling the tale, falsely accused Hair of stealing either her purse or her makeup.

How much money was raised that night, or from the sale of artwork, is unclear. When asked about it decades later, the Stewarts' attorney, Michael Warren, didn't know. Suzanne Mallouk, Michael's girlfriend, estimated the haul at approximately ten thousand dollars, most of it derived from the sale of a single work by Haring.

All that talent had come together in the aftermath of violence. No one, including Madonna, let the music and the art obscure the reason for the event: a gentle, artistic young man whose life had been cut off prematurely. "I thought he was really cute," she said of Michael not long after he died. "He made one really strong impression on me, and that was that he was really fragile."

10 **Stop Protecting Killer Cops**

October 4, the day after the Danceteria benefit, a death notice ran in the *Daily News*. It began: "STEWART—Michael J. Devoted son of Millard & Carrie Stewart."

Michael's body lay in repose at a funeral home on Brooklyn's DeKalb Avenue. A service was held that evening at Emmanuel Baptist Church, as newsmen waited outside. In the East Village, this would be remembered as the last funeral before the deluge of AIDS.

Michael's family sat in the front of the pews, near his girlfriends, a row of young women who stood out, recalled an attendee, because "Mike had a predilection for white girls with red hair." At least a half-dozen friends from Pratt were there, too. It had been only a couple of years since Michael joined them to see New Order perform at the Ukrainian National Home.

That show was the English band's New York debut, and it closed with a nearly eleven-minute rendition of the gorgeous "Temptation." As Michael watched, the vocalist gripped the microphone with both hands, as if for dear life, and held it flush to his mouth. "Up, down, turn around / Please don't let me hit the ground," he sang. "Tonight, I think I'll walk alone / I'll find my soul as I go home."

Sitting now in the church, one of the Pratt kids, a cradle Catholic, was struck by the overt grief and wailing emotion on display during the service. Friends, family, and parishioners filed past the open casket. Michael was dressed in his favorite suit, one he'd recently worn during Dianne Brill's shoot in Mexico. He was wearing so much makeup, recalled a friend, he "almost looked white. It was a very heavy-handed job." The reconstruction of

his face was unsettling—it looked like him, but not really. That was, perhaps, the point, as if the Stewarts did not want to hide the damage done to their son.

Her mourning outfit finished with a pair of fishnet stockings, Suzanne Mallouk placed three bracelets inside the coffin. They were a gift from her father, symbolizing the Christian Trinity. She hoped they would protect Michael in the afterlife.

The next day, a second service was held, in Williamsburg, Kentucky, where the Stewarts were from and where much of the family still lived. Michael was buried in Briar Creek Cemetery, next to his brother David, buried six years before.

Carrie and Millard Stewart had now interred two sons.

Less than a week later, the spirited rage that fueled Haoui Montaug's protest in Union Square migrated fourteen blocks north and four avenues east. A group of young men and women had chosen a beautiful sunny day to picket the New York City Office of Chief Medical Examiner.

This was the idea of the Michael Stewart Friends Committee. The group was founded by Pyramid Club employees Stuart Cox and John Tucker (brother of Maureen, drummer for the Velvet Underground), and counted drag and art legends, a magazine founder, and a filmmaker among its members and supporters.

The fact that Gross had performed a second procedure the day after the autopsy and removed Michael's eyes for testing wasn't widely known. But the committee's organizers, who communicated with the Stewarts' attorneys, were aware of the medical examiner's actions and encouraged to use this information to amplify the demand for Gross's resignation. At least one member of the group saw the extraction of Michael's eyes as "the galvanizing fact" and the seemingly hapless Gross a convenient foil. "Dr. Gross was kind of our sideshow, where we're gonna just bring attention to the case and make him out to be the villain," Cox recalled.

As old ladies walked by, protesters stood outside the building armed with flyers—slightly modified versions of the one created for the Union Square protest by 3 Teens Kill 4 band member, painter, and polymath David Wojnarowicz. Gross was inside, wishing he were elsewhere. Indeed, he complained

to the mayor's chief of staff that, if only his car had a telephone, he could have been warned about the protest while in transit on the FDR Drive.

A man in a leather jacket and shades wore a sign: DR. GROSS STOP PROTECTING KILLER COPS. Mallouk, wearing a black blazer, puffed a cigarette as she spoke to a reporter. She recounted the events of September 15 and described Michael: He was so gentle and sweet, she said, that when they first started dating, she "thought he was gay."

The reporter gestured to a videographer. "May I ask why he's shooting this? What's this for?" It was Franck Goldberg, a young artist from France. Goldberg happened to be acquainted with Liza Béar, a filmmaker in Alphabet City who hosted a public access show on the arts. Béar had heard about Michael's case and had encouraged Goldberg to film whatever he could about it, starting with Haoui Montaug's protest in Union Square. He'd since shot Gross's rambling post-autopsy press conference and the mournful recollections of the Pyramid staff.

As Goldberg filmed, several dozen demonstrators began to march in front of the building.

Michael was murdered, Dr. Gross lies!
Stop protecting killer cops!
Michael was murdered, stop the lies!
Michael was murdered, Dr. Gross lies!
Stop protecting killer cops!

The chants increased in volume and fervor. Yellow cabs glided by as a Channel 4 cameraman surveyed the events.

Gross stole Michael's eyes, but we can still see! We want justice!

The crowd clapped to a beat.

Dr. Gross is a liar!
Unfit for public office!
We want justice! Stop the cover-up!
We want justice! Stop the cover-up!

Michael Warren, one of the Stewarts' attorneys, stood off to the side. Warren had been involved in prior protests, gathering with others outside the Bellevue gates hours after Michael died. There was "an official cover-up" in the works, he'd said. And now, over the din of another protest, he told a

reporter that by removing Michael's eyes, Gross had violated Section 4210-A of New York public health law: an individual who "makes, or causes or procures to be made, any dissection of the body of a human being, except by authority of law, or in pursuance of a permission given by the deceased, is guilty of a class E felony."

The calls for Elliot Gross to resign fell on deaf ears. When the medical examiner made clear he had no intention of stepping down, the Stewarts' lawyers petitioned Mayor Koch to fire him. Not only was it against the law for the chief medical examiner to extract Michael's eyes without the family's consent, they argued, but Gross had done so in the absence of the Stewarts' hired forensic pathologist, John Grauerholz. In their estimation, Gross was guilty of professional misconduct and had acted with "callous disregard for the rights and sensibilities of the petitioner, a black citizen of New York."

A petition with approximately four thousand signatures was served on October 14 at City Hall, delivered by Mallouk. Later that day, a Koch adviser asked the Office of the Corporation Counsel to look into the allegations.

The removal of the eyes was considered forensically significant by the Stewarts' attorneys and the protestors. It was evidence of a cover-up, they believed—an attempt to disappear proof that Transit officers had strangled Michael. There was even speculation, fed to the *New York Amsterdam News*, that the eyes Gross planned to examine during the post-autopsy section might not, in fact, be Michael's.

In truth, Grauerholz believed the medical examiner's actions, while not nefarious, were unnecessary. The presence of petechial hemorrhages didn't make for incontestable medical evidence, in his view. They could occur when the airway hadn't been blocked; conversely, one could have their oxygen cut off and incur no such symptoms. Therefore, the probative value of the hemorrhages to the case was, he thought, "somewhat marginal." At any rate, the eyes had been amply photographed, and any evidence of hemorrhages was documented.

Robert Wolf, the Mount Sinai internist also consulting for the Stewarts, essentially agreed. Though he believed that placing the eyes in formalin would destroy the hemorrhages, he knew that photographs of the eyes had been taken

and, furthermore, that the impressions of the doctors who conducted the autopsy had been preserved. Like Grauerholz, it was the internist's view that the removal of the eyes was a forensic nonissue.

For their part, the Corporation Counsel lawyers believed that the Stewarts' permission wasn't required to perform the procedure, while Gross himself felt he'd acted "totally within my legal authority."

He would not comment further until the release of the final autopsy report.

Gross had sent Michael's eyes to an ophthalmologist at Montefiore Medical Center, Paul Henkind, for processing. But instead of performing his examination there, the doctor had returned to the Medical Examiner's Office with the specimens so that the procedure and the tests he ran could be witnessed. There, Henkind was joined by Gleb Budzilovich, a New York University neuropathologist and consultant for the Suffolk County Medical Examiner's Office; the Stewarts' two doctors; and Gross and his deputy.

The group was there to conduct the further tests Gross mentioned during the post-autopsy press conference—on Michael's brain, spinal cord, and eyes. The conclusions drawn from the post-autopsy section would shape the final report.

The eyes and their extraction had been the subject of pain, anguish, and controversy. People had good reason to believe that Michael's eyes held information that could assist in establishing his cause of death. During the autopsy, Gross had found a hemorrhage in one of the eyes. Now, three weeks later, Henkind also found one.

Next, the doctors examined Michael's spinal cord, which sat on a dissection table. Once it was opened, they found blood in the subarachnoid space. This seemed at odds with what Grauerholz had observed when he examined Michael at Bellevue, when he'd seen no signs of a spinal injury. The blood might indicate force applied to the neck, Grauerholz noted, but he was not willing to draw conclusions about it. Moreover, he did not believe the spinal injury or the blood was evidence of neck compression.

Wolf was more definite in his determinations: he believed the blood in the spinal cord was evidence of a hemorrhage in the skull caused by a blow to the brain. *That's ridiculous*, Grauerholz told Wolf—he'd examined the brain

himself, and there was no hemorrhage present; nor was there anything in Michael's clinical history to suggest brain trauma.

Budzilovich made note of a hemorrhage on the lateral side of the spinal cord and a clot within the blood vessels. He considered this significant and, at Wolf's urging, took specimens. Wolf, though, didn't think it helped determine what had happened to Michael in Union Square. Contrary to Grauerholz, he considered the hemorrhage "trivial" and believed it suggested an injury had occurred after Michael's admission to Bellevue.

Outside the autopsy room, Gross and Budzilovich conferred. The cause of death was an injury to the spinal cord, the neuropathologist said, smacking his palms together to mimic the impact. The injury, he said, was the result of trauma.

Prior to the final autopsy report, Gross would repeatedly ask Budzilovich to confirm that the spinal cord injury had *not* been the result of hospitalization or "respirator brain." Each time, the neuropathologist affirmed his initial, energetically demonstrated opinion. Budzilovich allowed that he could not be certain, of course, but there was no evidence for an alternative explanation.

After the post-autopsy section, Budzilovich wrote up his report. The near certitude he'd shown Gross outside the autopsy room was gone, and in its place were the words "transverse necrotizing myelopathy, recent." This described the death of cells across the horizontal plane of the spinal cord. Gross, noticing that Budzilovich's description didn't account for the cause of death, asked why he had used "necrotizing" rather than "traumatic" to describe the spinal cord injury. The neuropathologist said that he employed the more neutral term (which could be, essentially, synonymous with "respirator brain") because, despite his apparent certainty outside the autopsy room, he could not be so definite under oath. According to Gross, Budzilovich told the medical examiner that, in this instance, "recent" meant "within ten to fifteen days." If one counted back from the autopsy, the range was so broad as to be useless; fifteen days meant Michael suffered the injuries prior to his admission, while ten days suggested they occurred during the hospitalization. Budzilovich later claimed that Gross had misunderstood him; in fact,

by "recent," he meant approximately two weeks. (Grauerholz, for his part, had always understood "recent" to mean within a day or two of death.)

Gross let Budzilovich's softer wording remain in the report. He had no reason to doubt the neuropathologist, who, in his time working for the Suffolk County medical examiner, had examined roughly three thousand cases of head injury. He'd also consulted a number of times for the New York City medical examiner, albeit only once or twice in cases of traumatic injury.

Even prior to Gross's final report, released two weeks after the post-autopsy section, impressions of what had happened to Michael continued to be shaped and solidified by press accounts. This was, in some measure, because Wolf, as he had after the autopsy, talked to reporters. The *New York Post* quoted the doctor asserting that the post-autopsy section had revealed "a large hemorrhage located at the upper spinal cord," which indicated that "vessels were ruptured possibly by a beating." In the *Daily News*, he declared that Michael had been subject to "a force like that of a choke hold."

11 **Radiant Children**

Jean-Michel Basquiat was shocked by Michael Stewart's beating. Known to have used the D Train as a canvas, the handsome, dreadlocked Basquiat was aware that his fortunes and Michael's could easily have been swapped. The artist didn't need to write on subway tile to catch the attention of police; one summer morning, back in their SAMO days, Basquiat and Al Díaz were drunk and chucking bottles when two rookie officers approached and asked the teenagers to produce their draft cards. It was a joke, apparently, and eventually the police let them be. But the possibility of violence was quite real. That understanding may have fueled a Basquiat painting completed in early October, grappling with the ferocious treatment of Black men at the hands of police.

Basquiat had depicted the armed agents of the city before. Coming off the *New York/New Wave*, a February 1981 group exhibition at P.S. 1 that put the painter in the company of, among others, Warhol, Maripol, and William Burroughs—"a coalition of punks," as one critic put it—Basquiat convinced gallerist Annina Nosei to let him participate in a show she was planning. In advance of the exhibit, Nosei gave the artist use of the two-thousand-square-foot studio space in the basement of her Prince Street gallery. (The implications of a white woman installing a Black man in her "underground lair," as Fab 5 Freddy described the arrangement, didn't sit well with some of Basquiat's friends.)

Working in Nosei's studio, Basquiat completed *La Hara*, a depiction of a red-eyed white policeman; and *Irony of a Negro Policeman*, an acrylic and oil stick work depicting a Black lawman in uniform. The latter was displayed in Nosei's

exhibition *Public Address* in October 1981, which placed Basquiat's work along-side that of contemporaries Jenny Holzer, Barbara Kruger, and Keith Haring.

It wasn't just the police and their attendant cruelties that interested the young painter. Basquiat had read *Gray's Anatomy* as a kid and had admired Leonardo da Vinci's anatomical drawing *Study of Arms*. Basquiat's *Back of the Neck*, a painting begun the next year, depicted the police's frequent targets, stripped down to their basic form. Using lines of white, yellow, and red against a black background, the artist showed a spine, a neck, and an arm positioned at a ninety-degree angle, in the style, perhaps, of a "Gable Grip," a choke hold used by police. The gallerist Nosei could see that, while only twenty, Basquiat already had a fully formed social conscience, so she wasn't surprised by the un-apologetically critical interpretation of law enforcement. The work wasn't just about color or design, she marveled decades later; it was about ideas.

Basquiat heard about Michael's hospitalization during a night out at the Roxy. In the middle of the dance floor, a man approached him and whis-pered the news in his ear. The artist, who once estimated that his work was "about 80% anger," reacted with passionate intensity. Later, he drew black skulls in crayon on paper on the floor of a girlfriend's apartment. He was so angry, he punctured the paper.

When Michael died, Basquiat went to Haring's Houston Street studio. The two had known each other since meeting years earlier at the School of Visual Arts. Haring, a student there, helped Basquiat get past a troublesome security guard. Later that day, Haring saw SAMO tags all over the SVA walls and realized he'd hung out with the elusive artist.

At the time, the two ran in different circles. Haring, skinny and ebul-lient, was drawn to graffiti, a form from which Basquiat, a more pensive personality, was starting to distance himself. All the same, there were vital commonalities. Patrick Fox, who knew both men, likened Basquiat to a lion and Haring to a panther—they were, he thought, "different beasts, but in the same jungle." There was, too, a shared work ethic. As one curator put it, these were "manic draughtsmen who drew constantly, whether in the studio, on trips or at the homes of friends and acquaintances."

They became good friends.

It was, therefore, not a surprise when Basquiat, that fall day in 1983, left a

finished painting on Haring's drywall: a silhouetted Black figure bookended by pink-faced, club-wielding police in blue uniforms. Then he left the city, off to Europe for a couple of weeks with Andy Warhol.

According to Warhol, while they were in Milan, Basquiat said he wanted to commit suicide. Warhol, by his own account, responded to this confession of desperation with a laugh, telling his friend he needed to get some sleep.

From Milan, Basquiat traveled to Madrid, where he met up with Haring.

When he returned to New York, Haring sat for a conversation with Rene Ricard. A poet and critic, Ricard had a gift for identifying the era's great talents. In 1981, he contemplated the new landscape in an *Artforum* essay titled "The Radiant Child" and deemed Haring and Basquiat its brightest stars. Nearly two years later, the two talked for an hour, recording the conversation— although, to what end isn't clear. Possibly they were simply filling time until the arrival of a photographer sent to shoot Haring for an issue of *People*.

The men, comfortable with each other, skittered from topic to topic. They talk about the type of black ink Haring was using in his art, which he'd liked enough to purchase while on a trip to Tokyo. Haring also delighted in a recent issue of the *Morning Call* sent by his mother in Pennsylvania, where he'd grown up. The newspaper profiled the artist, running a photo of him, hands in his pockets, posed in front of one of his own murals. Haring noticed something that tickled him.

"They used this photo of me standing in front of this drawing that has this huge dick on it. I can't believe how huge this dick is, but it's lost in all these other lines," he said. "I'm sure they didn't see it." The penis was unmistakably in the upper right-hand corner of the mural. But it was difficult to spot; even the reporter, who made the trek from Pennsylvania to interview Haring in his studio, had been unaware of the image's hidden member.

Ricard asks if Haring's mom noticed the massive penis.

"They didn't say anything about it," the artist said of his parents. "They stopped talking about sex a long time ago."

Ricard looked at a painting on tarpaulin Haring had done earlier in the year. It was of Mickey Mouse and E.T., both respectably erect, the extraterrestrial preparing to penetrate the eager mouse.

The Spielberg creation, Ricard observed, "has an enormous dick."

"It can extend like his neck, you know in the movie, when . . ."

Ricard had not seen the movie *E.T. the Extra-Terrestrial.*

". . . his neck up in the air, the same thing happens . . . he's gotta have a big dick to fuck Mickey Mouse."

"What's coming out of his asshole?" Ricard asked.

"Those are farts," said Haring, who as a child had loved to draw Mickey.

Ricard brought up Warhol, whose fondness for both Haring and Basquiat was well known. "You and Jean are his two favorite artists," the critic said. "I think Jean is a terrible bore." Ricard gossiped about Basquiat paying Warhol thousands of dollars a month to live in his carriage house.

"I don't think that's what's keeping him," said Haring, likely somewhat jealous of Basquiat's arrangement with Warhol.

"Oh, no?" Ricard said. "Andy is very polite. If he's going to keep a boy, the boy is going to pay for it."

Haring acknowledged that this was probably true. But, he said, "I don't want to be kept by anybody."

Ricard said that, initially, he hadn't understood Basquiat's work. It wasn't in the graffiti style.

Haring noted that Basquiat spent his entire life in New York, while he himself didn't arrive until 1978. "I thought it would have been real tacky to come and copy something that I really knew nothing about."

"Graffiti is just that," Ricard said. "It's the New York school."

Haring seemed to agree. "I can see—when I see mothers with little babies on the train, and the baby's eyes are going all over the place. That's where graffiti really starts from. You see the shit when you're six months old, on a train, riding a train. Your eyes go all over the place. There's no way I could start doing graffiti now. . . . It's too late. I can't learn that. It comes from seeing it from the time when you're born until the time when you're in school." (An odd assertion, as Haring had taken to the medium with great success.)

Haring and Ricard talked about the mayor's latest sally in his war against graffiti. Ricard observed, "He was on television a couple of weeks ago talking about graffiti, and how much he hates it."

It was perhaps inevitable that Michael's death would come up, as it was on

the mind of both men. That day, in fact, Ricard, joined by Edit DeAk and Diego Cortez, met with the Stewarts' attorneys to discuss Gross's conduct during Michael's autopsy. As for Haring, not long ago, he'd gone with Michael to a graffiti-related event on Central Park West. Afterward, during the taxi ride downtown, he and Michael talked about how stupid it had been.

Like much of the neighborhood, Haring attended the Union Square protest and had, in the subsequent weeks, kept an obsessive eye on the case's developments. He'd even done a drawing about the incident, depicting a man hanging upside down, legs bound, being beaten. Haring was hesitant to draw images like this, he told Ricard. "Those people are still out there. They're not locked up," he said of the police. For this reason, Haring believed that work depicting Michael would put him in a vulnerable position.

Ricard noted that, in cases such as Michael's beating, it was far easier for white New Yorkers to stick their necks out than it was for Black New Yorkers, for whom it was "so close to home."

As it happened, Ricard had just talked about Michael's case with Basquiat during a visit, but not for long. As the critic recalled, the painter believed Michael "should be let to rest in peace." Ricard, though, felt that someone who died so violently could *not* rest in peace. Indeed, he told Haring, the reason for laws is to slake society's "vengeance for crime, just to ensure, in fact, that people's souls do rest."

Haring believed that Basquiat felt otherwise because, to some degree, Michael had been emulating the painter the night he was arrested. "I mean, Michael wanted to be like Jean-Michel," Haring said. He felt Michael Stewart's case had drawn attention primarily because of his proximity to the downtown scene. "He looked like Jean-Michel. He was Jean-Michel's only real serious girlfriend's new boyfriend."

12 Mr. Morgenthau Declines to Meet

During his tenure as the thirty-fourth district attorney of New York County, Frank Hogan had made it clear he was an unabashed fan of the NYPD. A man of his office traditionally looked favorably upon police, whose cooperation was necessary for a successful prosecution, but Hogan was also pals with the department's top brass and owed his life to men in blue. In 1971, when a machine gun–toting Black Panther opened fire outside his home on Riverside Drive, two patrolmen standing guard absorbed the bullets. Whether out of gratitude or institutional indifference, the district attorney lived and breathed the NYPD and often chose to overlook criminality within the ranks.

Hogan's successor, Robert Morris Morgenthau, took a more nuanced position on the police, whether they be City or Transit. Tall, with glasses that sat heavily on the bridge of his nose, Morgenthau was patrician in bearing and bloodline. But he had a working man's appreciation for public service, formed decades earlier in the crucible of a world war.

Born in 1919, Morgenthau was raised in an extraordinarily accomplished family. His father was Franklin Roosevelt's treasury secretary, and his grandfather an ambassador to the Ottoman Empire under Woodrow Wilson. With schooling at Deerfield and Amherst, the young man was steeped in privilege. Still, he felt the pull of the burgeoning global conflict bubbling up in Europe. Morgenthau had no business enlisting, truly, as he was nearly deaf in one ear. But he faked the hearing test and joined the U.S. Navy a year and a half before Pearl Harbor.

Three and a half years later, on April 20, 1944, off the coast of North Africa, Nazi bombers torpedoed and sank Morgenthau's destroyer, the USS *Lansdale*. Morgenthau was pulled from the sea, but dozens of the *Lansdale's* shipmen perished in the Mediterranean.

Then Morgenthau was sent to the Pacific, where he was the executive officer of another destroyer, the USS *Harry F. Bauer*. For nearly two months, the *Bauer's* crew was pummeled by Japanese pilots—thirty-seven air attacks in total—and somehow all escaped with their lives.

Morgenthau came out of the war with a deep and expansive appreciation for those who served others, whether they be doctors, farmers, or waiters. (He was, in this limited way, similar to Gabe Pressman.) For Morgenthau, a chronicler later said, "it wasn't macho or anything like that; he didn't give a shit about people who risked their own lives. It was choosing public service—choosing community—over the individual."

The Boss, as his staff called him, ran on intuition. "Trust your gut, follow your instincts," he'd tell the ADAs. Not much of a talker nor prone to ultimatums, he didn't need to be domineering or demanding. But if the Boss went after something, he'd persist until he was satisfied. Morgenthau, an associate once said, "was merciless in pursuit of a goal."

When it came to police, Morgenthau was appreciative of their service. Chasing criminals on behalf of the public was a job he understood, and it had been his mandate ever since President John F. Kennedy appointed him U.S. attorney for the Southern District of New York. He did not diminish either the work of the police or the job itself, but he did not possess his predecessor's blind loyalty to the institution. Recalled one of his assistant district attorneys, "Mr. Morgenthau made it clear to anyone who would listen that he had an obligation to prosecute criminal activity, whether that criminal activity was committed by a street thug, a police officer, an elected official, or anyone else."

As district attorney of New York County, a post he'd held since 1974, Morgenthau had a kind of power that was unmatched in the city. Arguably, his reach surpassed even that of the mayor. Beame, Koch—it didn't matter; the Boss would remain in office long after they left Gracie Mansion. Yes, Morgen-

thau had to run for reelection every now and then, but New Yorkers adored him. This job security gave him the latitude to wield unique influence on laws and even the criminal justice system itself.

Three weeks after the autopsy of Michael Stewart, news trucks and reporters, including the indomitable Pressman, congregated outside Morgenthau's office. That morning, several dozen residents of the Stewarts' neighborhood stood in protest. Along with friends and neighbors of the Stewarts was a lawyer for the NAACP, pastors, New York City councilwomen, activists, a future deputy mayor, and representing the East Village art world, Diego Cortez, the charismatic curator of the *New York/New Wave* exhibition. It was a distinguished group and a show of strength.

For a while, the group discussed strategy. It was important, they decided, to position themselves as a liaison between their community and the DA. As cameras flashed, they went inside, took the elevator to the eighth floor—Morgenthau's floor—where they were shepherded into a conference room. A member of the group inquired, "Are we being sequestered?"

Some took seats around a table; others squeezed in behind them. Reporters stood on the room's periphery.

Mary de Bourbon, a spokesperson for Morgenthau, came into the room. She informed the group that Louis Clayton Jones, one of the Stewart attorneys, had misled them. There was no meeting scheduled that day with her boss. "Mr. Morgenthau declines to meet with this group because he felt it would be inappropriate, in view of the fact, as I've already said, that the investigation is very active." The DA, the spokesperson said, had agreed to meet with Jones, the attorney of record with whom he'd been in communication.

Michael Harris, pastor for Emmanuel Baptist Church, where the Stewarts worshipped, spoke up. "Mrs. de Bourbon, you understand that Mr. Jones wrote a letter at our request," he said calmly. "And we understand that Mr. Morgenthau has, in the past, met with citizens. Can you explain why, this time, he will not meet with us?"

De Bourbon said that, to the contrary, Morgenthau was quite pleased to meet with them, just not about Michael Stewart's case. Indeed, the district

attorney had met with members of the group before "to discuss recurrent conditions in your precincts, or to discuss problems which are plaguing your constituents." Still, he would have to decline that day's meeting, as it was, she said, long-standing policy not to talk about a pending, active investigation.

"Mary, you're talking about two issues here," replied C. Vernon Mason, another Stewart attorney, as a Channel 7 microphone hovered near his face. "One is the issue of police brutality. Michael Stewart is the most recent, tragic example of that. Mr. Morgenthau met with Reverend Butts, myself, and Alton Maddox to discuss *cases* that were pending at the time." (Calvin Butts was pastor of Harlem's historic Abyssinian Baptist Church.) The attorney went on to cite several instances when he and the DA had conferred, including after the death of Donald Wright, a Black teenager shot and killed outside a Harlem shoe store by an officer in December 1980. "There is certainly precedent within the last two years for Mr. Morgenthau to meet with citizens to discuss these issues."

As de Bourbon looked on, the attorney expressed concern that the initial listing of the cause of death as cardiac arrest had led to a halfhearted investigation of Michael's death. This, as well as years of negligence on the part of police and the District Attorney's Office, had engendered skepticism that Michael's case would be no different. "*That's* why we want to meet," he said. "We're talking about a recurrent condition. We're talking about an issue of *brutality*, the most recent example of which being the death of Michael Stewart."

Reverend Harris interjected with a request: that a grand jury be convened to conduct an investigation into Michael's death.

As it happened, Morgenthau's office that very day announced its intention to do just that. This would happen within a few weeks, de Bourbon said. She estimated that the investigation would conclude within a month, but of course it could take longer. It was the prerogative of the grand jury to pursue its lines of inquiry as long as it liked.

Mason asked de Bourbon if the officers involved in Michael's death intended to waive immunity and submit to questions from the grand jury. She declined to answer.

"One of the concerns about cases like this," said Mason, "Michael Stew-

art is *public* now. Everybody knows he's dead. Police officers *always* become anonymous after these things happen. We don't even know their *names*." The police's testimony would be vital, he said, especially given what he viewed as discrepancies in the findings of the medical experts.

De Bourbon wouldn't comment on this, either, but she took more pointed questions, some regarding the grand jury. The group, however, still wanted to hear directly from Morgenthau.

"Where is he? We want to talk with him," said Rev. Herbert Daughtry, who had been rallying public response to Michael's case since Stewart's admission to Bellevue.

As de Bourbon went to the district attorney's suite of offices on the other side of the hall, the men and women around the table chatted. De Bourbon returned. The Boss's position was unchanged. Daughtry chastised her for conveying a message that Morgenthau could have delivered himself.

"Even *if* there were some matters he would not want to discuss, he could have simply said, 'That is not within my purview at this time to discuss,'" said the reverend. "But he *should* have. It is *unforgivable*. It is utter *disregard* of a people. It is a dereliction of his duty. It is *contempt* for him to sit in his office and send you out here to speak to—"

"He didn't *send* me out here," de Bourbon said as Daughtry continued to talk. "Sir, I chose to *greet* you, rather than turn you away at the doors, because *I* didn't know you were *coming* here today!" De Bourbon's eyes were wide and pleading, her composure tenuous. She had been working for Morgenthau since 1977 and would later remember how out of her depth she felt during this meeting. She hadn't realized how strong the anger was running through the group, and as she stood there, it was coming upon her how right they were to be angry. "I thought everybody could accept that we would do a full and fair investigation," she recalled. "But given the history that people of color have experienced, I didn't get it. I didn't understand that."

In the first months of 1983 alone, Black New Yorkers had seen Henry Woodley Jr. shot to death by a Housing Authority policeman in Harlem; Larry Peoples kicked and hit around the head and neck with a gun by Bronx narcotics officers, who feigned shooting him in the head and then refused to provide attention for his injuries; Larry Dawes killed after City police drove

onto the sidewalk, rammed his moped, then beat him; the police beating of seminary student Lee Johnson; and Cornelia Muamba thrown against a wall and cuffed by two Transit officers after she tried to prevent them from assaulting a kid who jumped the 125th Street turnstile.

And so on, month after month.

Some of the group asked to make an appointment with Morgenthau or, as before, to have the DA see them immediately. They began talking over one another. It got to be too much for de Bourbon. "I'm not going to go running back and forth like a wild woman all day!"

"We would like you to run back and forth because somebody has lost their life," Diego Cortez shot back. "I think it's worth running around a little bit, *on your feet*, over a matter of somebody's death."

All told, the group assembled for several hours.*

Morgenthau quietly left via a private elevator and went home. But the following day, he gave the attorneys a meeting. Over two hours, they spoke of their doubts about the chief medical examiner's impartiality.

"Additional information concerning the conduct of the Office of Chief Medical Examiner has come to our attention," Clayton Jones wrote to the district attorney a few days later. "This information, along with a plethora of other evidence of an official cover-up in the case of Michael J. Stewart, prompts us to request a postponement of the grand jury process pending a comprehensive review of the entire circumstances of that case."

The lawyers remained skeptical of Morgenthau as well, and the distrust wasn't without merit. Even if one stipulated that the man was uniquely skilled at the job and had a liberal's good intentions, those intentions slammed into the reality of what it took to indict a policeman, never mind obtain a conviction. They'd seen it again and again. The Manhattan district attorney couldn't even convince a grand jury to hand down charges for the white officers whose abuse had led to congressional hearings on police brutality.

Morgenthau declined the attorneys' request and empaneled a grand jury.

*The *Daily News* reported that the protest lasted for four hours, but the *New York Times* put the estimate at two hours.

13 The Gross Report

On November 1, 1983, thirty-four days after Michael's death, Elliot Gross sent Robert Morgenthau the final autopsy report. The chief medical examiner had, in some ways, grown more tight-lipped over the past month: this time, he refused to give the Mayor's Office a preview of his conclusions.

Maybe this was a result of pique. Not even two weeks earlier, a Koch adviser had spoken to the corporation counsel about reviewing Gross's work. Or possibly the medical examiner was simply being circumspect, as he'd soon be appearing before the grand jury. Whatever the reason, Grace Mansion would learn the results of Michael's autopsy along with the public—from a statement Gross sent out over the wires.

Gross wasn't just annoyed with the Mayor's Office. He also resented how certain reporters had treated him, and he had decided to take a retributive attitude toward the press as well. The morning after he shared the autopsy results with Morgenthau, the chief medical examiner telephoned a few favored reporters to give them information about the case. This attempt to exert control backfired when other journalists got wind of it and angrily showed up at Gross's office to insist on a press conference. The Mayor's Office, perhaps as payback for his stinginess with information, told Gross to accede to the press's demand.

And so, just as he'd done after the autopsy, the chief medical examiner of New York stepped up to a bank of microphones. With a massive black-and-white aerial photo of Manhattan, a sliver of his fiefdom, as his backdrop, he gripped the lectern.

Every local news station was present.

Gross began by regurgitating the initial findings, announced the day after Michael died: that the cause of death was determined to be "cardiac arrest with survival for thirteen days. Bronchopneumonia. Pending further study." He reiterated that the examination performed two weeks earlier had been of the brain and spinal cord.

Now, he told reporters, a cause of death had been reached. "The final cause of death," Gross said, "is upper cervical transverse necrotizing myelopathy." He continued, using a battery of medical terminology: "Cardiac arrest with survival for thirteen days. Ischemic cerebral necrosis. Bronchopneumonia. The upper cervical transverse necrotizing myelopathy refers to a physical injury to the spinal cord in the upper neck. The ischemic cerebral necrosis refers to the condition of the brain resulting from absence of oxygen following cardiac arrest."

Conspicuously, there was no mention of Michael's eyes or any specifics about what, exactly, had caused his heart to stop beating in the first place. Nor did the medical examiner make mention of the notable fact that his deputy, Josette Montas, had refused to countersign the final autopsy report, believing she lacked sufficient information to establish a cause of death.

It became clear now how much Gross's findings were shaped by Gleb Budzilovich, the New York University neuropathologist whose counsel he'd sought. The medical examiner had chosen to abide by Budzilovich's official conclusion, that the damage to the spinal cord was the cause of the cardiac arrest. It's a measure of Budzilovich's influence on Gross's thinking that the medical examiner would eventually acknowledge that, left to his own devices, he would have signed the cause of death as "cardiac arrest while under restraints and in custody, pending further investigation."

The journalists in the room had a sense that this explanation of what had caused Michael's death didn't make a great deal of sense. They began asking questions before Gross even had a chance to invite them.

"Dr. Gross, what are the possible causes for the physical injury to the spinal cord and the upper neck? What is your best guess?"

"As far as, um, the basis for injury to the cord, it would be inappropriate for me to comment on that at this time, pending an appearance before the grand jury."

The questions continued, even when the reporters knew answers wouldn't be forthcoming.

"Dr. Gross, as the medical examiner who signs the death statement, you have to indicate a manner of death: homicide, accidental, or undetermined. Which is it?"

"Dr. Gross, isn't it normal for the medical examiner to indicate cause of death, whether it's homicide or suicide or undetermined?"

"But is it your view that you cannot, at this time, determine those categories? You're leaving it to the grand jury? Or, if you're asked a question in front of the grand jury or by the DA, will you give your opinion?"

"Dr. Gross, what degree of force, from whatever manner, however it came, what kind of force was necessary—"

And so on.

Gabe Pressman was among the reporters shouting questions, of course. He asked if there was an inconsistency between the new findings and the preliminary findings. Gross restated, word for word, the preliminary cause of death and unhelpfully added that "the cause of death has been amended to indicate the transverse myelopathy, and as a result of the further study having been concluded . . ."

Pressman asked Gross if he was surprised by anything he'd learned during the further examination of Michael.

"There are always surprises in any autopsy," the medical examiner replied.

A reporter asked about petechial hemorrhages.

Gross gave a stuttering answer, and no reporter followed up.

The fusillade continued.

"Dr. Gross, do you regret having made your initial statement on September twenty-ninth that there did not appear to be anything other than cardiac arrest in the cause of death?"

"Dr. Gross, it is still unclear whether your opinion that there's no evidence of a beating has now changed, in light of the new finding."

"Dr. Gross, did he have any other injuries that you can tell us about?"

"When are you going to be testifying?"

"Dr. Gross, did you, in your report to the district attorney, list a manner of death?"

"Right now, do you have an opinion on whether excessive force was used on Michael Stewart?"

"It would be inappropriate for me to comment further as to how that injury occurred. I *will* testify before a grand jury—"

Someone—who was it?—asked a question, *the* question on the mind of the protesters: "Dr. Gross, can you explain why you secretly removed the eyeballs without the consent of the family or the presence of the independent pathologist?"

"The examination was, uh, conducted within the scope of my authority."

One more from Pressman, who seemed to have a private line to Gracie Mansion: "Is it true that City Hall asked you to see us today? That you didn't intend to have a press conference and that the mayor asked you to?"

Gross replied that the press conference was held in response to press inquiries.

And then it was over, as the medical examiner left the lectern, notes under his arm.

Gross had said little of consequence—which is to say, on some level, he'd done his job. That had not gone unnoticed. The next day's *Newsday* pointed out how the chief medical examiner had carefully avoided language like "strangulation" and "physical force" in favor of less specific phrasing like "physical injury to the neck"—a phrase that might be used to describe something as harmless as a mosquito bite or as severe as a beheading.

Holding court on the sidewalk outside Gross's office, the Stewarts' lawyers told reporters that the vagueness of the medical examiner's findings was why it was so difficult to convict a cop in the killing of a civilian.

"Do you think the facts all will come out eventually?" asked a curly-haired woman from radio station WHN.

"The facts are subject to interpretation," one of the attorneys noted, "and I have difficulty with Dr. Gross's interpretation in these matters."

14 New York City Pigs

The grand jury had been empaneled for a week or so. There were twenty-three jurors in total, all residents of Manhattan. One was a ghostwriter of a couple of bestselling Hollywood memoirs. Two worked for investment banks. Together, they'd all be serving over the next eight months, frequently seeing three or four cases a day on the fourth floor of the Louis J. Lefkowitz Building, which sits at 80 Centre Street in Lower Manhattan. The room was set up a little like a college lecture hall, with jurors seated above the area where the prosecutor would interview witnesses. With each case, the jurors would listen to evidence and vote on whether there was enough there for an indictment—that is, if the case should go to trial. The proceeding was shot through with secrecy: the jurors weren't sequestered, but they could talk about the case only to one another and only within the confines of the grand jury room. It was illegal for a juror to approach the press, and vice versa.

One of the cases they'd heard seemed particularly tragic. A Connecticut woman and her children had been killed that September when a cement mixer rolled onto the roof of their car parked in Manhattan's West Fifties. According to the police, the car was flattened "like a pancake." The driver of the cement truck, a Brooklyn man, was charged with criminally negligent homicide and driving while impaired.

The grand jury declined to hand down a true bill—a decision by a grand jury to indict a criminal defendant.

For Ronald Fields, one of the grand jurors, the problem was that proof of the driver's intoxication had not been presented to the jury. Fields, a French teacher, had instead learned the damning information from newspaper coverage. He

resented that the grand jury was never informed of this point and felt that the inherent covertness of the process was being used as a shield for prosecutorial incompetence. Three people had died, and now the man clearly responsible was walking away.

Aggressively inquisitive, the juror secured a meeting with H. Richard Uviller, a professor of law and an authority on criminal procedure at Fields's alma mater, Columbia University. What, Fields wanted to know, were the rights and responsibilities of the grand jury?

In a letter to Fields, Uviller explained that the grand jury was "an independent body of citizens, empaneled and responsible only to the court and to their own conscience. The District Attorney and his staff serve only as a counsel to the grand jury, not [as] a master."

The relationship between the prosecutor and the grand jury tends to be harmonious, Uviller explained: the prosecutor subpoenas witnesses when asked and is mindful of the questions a grand jury wants directed at said witnesses. To Uviller's knowledge, it was rare for the relationship between a New York County grand jury and a prosecutor to sour into acrimony. In 1935, a "runaway" grand jury, upset that the district attorney was attempting to cripple its investigation into racketeering, barred the DA and his staff from the jury room. The situation eventually grew so fraught that the governor himself had to intervene.

"I am in no way suggesting this occurrence as a model," noted Uviller, who then elegantly addressed a question from Fields about the grand jurors' obtaining outside sources of information: "I would advise that—aside from what one has learned from general experience as a citizen of the community—it would be improper for a juror or the jury to inform itself of facts or conditions relating to a specific matter except by the orderly presentation of record evidence before them in session. The law has adequate means for the jury to call for *anything* relevant to a proper inquiry to be produced before them." This, Professor Uviller maintained, "must be the sole means whereby they learn the facts necessary to the performance of their duty."

On October 24, just a day or so after Fields received Uviller's response in the mail, he joined his fellow grand jurors at Centre Street to hear evidence in a new case: *People v. John Doe.* This was Michael Stewart's case, and the ba-

sic contours of it were already familiar to many jury members, thanks to the media attention the case had received. Fields himself had seen TV segments by Gabe Pressman and Pressman's feisty competitor, Channel 7's Lou Young.

The District Attorney's Office was well aware that obtaining an indictment against the three officers would be a challenge.* Even Solomon Wachtler, the chief judge of the New York Court of Appeals (who once famously suggested that a district attorney could persuade a grand jury to indict a ham sandwich), believed the usual calculus didn't apply when the accused was a member of law enforcement. Not only were district attorneys less inclined to indict police, but grand jurors would hesitate to hand down a true bill. "Every citizen is inclined to favor law enforcement, when it comes to a bad encounter, because they're quick to think that the police are on the side of good and just causes," Wachtler observed, attributing the tendency to the influence of television shows where police were portrayed, invariably, as heroes. A juror's mindset, he went on, was "These are our guardians. These are the people that we look to for protection. And so we're going to give them the benefit of the doubt."

The Stewart case was presented by Assistant District Attorney John Fried. A boyish thirty-six-year-old from New Jersey, Fried had been an ADA since 1972. He'd ascended to chief of the Rackets Bureau, which conducted investigations into criminal enterprises. He also supervised cases involving police brutality. The Stewart case had initially been assigned to a pair of more junior prosecutors, but ten days before it went to the grand jury, it was handed to Fried.

Fried quickly dispatched two investigators, one Black, one white, to find witnesses who could illuminate what befell Michael before he was admitted to Bellevue. These were civilian investigators, as it would have been bad form to employ City police to effectively investigate themselves. "Nobody," recalled another assistant district attorney, "was gonna trust the cops."

The two trench-coated investigators canvassed buildings and streets around Union Square. They found a single ground-level eyewitness, Robert

* John Fried, in a February 2023 interview, disputed this: "I don't think we gave it a moment's thought as to the fact that they were police officers."

Rodriguez, the auxiliary police officer who claimed to have seen, during his shift at the Blimpie at Fourteenth Street and First Avenue, the Transit officers assault Michael as he was escorted out of the subway.

Inevitably, the investigators made their way to 31 Union Square West, the site of the Parsons dormitory. They started at the bottom floors and worked their way up, knocking on doors to find people who were awake in the early hours of September 15, 1983. The investigators found dozens of witnesses, nearly all of whom were college freshmen. One, though, was a woman in her sixties who lived on the eleventh floor. Rousted from her bed by the noise outside, she'd seen Michael being kicked by officers.

Some witnesses refused to cooperate with the investigators, but they were the minority. "I was blurting out everything," recalled Timothy Jeffs, one of the Parsons students. "I was just excited to say what I saw."

A list of these witnesses was drawn up. The chosen were told to report to Centre Street to give their testimony to the grand jury. A preliminary version of their accounts had already been documented in a questionnaire administered by the district attorney.

The grand jury questions were mostly generated by Fried, but some were suggested by the jurors themselves, who would whisper in Fried's ear or pass him a note. The ADA was, to some degree, a conduit for the jury, which lacked the power to subpoena witnesses but could instruct the prosecutor to do so.

For the witnesses, the process was not anxiety-provoking. It wasn't akin to a criminal trial, where they would have been vulnerable to cross-examination. One witness would later recall the experience as having "a fact-finding feel to it."

That was by design, as the mandate of a grand jury is to hear evidence put forth by the prosecution that forms the basis for its deliberations. For months, the jury heard testimony from Michael's coworkers at the Pyramid, student witnesses, Drs. Gleb Budzilovich and William Cole, Bellevue nurses, and the Transit officers involved.

Elliot Gross testified in January, a few months into the proceedings. It was a stressful time for the medical examiner. That very month, a state supreme

court justice had ordered a hearing to determine if Gross's office had mishandled Michael's case.

At least twice prior to his testimony, the chief medical examiner and Budzilovich had met with Fried to discuss what caused the injury to Michael's spinal cord. In one meeting, using a chart and photos of the cord, Gross theorized that the injury could have been the result of someone ramming or spearing Michael's head. Another possibility was that he'd been restrained and thrown into a car, hitting his head. Less likely, but still conceivable, was that Michael's spinal cord had been injured when his head was twisted backward. What wasn't at all likely, Gross told Fried, was that the spinal cord had been injured in a fall.

Budzilovich, too, had changed his mind, but to a lesser degree. He'd written in the report following the post-autopsy section that Michael's spinal cord injury could have been due to the respirator or from trauma. However, he'd reconsidered *when* this had happened. Previously, he'd suggested that the injury occurred up to fifteen days prior to the autopsy; now he believed the injury was sustained within seven days of Michael's death—well after his admission to Bellevue.

The hours crept by—weeks, months of minutiae-filled testimony. The slow and deliberate accumulation of information, doled out in daily three-hour increments, was sometimes insufficient to hold the jurors' interest. As an attorney for the Stewarts told the *New York Amsterdam News*, "Some members of the grand jury were half-dozing and others were in a deep sleep."

The witnesses noticed the sleepiness, too. "Literally nobody cared at all what I was saying," Jeffs, the Parsons student, recalled.

The testimony of the Transit police, though, gathered the room's attention. The officers hadn't been compelled to testify, but their attorneys believed that telling their side of the story would convince the jury not to indict. The jurors, however, did not react in the reverential manner someone like Judge Wachtler might have predicted.

"They're fucking liars," said Lily Nazario, asked decades later about the officers' testimony. An administrative assistant at Shearson Lehman, Nazario, at only twenty-one, was the youngest member of the jury. "They are protecting

each other. And we're talking about someone that lost his life! I felt like there was no remorse."

Fields, for his part, doubted the police's story about Kostick's having caught Michael defacing the subway. He wondered: If Stewart was caught vandalizing the subway, why hadn't the police produced the spray paint or markers for the jury's inspection? That was, Fields recalled, "one of the big red flags for the veracity." Anyway, he felt that the district attorney's focus was misdirected. "The decision to make the case about *these* cops protected the real perpetrators of Stewart's death," he said years later. "The actual crime was at First Avenue, not Union Square."

It wasn't that Fields doubted the students' accounts of the violence they'd witnessed—far from it. In his view, however, the truly consequential physical harm to Michael had occurred earlier in the night. Here Fields was influenced by the eyewitness testimony of Rodriguez, which had detailed the assault on Michael at the subway entrance that left the young man, as Fields put it, "flopping around on the sidewalk like a fish out of water." In other words, as far as Fields was concerned, the investigation should have targeted the first Transit officer to encounter Michael that morning: John Kostick.

Decades later, Fields was fairly sympathetic toward other officers on the scene at Union Square, who, perhaps believing Michael to be on drugs, had acted in a manner that was negligent but not, in his view, malicious. "I guess, in their best judgment, they hog-tied him so he couldn't harm himself," he said. "But his body was acting spastically, so what would you do?"

Just a month or so into the proceedings, Fields began to chafe at the limitations imposed on the grand jury. Much of the testimony from the police, from the witnesses, from Gross, struck him as contradictory. None of it, he believed, adequately explained the injuries Michael sustained. Fields wanted more information, and he saw it as falling within his rights, if not being his obligation, as a grand juror to obtain it. He recalled Professor Uviller's words: the DA was "counsel to the grand jury, not a master."

To get a better sense of where Michael's body was that morning relative to the police and the emergency vehicle, Fields trekked to Union Square and took photos. He hoped this would give him and the other jurors a clearer picture of what had happened. When he returned to Centre Street, he gave a photo

to Fried. The ADA marked it as evidence, but issued a warning: neither Fields nor any other grand juror was authorized to visit locations mentioned during testimony. A juror acting on their own lacked investigative and legal power. Such authority was granted only collectively, to the grand jury as a whole.

The grand jury investigation proceeded in standard secrecy, the newspaper leak of drowsy jurors notwithstanding. Although testimony was shielded from the public, Michael's death continued to reverberate with civil rights leaders and members of the New York art world. The killing had also gained the attention of another group of people, one that was willing to signal its anger at what had happened in defiantly lawless ways.

The United Freedom Front was a clandestine militant organization founded in the mid-1970s by a pair of Vietnam War veterans and their wives. At a time when underground groups were increasingly common, the UFF still managed to stand out. As described by Bryan Burrough in *Days of Rage*, the group was composed of two "blue-collar couples—later three—who robbed banks, engaged in deadly shoot-outs with police, and bombed courthouses, military installations, and multinational corporations, all while raising small children, eventually nine in all." The group's conception of justice did not involve the slow, uncertain grind of the legal system. Rather, the UFF embraced actions of "armed revolutionary love" as means to oppose South African apartheid and the United States' foreign policy in Central America.

The original two couples, Raymond Luc Levasseur and Pat Gros and Tom and Carol Manning, chose as their first target the Suffolk County Courthouse in Boston. Levasseur planted the bomb; Gros called in the threat.

On April 22, 1976, at 9:12 in the morning, a clerk in the probation department heard a boom and was knocked unconscious by the force of the blast. "When I came to," she told a reporter, "I didn't know whether I came to in this world or another."

In all, the explosion injured twenty-two people. One man had his leg blown off. The violent toll surprised even the bombers, who believed sufficient steps had been taken to avoid collateral damage.

"This is but the sound before the fury of those who are oppressed," the group wrote to a local alternative newspaper. The action had been taken, they

said, to press for prison reform. The note included a list of demands. "We wish to make it clear at this time, that if these demands are not justly dealt with, there will be further attacks against the criminal ruling class."

It wasn't a hollow threat; over the coming years, the United Freedom Front would attack more than a dozen targets. At least once, its actions had fatal consequences. In 1981, Tom Manning and Richard Williams, another member of UFF, shot and killed a New Jersey state police trooper during a routine traffic stop.

All the while, the couples moved from suburb to suburb, successfully evading arrest. The FBI, which named Levasseur to the agency's list of Most Wanted fugitives, was baffled. During this decade, the UFF was not the only militant group "operating in clandestinity, blowing shit up," a member's attorney recalled. "The FBI could never fucking figure out who was who."

On May 12, 1983, at 11:10 p.m., an attaché case with the word *bomb* written on it exploded at the Army Reserve Center in Uniondale, Long Island. No one was inside the building at the time, and only the lobby was damaged. An hour later, a briefcase exploded in front of the Naval Reserve Center in Whitestone, Queens. Again, there were no injuries, but windows were shattered, and a hole was blown in the building's garage door. Then, in August, bombs were set off at the Bronx Army Reserve Center, inflicting similar damage.

At each scene, law enforcement found statements from the UFF. In a missive taking credit for the Whitestone bombing, the group cited the Reagan administration's decision to help the El Salvadoran government defeat leftist rebels under the guise of stemming communist aggression. "These lies," the group wrote, "will not cover the truth and reality."*

Now the United Freedom Front began to plan another action: a tribute to Michael Stewart, who they believed had been strangled by police. The navy recruiting station in East Meadow, New York, was an attractive target because it was part of the martial apparatus sending "Black and brown men to kill some more Black and brown people in Central America," as a member would put it.

* A decade later, the world would learn that the El Salvadoran military murdered civilians on the United States' dime, with the support of the White House.

Asked years later when precisely the attack was conceived, Levasseur was coy. He said, "Common sense says to me that if you want to step out and show your outrage about Michael Stewart's murder, in a day you can be out there with a plaque on or a banner. If you're going to do something more extensive, it requires a little bit of planning and logistical challenges." To Levasseur, Michael's death epitomized the United States' systematic mistreatment of its Black citizens, ongoing in the country since the days of slavery. He saw global analogues to the violence, too: "Michael was strangled to death, so, to me, it was not a great stretch politically to connect the issue of apartheid in South Africa with apartheid in America."

This view about Michael's cause of death was shared by the Michael Stewart Friends Committee, which helped fund-raise for legal bills, marched in the city's art parade, and picketed the New York City Office of Chief Medical Examiner. As the year drew to a close, however, the Stewart lawyers, who had previously encouraged the activists, privately repudiated the group.

Despite that setback, activism on behalf of the Stewarts continued, and it, too, inspired the militants. Levasseur's wife, though, was touched by Michael's story for a different reason from that of others in her group. Pat Gros aspired to be an artist and was under the impression that Michael had been farther along in his career than he was. She believed that the Transit police had seen the alleged graffiti as a political act and rebellion.

On December 13, at 11:38 a.m., a switchboard operator at the recruiting station in East Meadow took a call. Bombs were set to go off in twenty minutes. "Get out," the operator was advised. Ten minutes later, two bombs in an attaché case exploded on the building's third floor. No one was hurt, but considerable damage was done to the building. The bombs had been placed in a stairwell, said a police spokesman, because "the idea was not to injure or kill people."

A typewritten statement left in a Houston Street phone booth announced that the strike was dedicated to Samuel Smith, who had been killed by police in 1981, and to "Michael Stewart, community artist, who was brutally murdered by the New York City pigs."

15 **Private Detective**

The grand jury investigation into Michael's death marched on. One month had passed since the East Meadow bombing, and Ronald Fields was once again in trouble. A man of estimable certainty, the French teacher had let his assumptions about the latitude given to the grand jury cloud his judgment. A friend of his passed along press releases disseminated by the Office of Chief Medical Examiner. One pertained to the preliminary autopsy, the other to the post-autopsy section. A juror bringing in outside materials unvetted by the prosecution was frowned upon, but Fields did not refuse the documents.

John Fried had never been in a situation where a grand juror was gathering their own evidence. He decided to call a small meeting in the grand jury bathroom. He asked Fields to be there, and a few others, including a fellow ADA, the grand jury warden, and a stenographer.

Fields came with the press releases in an envelope. "As far as I'm concerned," the juror said, "it's just a public record."

"It may very well be a public record and you may very well have a right as a grand juror to have this record," replied Fried, who asked that the teacher confirm that he had not discussed the secret proceedings with the acquaintance who had obtained the press statements—or, for that matter, anyone else.

Fields confirmed that he had not.

Fried said it was the job of the district attorney not just to present evidence to the grand jury but also to protect the rights of those under investigation. It didn't matter if that person was an anonymous New Yorker or Edward Irving Koch himself; by rights, everyone deserved a fair hearing. If

the grand jury returned an indictment based on the law and the facts, so be it. But the investigation must be done in accordance with the rules. If the case proceeded to trial, it would need to withstand judicial scrutiny.

Fried continued: "When individual grand jurors go out and gather information that is not in the record, there is no protection afforded to the individual accused of the crime, because no one—not myself and not a magistrate later on—will ever be able to determine what influenced that grand juror in reaching his decisions. And, number two, there is nothing to protect the individual from the possibility that that grand juror may have used that information to influence other grand jurors to vote in a particular case."

Fried delivered the forceful upbraiding in the absence of the other jurors. He wanted his point to be unambiguous, and he issued a warning: "If I come upon one more instance where you take it on your own to gather evidence in this case, I will see to it that you are removed from this jury." The ADA asked if he'd made himself clear.

"Yes," Fields said. "Might I answer, though, to your points? Very briefly."

Sure, Fried said.

"I feel that my function as a grand juror is a separate function as yours, and the grand jury is not an extension of the DA's Office," Fields said. "Perhaps wrongly so, but I do feel that at times blinders are applied, that we are told that you are the sole interpreter of the law and we are—"

"The court," Fried said, interrupting. "I share the role of interpreting the law with the court. You don't interpret the law and no one else other than myself, Mr. Kougasian, and the court—no one else can instruct this grand jury on matters of law," he added, referring to Peter Kougasian, another ADA.

"But I believe that the law states that the grand jury is an independent body and not an extension or the servant of the DA, but it is—"

"It is an arm of the court," Fried said.

"But it's independent from the DA's Office," Fields replied, sticking to his point. He argued that jurors were statutorily allowed to bring in any information that had "come to their knowledge," which included press statements from the Medical Examiner's Office.

Fried disagreed. "If you had the medical examiner in front of you now, you can ask him for press releases," he said. "This was an effort by you to gather information which the grand jury has a right to gather and you have the right to gather as a private citizen—but not as a member of this grand jury." Fried then again threatened to have the teacher removed from the jury if he took it upon himself to be "a private detective."

Before everyone left the restroom, Fried marked the press statements as People's Exhibits A and B.

On April 9, 1984, about four months after the grand jury's empanelment, Fields's actions were addressed by the New York Supreme Court. Earlier in the week, he'd picked up the phone and called Shirley Levittan, the supervising judge of the grand jury.

Levittan's background was unusual. She had worked for the Office of Strategic Services in Europe, and like Fields, she was fluent in French. "It wasn't as exciting as it sounds," she'd once told a reporter about her work overseas during the war. "I wasn't a Mata Hari." She graduated from New York University Law School in 1956 and was appointed to the criminal court by Mayor John Lindsay in 1969. Three years later, she made history by overseeing the first conviction of a ticket scalper.

Levittan had been on the state supreme court bench since 1974.

The judge met with Fried, Kougasian, and the jury's foreperson, Diane Ciccolini. The judge wanted to hear the foreperson's thoughts on Fields. "I gather," Levittan said, "he feels that the investigation in the grand jury is not being conducted properly. It would appear, although I don't want to put this down as a definite matter, that he has done some investigation himself, which makes me very uneasy."

Ciccolini, who was in her late thirties and worked in financial services, told the judge about how Fields had gone out on his own to take photographs of the scene and also about his contact with the Columbia professor. Now, she reported, Fields wanted a meeting with Morgenthau and the governor of New York. Ciccolini noted that the photographs he'd snapped had been entered into evidence.

"The picture he took?" Levittan asked.

"Well, it was never clear who took the picture, but he did give it to me," Fried said. "Two photographs that looked like they were taken from the roof of Thirteen Union Square West."

Fried said he had met with Fields to discuss the infraction, referring to the restroom meeting.

"I really find it very disturbing," the judge responded. She recounted how, in the phone call with Fields, the juror claimed that his opinion of the investigation's inadequacy was shared by many of his fellow jurors—though perhaps not a majority. "This is a grand jury that must act as a body," Levittan now said to Ciccolini. They were welcome to talk to her as a group, and were scheduled to do so the next day. But now the judge was having second thoughts.

Ciccolini replied that Fields's opinion was hardly representative of the opinions of the other twenty-two grand jurors. Nearly the entire panel, save perhaps for two individuals, "have been extremely pleased with the way ADA Fried has delivered the case to us."

The judge asked if Fields had done anything else questionable.

Ciccolini claimed Fields had shared evidence about witnesses that hadn't been presented by the assistant district attorney. He'd also called her on at least a half-dozen occasions to ask if she'd seen a news report or read a certain story pertaining to the case. Ciccolini acknowledged that she had been bothered by Fields's actions and perhaps should have approached the judge earlier. "But for a while there," the foreperson said, "we straightened him out."

Now, though, Fields had apparently become un-straightened. Ciccolini said he had lately begun sharing information she perceived as biased against the Transit officers. "It's almost like he is on a crusade to discredit the police," she said. It was frustrating.

"That frustration is understandable," said the judge, who promised to speak with the teacher. "He may undermine the whole process, and that would be the most unfortunate thing of all."

Ciccolini told the judge that Fields and juror number fifteen—Sandford

Dody, the Hollywood ghostwriter—had had dinner together, but the judge dismissed that concern.

"It's not fatal or anything," she said.

The next day, Levittan held a hearing so she could talk to Fields, who arrived with pages of notes in tow. Why, Levittan asked, do you believe the grand jury investigation has been improperly conducted?

"The DA's office has dragged its feet," said Fields, who claimed that Morgenthau's office had waited six weeks from the time Michael was hospitalized to actively investigate the case. "In six weeks a lot of witnesses had a chance to disappear or not be around." Of more consequence, he said, was the direction of the case. The grand jury had been told that the case was *at best* circumstantial—that only three of the eleven officers at the scene could be indicted.

"There are three witnesses, three perpetrators who committed another crime—perhaps the crime might be the crime of having failed to protect Stewart," Fields said. "But we are being limited to our scope of inquiry, and many decisions have been taken which I feel are not legal decisions."

"Are you an attorney, sir?" the judge replied.

No, said Fields; he was a teacher.

"What do you teach, out of curiosity?"

Elementary school, Fields said.

Fields complained that the grand jury investigation was dragging. He said the jurors were getting antsy. Also, they wanted to hear from a particular officer about what *another* officer had said, a request that was denied by the prosecutor on the grounds that it would constitute hearsay evidence. Finally, said Fields, notes from James McCarron, one of the officers on the scene the night of Michael's arrest, had been entered into evidence but were not shown to the jurors.

"You know, there is nothing that you have told me so far, sir, that is particularly unusual in a complex grand jury presentation," said Levittan. "This is a complex matter, and the grand jurors must proceed circumspectly, slowly, and deliberately. Hence the admission of improper evidence can defeat the whole purpose."

What else, asked the judge, is bothering you?

The jury, Fields said, wanted to subpoena either a member of the Stewart family or the attorney Louis Clayton Jones, in order to learn if any further witnesses had come forward. Based on statements Jones had made to the press, Fields believed he would be willing to disclose such vital information and suggested that it was only animus between Jones and Fried that prevented the attorney from testifying.

Levittan wasn't happy that the juror had broken the rule about consuming media related to the case. The judge explained that while she understood how important the case was to Fields—as it was to many New Yorkers—this was no excuse for impropriety.

"I understand," Fields said. "It has to follow its proper course."

Still, as the conversation continued, he reiterated his displeasure that the district attorney wasn't focusing on what had occurred outside the subway entrance at First Avenue the night of Stewart's arrest: "I feel it's very possible that a homicide was committed there and, at least, we know there was an assault committed there."

"Has there been any direct evidence?" the judge asked. "Is there anyone there who said, 'I saw Officer A or Officer B do such and such'?"

There was the auxiliary officer Robert Rodriguez, who saw a single officer exit the subway, Fields said.

"And does [Rodriguez] identify that officer?" Levittan asked.

Fields acknowledged that Rodriguez could not identify him, "but we have a witness who was a Transit clerk who saw the officer arrest Stewart and take him up the stairs, and there was no other officer present."

The judge expressed sympathy, but she told Fields that he must comport himself in a manner befitting a grand juror. She reiterated what the ADA had already made quite clear: *Don't conduct your own investigation. Don't share evidence.* Otherwise, all the work they'd done may have been for nothing: in the event of an indictment, defense counsel might realize that some of the evidence had been outside the record.

"That entire indictment," the judge said, "will be dismissed."

Fields left the room so the ADA and Levittan could talk. Fried had a request: Remove Fields from the grand jury. He went over the juror's various

transgressions. "I would feel derelict in my duty if I didn't make the application to remove this juror, so that the rights of the defendants—if they be defendants—are protected."

"These matters, Mr. Fried, are matters of degree," Levittan said to the prosecutor, though she agreed to warn Fields that he faced removal if his conduct did not improve. But that was a drastic, last-resort measure. She denied Fried's application.

When Fields returned, the judge asked for assurance that he would stop conducting investigations outside the grand jury room.

"You have my promise on that," Fields said.

Back home in Ohio a couple of weeks after the East Meadow bombing, the United Freedom Front was staying underground, keeping a step or two ahead of federal agents. They kept an eye on the news. "We always stayed informed as much as we could, reading the national newspapers and leftist publications," Pat Gros recalled. "We lived in the world as much as possible."

Once, while watching television, they saw themselves on the *CBS Evening News*. The idea of surrendering was briefly considered and quickly discarded. The revolutionaries also continued to monitor coverage of Michael's case. Unbeknownst to the UFF, the grand jury's duties appeared to be complete.

On May 31, 1984, about six months after the jury was empaneled, Judge Levittan met with Fried, Fields, and Ciccolini. This time, Robert Morgenthau, who'd been getting frequent briefings on the case, joined them. Fields was getting his wish: an audience with the district attorney.

Levittan told the group to make itself comfortable.

"I am here as a citizen," Fields said. "I understand my role as a grand juror. I have not let my personal feelings about the case enter in my deliberations." Indeed, he had not; the teacher had voted against the indictments. Fields proceeded to make one last statement. Over the course of several minutes, he told Morgenthau what he'd found inadequate about the evidence presented to the grand jury. Fields complained, again, that the investigation hadn't started until six weeks after Stewart's death, that there was evidence of strangulation, that the arresting officer's background hadn't been carefully scrutinized, that the district attorney had erred by focusing disproportionately on Union Square.

Morgenthau took particular issue with Fields's statement about when the investigation began. "Two ADAs went up to the precinct the day Mr. Stewart was arrested and started their investigation immediately," the district attorney said, correcting the juror. "First of our subpoenas went out on September 19, nine days before Mr. Stewart was actually dead. This investigation started really at the very beginning."

The judge asked if the twenty-three-member jury had voted. Only twelve were necessary to bring criminal charges.

Yes, said Fried. An indictment copy would be filed shortly.

16 **Absolute Secrecy**

From the moment the New York County District Attorney's Office began to interview the student residents of 31 Union Square West—even before the grand jury was empaneled—John Fried contemplated charges of manslaughter, reckless manslaughter, or negligent homicide. A murder charge was not under consideration. "We had no basis to believe that the officers intended to kill Mr. Stewart," Fried said years later.

Now, after seven months, more than sixty witnesses, and five thousand pages of testimony, the grand jury handed down a true bill—the decision to indict a criminal defendant.

The ADA was aware that trouble awaited—he had, after all, attempted to have Ronald Fields disqualified—but the actions of the jury had left him no choice. The law mandated that he move forward. As Fried would put it, "Once they voted the indictment, the law required that we were obligated to file it. And upon filing it, the court was obligated to issue arrest warrants. And once the court issued arrest warrants, we were obligated to execute those arrest warrants."

On June 1, 1984, District 4's John Kostick, Anthony Piscola, and Henry Boerner were arrested and charged on six counts: manslaughter in the second degree, criminally negligent homicide, reckless endangerment in the second degree, assault in the third degree, hindering prosecution in the second degree, and official misconduct. Each officer faced more than twenty years in prison.

At arraignment, the three officers stood in front of Justice George Roberts. Dressed in suits and ties, their hands clasped at waist level, and wearing

impassive expressions, the officers pleaded not guilty to all counts. Released on their own recognizance, they were suspended without pay.

At a news conference, Morgenthau explained that the Transit officers had been charged with "either directly causing the death of Michael Stewart or, by their inaction, permitting other police officers to assault him." The district attorney was blunt: "If they didn't do it themselves, they let it happen." Evidence that additional officers were involved hadn't materialized, Morgenthau told reporters, but he believed there were as many as eight accomplices.

After the district attorney's announcement, Louis Clayton Jones spoke with reporters himself. There was no satisfaction to be had from the manslaughter charges, the Stewart attorney said: "If this had been a white boy who had been beaten by eleven black officers, you would have had murder indictments within two days." Jones believed the indictments were effectively worthless. His colleague Michael Warren echoed the sentiment: "The manslaughter indictment is a half-hearted effort by Mr. Morgenthau to appease an outraged community."

Police weren't often charged in a line-of-duty homicide, so this local story was picked up in newspapers as far away as Austin, Texas; Palm Beach, Florida; Cedar Rapids, Iowa; and Bremerton, Washington. If there were any doubt about its significance, the *Daily News* pronounced the officers' indictments "the most serious case of brutality ever brought against Transit Police."

Indictments of such a magnitude were indeed unusual. Only a decade earlier, when Thomas Shea was charged for fatally shooting Clifford Glover, there had been no known precedent for a City policeman being indicted for a line-of-duty homicide.* In fact, the New York City mayor inadvertently admitted that police were rarely held to account, even provisionally, for violent acts committed on the job. When Koch finally testified at Rep. John Conyers's hearing on police brutality—which had resumed in Brooklyn in November, moving from Harlem—he decided to use part of his allotted time to rebut the many examples of brutality offered at the prior hearing. "In twenty-four of twenty-five cases which were investigated by grand juries

* In fact, as Thomas Hauser revealed in his book *The Trial of Patrolman Thomas Shea*, a New York City policeman named Robert McAllister was charged in the killing of an unarmed Italian man in 1924. McAllister was acquitted.

or the Department of Justice," Koch attested, "there were no findings of any criminal action on the part of the police."

The statistic implied that the cases lacked merit, but it could easily be interpreted as confirmation that grand juries were, as the eminence Judge Wachtler believed, disinclined to indict law enforcement.

In their own statements to the press, the Transit Police touted the commendations earned by Piscola and Boerner, while the PBA president attributed the indictments to distorted media coverage. This was also the view of the trio's District 4 colleagues, whom a *Daily News* reporter described as "somber, gloomy and bitter." One officer told the tabloid that the only plausible justification for the indictments was public pressure, while another said it was the fault of journalists. District 4 officers covered their badges with their hands when in the presence of reporters, so journalists couldn't identify them.

Morgenthau still had one more disclosure to make about the Stewart case. On the heels of his announcement about the charges against the three Transit Police officers, he informed reporters that, at his behest, the grand jury had considered criminal misconduct charges against the City's chief medical examiner.

Elliot Gross, in the immediate aftermath of Michael's autopsy, had said there was no evidence of physical injury—only to declare, a month later, that Michael had died as a result of "physical injury to the spinal cord." That Gross's initial finding was preliminary didn't seem to matter; the jurors were skeptical of his testimony. "Elliot Gross *lied* on the stand, you know, in front of us," one recalled years later. "And we *knew*, you know, what he was doing!" But despite their low opinion of Gross, the grand jury declined to pursue charges against him.

Perhaps that was for the best; Morgenthau had, as usual, a lot on his plate. His staff of hundreds of assistants were trying all sorts of cases. Of late, they were prosecuting a pair of landlords for terrorizing tenants, including an elderly man thrown down a flight of stairs. Then there were the interns Morgenthau had just brought aboard. Ever the savvy media operator, he'd hired the children of television news anchor Dan Rather and of *New York Times* editorial page editor Max Frankel. And at home, there was a baby boy,

born in March. At sixty-five, with five children already from a prior marriage, Morgenthau was captivated by baby Joshua and toted him around in a sling.

The Boss maintained his focus, however. He would not let Gross's issues get in the way of his making the best possible case, and he engaged an outside medical examiner to review the evidence.

A week after the indictments, the foreperson of the grand jury, Diane Ciccolini, contacted Fried. She had information to share with the court.

The following Monday, June 11, Fried and Ciccolini returned to the chambers of Judge Levittan. After the grand jury voted to indict the police, said Ciccolini, Ronald Fields shared information that he'd learned about the arresting officer, John Kostick. A friend of Fields's knew a man who boxed at the same gym as Kostick. The friend revealed to Fields that the Transit officer was a bigot.

Levittan asked if Fields had shared this information with other jurors.

"To the best of my knowledge," Ciccolini replied, "I am the only one he said this to."

Fried noted that Ciccolini had not inquired of fellow jurors whether they, too, had been told about Kostick's alleged racism. The judge said she'd have to gauge the degree to which this might have tainted the vote.

Fried then recalled something from Kostick's grand jury testimony, which the officer gave on May 29—two days before the panel voted to indict. Near the end of the testimony, the ADA asked each juror if they had further questions for the officer. Fields requested that Kostick be asked if he boxed. Fried inquired if the witness boxed professionally, to which Kostick said no. And as an amateur? Kostick said no. But then Fried asked Kostick if he boxed as a hobby. "Well," Kostick replied, "I work out at the Y."

"Quite frankly, I did not know the significance of the question," Fried said to the judge. "I thought it would cause no great prejudice to the defendant or prospective defendants to pose the question. So that's why I permitted the juror to ask the question through me."

Judge Levittan said nothing.

As the jury's foreperson, Ciccolini appeared to understand the issue this created. In an apparent bid to salvage the indictments, she asked the judge

not to penalize the other jurors, "who have given much time, care, and concern to this case."

The next day, Levittan held a hearing at Centre Street. Among the assembled: a pair of assistant district attorneys, including Fried, and a quorum of sixteen jurors. The judge said that while it was always enjoyable to see grand jurors, "this session is something less than a pleasure."

The jurors' months of work was at risk, she said, and this was disturbing. Levittan acknowledged that the case was perhaps vexatious, but the grand jury could not act in the manner of a mob: "It is very frustrating to work in accordance with the law. In totalitarian countries, that's not necessary." Levittan cited China and its propensity to shoot "drug addicts" on little more than suspicion.

The Michael Stewart case was important, she said. If it fell apart because of the grand jury's actions, the conclusions would be ominous. "It will prove that totalitarian countries are right and that democratic countries are wrong." Therefore, the only avenue left was to investigate the degree to which Ronald Fields's actions had damaged the jury's integrity.

She would meet with the jurors one-on-one. Fields, who viewed Levittan as a "tough cookie," would be first.

"I'm not going to bite you, Mr. Fields," Levittan said.

The judge asked the juror to put his hand on a Bible. She then confronted Fields with the information about Kostick disclosed the day before by Ciccolini. The judge wanted specifics.

Fields said that he'd heard the vague allegation of Kostick's racism prior to the vote to indict. He believed he hadn't shared the information with other jurors.

Levittan wanted to know precisely what he'd heard about Kostick and the identity of his source. The juror said he couldn't divulge the latter, as he'd made a promise to preserve his friend's anonymity. It was no different, in his mind, from the oath he'd just sworn. Levittan said that was fine, for the time being, but the substance of the conversation must be divulged.

Fields's answer was rambling. "The substance, basically, is that this person knew somebody who knew John Kostick," he said at one point and explained

that, according to his source, the officer had, for one reason or another, been rejected by the New York City Police Department. "And he was an amateur boxer. I believe it was at the YMCA at the East Side that he trained, and basically that was the substance of it."

When Levittan asked how the subject of Kostick had come up, Fields said that they had happened to discuss cases where police officers had killed people.

The judge was incredulous that the topic was raised without prompting. "I mean, nobody meets you in the air and says to you—"

"No, no," Fields said. "I was speaking in generalities about, you know, the—that I had been on the grand jury. We were investigating a lot of things and—"

Levittan asked if Fields had mentioned the Stewart case specifically.

Fields said he had not. Two or three other cases were mentioned during his conversation with his friend, including an incident where a Housing officer had shot and killed a man. Fields heard about the case from a coworker who had witnessed the shooting and testified in front of the grand jury.

Levittan remained puzzled how such a subject had organically become a topic of discussion. She reminded Fields that grand jury proceedings must be secret and that outside information wasn't allowed. To underscore the importance of adhering to such rules, the judge brought up the famous line from U.S. Supreme Court justice Benjamin Cardozo: "Because the constable blunders, the defendants must go free." In this case, a jury blunder might vitiate the proceedings. "Now, when you voted, wasn't this in your mind?"

It wasn't, said Fields, who said he could differentiate between information introduced during the grand jury from information he learned outside the grand jury.

The judge lost her patience. "Please understand me, Mr. Fields. I do not think you are malicious. I do not think you are corrupt. I do not think you are doing this to be mean. But you are stepping into waters that you do not understand.

"I wouldn't think of teaching your [French] class," continued Levittan, who happened to have taught the subject at Syracuse University. "Why do you think of being a lawyer?"

The judge returned to the matter of Fields's conversation with his friend at the gym. She demanded the man's name and promised not to call him unless it was necessary.

"It's a betrayal of trust," Fields protested.

"You have betrayed my trust, sir," the judge replied.

Fields gave the judge the name of his friend, an IRS employee who lived in Manhattan.

John Fried asked what precisely Fields's friend had said about Kostick.

"He knew somebody who worked out with him at the gym," said Fields. "And that they had talks and that he didn't seem—generally didn't seem to like Black people." This was vague hearsay but was sufficient to concern Levittan and Fried.

The friend also mentioned Kostick's rejection by the NYPD, which was not public knowledge.

Clearly, Levittan and Fried would need to interview the rest of the grand jury.

A woman named Patricia Cohen was first. Levittan asked a question she would put to all the jurors: "Did Mr. Fields or any other grand juror ever tell you of any information that he had obtained outside of the grand jury proceeding with regard to any police officer's specific attitude towards race?"

No, Cohen replied.

"Okay," said Levittan, "that's the answer we want."

The next juror, Lily Nazario, gave the same answer.

Sandford Dody followed. Dody, sixty-five, had in his youth aspired to be an actor and even delivered the opening lines in Betty Grable's 1944 movie *Pin Up Girl*. But success came only when he ghostwrote the memoirs of those who'd truly made it, including Bette Davis and Helen Hayes. The life of chosen anonymity hadn't been Dody's dream, but as with acting, ghosting required a willingness to sublimate the self. "Unseen by everyone—except on rare occasion by the subject who pretends blindness but winks conspiratorially," Dody wrote in his own memoir.

But now, in the presence of Levittan, he was very much seen, and he told the judge that Fields had not passed along to him the racism-related

information. The ghostwriter had written Levittan a letter, and she took the opportunity to compliment him on its style. If this was meant to disarm the juror, however, it didn't work.

"I did not write you for the literary criticism," Dody said, explaining that he, like his dinner companion Fields, took issue with how the Stewart case was being handled. "I felt it is very important for us as grand jurors and New Yorkers to pursue the case further, and I was stunned when I read in the paper that—"

Levittan interrupted and said she was taking his letter under advisement.

Dody began to ask if someday he might be able to write about the grand jury. The juror hadn't finished asking the question before the judge said no.

Levittan summoned another juror, Arthur Carroll, who recalled that, while Fields hadn't disclosed information about a specific officer, he *had* mentioned consulting with H. Richard Uviller, the esteemed Columbia University professor.

When it was Ciccolini's turn, Levittan asked if Fields had told her anything beyond what she'd already disclosed to the court. He had not. "Were Mr. Fields's vote [to be] nullified," asked Levittan, "[would] there [be] enough votes to vote the indictment?"

"Oh, yes," Ciccolini said. "Yes."

Mildred Barreto was next. The juror said that, a mere half hour earlier— just before the session began—Fields had told her of unspecified "outside information" regarding Michael's case.

Another juror, Paula Weitzman, said there was discussion among the jurors of racism, but that hadn't been instigated by Fields. "We spoke among ourselves," she said. "There was some reference that there might be a racist." When asked if Fields had mentioned a specific officer, the juror identified "the younger one, we all thought the younger witness was a little peculiar." Kostick was, at twenty-five, the youngest of the three officers, and baby-faced.

Caroline Greenberg was next. Levittan asked if Fields or any other jurors had given her outside information about a particular police officer's specific attitude toward racism. No, said Greenberg, but the weekend following the indictments, Ciccolini "told me something he had told her."

Levittan then recalled Ciccolini. Three jurors were currently away on vacation and unreachable, the judge said. "Assuming for a moment—and this is just an assumption for mathematical purposes—if all four of those persons' votes were stricken, would there still have been sufficient votes to sustain the indictment?"

"I believe so," the foreperson replied.

"Against all defendants on all counts?" said an ADA.

"On all counts, yes."

The foreperson was excused, and Fields was called back—mainly, it seemed, so Levittan could berate him. The judge said that if Fields behaved himself, the indictments might be rescued. But he had already done much damage. He was a clever man, she said, but he needed to stop talking about the case. "You must not do the things that you have been doing, contrary to what we spoke about," she said. Once again, she implored, "You must not talk about this case." Fields could, she suggested, talk about the weather, about school, about anything, really, except the Michael Stewart case.

Fields said he understood.

Levittan told him that, given the circumstances, it was imperative that she talk to his friend, the IRS employee who had passed along the information about Kostick.

Before Fields left, Fried asked him if he had written to anyone about the case. Replied Fields: "Only one person when I felt there were problems—that was the special prosecutor."

17 **An Unsworn Witness**

No special prosecutor had been appointed. Fields had, in fact, written to the *Office* of the Special Prosecutor, which had been created just over a decade earlier by Nelson Rockefeller, in the wake of the damning Knapp Commission. The office, tasked by the governor with investigating corruption within the criminal justice system, empowered an assistant to the state attorney general to supersede the five New York City district attorneys. In a letter, Fields was informed that the office had found no evidence of corruption in the Michael Stewart case.

The idea of having a special prosecutor assigned to Michael's case was not new. The Stewart attorneys, who felt that the Transit Authority, the Office of Chief Medical Examiner, and the Manhattan District Attorney's Office had stymied attempts at a thorough investigation, long believed one was necessary. Within weeks of Michael's death, they began calling for New York's governor, Mario Cuomo, to appoint a special prosecutor on account of "a systemic pattern of deception, lies, secrecy and collusion . . . so obvious and blatant as to suggest that it is routine."

William Augustus Jones, a deep-baritone Brooklyn pastor who'd been among the clergy seated around the table at the District Attorney's Office, was enlisted to help pressure the governor. Reverend Jones had arranged a sit-in at Cuomo's World Trade Center office. When that failed to result in an audience, Carrie Stewart and others had traveled to Albany, the state capital. This time, Mrs. Stewart was able to directly plead her case. She appealed to Cuomo as a parent, mentioning that his son Andrew was about the same age as Michael. "It could have been him," she said.

The governor had rebuffed her request, preferring to let the grand jury complete its investigation. But now that the grand jury's duties were ostensibly finished, Louis Clayton Jones made another attempt.

Over the winter, Andrew Cuomo had been hired by Morgenthau as an ADA, and Jones's letter to the governor concluded with a tacit nod to the nepotism at play in the District Attorney's Office. "We trust, however, that your judgment in this matter will not be influenced by your familial ties to that office," the Stewart attorney wrote, "and that the conflict of interest inherent in the relationship will prompt you to seek independent counsel in arriving at a decision herein."

The reply took more than three months to arrive, and it came not from the governor, but from Lawrence Kurlander, Cuomo's director of criminal justice and a close adviser; he'd been Cuomo's first hire after the 1982 election. "In general, the power of the superceder [sic] is only used when a district attorney has become incapacitated, refuses to proceed, or has himself been accused of criminal conduct," Kurlander wrote to Jones. "In view of the pending indictment and the complexity of this investigation, it is not possible to justify departure from this general rule in this instance."

Years later, Kurlander maintained that there was "not one bit" of merit to the call for a special prosecutor. Morgenthau, after all, was one of the most respected prosecutors in the country. But there was also a precedent for restraint on the part of the governor's office, unmentioned in the letter: a hostage situation.

On Cuomo's eighth day in office, he was confronted with a crisis upstate at a wretched institution. Ossining Correctional Facility, known as Sing Sing, was overcrowded, poorly heated, and a "firetrap," as a report later put it. On January 8, 1983, inmates took nineteen guards hostage in B Block. Their demands were shouted over a bullhorn and then broadcast on the news. Cuomo spearheaded negotiations from the World Trade Center as his spokesman, future Meet the Press host Tim Russert, talked to reporters. Well aware of what had happened at Attica Prison in 1971, which had resulted in forty-three deaths, the governor refused to use force to overwhelm the prisoners. After fifty-three hours, the hostages were released, uninjured, and inmates relinquished control of the facility.

That it ended with relatively little bloodshed was, in the opinion of the Governor's Office, a credit to Cuomo's refusal to act on impulse. Nobody stormed the castle. Calm deliberation won the day, politics be damned. For Cuomo and his advisers, the events at Sing Sing would establish a template for how to handle difficult situations. By the time they were confronted with Michael's case months later, they'd learned to tread lightly when it came to involving the Governor's Office in sensitive affairs. "In the case of Ossining, we were directly responsible. In the case of Michael Stewart, we were only secondary players—but [with] the same kind of circumspection. Don't jump in," Kurlander recalled. "Just don't worry about what the political implications of this or that are."

Those at the governor's office may not have believed in the necessity of the special prosecutor, but they understood that Michael's case was important. Newspaper stories about it were clipped out and passed around internally. One was a *New York Times* editorial that evinced skepticism about the indictments of Kostick, Piscola, and Boerner. "Why were three singled out?" the *Times* asked. "The evidence didn't indicate which of the 11 did what." Cuomo's staff also flagged a pair of items from the *New York Amsterdam News*: an editorial calling for a special prosecutor and grand jury ("It should be clear to Governor Cuomo that there are no other real options") and a reprint of Gabe Pressman's commentary asserting that Cuomo could, under the 1907 Moreland Act, appoint an investigative commission.

The pretrial hearings began that June on the eleventh floor of the Manhattan Criminal Courthouse. The staid proceedings quickly turned raucous as supporters of the Stewarts shouted, *This is a sham!* and *There is no justice for Black people in this court!* Judge George Roberts demanded silence, but the shouts continued, from both Black and white members of the gallery.

Killer cops!

Remember Michael Stewart!

On the judge's orders, a woman identifying herself as a member of the Anti-KKK Committee was held in contempt and fined one hundred dollars.

The columnist Murray Kempton, seated in the gallery, watched Carrie Stewart's face during these eruptions and noted her obvious disapproval. She

later remarked that justice for Michael was the family's priority and that such outbursts were counterproductive. The column filed by Kempton, filled with his famously long, baroque sentences, elegantly laid bare the prosecution's inadequacies:

> It appears obvious that Morgenthau's grand jury contemplated what seems to have been in essence a lynching, despaired of finding a witness who could testify to the crime of homicide and had to resort instead to an indictment that, at bottom, does no more than impute the crime of a policeman's failure of responsibility to the prisoner in his charge.

Kempton also criticized the police for how they'd portrayed Michael in the press, and he argued that law enforcement's initial version of the story ought to be greeted with skepticism:

> The earliest news reports of the Stewart case were, as always, hopelessly dependent on the transit police version. They described a cocaine-crazed suspect who had sunk into "what is believed to be a drug-induced coma" while his solicitous bearers were conveying him to the hospital. The TA's public spokesman said that, while its policemen had indeed restrained Stewart—with gauze naturally—the hospital had "reported no sign of head injuries."

"Every one of these assertions," Kempton wrote, "has turned out to be false."

As the slow legal grind continued to play out in the courtroom, behind the scenes the indictments were shaky. The same day Kempton's column appeared in print, an attorney named William Kunstler wrote a letter to Judge Levittan on behalf of Ronald Fields, to whom he was giving informal, gratis legal advice. Over the years, Kunstler's client list had included Lenny Bruce, the Chicago Seven, Malcolm X, and Stokely Carmichael—he had a pronounced affinity for people who stirred up trouble. The lawyer asked the judge to meet with Fields, who wanted another opportunity to "detail his complaints."

The judge declined his offer: "I do not believe that a meeting with a single juror and extrinsic counsel . . . to discuss the deliberations of the jury as a whole would be appropriate or, indeed, lawful."

On July 13, John Fried sent a binder to Judge George Roberts, an inch-thick collection of transcripts pertaining to Ronald Fields. This wasn't an act of kindness on the part of Fried, but the result of a joint motion filed by the defendants to inspect grand jury minutes. This routine procedure allowed the court to discern if the evidence before the jury created the probable cause necessary to support the indictment. Morgenthau's office produced the minutes, and Roberts turned over the documents (including the binder) to Kostick's lawyer later that day.

Fields's role in the grand jury would not stay private for much longer.

One morning some weeks later, Lou Young, of Channel 7's *Eyewitness News*, was at his desk when the phone rang. He'd been on Michael's story for months. Young was initially reluctant to pursue it. He was still quite green, and the story was considered the domain of Gabe Pressman, whose work, a *Village Voice* columnist grudgingly acknowledged, "kept the story alive despite the lack of interest in it in the print media." But Young's producer had been adamant: *You do the story every day until you stop.* Young chronicled the case obsessively, talking to lawyers, to Michael's friends, to witnesses. He was so prolific that the network ran a newspaper ad touting the comprehensiveness of his coverage.

The man on the phone claimed to be a grand juror in the Stewart case. He didn't give his name. "This is a bigger story than you could possibly imagine," he said. "Stay on it."

"No offense, sir," Young said, "but are you supposed to be calling me?"

It was Fields, of course, who was still tracking Michael's case. As far as Fields was concerned, the truly rigorous coverage was being done by Young, Pressman, and two reporters at the *Times*, Sydney Schanberg, who had won the Pulitzer Prize for his stories on Cambodia, and Philip Shenon. Thus far, Schanberg's reportage had focused on the chief medical examiner, while Shenon had centered his writing on Morgenthau's handling of the case.

It was Shenon's name on an August 23 story headlined "Juror Is Called Tainted in Transit Officers' Case." The *Times* recounted how Fields had

"conducted his own investigation" and "gave some of his findings to other members of the grand jury."

All the details had been in the binder passed from Fried to Judge Roberts to Kostick's attorney, Barry Agulnick. Prior to reviewing the grand jury minutes, the lawyer had been unaware of Fields's actions. Agulnick knew his client had been granted a reprieve, but the district attorney was certain to retry the case. The lawyer told a tabloid that Fields, who had voted against the indictments, held a "personal vendetta" against his client.

The attorney asked Roberts to dismiss the manslaughter charges.

It didn't happen immediately. But several weeks later, Roberts announced his plan to interview each of the twenty-two grand jurors—all but Fields. The judge ordered Morgenthau to have them brought to his chambers before the next hearing.

The odds of swift and unambiguous justice were always long. Sure, Peter Marsala, the accused officers' former union rep, was convicted in April and sentenced to seven and a half years for acts a judge called "vicious and sadistic." But such a resolution in a case of police brutality was the exception, not the rule. Over the last five years, Morgenthau's office had indicted nine other Transit policemen for assault. Five of the cases were pending, while three had ended in acquittals. The lone conviction resulted in the accused spending one day in prison.

On October 5, 1984, the state supreme court dismissed the charges against Kostick, Boerner, and Piscola. "Cops Win Round in Graffiti Death," blared the front page of the *Daily News*.

Fried had argued to Roberts that, to the extent that Fields had engaged in an investigation, it was worthless and had not influenced the case one way or another. Therefore, the indictment should not be dismissed. The judge wasn't persuaded.

"It's unfortunate that one grand juror's misconduct has required the dismissal," a resigned Morgenthau said during a press conference. "We made every effort to prevent this from happening." The DA acknowledged that the prosecution had even asked that Fields be dismissed.

This was apparently an unprecedented event—the first time an indictment

was dismissed as a result of grand juror misconduct. The actions of Fields, whom Roberts characterized as "an unsworn witness against the defendants," tainted the entire case.

A second grand jury would have to be impaneled.

Fields would thereafter maintain a defiant lack of regret over his role in the events. "I wish more grand juries would know that they are not at the mercy of the prosecutor—that they're really the bosses, as a collective group," he would say decades later. "I realize that, intellectually, you could vote an indictment and the prosecutor could ignore it, or decide he's not going to go ahead with it. But that power was laid by the founding fathers and in English law upon a group of citizens."

For her part, Mrs. Stewart didn't even feign surprise at the case's dismissal, and declared that the indictments were insufficient anyway. "We expected something like this," she said. Whatever her expectations, Mrs. Stewart was on the verge of tears as she spoke. "We're still searching for justice. We're looking for the truth."

18 Eleanor Bumpurs

That October, just weeks after the indictments were dismissed, a Black woman named Eleanor Bumpurs was shot in her apartment.

Sixty-six years old, arthritic, and weighing nearly three hundred pounds, Bumpurs had passed a life contoured by physical limitations. She could not strike a match to smoke a cigarette. She could not hold a popsicle. She could not walk without dragging her left leg. She barely had the capacity for lateral movement. As a friend of hers confided to a reporter, "We didn't know what else to talk about but our pain."

There were psychological difficulties, too, and years of treatments at Bronx Psychiatric Center and Lincoln Hospital. On at least two occasions, police were called with a request that Bumpurs be hospitalized. Mental difficulties could veer into violence. There were reports of neighbor children being threatened with a knife.

Bumpurs's precarious mental state had, in recent months, deteriorated—to such a degree, in fact, that an entirely false, lethal rumor gained purchase: that she would heat lye on her stove and, if provoked, weaponize the boiling liquid.

Elna Gray Williams was born in 1918 in Louisburg, North Carolina, the lone daughter among a slew of sons. Raised under Jim Crow, she would later tell tales of the Ku Klux Klan herding Black people into the woods and beating them to death, of homes burned to the ground.

In 1942, Williams served eight months in a Raleigh prison for assault with a deadly weapon. Within a few years of her release, she moved to New York

City in the company of a man named Bumpurs and, over the next decade or so, lived in Manhattan, Brooklyn, and the Bronx.

Bumpurs had seven children, five daughters and two sons. She often took domestic service jobs for minimal pay, but her children did not feel deprived. Theirs was a life rich in radio entertainments, birthdays, holidays, and home-cooked dinners—meals of fried fish and peach cobbler, cornerstone dishes of Bumpurs's native South. "Everything was from scratch," her daughter Mary told writer LaShawn D. Harris. "She could make water smell good."

Eventually, medical issues pushed Bumpurs into early retirement, circumstances that made monthly Supplemental Security Income benefits a necessity. Despite the poverty, however, the children remained clothed and fed. But even that precarious equilibrium would be upended.

In November 1973, Bumpurs, then fifty-five, was arrested in Brooklyn on charges of possession of a dangerous weapon and menacing. She pleaded guilty to all charges and served no time in jail. Nearly three years later, in October 1976, Bumpurs grabbed a knife and disappeared for two days. When she returned, she slashed her daughter's hand. Diagnosed with acute psychosis, Bumpurs was hospitalized for two months at Bronx Psychiatric. Sometimes she professed to see her dead brothers walking through walls. Her hospital file notes that, the following March, Bumpurs "was walking around with a knife—slashing at the air and threatening her children."

In September 1982, Bumpurs moved into Apartment 4A of Sedgwick Houses, in the Bronx, not far from her daughters. The monthly rent at the O'Dwyer-era Housing Authority project situated near the George Washington Bridge was $80.85, including utilities (equivalent to approximately $260 per month today).

Bumpurs spent much of her time in 4A monitoring goings-on outside her window. She was friendly enough, her fellow residents decided, if a bit reclusive. But the apartment had become uninhabitable, she believed, with a broken pipe in the bathroom, a broken stove, and a broken hallway light. So, Bumpurs reached for the only weapon in a tenant's arsenal: nonpayment of the monthly rent. Hers had risen by sixteen dollars over the past year. She had always paid on time, but in April 1984, she withheld the money. She resumed payment the following month, only to stop paying altogether in July.

The Housing Authority sent a fourteen-day notice. When that period elapsed, an agency employee went to 4A to verbally deliver a three-day notice. Through the door, Bumpurs told the man she was withholding the rent on account of the maintenance problems. When informed that the problems would be fixed, she agreed to pay up. But when the maintenance workers appeared, Bumpurs refused to let them in—or to pay the rent.

This led to an escalation.

On August 8, at the behest of the city marshal, the Housing Authority served a petition of eviction. This was followed, during the first week of September, with a warrant for eviction. Then came a notice to vacate the apartment within seventy-two hours. That notice was then suspended as the Housing Authority and Sedgwick Houses personnel attempted to secure assistance for Bumpurs.

In the last days of the month, Sedgwick Houses' assistant housing manager, Barry Carey, called one of Bumpurs's daughters, Terry, to discuss the situation, but he found the number disconnected. On September 28, Carey spoke by phone with Bumpurs herself, who reiterated that her stove and bathroom were unusable. She told the assistant manager that "people had come through the windows, the walls, and the floors, and had ripped her off." Later that day, when Carey and Richard Wallach, a housing assistant, visited the apartment, Bumpurs again said the place required repairs. As the three talked, she pointed a large carving knife at Wallach and said, "I'm going to get him."

Carey sent letters to both Mary and Terry, requesting that they contact him regarding a "matter of utmost importance." On October 2, Mary called Sedgwick's management office. When informed of the pending eviction, she promised to talk to her mother. The letter to Terry was returned to the post office a week later.

On October 11, Bumpurs again told Carey that maintenance men could make repairs inside 4A. But when they showed up the next day, Bumpurs was armed with a knife. Still, the men inspected the apartment and found that neither the stove nor the light switch was broken. In the bathroom, they found cans of excrement, which Bumpurs attributed to "Reagan and his people."

The next day, Herman Ruiz, a caseworker from the New York City

Department of Social Services, called Bumpurs. She told Ruiz that the rent had been paid and that she would admit Housing Authority workers to make the needed repairs. Then she called him stupid and hung up the phone. When Ruiz visited 4A several days later, Bumpurs refused to open the door.

The caseworker went to Mary's home and left a note in her mailbox. This was an emergency situation, he told her, and she should contact him immediately. The same day, Ruiz returned to Sedgwick Houses and told Bumpurs that assistance was available in her avoiding the scheduled eviction. Upon returning to his office, Ruiz requested a psychiatric examination for the distressed woman.

On October 22, Bumpurs hung up the phone on a Social Services employee. That same day, a warrant for her eviction arrived. The missive noted that if her outstanding rent of $417.10 were paid, she could remain in the apartment.

Three days later, Ruiz and a psychiatrist visited 4A. Bumpurs met them armed with a kitchen knife and informed the psychiatrist that Reagan and Fidel Castro had killed her children and that her neighbors coveted her apartment for use as a brothel.

The psychiatrist believed that Bumpurs was experiencing delusions and hallucinations and was psychotic. He felt that, should an attempt be made to disarm her, she might be inclined to use the knife as a weapon. He recommended hospitalization subsequent to the eviction.

At 9:30 in the morning on October 29, a group assembled at Sedgwick Houses: the city marshal, the Sedgwick Houses' manager, two caseworkers from Social Services, two emergency medical service technicians, a Housing Authority maintenance man and moving men, and a pair of Housing Authority police officers, Vincent Colombo and Harry Carrasquillo. The officers were given Bumpurs's psychiatric evaluation, which indicated her size and her emotional state and noted that she sometimes carried a knife. Earlier that morning, they were told—maybe by a Housing Authority police officer, but maybe not—that Bumpurs had a "history of throwing lye."

"We're probably going to be taking a violent EDP into custody," Officer Columbo radioed back to his station, deploying the same initials for "emotionally disturbed person" that Transit officers had used to describe Michael Stewart after he was hog-tied. Colombo requested backup and an ambulance.

Colombo was the first to approach the fourth-floor apartment. He knocked, identified himself, and told Bumpurs to open the door.

"Come on in, motherfuckers," Bumpurs screamed back. "I have some shit for your ass."

Repeated requests to open the door were ignored. A neighbor tried to coax her out, but Bumpurs claimed not to know who the neighbor was. When an officer threatened to remove the door's lock, Bumpurs yelled another death threat. It was at this point that the group radioed for assistance from the New York City Police Department's Emergency Service Unit.

ESU officers John Elter and Leonard Paulson had been on patrol in the Bronx. They arrived on the scene soon after the call. Colombo told them that Bumpurs was emotionally disturbed, elderly, and "very big"; that she tended to brandish a knife; and that she "possibly could be cooking some lye."

It wasn't yet 10 a.m.

Elter knocked on the door of 4A.

The ESU officers were heavily armed and theoretically equipped to handle a variety of situations, from suicides to animal attacks. The protocol was to approach individuals with Plexiglas shields and a U-bar, an eight-foot-long pipe topped with a U-shaped fork, used to restrain subjects. The implement, colloquially known as an EDP bar, allowed ESU officers to take a person into custody without harming them while also preventing injury to the officers.

Elter's knocks were ignored, as was his promise to remove the lock if Bumpurs didn't open the door.

Elter and Paulson went to their vehicles to fetch equipment. They requested a backup unit. "It seems she's thrown lye in the past and, uh, we're gonna attempt to break the door in," an officer told the dispatcher. The officers had a further request for the backup unit: "Bring a shotgun." An officer armed with a twelve-gauge pump-action shotgun was authorized to shoot in life-or-death situations. Warning shots were prohibited.

The request for the shotgun was almost certainly a result of the fast-spreading rumor about the lye. In fact, it was the opinion of a deputy chief that the Housing officers "were more fearful of [the] lye than the knife." The rumor, though, was entirely false, and the police did not attempt to substantiate it before breaching Bumpurs's apartment. Eventually, the police commissioner of New York City, Benjamin Ward, would trace the belief's origins to a meeting at Sedgwick Houses earlier that morning. But that was disputed by the meeting's attendees, including caseworkers. A team of *Daily News* reporters who investigated the Bumpurs case the following month concluded that the source of the rumor "remains a mystery wrapped in a shroud of conflicting statements."

Returning to the apartment, the ESU officers repeated their demand that Bumpurs open the door.

"Don't come in, somebody is going to get hurt," she yelled.

The cylinder of the door's top lock was punched out, leaving a hole through which the officers could peer. They saw inside the apartment a cloudlike haze; a smell emanated from it that seemed corrosive. Bumpurs stood near the door, a kitchen knife held at a forty-five-degree angle.

Elter asked Bumpurs to relinquish the knife. She refused. Paulson radioed confirmation that the tenant was armed. The other Housing policeman, Carrasquillo, confirmed that Bumpurs had earlier been seen with a knife and that they'd noticed a chemical smell in the air.

Now Bumpurs wasn't at the door, and occasionally an officer would open it and peek inside to see what she was doing.

At 10:07 a.m., the ESU backup units arrived. The supervisor, Sgt. Vincent Musac, and officers George Adams, Richard Tedeschi, and Stephen Sullivan had been told that an EDP armed with a knife and possibly cooking lye was barricaded in her apartment. Elter told them to come upstairs with protective vests, Plexiglas shields, gas masks, and a shotgun. Tedeschi grabbed the twelve-gauge. As they rode up in the elevator, he bent down to tie his bootlace and handed the weapon to Sullivan.

Adams and Tedeschi stood in the congested hallway outside 4A. They looked through the hole and saw Bumpurs, knife in her right hand. Adams implored her to come out, stressing that he simply wanted to talk. She didn't

acknowledge either officer. Both noticed the mysterious haze that hung in the apartment. Sullivan thought it smelled like insecticide.

Attempts to talk with Bumpurs having failed, the ESU officers discussed alternative measures. The idea of opening the door quickly and pinning the woman between it and the wall was rejected because they believed there wasn't sufficient space to incapacitate her. Taking the door off the hinges was also briefly entertained. Then an officer, opening the door a short ways, noticed that Bumpurs had left the kitchen and moved into the living room.

It was time to breach the apartment.

The plan was conceived on the spot. The officers were equipped with gas masks and bulletproof vests. Elter was to carry the U-bar, Adams and Tedeschi were outfitted with Plexiglas shields. Sullivan, carrying the shotgun, had neither a gas mask nor goggles, as either would have impeded his vision. Elter entered first, followed by four other officers. One stayed by the entrance.

Bumpurs was sitting on a stool in the living room, still holding the knife. When Elter was a couple of strides into the apartment, she stood up and approached. The officers shouted at Bumpurs to drop the knife. Elter placed the U-bar around her midsection to block her. According to the officers, she pushed the U-bar out of the way. Adams, shield around his arm, attempted to block her approach as Elter was otherwise unprotected. Bumpurs jabbed at Adams's shield four or five times with the knife. The U-bar failed to pin her, and she continued to progress. When Elter lost his footing, Bumpurs nearly knocked the U-bar to the floor. Adams tried to pin her right arm with the shield, but she slashed at him. Adams stepped back and fell.

According to the officers, Bumpurs seemed to be "coming over the top of the shield" at Adams, who crouched and used his shield as protection. Elter, who had regained his footing, pushed Bumpurs with the U-bar. This attempt failed, too, as she pushed the bar to the side. Off balance, he fell forward.

With Elter and Adams both vulnerable, and within two feet of Bumpurs, Sullivan shouted several times for her to relinquish the knife. Sullivan would testify that Bumpurs ignored him and continued to advance toward Elter. Sullivan, standing a few feet behind the officer, stepped to his right and ordered her to drop the knife.

Again, she refused.

Sullivan fired a shot from the hip. The round hit Bumpurs's right hand.

Estimates of how long Sullivan waited to fire his second shot vary: "almost a second," "about a second," "three seconds," "almost immediately," and so on. A neighbor characterized the intervals like so: "Bam, bam, one right behind the other."

Sullivan pumped another shell into the chamber. The second round struck Bumpurs in the chest. She backed up to the corner of the kitchen doorway, turned, and, her back kissing the wall, slumped to a sitting position.

The entire confrontation had lasted no more than forty-five seconds.

Bumpurs was taken to Lincoln Hospital in the Bronx. She was brought to an operating room but was declared dead at 11:35 a.m.

The differences in the estimates of when Sullivan took his second shot aren't trivial. Sullivan himself maintained that the second shot was necessary because the first—which blew off a number of the woman's fingers—did not noticeably affect Bumpurs, who continued to move forward. The police would claim that, even after the first shot, Bumpurs continued to grip the knife and that this justified Sullivan's second shot. The assertion was difficult to square with the observations of Harold Osborne, director of the emergency medical residency program at Lincoln Hospital. The doctor found that several of Bumpurs's fingers had been blown off in the first shot. In Osborne's view, Bumpurs's right hand "essentially was a bloody stump"—which threw into question Sullivan's claim that the second shot was necessary.

It wasn't long after Eleanor Bumpurs's burial on Staten Island and the well-attended funeral service—Ruby Dee and Ossie Davis made an appearance—that the press began to link her name with Michael Stewart's.

"The tension between the minority community and police seems to have changed subtly for the better," suggested a *Daily News* reporter, "despite the shooting by police of 67-year-old [*sic*] Eleanor Bumpurs during a botched eviction earlier this month and the fatal beating of graffiti artist Michael Stewart—allegedly by transit cops."

This bordered on wishcasting. Despite a major change at the top earlier in the year, when Koch had sworn in Ward as the city's thirty-fourth po-

lice commissioner—the first Black man to hold the position—the change in personnel had done little to bridge the gap between how the NYPD treated Black New Yorkers and the far better level of treatment Black New Yorkers felt they deserved.

It was inarguable that police used disproportionate force for misdemeanors. This was confirmed by John Conyers's report, released within weeks of the Bumpurs shooting. (The hearings ended in November 1983.) The congressional committee had found that brutality cases involving Black citizens often stemmed from "minor incidents." "Police in some New York communities are relatively quick to comment on behavior by blacks which would be overlooked in whites," the authors wrote, noting that when Black New Yorkers were involved, "these confrontations rapidly accelerate to arrest and/or injury."

In both Michael's case and the Bumpurs case, white New Yorkers were often inclined to believe that the victims, on some level, had it coming. The notion that Bumpurs in particular had brought her death upon herself was widespread enough that it found purchase at St. George's, a prep school nearly two hundred miles away from the Bronx, in Middletown, Rhode Island. At Sunday chapel service, a Black student asked his white classmates, "Does anyone think that woman deserved to die?"

A sophomore, Tucker Carlson, raised his hand.

City Hall's response was less hardhearted, but not by much. It was the belief of the mayor's office that these killings—of Michael, of Bumpurs, of the many attested to at the congressional hearings—had been brought about through a series of unfortunate events, not the inevitable result of deeply ingrained, racist policy decisions. Koch, of course, was already on record saying there wasn't "so much as a scintilla of evidence" that police brutality was systemic. Now, in the aftermath of the Bumpurs case, the mayor was equally confident that the woman's race was incidental to her killing.

At a town hall in Harlem weeks after her funeral, Koch told an audience of hundreds that his administration accepted responsibility for the shooting death. He was skeptical, though, that Bumpurs's Blackness had been a factor.

"I know there will always be the question of whether, if she were white, would she have been subject to the same acts," he said.

No, no, shouted people in the crowd.

"We will never know," Koch said.

Replied members of the audience: *We know*.

19 Simultaneous Probes

It had been more than a year since Elliot Gross delivered his final report into the death of Michael Stewart. New York City's chief medical examiner ended 1984 on a high note, as hundreds of city pathologists comprising the National Association of Medical Examiners elected him president of the organization. But whatever optimism this may have occasioned would be fleeting. Just past midnight on Sunday, January 27, 1985, the city's corporation counsel, Frederick A. O. Schwarz Jr.——great-grandson of the founder of the beloved Fifth Avenue toy store——was soaking in a bath when he took a phone call from his deputy: *It's time to investigate the chief medical examiner of New York.*

In a matter of hours, the first installment of a massive multipart series on Gross's office by the *New York Times* would land on newsstands and in mailboxes. Philip Shenon's above-the-fold story, titled "Chief Medical Examiner's Reports in Police-Custody Cases Disputed," was brutal in a manner that belied its wishy-washy headline. The lede alleged that Gross had "produced a series of misleading or inaccurate autopsy reports on people who died in custody of the police," and over the next five thousand words, a damning story was told about his career. Shenon chronicled the black marks of Gross's nine years as Connecticut's chief medical examiner, including the failure to "analyze a key piece of evidence——a bite mark on a murder victim's shoulder——before the body was cremated" in one case and a misreporting of "the direction of a bullet through a victim's head" in another. According to the *Times*, Gross conceded the errors, but said they'd taken

place when his wife was seriously ill. Shenon also mentioned Gross's handling of the recent cases of Eleanor Bumpurs and Michael Stewart. Of the Bumpurs case, he wrote, "The pathologist who performed the autopsy found that Mrs. Bumpurs was hit by two shotgun blasts. But according to the pathologist, Dr. Jon S. Pearl, Dr. Gross ordered the cause of death reworded to leave open the possibility that she was hit by just one blast, as the police had reported." When it came to the Stewart case, the *Times*'s gloss was no less scathing. The medical stenographer who was present for the autopsy "was convinced that Dr. Gross was trying to hide the true cause of death."

Koch, who habitually read the Sunday edition early, digested the story on Saturday night. He couldn't ignore the most powerful paper in New York, and he called the city's lawyers before the issue hit the newsstands.

Within days, the corporation counsel Schwarz and David Sencer, the city's commissioner of health, advised Koch to appoint an independent special counsel to investigate the Medical Examiner's Office. Such an inquiry would ordinarily have been the purview of the city's Department of Investigation, a capable independent body, but for the sake of appearances and out of a desire to head off accusations of conflict of interest, an outside party was necessary. Conveniently, there was a recent precedent: the prior summer, Koch had allowed a corporate lawyer to investigate the Human Resources Administration, which the mayor believed had mishandled child abuse cases.

It was, Koch's advisers believed, important that a probe into Gross be not only fair but also *perceived* as fair—whether Gross was exonerated or not. "There should not be a whiff of suspicion that the result was designed to protect the city from liability, or from criticism, or to insulate from collateral attack actions previously taken by prosecutors in homicide cases," Schwarz warned his colleagues. "Conversely, if the conclusion is that Dr. Gross misused the powers of his office, there should also not be a whiff of suspicion that the fact-finders were trying to insulate the government from criticism by showing that they were tough on a highly publicized matter involving sensitive issues."

Koch chose Arthur Liman and Max Gitter, partners at Paul, Weiss, Rifkind, Wharton and Garrison, a white-shoe firm in Manhattan. The two

attorneys brought on a staff of more than a dozen, a team composed of pathologists, chief medical examiners, and a passel of Manhattan's bright young lawyers.

The *Times* story spurred further calls for the medical examiner to quit. Its columnist, Sydney Schanberg, wondered why he'd been hired in the first place. Furthermore, he wrote, "Why, when disturbing allegations began to surface at least as early as 1982, did it take a front-page newspaper series in 1985 to stir City Hall into action?"

Gross had no intention of resigning, he told the *Daily News*, and pronounced the allegations "unfounded." As a compromise, however, the medical examiner agreed to relinquish his day-to-day work to a deputy, which would give Gross time to cooperate with the Liman-Gitter investigation and a new concern: a ten-million-dollar lawsuit filed by the Stewart family against his office.

In short order, Gross's problems worsened significantly. The second story in the *New York Times* series, published the next day, focused on Michael's case. The paper painted Gross as deceptive, and the on-the-record sources were even less measured. "Dr. Gross has lied," the Stewarts' doctor, Robert Wolf, told Shenon. "He has couched the lie in language that is so obviously absurd that, even without any medical education, people should be able to deduce that he lied."

That same day, a second investigation into the Medical Examiner's Office—this one at the behest of Governor Mario Cuomo—was announced. The *Times* revelations were "serious and disturbing," the governor said in a statement, and they raised "important questions concerning the proper functioning of this office and its relation to the state's criminal-justice system."

Responsibility for the Albany probe fell to the state's health commissioner, David Axelrod, and the criminal justice coordinator, Lawrence Kurlander, who were allotted thirty days to determine if the actions of the Medical Examiner's Office could be considered grounds for misconduct.

The barrage aimed at Gross wasn't over. Additional investigations were announced. One was headed by the state's attorney general, Robert Abrams. The other was led by the U.S. attorney for the Southern District of New York, Rudolph Giuliani, who promised that the inquiry would encompass not just Michael's death, but the shooting of Eleanor Bumpurs as well.

The Office of Chief Medical Examiner was now the target of five simultaneous inquiries.

Gross tended to be soft-spoken and retiring in public, but privately he could be aggressive. He began planning a forceful response to the *Times* stories. The counterattack would end up being headed by two Graf Zeppelin–size machers on the New York scene, each of whom happened to be named Howard.

Howard Squadron was an attorney who'd represented Gross for four years, ever since the firing of the previous chief medical examiner, Michael Baden. (Baden, rather than take a demotion, sued unsuccessfully to reclaim his position.) Squadron got a call from Gross the week before publication of the first *Times* story. Gross had spoken to Shenon and was disturbed by the tenor of the reporter's questions.

The medical examiner was something of a black sheep in Squadron's universe, headquartered in an office on the twenty-fourth floor of a Fifth Avenue skyscraper where he met with clients that included presidents, media barons, and nightlife titans. The lawyer marveled that the medical examiner could afford him on a five-figure salary. And even if Gross *did* have trouble with the bills, well, it wasn't Squadron's style to let a client dangle.

When the story came out, Gross called again. Squadron was on the tennis court, and he returned his client's call in the afternoon. The lawyer was taken aback by the strident tone of the *Times* story. "You would have thought," he told the *Daily News*, "they were exposing Jack the Ripper."

Squadron contacted the *Times*. Meanwhile, he counseled Gross not to resign.

Press interest in the medical examiner was intense, and Gross's lawyer was quickly overwhelmed by the media onslaught. The next day, Monday, he called Howard Rubenstein, leader of the eponymous public relations powerhouse that represented such New York boldface names as George Steinbrenner, Leona Helmsley, and Donald Trump.

Rubenstein disagreed with Squadron on a key point; he advised Gross to step aside and to release a statement immediately announcing the move. The PR man also suggested that the chief medical examiner hold a press confer-

ence so as to publicly counteract the charges in the *Times*. "Prepare your case as if you were going into a court of law," Rubenstein instructed Squadron. That Tuesday, following two days of front-page stories from Shenon, Gross took a leave of absence.

Over several late nights, Squadron's attorneys assembled press kits as thick as Manhattan phonebooks, filled with autopsy reports and other documents. A partner prepped Gross, who, Squadron acknowledged, "is not a great communicator." Squadron also went after the *Times* himself. He had run into gossip legend Liz Smith, who asked if Gross planned to sue the newspaper. "Yes," he replied, "and you heard it here first!"

Amid the prep work, Squadron received a tip about John Grauerholz, the forensic pathologist hired by the Stewarts. Grauerholz was present at Michael's autopsy and had been extensively quoted in Shenon's second story. He disputed the official cause of death, implied that Gross hadn't tried to contact him prior to the removal of Michael's eyes, and that, by removing the eyes and placing them in formalin, the medical examiner had destroyed evidence of asphyxiation.

The tipster told Squadron that the Stewarts' forensic pathologist was, unbeknownst to the family—and, presumably, the attorneys—an acolyte of Lyndon LaRouche Jr. LaRouche, a perennial candidate for president, was an inveterate conspiracy theorist. "You know, Grauerholz testified for LaRouche," the caller told Squadron, "and some of the testimony was outlandish."

Rubenstein and Squadron took the tip to a mutual client, Rupert Murdoch, owner of the *New York Post*. This was an ideal venue for a leak, as the *Post*'s hatred of the *Times* was commensurate with its love of police. The paper began a campaign of cover stories: "Gross Cuts Up the *Times*" and "What the *Times* Didn't Print," the latter working in the tip about Grauerholz. The series was written by a team of reporters, two of whom were rumored to have conducted private investigations for Murdoch himself.

"Giving testimony for LaRouche during a libel suit against NBC in Federal Court in Virginia last October, Grauerholz said that he believed former Democratic presidential candidate Walter Mondale was a KGB agent," read a *Post* dispatch.

Newsday pursued leads about the pathologist, too, revealing that he'd once boasted of devoting "84 hours a week" to LaRouchian groups.

The press conference was held in Squadron's office on Sunday, typically a slow news day. As it happened, the *Daily News* that morning had published a story on John Kostick, the Transit officer who arrested Michael. New Yorkers would finally learn what Ronald Fields had so carelessly shared with the grand jurors: that Kostick had applied to the New York Police Department and failed the psychological exam. The Transit Authority was aware that he'd failed the test and apparently didn't care, the tabloid revealed. Officials wouldn't say precisely why Kostick had been turned down by the NYPD, but according to the *Daily News* story, rejected candidates tended to fall into at least one of four categories: psychotic, dependent on alcohol or drugs, vulnerable to stress, or prone to violence.

Gross sat next to his attorneys and PR men. The room was so crowded with camerapersons, photographers, and reporters—each of whom had been given the packets of refutational material—that Squadron remarked it should've been held in a ballroom instead.

Gross read off a seven-page statement that served as his rebuttal to the *Times* allegations. "I have never participated in any cover-up in connection with any police custody case or any case whatsoever," he said. "It is not in my interest or in the interest of any public official of the city to participate in a cover-up, and I do not know of any public official who has done so." The medical examiner characterized the allegations as a "malicious campaign of slander."

Then Gross took questions, which were often interrupted by Squadron and precipitated loud exchanges between the lawyer and the reporters. Some of the questions concerned Michael's case, a focus of Giuliani's federal investigation. A reporter asked about the second grand jury investigation into Michael's death, about which there had naturally been little press coverage. Gross took the opportunity to question the character and acumen of Grauerholz.

Amid the denials of a cover-up, there was a notable evolution in Gross's public statements about Michael's wounds. The medical examiner speculated

on their cause in a way he had not during his previous two press conferences about the case.

"There was evidence of injuries which could have been inflicted by fists, by feet, by a nightstick," Gross told the press. "There are injuries which can also occur as a result of a deceased falling while on the ground, while being put into a vehicle."

A young, energetic reporter who'd joined the *Times* the year Michael died was struck by the chief medical examiner's remarks. "For the first time, Dr. Gross said Mr. Stewart's death might be attributable to injuries sustained during an altercation with the officers," wrote Maureen Dowd. "Even as he defended himself, Dr. Gross moved closer to the position of his critics."

The press conference lasted ninety minutes. Before the proceeding broke up, a reporter asked Gross if he would be exonerated by the city, state, and federal investigations.

"There's no question that I will be," he said.

Gross wasn't the only public official facing scrutiny. Robert Morgenthau also had come under pressure of late. The Manhattan district attorney remained a towering figure. But for the moment, he was just vulnerable enough that he couldn't glide to reelection as he had before. His primary challenger was C. Vernon Mason, one of the Stewart attorneys.

The bid to prevent Morgenthau's fourth term was, at best, a long shot. But that it had been mounted at all reflected a certain discontent—with Morgenthau, but also with New York City's system of law and order. Even as the population declined, the rate of murders, muggings, and misdemeanors had risen. The halls of justice were swamped as the average criminal court judge handled 120 misdemeanor cases a day, or one every four minutes—a state of affairs that to Morgenthau was "madness." The state supreme court, which oversaw felony cases, was similarly overburdened. "Better than we have any right to expect," observed a dispirited judge, "but worse than can really be imagined."

For Morgenthau, Mason's eventual share of the vote—nearly a third of the total—was akin to a brushback pitch. "He's always seen himself as this

bastion of progressivism and suddenly here were Blacks kicking the shit out of him," Cuomo later remarked.

The Boss should not have been surprised. All the warning signs were there months earlier, when another client of Mason's became the victim of an unlikely hero.

On December 22, 1984, Bernhard Goetz boarded a downtown 2 Train. A pale, reserved-looking man in his late thirties, he was wearing glasses and a blue windbreaker. He reminded a fellow passenger of Mister Rogers. Goetz was the proprietor of an electronics business operating out of his apartment in Greenwich Village. It was a successful, low-overhead endeavor, and he had managed to quietly sock away more than $100,000, a small fortune at a time when the median rent in Manhattan was about $350 a month.

He took a seat. Under the windbreaker in his waistband holster was an unlicensed revolver. Goetz had decided to secure the gun after a mugging near four years earlier left him with sustained knee damage. It was, though, an onorous time to buy a gun in New York State. Only months prior, Governor Hugh Carey, at his wits' end with the city's escalating violence, signed one of the country's strictest gun control laws. Among the imposed burdens was the necessity to prove one had a "special need" in order to secure a license. Goetz was rejected. But on a visit to family in Florida, he purchased a Smith and Wesson.

People carrying guns on the subway was not new—nor was the resulting violence. In 1971, a real estate agent with a snub-nosed Colt revolver shot two men as the train entered the Astor Place station. Eight years later, a passenger on the southbound Lexington Avenue IRT shot a man who threatened him with a knife. In early 1984, a Brooklyn man shot a mugger during a "fierce struggle" in the East Broadway station. He'd purchased a .38 after one too many altercations with gangs.

Now, with Christmas a few days away, Goetz sat on the rumbling train.

His revolver was loaded, and he had an additional five rounds in his holster. In a relatively empty car, he had chosen a seat across from Troy Canty and Barry Allen and to the left of Darrell Cabey and James Ramseur. The four had caught the train uptown, in the Bronx. Ramseur and Allen were eighteen, while Canty and Cabey were nineteen. Each member of the group was Black. Canty and Goetz exchanged some innocuous words. Then Allen and Canty stood up, and the latter asked Goetz for five dollars.

Goetz stood up, unzipped his jacket, and asked the young man what he'd said. Canty repeated the request. Goetz would later say he was sure Canty was armed and that when the young man then smiled at him, he read in the smile a desire "to play with me like a cat plays with a mouse." It was at that point, Goetz said, that he decided to shoot them all: "I knew what they were going to do." In quick succession, Goetz gunned down Canty, Allen, Ramseur, and then Cabey. Then Goetz bent down and said to Cabey, "You seem to be doing all right. Here's another," before severing his spine with a second shot.

A train conductor approached Goetz and asked for his gun. Goetz refused to hand it over and fled, first to his apartment on Fourteenth Street and then to Bennington, Vermont, where he burned the windbreaker and buried the gun.

There was a brief return to New York City to retrieve some belongings from his apartment, but then Goetz rented a car and again drove north. The next day, more than a week after his abscondment to New England, he walked into the Concord, New Hampshire, police headquarters. "I am the person they are seeking in New York," he announced.

The Concord police interviewed Goetz, then handed him off to a Manhattan ADA and New York City detectives. Goetz apologized, saying he had no desire to talk. But he did. "I may be the biggest piece of bleep in the world," he said, his reluctance to curse surprising in someone who had shot up a subway car, "and you can drag me through the dirt, I don't care, but there is a bigger issue and that is the government of New York City is a disgrace."

Goetz complained about the lawlessness, the anarchy, and the legal system he saw as inadequate. He professed to be unbothered by what he'd done. "I wanted to kill those guys," he said. "I wanted to maim those guys. I wanted

to make them suffer in every way I could—and you can't understand this because it's a realm of reality that you're not familiar with. If I had more bullets, I would have shot them all again and again. My problem was I ran out of bullets."

Canty, Allen, and Ramseur were briefly hospitalized for their wounds. Cabey, however, was paralyzed and suffered brain damage. It was he who would end up represented by C. Vernon Mason, the Stewart attorney running against Morgenthau.

The Manhattan DA charged Goetz with more than a dozen felonies, including four counts of attempted murder. The judge set his bail at fifty thousand dollars.

For many New Yorkers, and non–New Yorkers, Goetz was a hero. While he sat in Rikers, thousands of dollars swelled a bail fund, while the comedian Joan Rivers sent a telegram of support with an offer to chip in as well. THUG BUSTER T-shirts were sold on the streets. The Guardian Angels, a volunteer group that believed it was protecting the public with its flamboyant street patrols, hit up eager straphangers for Goetz's defense. There was even noticeable support among Black New Yorkers, to the palpable consternation of the *New York Amsterdam News*, which noted that the public reception to Goetz's actions would've been awfully different if the victims had been white.

The public was fed reports that the victims had been armed with sharpened screwdrivers, a factoid* that wouldn't die even after journalist Jimmy Breslin revealed that police had found only two implements in their pockets, neither of them sharpened. But the truth didn't matter: Goetz had become an avatar for the fear and rage coursing through the city, with a near majority of residents approving of his actions.

The portrait forming of Goetz wasn't even particularly flattering. The *Daily News* described a "humorless law and order buff" who'd burned down a newsstand and been removed from his co-op board after making racist comments. "'A Little Strange'" was the tabloid's headline. The *Times* called him "sad and

* "Factoid," as coined and defined by Norman Mailer in 1973, meant "facts which have no existence before appearing in a magazine or newspaper, creations which are not so much lies as a product to manipulate emotion in the Silent Majority."

frightened and confused." But that's not how New Yorkers saw him. The chairman of the state's Republican Party loftily captured the prevailing sentiment, telling a reporter that Goetz "was defending New York society."

Breslin threw up his hands and acidly suggested that Goetz could be mayor.

The ardor had gotten so out of hand that Morgenthau, unsettled and eager to "enlighten the public," as a former ADA put it, leaked Goetz's confession. The confession introduced New Yorkers to a remorseless man who regretted only that he hadn't gouged out Troy Canty's eyes with his car keys.

Still, the grand jury went easy on Goetz, voting only to indict on the charge of unlawful gun possession. "It was the view of the grand jurors that Mr. Goetz was justified in taking the force that he did," Morgenthau lamented.

The district attorney's regret was not a salve for most Black New Yorkers, who felt that the degree to which the law was applied depended on one's race; that is, the law was unequally applied—if at all. The grand jury's charges were a flagrantly insufficient response to a savage act. Indeed, in light of the beating of Michael Stewart and the shooting of Eleanor Bumpurs, it appeared white men could end the life of Black people and be rewarded with praise and understanding, if not outright adulation.

The press bestowed Goetz with the moniker "'Death Wish' Vigilante," a nod to the 1974 film in which a craggy-faced Charles Bronson hunts muggers around New York City in reprisal for a home invasion that cost the life of his wife and the innocence of his daughter. The movie was followed by *Death Wish II*, in which the star, still craggy-faced, hunts down gang members in Los Angeles in reprisal for a home invasion during which his daughter was abducted and then raped. A third film in the series, set once again in New York City, had been in the works for years, but Bronson was hesitant to dust off the role, so the studio offered it to Chuck Norris, who declined. According to the film's producer, Bronson changed his mind after the Goetz subway shooting. Released a few weeks before Thanksgiving 1985, *Death Wish III* portrays yet another cycle of violence. Despite terrible reviews, it was a box-office success. During publicity interviews, Bronson was frequently asked about what seemed to be a real-life inspiration. "I get asked a lot about that, and I never say a word. Anything coming from me

might influence the jury," he told a reporter. "Let's just say I don't approve of muggers."

The case of Bernhard Goetz had achieved such ubiquity that even Ronald Reagan saw fit to weigh in, telling reporters that the impulse to take the law into one's own hands would lead to "a breakdown of civilization." Despite the pervasiveness of the Goetz story and its familiar components—Black victims and white perpetrator, the subway setting, and the involvement of the Manhattan district attorney—the shooting would not, in its immediate aftermath, leave a cultural footprint of the sort that followed the beating and death of Michael Stewart. No contemporaneous outpouring of paintings or graffiti, save for a lone POWER TO THE VIGILANTE. NEW YORK LOVES YA! spray-painted along the East River Drive. While the Goetz case had the attention of the East Village's Fab 500, as it did all of New York City, almost no one engaged in a defense of the shooting's victims, whether through art or deed.

Why did the violence not receive more outcry among the cultural set? Who can say, after so many years. But the East Villagers were not acquainted with Bernhard Goetz's victims, as they had been with Michael Stewart. Perhaps they saw the shooting as anomalous—not foreseeing in the crime the repetitious horror that gun violence would become—and the perpetrator a mere civilian, rather than a uniformed functionary of the city. Or maybe, with the media coverage so immediate and ferocious and widespread, they saw no demand to help publicize the tragedy.

There was, however, at least one East Villager inspired by the event: Otto von Wernherr. A resident of New York City since the mid-1960s, von Wernherr had been described as a "raw-boned German aristocrat" with "Peter Lorre's accent and Henry Kissinger's energy." He'd made a name for himself first as the publisher of *Little Black Book*, a glossy magazine filled with lively personals ("Copywriter, slightly out of his mind . . . desires with breathless impatience a cute, blue-eyed Scandinavian-type blond . . .") that extracted money from both the authors of the ads and the lonely hearts who wanted to meet them. Von Wernherr then drifted into music, producing a few songs for Madonna. He also tried acting, starring in *Liquid Sky*, a popular indie film about (more or less) aliens who land on the roof of a Manhattan penthouse in an effort to acquire heroin.

The self-styled troubadour's response to the subway vigilante was a composition created using a Fairlight CMI synthesizer and titled "The Saga of Bernhard Goetz." It was essentially a paeon to the gunman, sung from Goetz's perspective. "I didn't really have to shoot," warbled von Wernherr, "I *really* didn't give a hoot." The song's producer, Clive Smith, was leery, finding the piece somewhat exploitative, he recalled, but "at that time, it was just an opportunity to sort of hone my craft a bit and to realize somebody else's vision."

The single was, unfortunately, well made and catchy and was mastered by veritable legend—Greg Calbi, an engineer who'd worked with Bruce Springsteen and Bob Dylan, while Smith's previous project was with Hall and Oates. "A good electric boogie beat but no understanding," decided a critic from *Spin*.

Midway through February 1985, Breslin assessed the state of the city and found it wanting. The columnist was outraged that Bernhard Goetz had been indicted merely on gun charges, and he knew where to lay the blame: Morgenthau. The Manhattan district attorney, Breslin wrote, "appears to have fallen apart in the Goetz case." In Breslin's estimation, Morgenthau's flubbing wasn't limited to the subway shooting, but included a couple of other notable failures. There was the bloody killing of Eleanor Bumpurs, which resulted in charges of only second-degree manslaughter. Meanwhile, Michael Stewart's case had been languishing with the second grand jury for months. "Morgenthau has had the Stewart case for so long," he jeered, "that you have to give the year after each date concerning the matter."

In fact, the wait was almost over. In a matter of days, the Transit police involved would face new charges.

21 **Failure to Protect**

A year and a half since the violent morning in Union Square, and Michael's family and supporters seemed no closer to learning the truth or seeing justice done. There was progress, however. On February 21, 1985, after months of testimony and dozens of witnesses—many of whom, it should be noted, were compelled to address two separate grand juries—Robert Morgenthau announced new charges against the Transit officers. This time, John Kostick, Anthony Piscola, and Henry Boerner were charged with criminally negligent homicide and assault and each faced up to twenty-five years in prison. The three officers, along with District 4 colleagues Henry Hassler, James Barry, and Susan Techky, were charged with perjury as well.

New York State Penal Law provided a basis for the charges, with Section 15.10 outlining the minimum requirement for criminal liability as "the performance by a person of conduct which includes a voluntary act or the omission to perform an act which he is physically capable of performing." That is, a person could be charged not just for committing a violent act but also for failing to prevent one from happening.

The Manhattan District Attorney's Office had found a Sullivan County decision from the late 1970s, *People v. Kazmarick*, in which charges were upheld against a man who'd drunkenly started a deadly fire. The county court ruled that, as he had neither extinguished the fire nor warned others of its danger, such "acts of omission" were sufficient to sustain charges under Section 15.10.

As far as Morgenthau knew, the charges against the Transit police were without precedent in New York State. The case was an argument that an

officer had an affirmative duty to protect his prisoner from harm, even if that meant arresting a fellow officer. The charges were, in other words, not about an action as much as about an omission of an action.

"What this indictment means," Morgenthau said, announcing the charges, "is that when a police officer makes an arrest, he is responsible for the prisoner in his custody. If he beats him up or he permits some other officer to beat him, he is now going to be held legally responsible."

The Transit police also faced perjury charges, for lying about what had been done to Stewart. "We had all the police officers who saw no evil, heard no evil," the DA continued. "Nobody saw anybody beat up this prisoner."

Charging the arresting officers with a failure to protect Michael from each other was, observed *Newsday*, "a novel theory" with roots in civil rights law, and it had been affirmed by appellate courts. The New York Civil Liberties Union speculated that these indictments might chart a new path in prosecuting police brutality cases. "The theory underlining this case is perhaps the most important development in stemming the tide of police abuse," an attorney for the NYCLU told a reporter. "It makes police officers strictly responsible for their prisoners. It holds them accountable." However, this optimism papered over a weakness of the case. Despite the lack of doubt that violence had occurred, prosecutorial creativity was necessary precisely because not one of the many witnesses to Michael's beating could identify which of the officers had struck him.

Compared to the charges from the prior June, these were less severe. What had been second-degree manslaughter was now criminally negligent homicide. Circumstances, and the available evidence, had changed. This was due mainly to Elliot Gross, who, following the autopsy of Michael, had said his preliminary finding for cause of death was cardiac arrest and bronchopneumonia. There was no evidence, he'd said, of death being the result of physical injury. More than a month later, having finished the examinations of Michael's body, he revised his findings, sharpening them: the death, he said, was the result of upper cervical transverse necrotizing myelopathy—in layman's terms, an injury to the spinal cord. More recent, during the press conference in his attorney's office, Gross allowed that the injuries could've been inflicted "by fists, by feet, by a nightstick."

The medical examiner had also deviated in his testimony before the second grand jury—and this would prove both crucial and frustratingly mysterious. In describing the difference, Morgenthau would only say that it was "somewhat different" than the testimony before the first grand jury. Years later, it wouldn't be clear what that difference was, but the upshot was that prosecutors could not use the prior cause of death as the basis for the new indictments.

Even in their hollowed-out form, the indictments were still monumental. New Yorkers were accustomed to their police operating free of consequences for any violence they committed on the job; the charges represented a significant break from such a reality. The *New York Times* pronounced the death of Michael Stewart "one of the most widely publicized cases involving charges of police brutality in the city's history."

In the year and a half since Michael's death, his contemporaries had continued to flourish. Haring's work was the subject of a book of photography and featured in *Vanity Fair* and *Newsweek*. Basquiat, represented now by the rising star art dealer Mary Boone, had his first show at her gallery and appeared, barefoot in a suit, on the cover of the *New York Times Magazine*. They were all achieving the dream of their particular New York set: to make their mark not just on the city but beyond.

You could say Michael had attained fame, too, but it was the unwelcome, posthumous sort bestowed on one who has been struck down before he gets to make what he will of his life. As *Daily News* reporters noted, Michael had been "a virtually unknown model and a would-be artist, but his death made him a cause célèbre." This was no consolation for the Stewarts, of course, as for all the attention the case had received, they'd still been denied justice for their eldest son.

Justice was indeed elusive, in part because it was unclear what that meant. It seemed to depend on one's vision for the world. Was justice achievable through the courts, the arena that, in Judge Shirley Levittan's view, separated the United States from totalitarian regimes? Or, as many New Yorkers seemed to believe, did it require a Goetz-Bronson model of vigilantism? Certainly, amid the Reagan era's grimy, punishing austerity, solutions that didn't

rely on the state held an understandable appeal. Who needed a judge and jury if you had an executioner?

Even the chaos agents who believed they were agitating on Michael's behalf couldn't agree on a tactic. Ronald Fields chose to muck up the grand jury process, but at least he endeavored—as he saw it—to stay within the letter of the law. The United Freedom Front, however, made no such effort, was under no such illusions. And they were not alone in seeing extrajudicial measures as the preferred course of action.

An employee in the building spotted a pair of women tinkering with ceiling tiles in the bathroom of the Patrolmen's Benevolent Association, the police union. Officers, alerted to the sighting, searched the room and found nothing. Then, eight days later at 1:03 a.m., a bomb exploded on the twenty-first floor of 250 Broadway in Lower Manhattan, across from City Hall.

It was February 23, two days after the announcement of the indictment.

Within minutes of the blast, the Associated Press received a call. The reporter who answered the phone heard a recording of a woman's voice: "This is Red Guerilla Defense. Tonight, we bomb the offices of the PBA, which promotes racist murder and killer cops." Earlier in February, more than ten thousand police officers—approximately half the NYPD—had gathered to protest the indictment of Stephen Sullivan, the officer who shot Eleanor Bumpurs. Outside the office of the Bronx district attorney, Mario Merola, they shouted and marched, carrying flags and banners. *Mario beats his wife*, went one chant. *Merola must go*, went another. Then the head of the Patrolmen's Benevolent Association gave a speech promising solidarity with Sullivan. The bombers alluded to the rally in their recording: "The ten thousand racists are not one hair on the heads of Eleanor Bumpurs, Michael Stewart."

A half hour before the explosion, a superintendent had also gotten a phone call and cleared the thirty-one-story building.

The outfit calling itself Red Guerilla Defense was, in fact, the May 19th Communist Organization. Named for the shared birthdays of Malcolm X and Ho Chi Minh, M19 was, like the United Freedom Front, a clandestine group with a penchant for using violence. But it diverged in at least one

respect: it was the first group of its kind founded and led by women—a reaction to the misogynistic tendencies of the Weather Underground. (Select men, however, were allowed into its inner circle, as historian William Rosenau has written.) Members disdained mainstream feminism and chose to enact political change through other means. M19 was responsible for actions at locations as varied as the U.S. Capitol (where bombs left a fifteen-foot tear in the building's north wing), the Israeli Aircraft Industries building in New York, and the South African consulate in Midtown Manhattan.

The members were particularly animated by the actions of police, whom they deemed "the frontline enforcers of a system of colonization of Black, Puerto Rican, Mexicano-Chicano, and Native American peoples." In a communiqué, the group wrote that the police were protected by the courts and district attorneys and by Elliot Gross, who they believed had "distorted and destroyed" evidence at Mayor Koch's behest in the case of Arthur Miller, a Black man choked to death by the NYPD. The PBA headquarters was chosen as a target, a member of M19 later told a filmmaker, because the union defended police accused of violent acts.

As a result of the explosives planted by M19, water pipes ruptured throughout the building. Despite the phone call ahead of time, two maintenance workers were injured.

Given the similarity of the bombing to the actions of the United Freedom Front, the FBI at first attributed the bombing to them, believing the group was just now operating under another name. At a glance, it wasn't far-fetched: both groups took steps to mitigate the human toll (not always successfully) and had cited Michael Stewart's death as a reason for taking action. But even if the UFF had wanted to bomb the police union offices, it couldn't; the previous November, most of the group's members had been arrested in a raid in Ohio. Two days after the raid, Ronald Reagan won his second election—a grim reminder, if needed, that the UFF's revolution was over.

The next spring, five UFF members stood in a federal courtroom in Brooklyn for arraignment. They had been indicted on charges related to ten bombings, committed over a span of twenty-six months, including the 1983

attack on the navy recruiting center in East Meadow. When asked how they would plead, four defendants—Raymond Luc Lavasseur, Patricia Gros, Jaan Karl Laaman, and Richard Charles Williams—each replied, "I am guilty of no crime." But the fifth, Barbara Curzi, read from a two-page statement: "There is no justice for oppressed people in Amerika. Not when killer cops murder with impunity."

"I want a guilty or not guilty plea," the judge replied. When Curzi continued reading, he asked marshals to remove her from the courtroom. Curzi kept up the recitation as she was carried out by the elbows.

Gros then resumed where her comrade had left off. The judge asked that she, too, be taken away, and Laaman picked up the relay, reading, "There is no justice in the murders of Clifford Glover, Michael Stewart, and Eleanor Bumpurs by terrorists wearing the uniform of the N.Y.C. police department."

As the defendants were hauled out of the courtroom, dozens of supporters in the gallery began to agitate. *You're fascists!* they screamed, as FBI agents looked on from the front row. *You're killers. You marshals are animals.* And then the skirmish began.

"Eight marshals and the other defendants rolled around on the floor in a mass of flailing arms and kicking feet," wrote a *Newsday* reporter, who heard a marshal tell Williams, "You killed a trooper; we're going to get you." Order was restored soon enough, however, when the defendants were zapped with five thousand volts from stun guns.

The judge entered not guilty pleas on their behalf.

Ever since the *Times* series on the Chief Medical Examiner's Office, a slew of investigations ordered by increasingly higher levels of government had been in the works. Two reports were already public.

The city's Department of Investigation spent thirty days interviewing witnesses, making site visits, and reviewing approximately five hundred documents pertaining to the office's management and operation going back to 1979, the year Gross took over as chief. The resulting report reflected the hangover from the fiscal crisis: shortages of staff, inadequate laboratory equipment, very little supervision and formal training. It was a miserable

place to work, where employees were discouraged from laughing, and even talking, in the hallways.

The state's investigation, overseen by the health commissioner, produced a report that was equally harsh. The Medical Examiner's Office was found to be "understaffed, undertrained, underequipped and underfinanced" and was "failing to fulfill its basic public service mission as a medico-legal investigative agency providing reliable, timely and scientific autopsy reports and death certificates." Such shortcomings were so severe that the office's ability to "contribute credibly and effectively" to the criminal justice system could no longer be presumed.

Meanwhile, a third investigation, headed by Arthur Liman and Max Gitter, had been humming along since late February, with a team of lawyers and medical examiners meeting daily to scrutinize each of the dozen cases that the *Times* reporter Philip Shenon had highlighted in his series. Pairs of attorneys were assigned to specific cases, for which they wrote drafts of summaries, interviewed relevant sources, and examined Gross's role in each. One of the less pleasant aspects of the work was the viewing of autopsy photos. "The first time you see autopsy photos, you want to throw up," recalled Richard Tofel, one of the younger attorneys. "And then, you know, literally by the fifth day, you're sitting there eating a blueberry muffin."

Liman and Gitter's report was issued in April. Cumulatively, the group interviewed more than 150 witnesses and reviewed in excess of 100,000 documents. The conclusions were sometimes scathing, describing the Medical Examiner's Office as a "den of suspected intrigue and counter-intrigue" and as sufficiently damaged that it now lacked credibility. But the report was, in the end, considered exonerating. The group determined that Gross, despite his well-tabulated faults, had not engaged in a cover-up.

The authors didn't believe Gross had obstructed the Michael Stewart investigation, but they found his performance troubling. It would have been a difficult case for any medical examiner, they reasoned, but had been doubly so for one keen on finding answers solely in the examination room. Gross had not had access to eyewitness accounts, which were not available until the grand jury investigation. But he had been privy to *some* information. The medical

examiner had erred by failing to do a close review of the records from Bellevue and by not discussing Michael's case with admitting doctors.

Given his lack of information, Gross's decision to provide a preliminary cause of death to the public so soon following the autopsy, at the very time that his words carried the most weight, was deemed a misstep. If he had to say anything, suggested the authors, "Cause of death is unknown, pending further investigation and study" would have sufficed. Had he not learned his lesson from the Tennessee Williams autopsy? Opacity might have spared the medical examiner grief back then and perhaps forestalled the headache that came from attributing Michael's death to cardiac arrest.

Toward the end of the report, the authors asked a question that was ostensibly beyond the scope of their mandate: What was the cause of Michael Stewart's death? The medical examiners on the team surely had opinions on the matter, but with the impending trial, they were constrained in what they could commit to the page. They declined, for instance, to say what had caused the cardiac arrest. Still, even the hedged words pointed toward a guilty party.

"All of our advisors are satisfied, to a reasonable degree of medical certainty, as is Dr. Gross, that Mr. Stewart died as a result of the injuries he sustained in being restrained—or beaten—by the transit police," they wrote. "Suffice it to say, none of our experts or Dr. Gross believe Stewart died from a fall or from natural causes."

Left unstated in the published report, but certainly implied, was a lack of confidence in the *Times* series that sparked the investigations. A significant on-the-record source voicing the idea that Gross had engaged in a cover-up was his medical stenographer, Siegfried Oppenheim. In an interview with commission lawyers, Oppenheim struck the attorneys as notably unreliable when he could not correctly recall the number of Transit officers in Gross's office prior to the first press conference, and he altogether forgot the presence at the autopsy of William Cole, the chief medical resident from Bellevue. In another instance, recalled one commission lawyer, the attorneys heard a recording of a Shenon interview—provided by the very source on the recording—in which the reporter seemed to encourage the source to say things about Gross they plainly did not believe. There was discussion

among the report's authors of directly criticizing the paper, but ultimately that would remain mere subtext.

It was time for Gross to resume his day-to-day work, and the chief medical examiner was jubilant. "I plan to stay a long time," he announced at a press conference and disclosed plans to bring a libel suit against the *Times*.

The stakes of the Michael Stewart trial were stark: Would law enforcement face repercussions for a homicide committed in the line of duty, especially if the victim were Black? For the officers charged in Michael's case, the answer up till now had been no.

Weeks later, in July 1985, jury selection in the Stewart case was complete. The voir dire process had been unusually drawn out because the prospective jurors met with the defense and prosecution one by one, rather than in groups. In theory, this arrangement could benefit either side, but in practice it enabled the police's attorneys to scrutinize each juror for a bias against law enforcement.

This time, the indictments would not be dismissed. The case was ready for trial.

Robert Morgenthau wasn't an underdog, but he was, for the first time in his storied career, facing sustained criticism. For months, he'd been blasted over his handling of the Bernhard Goetz case. Although he'd finally indicted Goetz for attempted murder in March, civil rights and religious leaders fumed that the district attorney hadn't obtained the indictment after the initial charges in January. This was, they believed, because the victims—all of whom faced unrelated criminal charges—were denied immunity before the first grand jury. The leaders, predominantly Black, were also frustrated that Morgenthau had failed to obtain murder charges in the Stewart case and perhaps had even slow-walked the investigation.

Morgenthau was annoyed by such criticisms, and he cursed at a *Times* reporter who brought them up. Here, at last, was a chance to prove he could indict the police and get a conviction.

22 Ricochet

Robert Morgenthau hadn't let a bit of criticism deter him from running for a fourth term. He'd been Manhattan district attorney since 1975 and had no intention of stepping aside. Indeed, his tone during the announcement of his candidacy was rather cocky, even if it simply reflected pride in his record. "There are fifty-three thousand people who may not be voting for me, not because I have not done my job but because I have done it so well," he bragged, alluding to the number of felony convictions obtained during his decade in office.

The defense argued that Morgenthau's announcement, made the day before the trial was to commence, had tainted the jury—such was the DA's power that he could influence a case he was not personally prosecuting. This was a stretch, but as one of the attorneys acknowledged years later, "You throw shit against the wall, and sometimes something sticks." Anyway, it fell to the presiding judge, Jeffrey Atlas, to discern if this was true. He interviewed the jurors, one by one, to ensure they were still capable of serving. The seven men and five women, chosen from a pool of more than five hundred, were asked if they'd been unduly influenced by Morgenthau's announcement. Atlas determined that they had not and that a trial could go forward.

For Atlas, appointed to the bench by Koch in 1980, this case was unique. The judge would recall it, years later, as his first in which police were on trial for a line-of-duty homicide.

On July 18, 1985, the trial began in the state supreme court. Michael's parents, Millard and Carrie, sat in the front row. Mrs. Stewart held a single red rose.

John Fried, the assistant district attorney, had done months of preliminary work. He'd gamed out his direct examinations, what witnesses he'd call and in which order, and what those witnesses would testify to. He'd prepped witnesses for both direct and cross-examination and had considered legal issues that might arise during the trial.

Standing in front of the jury box, after all that preparation, the soft-spoken prosecutor ticked off the bare facts of the case: Early one morning in mid-September nearly two years before, Michael Stewart had been arrested. He was probably drunk and had resisted. Under arrest, he was taken to Union Square, near the entrance to the District 4 precinct. Approximately forty minutes after his arrest, Michael was kicked, beaten, and choked by Transit police. He screamed at such a volume, said Fried, his eye on the jurors, "that he literally awakened the whole neighborhood."

"Everyone," the ADA told the jury, "looked out the windows."

The three charged Transit officers had failed to "protect the life and health of a person under arrest and in their care, custody, and control," Fried said. Because of that failure to protect a prisoner in their custody, the officers were being charged with a number of crimes, ranging from assault and criminally negligent manslaughter to perjury. The most serious charges were being made against Officers John Kostick, Anthony Piscola, and Henry Boerner because they alone had been with Michael on the ride to Bellevue Hospital and were, therefore, entrusted with his care. Susan Techky, Henry Hassler, and James Barry, who were also present in Union Square, were charged with perjury for telling the grand jury that Michael's assault had not taken place.

In a case where the victim was shot in the head or stabbed in the heart, the cause of death would've been unambiguous. But Michael's precise cause of death was a complicated, loaded issue. The thirteen days of medical interventions had left him with injuries. None of the doctors who examined him found the sort of wounds—a ruptured spleen; broken hyoid bone; fractured arms, legs, or ribs—that would allow the prosecution to present a single cause of death. Absent those indicators, Fried was compelled to give the jury several options: cardiac arrest caused by the beating, cardiac arrest caused by neck compression, or a combination of the two. "I don't recall ever having a cause of death as complicated as this," he'd acknowledge.

The prosecutor wasn't worried: he had a lot of faith in the intelligence of the Manhattan jury pool. This wasn't unfounded; he'd picked sharp people, including an editor at *The New Yorker* and a future editor at *Esquire*. Still, the group would be asked to absorb a great deal of information over the course of the trial. Prosecution witnesses alone would exceed sixty, dozens of whom were college students then living at 31 Union Square West. The prosecutor was candid, careful not to overpromise. He acknowledged that not one of the witnesses could say that any single officer among the six actually struck Michael.

Once Fried was finished, attorneys for the Transit officers took their turn.

"No one will come into this trial and say that John Kostick abused Michael Stewart," Barry Agulnick, Kostick's lawyer, promised the jury. A former prosecutor, Agulnick specialized in defending law enforcement, a practice he began in the wake of the Knapp Commission on police corruption. He had won multiple acquittals in homicide cases involving Transit officers. Agulnick, who was overseeing the defense, described Michael as a threat, saying he was "kicking uncontrollably the entire time and [that] it took eleven officers to finally subdue him." His death, the lawyer contended, was the result of "cardiac arrest precipitated by drinking huge amounts of alcohol and exerting himself," rather than "anything these officers did." Agulnick emphasized this point, noting that when Michael had done "a header" into the subway steps, there'd been enough alcohol in his system "to get two people drunk."

The tried-and-true message: the victim brought it upon himself.

The rest of the defense—there were six attorneys in total, one for each officer—augmented Agulnick's remarks by telling the jury that Michael fought like a "psycho," and describing his desperate resistance to arrest as "frenzied."

"Michael Stewart is dead," a lawyer contended, "because of what he did to himself."

Fried began introducing witnesses. Carefully guided by the prosecution, the first individuals to take the stand would paint a picture of Michael Stewart's last night alive and well, from his arrival at the club to the moment his friend waved goodbye to him at the subway. The opening witness, purely for scheduling reasons, was an exception. Before receiving firsthand accounts

of Michael happy and healthy, Rebecca Reiss would recount watching him being beaten.

In a quiet voice, Reiss, twenty, regurgitated her memories of September 15, 1983. Around three o'clock that morning, the student, then a freshman at the New School for Social Research, had just returned to her room on the fifth floor when she heard "unusual sounds" coming from the street. Out her window facing Sixteenth Street, Reiss could see police shove a man to the concrete on the north side of Union Square Park. She told Fried about the screams. "Oh, my God, someone help me, someone help me!" followed by "What did I do? What did I do?" The man was then shoved against a car, chest first, as officers attempted to cuff his hands behind his back. After the man pushed the officers, Reiss saw the police topple him to the pavement.

"What happened next?" the prosecutor asked.

"One of the officers was kicking the man, and the other officers were hitting the man."

"What was the man doing?"

"The man was yelling, 'Oh, my God, someone help me, someone help me.'"

Fried asked Reiss to demonstrate to the jury exactly what the kick looked like. She left the witness box and approximated the kick, which she'd described as "moderately fast."

As Agulnick watched, he jotted inconsistencies on index cards. No matter how well the students were prepped for testifying, there were bound to be discrepancies between their grand jury testimony and what they said at trial. The defense attorney ticked these off during cross-examination: In late 1983, Reiss had not said anything to the grand jury about the screams. Why not? Had her roommate been awake during the beating or not? Was the window open or closed? At the time of the incident, had Reiss been on the lofted bed, on the ladder, or on the floor? Well, which was it?

There was an inherent imbalance to the exchange. The accumulated discrepancies, no matter how insignificant, could effectively give the jury an excuse to call into question the veracity of the more consequential claims.

Once Reiss finished her testimony, witnesses were called to refute the defense's portrait of a severely drunken man whose frenzied spasms posed a threat

to the physical safety of the police. The first was Mark Burkett, a blond-haired doorman at the Pyramid Club and sometime musician (of whom Warhol had written in his diary, "He looks regular, you'd never think he was gay"). On the night in question, he'd last seen Michael around midnight.

Burkett told the jury that he and Michael had chatted for about thirty minutes. Michael was in a good mood. No whiff of alcohol on his breath, no slur in his speech, no stumble in his gait. As far as Burkett could tell, Stewart simply wasn't drunk.

"Why do you say that?" Fried asked.

"Because the way he was acting," Burkett replied.

"Did you see any bruises on his body?"

"Maybe a few pimples, that's about all."

Under cross-examination, Agulnick questioned the credibility of the witness's recollection. Did the doorman believe it was the case that drugs were consumed at the Pyramid?

"It's not supposed to, but it may," Burkett allowed.

The next witness, Susan Brown, had tended bar at the Pyramid that evening. She testified to serving Michael two, maybe three mugs of beer over an hour and a half. Like Burkett, she detected no intoxication in him. On cross-examination, however, Brown acknowledged that she had not been the only bartender on shift that evening, which left open the possibility that another bartender had served the young man additional drinks.

The day's final witness was Patricia Pesce, the woman who met up with Michael at the Pyramid after midnight. Her brief, bright interlude in his life had since taken on an outsize importance, not just to her personally, but in the understanding of how those last hours unfolded. On the stand, Pesce testified that Michael had had nothing to drink but a sip of her rum and orange juice and had not ingested any drugs. She told Fried about sharing a cab with Michael uptown and depositing him at the subway on Fourteenth Street. When she left him, she said, Michael had been sober and unbruised.

Under cross-examination, Agulnick suggested that Michael had intended to jump the turnstile because he was broke and that Pesce knew it. The lawyer asked if she and Michael had committed any crime that night.

Fried jumped to his feet and objected. Pesce's cross-examination was over for the day. When it resumed the following day, Agulnick suggested that the young woman's testimony couldn't be trusted. Pesce had an inexcusable bias: she'd been in touch with Mrs. Stewart, and if that weren't disqualifying enough, the family's attorneys had represented her during the grand jury appearance. Pesce had indeed developed a bond with Michael's mother, formed during those long days and nights at Bellevue. When Eleanor Bumpurs was shot, Mrs. Stewart called Pesce, and they would keep up with each other for years after.

Agulnick argued that Pesce's reliability as a witness was further diminished because of her activist proclivities. In the months after Michael's hospitalization, she'd demonstrated at various protests around the city and had advocated for the removal of the chief medical examiner. She'd also participated in a sleep-in at the governor's office, in the hope of pushing Cuomo to appoint a special prosecutor in the case.

The defense could not persuade Pesce to back off her testimony.

Eleven days into the trial, John Dempsey took the stand. He was the Transit detective assigned to investigate the beating the morning after, and he was present in the courtroom to read notes taken by Peter Kougasian, the assistant district attorney who interviewed the District 4 police in the late morning hours of September 15, 1983. The purpose of the testimony was to place specific officers at the scene because the student witnesses' vague descriptions weren't sufficient. This was part of the People's workaround.

The Transit officers had told Kougasian that Michael was driven to the substation in Union Square and that, once outside the van, he'd made a run for it. He was screaming and acting violently. An officer then attempted to cuff his ankles. When that failed, that officer and others wrapped the prisoner's legs in gauze. According to the ADA's notes, no Transit officer had seen Michael hit, choked, bleeding, or turning blue. From the prosecution's vantage, this wasn't an ideal message to send to the jury. All the same, putting the police in Union Square at the same time as Michael was a necessary step if they were to obtain a conviction.

The next witness for the People was singular—the only person who had

a ground-level view of Michael Stewart being led out of the subway. Working a shift at Blimpie, Robert Rodriguez had seen what unfolded from a distance of approximately two hundred feet. As an auxiliary police officer—considered the eyes and ears of a neighborhood—he had more credibility than the usual bystander.

Rodriguez had previously given an account of what he'd seen to an NYPD detective. "Witness, stated that he observed a Transit Police Van, pull up to the 14th St Subway Station, with its red lights flashing . . . He observes a uniformed P.O. come out of the subway with a (male black) who was apparently handcuffed behind his back, the officer was holding by the arm, a suffel [*sic*] ensued the officer was assisted by two other officers from a police van, the officers through [*sic*] the male to the floor and sat on top of him." It went unmentioned by the press, but the report was taken at 2 a.m. on September 16—less than twenty-four hours after the incident and before the first newspaper containing an account hit the newsstands.

Rodriguez told Fried that he'd been at work wrapping bagels when he saw a Transit officer and a handcuffed prisoner exit the subway. "And suddenly," he said, the officer "grabbed the prisoner by surprise and then threw him down to the concrete cement floor. The Transit police officer then threw himself on top of the prisoner."

After a few minutes, additional officers arrived on the scene, at which point the first officer extricated himself from the prisoner. "Then this big Transit officer took over," said Rodriguez. "He grabbed the prisoner, turned him over. He slapped the prisoner. Then he kneeled down and picked him up by the chest, like he was taking a real look at him. He pulled him towards him. They were face-to-face. And then he let him go. His head hit the concrete." Rodriguez said he'd seen an officer "make a kicking motion" toward the prisoner, which caused the latter to "ricochet."

Rodriguez's testimony now concluded, the judge excused the jury. Fried had a disclosure to make. The ADA informed Atlas that on two occasions in 1976, Rodriguez had been evaluated at Bellevue Hospital and diagnosed with schizophrenia.

Fried asked Atlas to prohibit the defense from questioning Rodriguez about his medical history, as it was, in his view, not relevant. Agulnick

argued that Rodriguez's hospitalizations were quite relevant, as the witness apparently suffered from visual and auditory hallucinations. Atlas ruled in favor of the defense, a decision that he himself would question decades later.

The next day, Rodriguez sat in the witness box.

"I will not have a witness deliberately or accidentally hurt," the judge warned. "I expect that the cross-examination will be discreet."

Whether Atlas truly expected this was unclear.

"Did you have a mental disorder in 1976?" Agulnick asked.

"Nervous," Rodriguez replied.

"A nervous disorder?"

"Yes."

"In 1976, did you have hallucinations and visions?"

"No."

"In 1976, isn't it true you slashed your wrists with the intent of taking your life?"

"Yes, it's true," Rodriguez said. "Do you want to see the marks to verify it?"

He glared at the attorney and pointed to his wrists. Rodriguez had been treated for emotional issues since childhood, and he told the jury he'd slashed both wrists in the suicide attempt. According to doctors' notes, which Agulnick entered into evidence, Rodriguez had tried to end his life in a church. He'd been drawing a Social Security check ever since.

Agulnick's demolition of the People's witness elicited a smirk from his client, Kostick, and despair in the gallery. "Even a madman could tell when somebody is being brutalized by the police," said a Black spectator within earshot of a reporter. It had taken only one day on cross for Rodriguez to be reduced to a "mental patient on disability," as the *Daily News* put it with tabloid bluntness.

Murray Kempton, *Newsday*'s sage, was offended on Rodriguez's behalf. The man he'd seen on the stand had no animus toward police—the witness's respect for the badge was such that he had introduced himself as "APO Rodriguez," a proud acknowledgment of his service as an auxiliary police officer—and had reported what he'd witnessed out of a sense of duty. And for what reward? "Every aspect of his previously tortured spirit was spread

out for public ventilation," Kempton wrote. "Robert Rodriguez did what he took to be the good citizen's duty and his ordeal yesterday may explain why the good citizen is so endangered a species."

The next day, the defense continued goading the loquacious, jittery Rodriguez into creating doubt about his story. On the stand, he wound up insinuating that the prosecution had itself tried to cover up police complicity in Michael's death. The ADAs who had first interviewed him, he claimed, had questioned whether he'd been able to pay sufficient attention to what was unfolding outside Blimpie and had suggested that he "take a vacation until this whole thing blows over." When Agulnick asked if Fried, the lead prosecutor on the case, was also party to the cover-up, Rodriguez replied that he wasn't.

The defense kept Rodriguez on the stand for three additional days, as each attorney wanted their shot. They tripped him up on discrepancies of questionable relevance—for example, he'd told Fried on the stand that Transit police had "roughed [Michael] up real bad," whereas he'd told the grand jury they'd "beat the hell out of the guy."

Rodriguez had been so torched, observed the *City Sun*, a Black newspaper in Brooklyn, that there could be no expectation, "even at this early date, that the murderers . . . of Michael Stewart, those who wear the Transit Police Department uniform that has become their cloak of immunity, will be brought to real justice."

The prosecution did achieve a minor victory. Rodriguez had written up an account of the incident that the defense tried to block because it was improperly dated. Atlas allowed the document to be entered into evidence anyway. Agulnick took noisy issue with the judge's ruling and demanded to cross-examine Rodriguez once again.

"This is my courtroom, not yours!" the judge shouted, out of the jury's earshot.

Atlas had lost patience with the defense's lead attorney, whose demeanor was often antagonistic. "This witness has been on the stand for six days," the judge said, "and if you don't think that is latitude, I don't know what is."

23 The Students

The trial had gone on for nearly a month before the jury (and, by extension, the public) heard an account of the night of Michael's arrest from someone other than people who had spent time with him that evening or were witnesses on the scene. That August day, as summer temperatures reached the nineties, the words of Susan Techky were shared in court.

Under the Fifth Amendment, the Transit officer could not be compelled to testify—a right each defendant would invoke. However, testimony to the first grand jury, which placed them at the scene of Michael's beating, was admissible. Therefore, a transcript would be read to the jury by a court reporter as the defendant, wearing a black-and-white dress and beret, looked on.

In Techky's recounting, she had just concluded her shift at 3:05 a.m. when she heard screams outside District 4. Running up the stairs, just behind Henry Hassler and ahead of James McCarron, she found John Kostick and Anthony Piscola trying to restrain a prisoner who was face down with his hands cuffed behind his back. Techky, too, tried to hold the man down.

"I was leaning on his back," the court reporter read. "He was what we considered an . . . emotionally disturbed person." Michael was "bucking, kicking, and scratching," according to Techky, who said she'd never seen "a prisoner react so violently." She believed he had been drinking, as she smelled alcohol on his breath. She wondered, too, if the man was on angel dust, such was his energy. "I couldn't imagine anyone being this strong, having this much fight in him." The Transit officer denied that Michael had been beaten or kicked.

By her own account, Techky knelt on Michael's back for approximately seven minutes.

Jimmy Breslin was watching the proceedings. A scrappy columnist who'd spent decades swimming against the East River currents, Breslin had an unusual eye for sussing out the truth where others had lazily embraced myth. In the Bernhard Goetz case, for example, when the press took it for granted that the teens were armed with sharpened screwdrivers, it was left to Breslin to report the truth—that the screwdrivers were dull and that *Goetz never saw them*.

Now, sitting in the gallery of a largely empty courtroom, Breslin observed a Staten Islander who, in several years on the job, had amassed a single dereliction (for losing an ID card) and civilian complaints for an ethnic slur and abuse of authority. Techky sat attentively, chin on fist, and said nothing.

Later that day, the tabloid veteran would file a column that captured the absurdity of the Transit officer's tale. Breslin wrote: "She would be called upon to say nothing this day, give no answers to either friendly or hostile questions. Her words merely were put into the record: A 150-pounder, handcuffed behind, had been a threat to six policemen."

With Techky's testimony entered into the record, it was time for more of the student witnesses to take the stand.

That afternoon, the prosecution called Nancy Jo Haselbacher. The nineteen-year-old was among the witnesses who, for the last week, had rotated through the court to testify about events that, after two years, were no longer top of mind.

John Gunderson, who'd been on the sixth floor of the dorm, had already told the jury about hearing the screams, about seeing officers kick a man lying on the ground while they beat him with a "stick or a club." When did he stop screaming? Fried asked. "During the hitting, he stopped," Gunderson replied. Like Rebecca Reiss, Gunderson had been compelled to sit quietly as his story was picked apart by the defense. He'd testified in November 1983 that he believed the police kicked Michael, but he hadn't been sure. Now, Agulnick pointed out, he seemed more certain. To a grand jury, the student had said that two or three officers committed the beating. Now the act was attributed to a single officer. Gunderson admitted that perhaps he hadn't seen anyone kick the man on the ground after all.

And so it went. Daniel Baxter, a Parsons student on the dorm's fifth floor, testified that the officers had hit and kicked Michael. Or, at least, he told Fried, that's what he assumed—after all, Baxter had seen the police "standing very close, right over him." But under questioning from Agulnick, he admitted that when he'd filled out a questionnaire for the district attorney, he'd been less than certain a beating had taken place.

"You knew this was a case involving allegations that police officers beat someone," Agulnick told the flustered student. "You knew how important it was for you to write down what you saw or didn't see in relation to the hitting, didn't you?"

Haselbacher, too, would have her memory questioned. Taking the stand, she testified to being awakened to the screams. Eventually, she'd looked out her window and saw a man on the ground. She'd seen him kicked.

"Did you attend a party on the fourth floor that night?" Agulnick asked.

Haselbacher couldn't recall.

"Did you have any alcohol?

She had not.

"How do you know that?"

Because, she said, "I don't drink."

Haselbacher told the attorney that, two or three minutes after she heard the screams, she looked out her window. At that, the lawyer referred to the grand jury minutes. During her 1983 testimony, Haselbacher estimated that she'd waited fifteen minutes before going to the window.

"You said that?" Agulnick asked.

"Yes."

"Was it fifteen minutes?"

"I don't think it was that long now."

"In other words, you think you made a mistake."

Her testimony concluded, she left the stand as the courtroom sketch artist scribbled away. As Haselbacher walked to the elevator, she was trailed by Breslin. He watched her leave the courthouse, black bag over her shoulder. "When she decided to take up designing," he wrote, "the Parsons catalog didn't say that she would be required to remember every detail of a night on which a young man was killed below her window."

The tenth student to testify, Candice Baker, fared no better. Baker, twenty, was concerned about testifying against the police and believed she could be subject to retaliation. She walked past a glare of cameras on her way into the courtroom, where she faced Agulnick from the witness box. In late 1983, she'd said there were "about ten" police surrounding Michael, one short of the actual number on the scene. "They seemed to be kicking him and I'm not sure what else." Now, under questioning from Agulnick, she put the number of police who kicked Michael at three.

"Was it like the Rockettes?" Agulnick asked. "Three police officers next to each other doing the exact kick at the same time?" The other defense attorneys appeared pained by Agulnick's question.

Baker had told Fried that several officers kicked Michael with "quick, jabbing" motions as he lay screaming on the sidewalk. Under cross-examination, she acknowledged that she'd previously said the police were not just kicking Michael, but beating him with clubs.

As Fried objected, Agulnick yelled: "You told a grand jury under oath—a grand jury looking for the truth—that officers used clubs to beat someone and you never saw that, ma'am. Is that correct?"

"Yes," Baker replied softly. "I was inaccurate as to what their arms may have been doing. That was an assumption I mistakenly made."

Agulnick also made a point to note that, in filling out a questionnaire for the district attorney, Baker had omitted any mention of Michael's having been kicked. When Fried reexamined the witness, he asked about her attitudes toward police officers. Over Agulnick's objection, and in the absence of the jury, it was revealed why Baker had left this information off the form. Her uncle, it turned out, was a Pennsylvania State Trooper.

Nearly a week after Officer Techky's testimony, the court heard James Barry's. The bespectacled sergeant had been on the job for nearly twenty years and had been written up once for what the *Daily News* described as "idle conversation."

Barry, too, painted a picture of police mustering to overcome a rampaging, solitary unarmed graffiti artist. When Barry arrived on scene, Michael—

whom he called an emotionally disturbed person and a "violent psycho"—was handcuffed behind his back and face down on the sidewalk. Kostick was squatting atop him in a pose Barry likened to a baseball catcher's. The prone Michael was "acting in a violent manner and screaming" and managed to grab Kostick's leg. Barry said he had had no choice but to pull Michael's hand away—a hand that was cuffed behind his back—because it was "dangerously close" to Kostick's gun. Barry put his nightstick between the cuffs, rendering Michael's hands immobile.

The legs were still a problem. The police hadn't been able to cuff them, so officers bound Michael's ankles with gauze. Even this measure didn't halt the kicking, though. "So, I reacted," Barry had told the grand jury. "I put my foot on the back of his legs and pushed his legs back down." At that point, an officer used gauze to tie the young man's feet to his hands. Then he was put into the emergency services van. Michael was still breathing, Barry said, and seemed fine: "I observed no injuries." He said he had not seen any of his colleagues either beat or kick the deceased.

A day later, the jury heard testimony from another Transit officer. In two decades, Henry Hassler, forty-one, had incurred four derelictions, including one for failure to appear at weapons training. Echoing Techky's and Barry's language, he described the prisoner as emotionally disturbed. Hassler had seen Stewart on the sidewalk "rolling from side to side" as if he were "a fish out of water," and he said he made sure the prisoner's ankles were held. He acknowledged that, in the moment, his greatest worry was that the officers might be kicked in the face. "I was concerned," he said, "about what was taking place south of his buttocks." Hassler characterized the arrest as "routine."

Such testimony, delivered to the courtroom by a court reporter, was double-edged: while it established that the six officers were present in Union Square at the time of Michael's beating—and, therefore, provided evidence that they'd witnessed the beating—it allowed the police's rosy version of events to go unchallenged. Fried would have difficulty convincing a jury that the Transit officers had failed to prevent Michael's death if they were already persuaded that no assault had even occurred.

"John Fried deciding that he was gonna put their testimony in was *fantastic*," Agulnick crowed decades later.

Until now, no one had claimed that any officers on the scene put Michael in a choke hold. This changed when Chris Seyster took the stand. The Parsons student had witnessed the events of that night from the dorm's seventh floor.

"I saw a police officer with a billy club under the man on the ground's neck," Seyster testified. "The man with the club was to the left of the individual on the ground; he was down on one knee, both hands on the ends of the club, with the other knee in the man's back, and he was pulling on the stick, upward." The choke hold lasted about thirty seconds, Seyster said. Then officers took Michael, now hog-tied, and threw him into the van "with a swinging motion, letting him fall."

Under cross, the defense couldn't find much to take out the sting of Seyster's testimony. One attorney noted that Seyster had told the second grand jury that the choke hold lasted ten seconds. Another was skeptical that Michael's screams were uninterrupted during the choke hold.

"So he was getting enough air through his vocal cord that you could hear those sounds a half a block away?"

"Yes."

At forty-nine, Anthony Piscola was more than a dozen years into his Transit career the night Michael Stewart was taken into custody. He was one of three officers whom Fried had identified to the jury as most at fault in the events of that night—by refusing to protect Michael from harm—and so, had been charged with criminally negligent homicide and assault. Now, as August drew to a close, a court reporter was set to read Piscola's grand jury testimony into the record.

This was the first testimony the jury would be hearing from a Transit officer about what had occurred at the initial site of the arrest, the subway station between First Avenue and Fourteenth Street. It served to refute Rodriguez's testimony that Michael had been severely handled: that Kostick had thrown him to the sidewalk and that another officer had slapped him, grabbed his throat, and let his head fall to the pavement. Piscola denied each

of these allegations, telling the grand jury that he "never observed physical abuse." However, he'd been on the radio and "unable to say that none of that occurred."

Once the prisoner was loaded into the van, Piscola recalled, the officers drove west on Fourteenth Street. While in transit, Piscola and Boerner were kicked. They tried to shield themselves with their hands. It fell to Kostick, who was seated next to Michael, to resolve the problem. To Piscola, it seemed as if Kostick and the young man were wrestling. "The upper part of Michael Stewart's body was extended into the rear compartment," Piscola said. "His neck and body were hyperextended over the back seat."

Piscola echoed Barry's dehumanizing description of Michael. "In police jargon," he said, "it was believed Stewart was a psycho."

Upon their arrival at the precinct at Union Square West, the prisoner ran. "Help! Help!" he screamed. Whereupon he was hog-tied, as the Parsons student Seyster had described, and loaded into the van for Bellevue. On the way to the hospital, the prisoner made no sound and did not move, but "the lack of activity did not seem to be significant." Upon their arrival at the hospital, a nurse remarked about "him turning blue," Piscola said. "That was the last time I saw Mr. Stewart."

Not a week later, the jury heard the testimony of Henry Boerner, who faced the same charges as Piscola. Boerner, forty-two, was a former marine. His record was unblemished save for a couple of instances, as when he was written up for failure to obey an order. Reporters present didn't record much of his grand jury testimony. What little was quoted made the point well enough: "I saw and did no violence to Michael Stewart."

Perhaps not, but as witnesses continued to make clear, *someone* had.

Annemarie Crocetti, who lived on the eleventh floor of 31 Union Square West, was a different sort of witness from the many Parsons students who had taken the stand. At sixty-five, she was exceedingly accomplished and deep into her career as a public health scholar with faculty appointments around the city.

In 1978, when she was teaching at New York University's Department of Preventive Medicine, Crocetti was one of seven appointees to President Jimmy Carter's National Commission on Air Quality. She chain-smoked

during the meetings, which wasn't helpful to the pro–clean air side of the commission. Two years later, in response to a bracing report on the effects of carbon dioxide on the climate, the appointees met on Florida's Gulf Coast to collaborate on proposals for federal legislation. During a post-breakfast meeting, members of the group took issue with the words "likely to occur."

"Will occur," an engineer suggested.

"What about the words: highly likely to occur?" a congressional science consultant asked.

"Almost sure," said a nuclear engineer.

"Almost surely."

"Changes of an undetermined—"

"Changes as yet of a little-understood nature?"

Finally, Crocetti, who hadn't said much until then, spoke up. "I have noticed," she said, "that very often when we as scientists are cautious in our statements, everybody else misses the point, because they don't understand our qualifications."

In other words, Crocetti understood the power of clarity to cut through confusion. She told Fried that she'd been sound asleep when she was jolted awake by the sound of a man screaming. Looking out her window, she saw police surrounding Michael. Two police officers kicked him as he lay face down on the sidewalk, she said. Crocetti left the stand to demonstrate the manner of the kick before resuming her testimony. Two officers, she said, had then "picked up the body and carried it a few feet, close enough to the van to be thrown in."

The next day, Crocetti sat for two hours of cross-examination. It turned out, part of her grand jury testimony hadn't been accurate. To both grand juries, she'd recalled an ambulance pulling up near the police. But while there had been an emergency services vehicle at the scene, no ambulance had been present. The defense used this error to call into question the rest of her testimony. Agulnick suggested that she'd been asleep or just confused when she'd gone to her window. Crocetti denied the accusation and said that her memory of the body's being thrown into the car was "crystal clear."

More than five weeks after the start of the trial, the prosecution introduced its twenty-fourth, and final, witness to Michael's beating.

Curtis Lipscomb, a Parsons student, testified that, upon hearing a scream for help, he looked out his sixth-floor window. "I saw a man face down on the sidewalk, pinned to the ground by an officer," he said. "I saw an officer with his knee in the man's back. The man's hands were cuffed behind his back." In Lipscomb's memory, at least one policeman kicked Michael, and at least one punched him.

Lipscomb recalled officers ascending the stairs from District 4. One stuck out to him because she had long blond hair. This eye for detail made Lipscomb the first witness to place an officer fitting the description of Susan Techky at the scene of the beating.

All told, a dozen witnesses testified that in the early hours of September 15, 1983, multiple officers kicked or beat Michael. The rest heard screams and saw the melee, but did not see the police strike Michael. All were, to varying degrees, diminished by the defense, which—equipped with grand jury testimony and a prosecution questionnaire—used what the *New York Times* described as "a hectoring technique that has brought many of the prosecution witnesses to whispered compliance."

For the students, who were accused in open court of being drunk or high, it was frustrating to have their memories discounted simply because of minor discrepancies or flimsy assumptions about their sobriety. Decades later, the last student witness, Lipscomb, still remembered how furious he was to be told that his own recollections and those of his classmates couldn't be trusted. "What are you talking about? I saw what I saw!"

24 Rested

Six weeks on, the jury had absorbed the testimony from dozens of witnesses to Michael's beating. They'd also heard, indirectly, from five policemen accused of either committing the crime or lying to cover it up—but not, as yet, John Kostick. It was Kostick, now twenty-six, who arrested Michael and who, eight hours after the drive to Bellevue, summed up the incident in a complaint for criminal mischief. He described witnessing Michael write graffiti on the subway wall, sitting on him while waiting for backup, and riding to the precinct. "Upon arrival at Dist. #4," he'd written with sterile economy, "deft. again became violent and necessary force was used to restrain deft."

Besides Robert LeBright, the token booth clerk who, early in the trial, testified that Michael had been calm when he stood by his booth, Kostick was the only other person who could attest to what had occurred inside the station. Nearly two years had passed since then, and now, finally, the arresting officer's side of the story would be heard in open court.

Once again, the court reporter read grand jury testimony into the record.

At approximately 2:30 a.m., Kostick entered the subway station and descended the stairs to the Brooklyn-bound side of the LL line. He saw a man write three letters on a wall with a felt-tipped marker. Kostick walked toward him and asked what he was doing. He detected no alcohol on the man's breath.

"Hey, man," was the reply. "You got me."

The Transit officer arrested him.

At first, Michael did not resist, Kostick said. But when they were standing by the token booth, he "took off like a shot and ran up the stairs." At the

top, "Stewart fell face-forward on the ground." Kostick recalled how he'd gotten on top of Michael and pressed his nightstick along his back, holding the prisoner in place until backup materialized. When Piscola and Boerner arrived, Michael was calm, Kostick said. It was only in the emergency services vehicle that he became violent. At Union Square Park, he fled the van, collided with an officer, and screamed for help. Legs bound with gauze, the now-incapacitated Stewart was "placed into" the van. During the ride to Bellevue, Kostick and the prisoner exchanged no words, the officer testified. At no point had the policeman struck or choked the prisoner, he said, and neither had his fellow Transit officers. According to Kostick, Michael was still breathing when he was wheeled into the hospital on a gurney.

By now, the jury had heard witness after witness say that the accused officers had beaten Michael in Union Square until he lay almost lifeless. Would they now believe the arresting officer's claim that, in effect, none of this was true? This was an officer of the law, so of course his words carried special weight, but he was also a man desperate to keep himself out of prison. Up until now, a juror intent on discounting the testimony of witnesses could find a pretext for doing so for pretty much all of them. The students? It was the middle of the night, and who knows how much they'd been drinking? As for the sandwich man at Blimpie, Robert Rodriguez, well, he'd once tried to kill himself. Even Annemarie Crocetti—she was eleven stories up. What could she really have seen or heard?

Short of a parish priest, unimpeachable witnesses did not exist. But medical professionals, who either administered care to Michael as he was dying or determined his cause of death, might provide dependable, unimpeachable testimony.

When Michael was admitted, recalled Lillian Conrad, he was bruised, blue, and had two black eyes. There was a red mark on his neck, too. It was clear to the head nurse of the Bellevue ER that the patient had been deprived of oxygen. "I could tell he wasn't breathing," Conrad testified. Even the young man's hands, tightly cuffed behind his back, were turning blue. Once the gauze was removed, Conrad saw wounds from his knees to his shoulders.

The next day, the defense sought to discredit Conrad's testimony. The neck injury? She hadn't documented it in her medical reports. Also, she'd been interviewed twice by television news programs: the defense wondered if this violated hospital rules. And was it suspicious, Agulnick suggested, that the Stewarts' attorney Louis Clayton Jones had represented the nurse during the grand jury investigation?

Judith Walenta, a veteran health care worker with degrees from Swarthmore College and New York University, took the stand next. Michael was swollen and bruised upon arrival, she said. There was a red abrasion on his neck at the level of his Adam's apple, swelling and discoloration all over his face, and liquid draining from his left ear.

According to Walenta, Bellevue was trying to paper over the case. Lawyers from New York City Health and Hospitals Corporation, which operates the city's public hospitals, had informed her that "if I discussed the case with anyone but them, in the event of a malpractice suit against the hospital they would not be able to represent me." It is not clear what, if anything, Bellevue was hoping to avoid with Walenta's testimony. But the nurse, who died in 2017, believed that by testifying, she was endangering her career.

Under cross-examination, Walenta acknowledged that she, too, had neglected to note the red abrasion in hospital records.

"So if you had seen an injury to the neck, you would have felt that it was important?"

"Yes."

"You would have written in your notes that there was a mark on the neck?"

"Yes."

"So you saw a mark on the neck and didn't think it was important?"

"Not at that time."

Fried then called to the stand doctors who had attended to Michael.

"He was in cardiopulmonary arrest," testified David Pizzuti, who oversaw the emergency team. Michael lacked a heartbeat and blood pressure—he was, in plain English, dead. But the team heroically resuscitated his heart.

Duncan McBride, the neurosurgeon who examined Michael a few hours after he was admitted, testified as well. The patient had exhibited no neurological

function and had "severe impairment of the brain stem." Tests confirmed that Stewart was comatose, while a CT scan revealed swelling on the left side of his head, but no brain damage or a skull fracture.

The jury had now heard from witnesses who'd attended to Michael in the terrible last stage of his life. The next knew Michael only in death.

For more than two years now, Elliot Gross's career had been moving from one turbulent event to another. Just that August, the New York State Health Department had served him with eleven charges of incompetence or negligence—the result of the investigation ordered by Cuomo. The charges weren't yet public, but within days of the announcement, word leaked to the *Daily News* that Michael's case was among them.

This was the fourth probe of Gross's office in seven months.

Gross, as he had before, denied any misconduct and pointed to the Liman-Gitter commission's conclusion that he'd mishandled cases but had not engaged in a cover-up. In a press conference held the day after the *Daily News* scoop, the medical examiner said he was a victim of both a lynch mob and a witch hunt, while his lawyer creatively likened the investigation to "a witch hunt by water torture." Still, Gross took a sixty-day leave of absence, in the hope that he could wait out the scrutiny and then be reinstated by Koch. The mayor, who was sympathetic to his plight, mused that Gross would probably sink a fortune into legal bills.

But Gross's luck took a turn. In September, the federal investigation begun more than a half year before by the U.S. attorney in Manhattan, Rudolph Giuliani, cleared the chief medical examiner of misconduct. Then, in October, the misconduct charges were tossed on the grounds that the state lacked the power to prosecute medical examiners. Even Louis Clayton Jones, an attorney for the Stewarts, seemed to soften toward Gross. In an interview with *Newsday*, he acknowledged that there was no evidence for the most explosive claim brought against the medical examiner, one that had animated the lawyers and activists alike: that the removal of Michael's eyes had been an attempt to hide evidence of strangulation. Gross, said Jones, "clearly did not engage in a coverup attempt." He blamed the doctors retained by the Stewarts, who apparently hadn't mentioned what had been known since the Liman-Gitter

report: that Gross, rather than obscure the condition of the eyes, had "fully photographed and documented" them during the autopsy.

This was the backdrop for Gross's relatively uneventful first day on the stand, October 3, 1985, the forty-second day of the trial. Wearing a gray-blue suit with a white handkerchief nestled in the breast pocket, the medical examiner testified about the autopsy he'd personally conducted in the hours after Michael's death. There were healing wounds, Gross observed, swelling in the brain. The heart, kidney, pancreas, brain, and liver were "essentially normal." There were bruises, but the X-ray revealed no fractures.

Gross defended his initial finding from September 1983—that Michael had died as a result of cardiac arrest, with no sign of physical injury. The results, he explained, had been preliminary, pending further study. (This was always overlooked; reporters carelessly conveyed the impression that Gross's opinion had changed, when it had merely been sharpened.) For a medical examiner, "cardiac arrest" was simply used "as a reflection of death," and it had been Gross's task to determine the source of that arrest. At the outset, he'd ruled out heart disease.

It was during his second day on the stand that Gross began to lose the jury.

The medical examiner acknowledged that he no longer stood by his final report, in which Michael's death was found to be the result of "a physical injury to the spinal cord in the upper neck." The decision seemed sudden, but it wasn't.

In January 1984, Gross met with Fried. They discussed the scenarios under which the cord injury could have happened. It was possible, said the medical examiner, that someone might have struck or butted Michael's head. Or that he'd hit his head when he was thrown, restrained, into the emergency services vehicle. The less likely but still plausible possibility was that someone had twisted Michael's head backward. The most fanciful scenario was that the injury had been the result of a fall. But by November, more than a year after the autopsy, Gross believed that the spinal injury had occurred after Stewart's arrival at Bellevue. Gross had consulted with Harry Zimmerman, the head of pathology at Montefiore, whom Gross considered the country's preeminent pathologist. It was Zimmerman's opinion that the damage to Michael's spinal cord was, in fact, the result of tissue decay

during hospitalization. Gross agreed, but did not alter the death certificate to reflect his change of opinion.

The spinal injury, Gross now testified, was secondary to cardiac arrest.

"What does the Zimmerman opinion mean?" Fried asked.

"That what had been interpreted as physical injury to the spinal cord and what had been given as the cause of death was not so," Gross replied. In other words, it seemed that whatever had killed Michael had not yet been disclosed by the medical examiner, either in prepared remarks or extemporaneously at a press conference.

Gross left the stand.

The defense asked Atlas to strike Gross's testimony from the record and have Zimmerman subpoenaed. Agulnick argued, fruitlessly, that the medical examiner's testimony should not be deemed "expert" because it was based on another pathologist's findings.

Gross returned to the stand the following Monday. He stated assuredly that excessive alcohol consumption alone hadn't killed Michael—a fatal level of alcohol in the blood was .35 to .40, and Michael's was found to be .22. But Gross would not, even after being asked repeatedly, articulate the cause of death. This was the sort of obstinacy that frustrated reporters, who in the weeks after Michael died wanted the medical examiner to connect the dots. He'd declined to do so then, and he still wouldn't, even if such clarity was required to convince a jury of the defendants' culpability or lack thereof.

Gross testified that Michael's cardiac arrest *could* have been caused by asphyxiation, but he wouldn't say that's what had happened. Gross did say that the injuries were "consistent with kicks and blows from a billy club" and that those injuries were, in turn, consistent with the hospital record. But these were healing wounds not related to the cause of death.

Fried gamely did his best to pin Gross down on this point. "Can you now formulate an opinion as to the cause of Michael Stewart's death with a degree of medical certainty, based on the clinical records, the reports of the consultants and your own post-mortem examination?" he asked during the medical examiner's third day on the stand.

"No," Gross replied, "I cannot."

Fried, though, was persistent. He knew that to determine the cause of death,

Gross must consider evidence beyond the autopsy report and hospital records, which he'd pointedly refused to do in the aftermath of Michael's death. Fried gave Gross nearly twenty variables pertaining to the night of Stewart's arrest, synthesized from eyewitness accounts of the beating and from testimony from Bellevue personnel about his injuries. Then, Fried said: Suppose Stewart's hands were cuffed behind his back, that a billy club was positioned under his neck and that the screams that could be heard across Union Square were suddenly terminated. Given those circumstances, what would you ascribe the cause of death to, with a reasonable degree of certainty?

Agulnick objected and momentarily kept Gross from answering.

However, during Gross's fourth day on the stand, the prosecutor attempted once more. He asked the medical examiner further hypothetical questions— "assumptions," he called them—based on the district attorney's investigation into the case. In this scenario, Michael had been kicked, choked, and beaten while in custody.

This time, Gross formed an opinion. But it was neither simple nor terribly clarifying. Michael's death was the result of "acute intoxication," "the effects of his being under restraint," and "the effects of blunt-force injuries." The alcohol sped up his heart rate, which was further quickened when he was hog-tied. Michael's breathing became labored. It was possible, said Gross, that a nightstick to the neck caused "a cessation of respiration" and, finally, the cardiac arrest.

The medical examiner's disposition was toward opacity, and yet he couldn't help but be revealing. In subsequent testimony, Gross admitted that his initial finding—that Michael's death was the result of the spinal injury—was "impossible." He hadn't changed the death certificate, or gone public with this realization, out of twin fears: that it would turn the medical examiner's office into a "three-ring circus" and that he'd be perceived as swayed by controversy. Gross even admitted how annoyed and anxious he'd been about the protests and media coverage directed at his office.

All told, Gross was tethered to the stand for eleven days. By the end, the jury was confused. "He was," a juror recalled, "not a very convincing witness." This hadn't gone unnoticed by the Stewarts' attorneys, either. "Gross has offered the court preponderous versions as to what caused Michael's

death and his flip-flops will create reasonable doubt in the minds of the jury," Louis Clayton Jones predicted to the *City Sun*.

Given the chance decades later to blame Gross for undermining the People's case, Fried would pointedly decline. After all, he'd prepped the medical examiner to testify, so nothing he'd said at the trial was a surprise. His fellow ADA Bridget Brennan shared this opinion, more or less. "We knew he'd get creamed," she recalled.

Unfortunately, as Gross was the chief medical examiner and had personally performed Michael's autopsy, not calling him as a witness wasn't an option. The prosecution had, however, taken steps to mitigate the damage he'd caused. They found a medical expert whose testimony would, they hoped, clarify the cause of death for the jury.

A cardiologist at Harvard Medical School, Thomas Graboys came to the stand with impeccable credentials. He was also clear-speaking to the point of bluntness. Now when Fried posed his hypotheticals, he got definitive responses: "I believe that the direct precipitant of the cardiac arrest was blows to the body, more specifically, around the back, sides, and chest," Graboys said. Being struck in those areas can cause abnormal heart rhythms, similar to when an athlete takes a blow to the chest, he explained.

Contrary to the claims of the defense and Gross himself, the cardiologist did not believe that Michael's alcohol consumption played a significant role in his death. "If given an individual who is terribly frightened, panicked and restrained, and with that amount of alcohol, there's just no way he would have spontaneously had a cardiac arrest." Something, he said, "would have had to provoke it." Graboys's medicalese plainly bolstered the prosecution's case that the "something" was a beating severe enough that Michael was briefly dead before he was comatose.

The final witness for the prosecution was Brian Blackbourne, the bald, bespectacled chief medical examiner of Massachusetts. The fastidious veteran of more than four thousand autopsies had read through the hospital and autopsy records and the witness testimony. He was unusually familiar with the case, having worked on the Liman-Gitter investigation into the medical examiner's office.

Blackbourne testified that Michael's injuries were inconsistent with the police officers' accounts of how they had restrained their prisoner. Stewart had, in his opinion, died of asphyxia brought on by a nightstick held against his neck.

In short order, the Massachusetts medical examiner was undercut on cross-examination, when the defense got him to admit that Michael's autopsy report didn't note injuries indicative of a choke hold. Also, Blackbourne had testified that the allegation of a choke hold was inconsistent with reports that Michael had been screaming. (This is, in fact, false. Talking or screaming requires moving air across the vocal cords, and the ability to do so simply means the airway isn't completely obstructed. That one can vocalize is *not* an indicator of sufficient breathing. In short, a person is perfectly capable of screaming while slowly dying of a choke hold.)

Blackbourne knew he'd been filleted, and he vomited in a courthouse bathroom at a break. Ultimately, his testimony cut two ways, as it corroborated Gross's opinion that blunt force had contributed to Michael's death. But now the jury had heard expert witnesses assign death to, variously, intoxication, the effects of restraints, disrupted heart rhythms, and asphyxia. That each doctor could be individually correct did not make this any less a muddled story.

After several months and approximately nine thousand pages of testimony, the People rested.

"Defense Shocker," blared the resulting *Daily News* headline. And it was. Eleven minutes after Fried rested the People's case, Agulnick rose. He and the other lawyers had been discussing the idea for months, ever since the police's grand jury testimony was read into evidence. They knew the jury would hear the officers' version of what had happened, from the grand jury transcript, but that their clients could not be cross-examined by the prosecution if they pled the Fifth. Then the defense attorneys had gone to Massachusetts to meet with Blackbourne, who agreed to speak to them prior to his testimony, and they returned convinced the prosecution couldn't prove the cause of death beyond a reasonable doubt. The defense didn't even bother talking to other expert witnesses as a contingency.

"Your honor," Agulnick said, "the defendant John Kostick will not present any evidence in this case." The other attorneys summarily rested their respective cases as well. It was a clear signal they didn't believe the People had proven their case.

Atlas allotted the attorneys a week and a half to prepare for summations.

25 No Evidence of Racism

The defense summations were spread over two days. Each of the six lawyers got their turn to address the jury of eight women and four men, nearly all of whom were white.

"It's the multiple-choice cause of death with mix-and-match theories."

"If you can't even figure out what the man died of, that's reasonable doubt."

Gross was a "pathetic character" who "set pathology back one-hundred years."

Brian Blackbourne was a "fly-by-night" witness.

The prosecution was "the product of political pressure, media pressure, media abuse and the pervasive intermeddling of Stewart family attorneys."

The defendants were "living in a nightmare" amid a "lynch mob."

"What happened on that street was not a ballet . . . We know there was a degree of force used, but it was used appropriately, not excessively, and it was used justifiably."

As for Michael: "a man who was out of control," a "madman," who was "not arrested because he was Black," but "because he broke the law."

The courtroom was filled to capacity as Fried addressed the jury for seven hours. Millard and Carrie Stewart were in their customary seats in the front row, as they had been each day of the trial.

Aware of white New Yorkers' generally favorable view of the police, the prosecutor made clear that the trial had not been a castigation of the entire force—those guardians of society that Plato wrote about. As far as the ADA was concerned, white police killing a Black man was "evidence [neither] of racism" nor of "police brutality in New York City."

The trial was simply a judgment of six defendants for their actions, or lack thereof, on September 15, 1983, between 2:45 and 3:30 a.m. Kostick, Boerner, and Piscola in particular had the authority and opportunity to save Michael's life, Fried argued. "They had the power to say, 'Stop this, enough, put an end to it.'" But they hadn't put a stop to it. Instead of protection, Michael had been given street justice.

It was during those forty-five minutes, when all the Transit police stood around and did nothing, that Michael's breath was beaten out of him. This was a pummeling that exceeded the bounds of reasonable force. It didn't matter that he had had too much to drink. It didn't even matter that he had resisted. "He was restrained with kicking, he was restrained with clubs, he was restrained with a nightstick across his neck," Fried said. "It's that conduct, that striking conduct, that brings us to this courtroom today."

Fried explicitly addressed the weakest areas of the People's case. He asked the jurors not to doubt the testimony of the witnesses. Yes, their stories didn't always line up, their recollections didn't always comport with what could be proven. Maybe some had seen hitting while others saw kicking. Another remembered a choke hold. What they witnessed was a matter of chance—what floor they were on, what time they'd awoken, what window they'd looked out of. But their motives were not in question. They were college freshmen with no bias against the police. What was their incentive to lie?

Even Elliot Gross deserved a modicum of grace. "The issue is not whether he should or should not be medical examiner," Fried said. "The issue is whether you believe him."

For the jury, determining guilt was a matter of deciding if six Transit police had contributed to Michael's death. "Look at how Michael Stewart, lifeless, motionless, quiet, silent, was put, tossed, thrown into the police van," Fried said. "Did they wrap up a dead man? Well, a man who [had] started to die? Yes, they did, and they weren't even aware of it."

It took Judge Atlas four hours to give the instructions. He explained the charges and omission liability—how it applied to those with legal duty to protect others. A failure to do so was "culpable inaction." The jury had the power to vote to convict Kostick, Boerner, and Piscola of criminally negli-

gent homicide even if they'd never so much as bumped into Michael. *The failure to act is the equivalent of the action itself.*

"Grit your teeth," Atlas said. "Gird yourselves. Go and be objective, not emotional. . . . Don't rush to judgment. Do it carefully. Be deliberate. Be sensible."

Deliberation went on for seven days, which made the prosecution cautiously optimistic. The jurors understood from the beginning that Michael, as one put it, "would not be dead if not for the cops." But the jury could not make sense of the testimony given by the medical experts, which had been contradictory and inconsistent. In particular, the testimony of Gross was a problem because the jury had little faith in the chief medical examiner's shifting opinions.

There was neither confusion nor skepticism about omission liability. "In fact," a pair of jurors wrote the next year, "we understood the principle and were prepared to hold the defendants accountable under it."

On the afternoon of November 24, the nearly all-white jury filed into the courtroom. There were a few smiles. The defense attorneys were sanguine; court officers had given Agulnick and his colleagues a sneak preview of the jury's decision. The forelady was asked if a verdict had been reached.

Kostick stood up.

As the clerk read each of the six charges, the forelady pronounced the judgment.

Not guilty.

"Thank God," said Kostick, who kissed Agulnick.

Identical verdicts followed for the other five defendants, whose family members clapped.

Carrie and Millard Stewart sat silently. Then Mrs. Stewart said, as she watched the jubilation on the other side of the room, "I'm just going to watch them enjoy this."

Remember Michael Stewart

The *East Village Eye* was a brash, frequently brilliant monthly magazine that was, more or less, the neighborhood's tastemaker. Artists lucky enough to grace its pages—Run-DMC, David Wojnarowicz, Keith Haring—had been found worthy by a staff whose judgment was as sharp as their interests were catholic. That was part of the magazine's vitality; it covered *everything*. The issue published the month of Michael Stewart's death included interviews with Bryan Gregory of the Cramps and the filmmaker D. A. Pennebaker, alongside a conversation with the defendants involved in the 1981 Brink's robbery, obits for Klaus Nomi and Ira Gershwin, and columns by Glenn O'Brien and Cookie Mueller.

The *Eye* was perceptive about the neighborhood and the horrors of the era that were eventually papered over in memory. Heroin, AIDS, and gentrification were as much a part of the East Village as the art and music. "It was a brutal time," recalled Basquiat's onetime tagging partner Al Díaz. "It wasn't all 'Let's go out with Madonna,' you know?"

Given the *Eye's* preoccupations, it followed that Michael's life and death were on the magazine's wavelength. The October 1983 issue featured a short, unforgettable investigative work by Spencer Rumsey titled "Murder + Lies." The story was illustrated with a photo taken by Suzanne Mallouk of a comatose Michael, tubes sprouting from his mouth. The *Eye* then ran a second, more comprehensive story in March 1985, just after the second set of indictments was issued. The author, Terry Bisson, was an aspiring journalist with an anarchist bent. He happened to be associated with the May 19th Communist

Organization, the clandestine, mostly female group that cited Michael's death as an impetus for its bombing of the Patrolmen's Benevolent Association headquarters.*

Bisson first pitched the story to the *Village Voice*, which had shown oddly little appetite for coverage of Stewart's case. But an editor gave him the go-ahead, and the feature Bisson wrote—arguably, the first comprehensive look at the killing—expertly chronicled Michael's social circle, the last night at the Pyramid Club, the beating at Union Square, and his death. Three weeks after Bisson filed, the story was rejected, reportedly because it would big-foot a *Voice* investigation into Morgenthau. Possibly, Bisson later mused, the weekly passed on it because "it stepped on a lot of toes, including the DA's." He was able to place the story with the *Eye*. Alas, it didn't get much traction, as the *Eye*'s reach and influence above Fourteenth Street were limited. Bisson gave up on journalism, but he would find his calling (as well as money and awards) in science fiction and fantasy.

Now, with the trial concluded, the *East Village Eye* ran something of a denouement: an editorial raging against an unjust verdict and the failure of anyone in a position of power to take responsibility. It was titled, "The Man Nobody Killed."

Even as the particulars of Michael's case were unusual—the rogue grand juror, the bombings, the involvement of artists like Madonna and Haring in raising money and awareness for the case—the lack of accountability captured by that headline with brutal concision was not. Viewed in its simplest form, what happened in Union Square was frighteningly typical. Approximately a third of the misconduct allegations to the New York City Civilian Complaint Review Board were made by Black New Yorkers; in 1986 alone, more than three thousand complaints were filed under "excessive physical force." Punishment remained rare, and in the months since John Conyers's congressional hearings, the roll call of victims and undisciplined police had only gotten longer. In one notable example, a pair of Harlem police, Charles

*According to Bisson, he had no part in the bombing. The organization, he told *The New Yorker*, believed he was a "petit-bourgeois intellectual" and didn't involve him in such gritty matters.

Ferranti and Francis Sancineto, forced one man to swallow cocaine and stuck a gun in the mouth of another. The two officers were briefly dismissed, but were returned to the force after the commissioner intervened. "We've always tried to help and do the right thing and this is what we get," Ferranti told a reporter.

Such cases were common enough that there was concern that the events of 1983 would be forgotten. That anxiety gave rise to an exhortation: "Remember Michael Stewart." The refrain had been percolating since 1984, when the words first appeared, graffitied in marker, around the East Village. An artist named Eric Drooker, a recent graduate of Cooper Union, saw the phrase and viewed it as more of an imperative command, for himself and all New Yorkers. *Soon enough,* he thought, *it's just going to recede into history.*

Drooker was familiar with the contours of Michael's case from what he'd picked up through WBAI, the tabloids, and in the neighborhood rumor mill. For Drooker, who'd done his share of tagging, a graffiti artist's being killed by police was sobering. He himself was white, but still, he identified with what had happened to Michael and understood how easily situations with the police could turn ugly. Drooker had seen David Wojnarowicz's flyers of skeleton police, created to promote the September 1983 Union Square protest, and was inspired. He made two posters, charcoal drawings in the style of German expressionism. The first, titled *Remember Michael Stewart*, depicted a skeletal Michael being choked with a nightstick, while the second, *The Cover-Up Continues*, showed him handcuffed and a cop in silhouette with his index finger to his lips—a demand for silence. Drooker designed a red button bearing a photo of Michael he'd cut out of the *East Village Eye*. "Remember Michael Stewart . . ." it read in sans serif typeface. A Stewart attorney had Drooker order a thousand buttons from a factory in Chelsea.

The words took hold, and could be seen on signs in front of the roughly sixty protestors gathered outside the criminal court after the verdict.

REMEMBER MICHAEL STEWART.

Michael had not been forgotten. His parents had faithfully pursued justice on his behalf for years. Friends like Suzanne Mallouk and Patricia Pesce would continue to act as custodians of his memory. And beyond his circle, the injuries he'd sustained at the hands of police inspired a small explosion

of work ever since news of his hospitalization was made public. Early on, while Michael was still at Bellevue, George Condo completed a portrait of him painted with gorgeous deep oils. Then, within weeks of Michael's death, Andy Warhol noticed a short tabloid item in which one of the Stewarts' doctors speculated on the cause of death. Struck, perhaps, by the juxtaposition of the story and the department store ad filling the right side of the page, Warhol silk-screened the broadsheet and over-inked and smudged the type. The work was titled *Daily News (Gimbel's Anniversary Sale/Artist Could Have Been Choked)*.

And now, after the officers walked free, several murals along East Eighth Street drew attention. One, near a plumbing supply shop, depicted Michael on a subway platform holding a spray can. "From the far left," wrote Jimmy Breslin, who wandered among the works, "a cop holding a club comes running."

Artists may have been most affected by Michael—who, more than anything, wanted to make his life as one of their number—but writers, too, were touched by his death. Toni Morrison, only a few years past her editorial career at Random House, had been brooding on a new project. Once, while waiting at the airport, she'd been taken with the antics of a lively Black child. What would happen, she wondered, if his life were cut short? She'd been thinking about it ever since. William Kennedy, Pulitzer Prize–winning author of *Ironweed* and founder of the New York State Writers Institute, commissioned a play from Morrison, who'd been the lyricist for an unproduced musical a few years earlier. The plan was for her production to mark the inaugural Martin Luther King Jr. Day.

Set in an abandoned cotton mill over two acts, *Dreaming Emmett* tells the story of a dead fourteen-year-old Black child who, in a dream, assembles a cast of characters from his own life. The teenager is exhausted—the afterlife afforded no peace—and decides to shoot a film titled *How I Spent My Summer Vacation*. This was revisionist history, he tells the audience. An imagined past in which he wasn't killed: "Way it would have been if I had my boys with me."

Within the reality of the play, the characters are actors in the teenager's

movie. These include the two men responsible for murdering him and the white woman whose false accusation gave them the pretext for their attack. In more than a dozen drafts, Morrison uses real names: "Carolyn," "Roy," and "J.W.," whom audiences would immediately have recognized as those responsible for the lynching of Emmett Till in 1955—Carolyn and Roy Bryant, and J. W. Milam. It was only months before the premiere that the Bryants became "Princess" and "Major," respectively, while Milam was renamed "Buck." Mamie Till, Emmett's mother, is "Ma."

Morrison had written about Till in *Song of Solomon*. She saw a parallel between the martyred child whose death set off the civil rights movement and the Black youth of the present cut down because of their skin color. Among the other inspirations, Morrison told a reporter, were the victims of the Atlanta Child Murders and Michael Stewart. It's possible, too, she had in mind Henry Dumas, a young Black poet who had been shot to death by a Transit officer on the 125th Street station platform in 1968. As an editor at Random House, Morrison had published a posthumous volume of Dumas's work in 1974.

America did not lack for murdered Black citizens. As Abena Busia wrote in an essay on the play's production, there was "a multitude of unmemorialized Emmetts whose stolen lives litter the landscape of US history."

As Morrison worked on the play, the great novelist seemed to put herself in the mind of the dead. On Random House stationery, in loopy script, she'd written:

> *What you did was*
> > *awful*
> *Not what I did*
> *It's who I was*
> *If I was white*
> *I'd be alive*

Then Morrison crossed out "who," writing "what" in its place. "It's what I was . . ."

Dreaming Emmett allowed a murdered Black youth the fantasy of retribution. Till could be as obnoxious as he liked to Major without fearing for his

life. "Look a here, man," Till says to Major. "You the Lone Ranger. Kill any Indians today? Or you still specializing in niggers? Nigger *boys* that is." The play is not, however, gleeful, but is grounded in the love and grief of Till's mother. At one point, Emmett flippantly asks if Ma cares about him. "Care about you?" she replies, looking at her palms.

> "What do you see here? Tell me. There's nothing in them is there? I had
> my hands full with you, with work with trouble. Now they're empty."

She continues, "Look here. I got nothing to hold. And nothing to drop."

Ultimately, Morrison seems to argue that while a fair amount had changed in the last thirty years—sometimes for the better—white people still treated Black people with utter disregard and posed an ever-present threat to their life and liberty.

"I wanna be up to date," Emmett says to Major. "So, am I the last Emmett Till?"

"No," replies the Roy Bryant stand-in. "You wasn't the first and you ain't the last. Every time one of you steps out of line, there's a responsible white man to show you where that line is. We will stop you in alleys; we'll stop you in the parks. We will stop you on the buses, the subways—anywhere you misbehave."

Morrison hoped to take the play to Paris once it wrapped up in Albany, but she never got the chance. The reviews were mixed, and after a single run, it was never staged again. Copies of the play were thought to be pulped. Morrison went off and finished *Beloved*, a novel she'd been writing about the wrathful spirit of a murdered Black child.

"I wasn't savvy enough about writing theater to evaluate what I thought was theatrically wrong with her play," William Kennedy recalled in 2022. "I just remember being *taken* by it."

Back in New York City, Elliot Gross returned to work, having been reinstated by Mayor Ed Koch after the verdict. "He's been through the fires of hell," the mayor said of the chief medical examiner, who'd been cleared in Giuliani's federal investigation. "How long do you keep the guy roasting?"

For Gross, this show of support wasn't enough. He wanted satisfaction from the newspaper he felt had wronged him. His lawyer, Howard Squadron, informed the *New York Times*'s general counsel that his client wasn't actually interested in money, that he simply wanted the paper to issue a correction. The *Times*, though, maintained that there was no error to correct.

Just shy of the deadline, Squadron filed papers in the state supreme court, making good on his long-standing promise to sue. Gross accused the paper of libel, slander, and conspiracy to libel and asked for $512 million in damages. Defendants included the *Times* as an institution, members of the staff—the *Times*'s executive editor and Philip Shenon, the reporter who'd written the series about the Medical Examiner's Office a year earlier, among them.

The wind seemed to be at Gross's back. After fifteen months, a special state prosecutor found that his handling of seven police brutality cases, including those of Michael Stewart and Eleanor Bumpurs, was not criminal. There was no proof of fudged autopsy reports or a cover-up in the cases under investigation. "The evidence disclosed, instead, that there were seemingly honest disputes between professionals with respect to the ways in which these autopsies were conducted and the conclusions reached in each one," according to the report. "The allegations which arose from these disputes were in some cases twisted, in other cases motivated by hostility and in still others the result of misunderstanding." The next year, however, Koch, citing leadership and management deficiencies, fired Gross anyway.

Gross went on to accept vastly less prestigious positions, including, for a time, as an assistant medical examiner in New Jersey. His libel suit against the *Times* was dismissed.

Late in life, Gross acknowledged that he should not have listened to Gleb Budzilovich, the New York University neuropathologist. Gross was certain that, absent Budzilovich's influence, he'd have arrived at the true cause of death—a combination of severe intoxication, effects of being under restraint, and blunt-force injuries—far earlier.

He was still aggravated that the press had presented his preliminary cause of death as if it were final. That misperception catalyzed all manner

of conspiratorial thinking that would linger for decades. But as for his own decisions, Gross didn't have regrets. After all, he said, "Regret entails having a certain emotional feeling." Emotion simply wasn't part of the job.

Gross knew from the beginning that the case would present a challenge. Those thirteen days when Michael wasn't dead but only barely alive injected a great deal of ambiguity into the medical evidence. It was clear the case would have been far simpler if Michael had been dead on arrival at Bellevue.

"Would I have liked fractures of the larynx?" Gross said. "That would've been very nice! Then I could have concluded right away."

As it happens, Gross was not alone in wishing for an alternate outcome. Jeffrey Atlas, the judge who presided over the trial, retired in 2005. He's had ample occasions to think about it: "Every time I hear something about a cop beating the crap out of somebody, I say, *Michael Stewart*."

In the aftermath of the trial, Atlas had no opinion about the jury's decision. In his decades on the bench, he'd questioned a verdict only once or twice and was, at first, still reluctant to do so forty years later. Instead, he praised the jury's intelligence, its willingness to absorb so much evidence. But then, asked again if the verdict should've gone another way, he was forthcoming.

"Today," he said, "I feel it would've been *right* to have convicted."

There's no indication that the Transit officers are similarly introspective. John Kostick, for his part, remains firm in his lack of culpability. "We should never, *ever* been indicted. This was a civil case, not a criminal case," he said decades later. "Yes, a death occurred. Yes. But please, I will say this: There was not one broken bone in this man's body."

After the trial, Kostick and the others remained under scrutiny. The New York City Transit Authority, the state agency that oversaw the Transit Police, tasked a retired federal judge with investigating the circumstances surrounding Michael's death. The Transit Authority, which controls the NYCTA, released the findings in January 1987.

The judge, Harold Tyler Jr., found fault at every level. Unquestionably, the decision to transport a hog-tied, unmonitored prisoner was a dereliction of duty on the part of Kostick, the arresting officer, whose testimony that he'd

seen Michael breathing en route to Bellevue was "demonstrably false." (This apparent lie led an MTA committee to recommend that Kostick—alone among the eleven officers on scene—face departmental perjury charges, an idea that was eventually abandoned.) But in Tyler's estimation, it was James Meehan, the Transit Authority police chief, who bore the greatest responsibility for the department's investigative failure. "By the early morning of September 15, it was obvious that a major and extraordinary tragedy had occurred: a prisoner in TAPD custody was brain dead at Bellevue," the judge wrote. Yet, Meehan "did nothing to investigate the tragedy, or to see that anyone else did."

Within days of Tyler's report, Meehan resigned. Or, depending on how one looked at it, he was forced out by the MTA and the NYPD. "The whole thing seems to be a witch hunt," Vincent Del Castillo, appointed as Meehan's replacement, said decades later. "To be honest, we had a Black man dying in police custody, where all the police officers were white. So it became more of a *political* issue than a matter of criminal conduct or administration or anything else like that."

At best, Michael's death was minimized by police. But to those who knew him, both well and in passing, what had occurred was brutal—an open and murderous assault on an unarmed man. This was certainly the view of Keith Haring, whose catapulting fame hadn't kept the superstar from monitoring Michael's story.

Haring kept a newspaper clipping about it on his studio wall. He made art that explicitly addressed the killing: His *Michael Stewart—USA for Africa* draws a parallel between respective apartheid states. Its subject is naked, his neck horrifically elongated thanks to a nightstick. Surrounding yellow figures cover their eyes. These were cowards, and the artist remained unsparing about those he held responsible for Michael's death.

In late March 1987, when Haring learned that Transit officers wouldn't face departmental charges, he wrote in his journal, "Continually dismissed, but in their minds they will never forget. They know they killed him. They will never forget his screams, his face, his blood. They must live with that forever. I hope in the next life they are tortured like they tortured him."

Other sources of death were also on Haring's mind. In the same journal entry, he acknowledged that he would likely contract AIDS or even had already. According to the artist Kenny Scharf, there were symptoms noted on Haring as early as August 1983—around the time the performance artist Klaus Nomi became among the first East Village artists to die of AIDS.

Now, though, Haring mourned the loss of Warhol, dead at fifty-eight after gallbladder surgery. The older man had been Haring's lodestar nonpareil—a patron, teacher, and friend. "He was," Haring wrote, "the personification of New York."

Basquiat, Warhol's former tenant, wept when he heard of Warhol's passing. As he had years earlier, during a trip to Europe, Basquiat pondered suicide. This time, he consoled himself with heroin. "I'm always alone," he cried. "I'm always alone."

Basquiat was rapidly deteriorating. With Warhol gone, Haring wrote of Basquiat, "there was almost nothing left, besides himself, to hold him together."

On August 12, 1988, Basquiat overdosed in his loft on Great Jones Street. He was pronounced dead on arrival at the hospital. He was twenty-seven.

Haring, too, was living on borrowed time. During a trip to Tokyo in July, he'd found a purple splotch on his leg. He got tested upon returning to New York. After hearing the diagnosis, he went to the East River and cried.

He died on February 16, 1990, at thirty-one.

As the eighties came to the close, many artists were still commemorating Michael Stewart. Michelle Shocked's 1988 song "Graffiti Limbo" lamented, "Michael Stewart was strangled to death / And when his case went to court / Not one cop was found guilty." The next year, Lou Reed's "Hold On" name-checked Michael (and Eleanor Bumpurs), too. But the work of greatest cultural footprint was yet to come.

In March 1990, a filmmaker from Michael's Fort Greene neighborhood attended the sixty-second Academy Awards ceremony. His movie was nominated in several categories, including Best Screenplay. To an incredible extent, the finished film resembled the plot the filmmaker had sketched out a few years before.

On Christmas Day 1987, he'd written in his journal, "I want the film to take place over the course of one day, the hottest day of the year in Brooklyn, New York. The film has to look hot, too. The audience should feel like it's suffocating . . ." The filmmaker envisioned a tale of "racial tensions," as he called them, exacerbated as the temperature rose. He'd heard that once the mercury hit ninety-five degrees, rates of homicide and domestic abuse jumped up, too. The film was to climax in a riot set off by the death of a young Black man named Radio Raheem, choked by a nightstick-wielding policeman.

The energetic filmmaker, who'd written and directed two features already, thought of the bloodshed in Howard Beach, a neighborhood in Queens, as inspiration for his third full-length film. The year before, a dozen white men beat two Black men, Cedric Sandiford and Michael Griffith, outside a pizza parlor. Sandiford survived, but Griffith was struck and killed by a car when he fled in desperation onto the Belt Parkway. The filmmaker made a note to retrieve Sandiford's trial testimony. He wasn't limiting his source material to a single atrocity, however. Two days later, he wrote, "It's Eleanor Bumpurs, Michael Stewart, Yvonne Smallwood, etc."

The movie was coming together with such clarity, and Shelton "Spike" Lee already had a title: *Do the Right Thing*.

By January 1988, the character of Radio Raheem and his storyline were further fleshed out. Lee saw Raheem as the epitome of cool, writing, "He never sweats, never exerts himself or wastes a motion."

Raheem's prized possession is his boom box, which he carries everywhere. On the movie's day in question, he brings the music into a pizzeria owned by an Italian American named Sal. This angers Sal, who takes a baseball bat to the boom box. Raheem attacks. His fate is sealed.

"The police arrive," Lee wrote in the journal, "and put a choke hold on Raheem, à la Michael Stewart." Then he collapses to the sidewalk, and the police kick him. In the script, Lee writes, "The officers all look at each other. They know, they know exactly what they've done. *The infamous Michael Stewart choke hold.*"

The script was finished in March. Shooting began in July and wrapped that fall.

Upon its release in the United States in June 1989, *Do the Right Thing* was an immediate hit, grossing nearly half its production budget after a single weekend.

By then, lawyers James Meyerson, George Hairston, and Jonathan Moore were at work on a civil action, underwritten by the NAACP's special contribution fund. A $45 million lawsuit had been filed nearly three years earlier against a number of parties, including the Transit Authority, the City of New York, and Elliot Gross. Unbeknownst to the attorneys, the NAACP had gotten a bit uncomfortable with the expenditures. "Since I have been overseeing requisitions, I am struck by the volume and request for payment," wrote one staff member to another.

Lee's movie presented an opportunity to help subsidize the lawsuit. It hadn't escaped anyone's notice that *Do the Right Thing* concluded with an all-caps dedication to the families of police brutality victims, including the Stewarts. Several weeks after the American premiere, Meyerson wrote to Lee. He'd already left messages at the director's office in Brooklyn and with Lee's lawyers. He explained that the litigation was as costly as it was righteous—particularly given that it might go to trial—and he appealed to Lee by invoking Michael's name. "We know that you are aware of the significance of this matter not simply to the Stewart family, who have suffered but nontheless [*sic*] endured over the years since Michael's death in September, 1983, but, as well, to the larger community of individuals who care about the human condition and truth and justice," he wrote.

Meyerson's request for a financial contribution was subtle, but it could not be missed. The attorney had spoken to the NAACP's executive director, who "has expressed a deep interest and desire to meet with you about the Stewart matter with the hope of enlisting your support for the final thrust in the efforts for this litigation."

The Stewarts' lawyer never got a response from Lee.

"I was a little bit cynical because Spike Lee obviously was a very public and visible proponent of the advancement of civil rights," Meyerson said years later. "And there was, you know, a little bit of, 'Put your money where your mouth is.'"

In May 1990, the negotiations between the two sides of the litigation began in earnest and led, several months later, to a settlement of $1.7 million. Neither the City of New York nor the Transit Authority would admit wrongdoing.

Haoui Montaug, who'd done more than just about anyone to publicize Michael's case, had begun calling his closest friends on the phone. It was June 1991, and he was wracked by AIDS. He couldn't wash himself or take himself to the bathroom. Montaug wanted control over his death. He wanted, as a friend put it, "to just control his destiny." Montaug had a plan, he told his friends: the nightlife legend would kill himself, and he wanted them present as the end approached.

Montaug called, among others, Lisa Edelstein. The two had known each other for years, from *No Entiendes* and Danceteria. After a 1986 profile by Maureen Dowd portrayed Edelstein, then twenty, as "New York's reigning Queen of the Night, Girl of the Moment," she was stalked by dozens of men and grew depressed and isolated. Montaug helped her recover.

Edelstein already knew many who'd been abandoned by their friends and family and perished from AIDS. One friend, desperate to end his suffering, committed hari-kari. Edelstein volunteered at Gay Men's Health Crisis, which gave her an aura of expertise at a time when reliable information on HIV/AIDS was scarce. Men in clubs pulled her into bathrooms to display marks on their arms or in their mouths. "We were going to funerals a couple times a week by 1985," Edelstein recalled. "Underneath all of that glamor and fabulousness and performance art was this incredible pain and absolute terror."

Montaug invited Edelstein to his Bowery loft. But she had moved to Los Angeles by then and had been cast in a production.[*] (Edelstein would go on to have a long, accomplished career as an actress.) She had plans to come to New York, but not until the day after. So Montaug and Edelstein bid each other farewell.

[*] *Circus*, a series by the producers of *Married . . . with Children*, was canceled before it ever aired after an executive called a studio bigwig a "fucking moron."

The gathering was later characterized as a party—"a final fabulous send-off," according to *New York* magazine. But that wasn't accurate. True, twenty friends had congregated in Montaug's Bowery loft, with Madonna joining over the phone, but such festivities as there were had taken the form of a discussion about Montaug's estate and a foundation he hoped to endow. Belongings were given away. Goodbyes were said. The group settled in to watch *The Simpsons*.

When the show was over, Montaug asked his friends to leave. Nearly everyone did.

Montaug had consulted the Hemlock Society, a right-to-die organization. He drank a cocktail of five Seconals and then fell asleep—but he awoke in the middle of the night in a rage. The remaining guests gave the dying man more pills, and soon he was gone.

Robert LeBright, the token clerk on duty the night Michael "walked fast" up the stairs, was shot to death on the job in 1997. LeBright was the victim of a botched robbery. At his funeral, a priest told mourners he'd "lived as a hero and died a hero."

Bernhard Goetz was eventually tried for attempted murder and other charges. He was acquitted, except for criminal possession of a weapon in the third degree, and served eight and a half months of a one-year sentence. In 2001, he ran unsuccessfully for mayor of New York City. Goetz exhibited no regret over his long-ago actions. He maintained a grudge against Jimmy Breslin: "He was an ass."

Michael Stewart's father, Millard, died on March 14, 2002, at seventy-seven. He was buried in Briar Creek Cemetery in Williamsburg, Kentucky. His wife, Carrie, still resides in the same house in Fort Greene.

In 2015, a year after a Staten Island policeman killed Eric Garner, New York's governor, Andrew Cuomo, issued an executive order in which he tasked the state's attorney general "to investigate, and if warranted, prosecute certain matters involving the death of an unarmed civilian, whether in custody or not, caused by a law enforcement officer."

Cuomo had been forced to take a step that his father, Mario, avoided all those decades before, when he was governor. Six years later, however, while the unit of prosecutors formed in response could boast dozens of investigations, it had no convictions.

In 1994, Isabel Wilkerson, who covered most of the Stewart trial for the *New York Times*, became the first Black woman to win the Pulitzer Prize in journalism. Her first book, 2010's *The Warmth of Other Suns*, was a study of the Great Migration. Her second, *Caste: The Origins of Our Discontents*—published shortly after the murder of George Floyd by Minneapolis police—documents America's racial stratification. Wilkerson likened the country to an old house. "The owner of an old house knows that whatever you are ignoring will never go away," she wrote. "Whatever is lurking will fester whether you choose to look or not."

It had taken more than thirty years, but the work Basquiat left on Haring's studio wall, painted days after Michael's death, was now getting a wider presentation. It had been a journey; the portrait of a silhouetted figure and nightstick-wielding police was cut out of the drywall when Haring left the Cable Building in 1985. Then it hung above the bed in his LaGuardia Place apartment. The painting, cradled in a gold frame, was untitled, as Basquiat understandably hadn't seen fit to name a work created on another man's wall. Soon, though, that would be necessary. In a last will and testament, Haring bequeathed *Defacemento*—a word that appears, bracketed by question marks, at the painting's top edge—to his goddaughter, Nina Clemente.

Several years into the Black Lives Matter movement, the painting, on loan from Clemente, traveled again. The move to the Williams College Museum of Art was at the behest of Chaédria LaBouvier, a Williams alum whose brother had been killed by police. The young Black scholar, interested in Basquiat since childhood, had organized an exhibition and discussion series called *Getting A Read On: Basquiat and Black Lives Matter*. The artist's estate had been calling the work *Untitled (The Death of Michael Stewart)*, but when it hung on the wall in Massachusetts, it bore the name that would stick: *Defacement (The Death of Michael Stewart)*.

On June 21, 2019, Basquiat's anguished testament to Michael Stewart's violent death at the hands of New York City Transit officers was now at the Solomon R. Guggenheim Museum, a stone's throw from the Central Park Reservoir. The Guggenheim was showing the painting as part of an exhibition curated by LaBouvier, *Basquiat's "Defacement": The Untold Story*.

On that opening night, *Defacement* was displayed alongside the giants of the old East Village: Warhol, Haring, Condo, and David Hammons, an exceptional Black artist whose screenprint-and-collage of Michael incorporated an *East Village Eye* headline: *The Man Nobody Killed*.

Michael's own work, for years held by his family and Patrick Fox, the Anderson Theatre landlord, was shown, too. As Guggenheim visitors milled about, Fox was struck by Michael's posthumous and temporary ascension to one of the most rarefied spaces in the art world. "He was a child, he was discovering who he was," Fox recalled. "It wasn't really fair, because, in a way, it can't go any farther than that. There was nothing to develop beyond what that show *was* in regard to his work."

Michael had once occupied Fox's dreams, appearing in them at his Anderson Theatre studio on the marquee level. Now his former tenant had returned to the forefront of his consciousness. Not just Michael, though—the rest of the East Village, too, the living and the dead. Extraordinary talents, across a swath of disciplines, brought together by a beating that sparked a neighborhood uprising.

Michael, Fox reflected, "had that power."

ACKNOWLEDGMENTS

The Man Nobody Killed is dedicated to my parents, Hank and Diane. It's hard to imagine the book existing without their support and willingness to read drafts.

As for the rest of the family, they endured two years of my talking about little else. So I am grateful for the patience of Laykoon and Eugene, Rachel, Adam, Dylan, Luca, Sherng-Lee, and particularly my brother-in-law, Michael Tomsky, who—thanks to his background in the Queens DA's office—took the brunt of my questions.

In another life, this book would be dedicated to Franck Goldberg. There are entire scenes, spread throughout, that would not exist but for the astonishing footage Franck shot decades ago and generously decided to share. He always knows where to point the camera, a true gift.

As ever, libraries, librarians, and archivists were vital, providing every last document I asked for, and just as often some I hadn't. Special thanks to Julia Robbins of the New York City Municipal Archives, Kevin Schlottmann of Columbia University's Rare Book and Manuscript Library, Jenny Swadosh of the New School Archives and Special Collections, the staff of the Library of Congress, Sara Logue of Princeton University Library's Special Collections, Anna Gurton-Wachter of the Keith Haring Foundation, and the Port Washington Public Library.

If you read the endnotes, it's clear that certain texts had an outsize role in forming the marrow of the book. Most prominent: Chaédria LaBouvier's *Basquiat's Defacement: The Untold Story*, Andrew Meier's *Morgenthau: Power, Privilege, and the Rise of an American Dynasty*, Kim Phillips-Fein's *Fear City:*

New York's Fiscal Crisis and the Rise of Austerity Politics, Brad Gooch's *Radiant: The Life and Line of Keith Haring*, Phoebe Hoban's *Basquiat: A Quick Killing in Art*, and Jennifer Clement's *Widow Basquiat: A Love Story*.

At its most gratifying, journalism is the privilege to learn as you go. But it requires people willing to entertain phone calls, texts, and requests for favors. Thank you to Penny Geyer, Karen Gehres, Steve Saracco, Thomas Hauser, Leon Neyfakh, and Patrick Fox. As for Barry Agulnick and William McKechnie: They knew where my sympathies lay and *still* shared everything they had about this case, including memories, scrapbooks, and newspaper clips. My gratitude is boundless.

Namwali Serpell was exceedingly generous with her rich knowledge of Toni Morrison's life and work. A single email from Namwali revealed a new world.

I'm grateful to Jerry of Villa Mosconi for his hospitality and drinks. There's no better place to talk without distraction.

Sometimes it's extra troublesome to find sources. Tom Junod, Nancy Franklin, Susan Morrison, Martha Coakley, Elizabeth Lederer, and Ronald Kuby selflessly sliced through the red tape and got me to the right people. Tricia Lawrence shared a key screengrab from the Stuytown Moms Facebook group that paid off nicely.

It takes a special sort to read rough drafts, which are at best middling. I had a murderer's row of such people, including Rachel Corkle, who took time away from parties; Jarett Kobek and his secret knowledge of Parsons; Josh Gondelman, who continues to be as good a person as he is an editor; and Ben Harper, whose feedback is one of the great perks of friendship.

Everyone needs a group of friends willing to soothe, cajole, and mock as necessary. Mine is the best. There's Morgan Jerkins, a world-beater with unerring instincts; Pamela Colloff, a genuine journalism hero; and Sarah Weinman and Lyz Lenz, who remain, respectively, an angel and devil on my shoulders.

Getting edits from David Grann is what I imagine it must be like to get jump shot tips from Michael Jordan.

If I ever go missing, I know with certainty that Meghan Doherty could find me in time for dinner—such is her skill as a researcher. Audrey Hall

did marvelous work in this vein as well, despite having to contend with the irritations of high school.

Samantha Schuyler, who checked *Last Call*, interrogated all my assertions here, too. As before, any errors, though, are mine alone.

Carrie Frye is the Robert Gottlieb of Asheville. The kindness and nurturing with which she elicits one's best work is a marvel.

But: this book doesn't make it out of the gate without David Patterson of Stuart Krichevsky Literary Agency. David and his colleagues, Chandler Wickers and Stuart Krichevsky, have been nothing but supportive and fierce advocates for this project.

The Man Nobody Killed is my second book with Celadon. In this, I've lucked out. Diana Frost, Macmillan's legal counsel, put my mind at ease. Christine Mykityshyn, Celadon's publicist, is why you're reading this. And Ryan Doherty—well, the writer-editor relationship is one of trust. I do, implicitly.

Lastly: Ruee and Elijah, still the best parts of my life.

NOTES

Prologue

1 *Not long after midnight*: Chaédria LaBouvier, *Basquiat's "Defacement": The Untold Story* (New York: Guggenheim, 2019), 116.

2 *"you did most of the talking"*: Terry Bisson, "The Murder of Michael Stewart," *East Village Eye*, March 1985.

2 *After leaving the Pyramid*: Paul La Rosa, "The Death That Won't Die," *Daily News*, October 11, 1983.

2 *Noticing Pesce's discomfort*: *Who Killed Michael Stewart?*, directed by Franck Goldberg (1986).

2 *"I'm going to show you my shirt"*: Patrica Pesce, interview by Franck Goldberg, 1983.

2 *"When you go to the top"*: Unpublished transcript of a conversation between Keith Haring and Rene Ricard, November 2, 1983, in the collection of the Keith Haring Foundation Archives.

3 *wasn't yet 3 a.m.*: Harold R. Tyler Jr., "Report of Special Counsel to the New York City Transit Authority," January 21, 1987, in the collection of the Municipal Library and Archives at the New York City Department of Records and Information Services.

1: The Park

5 *Ronald Reagan visited*: Kim Phillips-Fein, *Fear City: New York's Fiscal Crisis and the Rise of Austerity Politics* (New York: Picador, 2017), 303.

5 *"We're not going back"*: "Remarks at the New York City Partnership Luncheon in New York, January 14, 1982," Ronald Reagan Presidential Library and Museum, Simi Valley, Calif.

6 *"embodied the connection"*: Phillips-Fein, *Fear City*, 30.

6 *"a sense of sturdiness"*: Jennifer Callahan, "Glory Days," *New York Times*, January 2, 2005.

6 *15,000 city employees*: Kevin Baker, "'Welcome to Fear City'—The Inside Story of New York's Civil War, 40 Years On," *Guardian*, May 18, 2018.

6 *"Ford to City: Drop Dead"*: "Ford to City: Drop Dead," *Daily News*, October 30, 1975.

6 *Maintenance of the*: S. Osman, "'We're Doing It Ourselves': The Unexpected Origins of New York City's Public–Private Parks During the 1970s Fiscal Crisis," *Journal of Planning History* 16, no. 2 (2017): 162–74.

7 *No police were hired*: Michael Oreskes, "Fiscal Crisis Still Haunts the Police," *New York Times*, July 6, 1985.

7 *"almost invisible"*: LaBouvier, *Basquiat's "Defacement,"* 101.

7 *"If we who live"*: Edward Koch, Inaugural Address, January 2, 1978.

7 *poorly lit*: John Gunderson, interview by author, January 22, 2024.

7 *attended by ten thousand*: Andrew Glass, "First Labor Day Parade Held, Sept. 5, 1882," Politico, September 6, 2014.

7 *union men in bowler hats*: "Industrial Workers of the World (I.W.W.) Demonstration, New York City," Library of Congress, 1914.

7 *men with machine guns*: *New York City Guide* (New York: Random House, 1939), 199.

8 *"the most important space"*: Michael Shapiro, "Becoming Union Square: Struggles for Legitimacy in Nineteenth-Century New York" (PhD diss., University of Massachusetts at Amherst, May 2010).

8 *"Statues have been damaged"*: Deirdre Carmody, "Union Square Park to Undergo Overhaul," *New York Times*, November 29, 1982.

8 *"the shabby domain"*: Christopher Wellisz, "Union Square on Verge of Redevelopment," *New York Times,* August 14, 1983.

8 *"build a palace for junkies"*: Paul La Rosa, "Snag for Union Sq. Park Facelift," *Daily News*, August 13, 1983.

8 *Richard Gere, Patti LaBelle*: Henry Post, "Notes on the Underground," *New York*, March 9, 1981.

8 *the heavily bearded sci-fi great Thomas Disch*: "Obituaries: Thomas M. Disch," *Daily Telegraph*, July 9, 2008.

8 *were obligated to shout warnings*: Tina Wilson, "Antonio Lopez-NYC, When It Took My Breath Away," *Lounge Dream Book*, August 19, 2016.

9 *589 students*: Shannon Wilkinson, "Anatomy of the Entering Class," *Parsonspaper*, November 1983.

9 *home had to be at least 150 miles*: *Parsons Student Handbook*, 1983–84.

9 *"The room I shared"*: Ai Weiwei quoted in "What New York Was Like in the Early '80s—Hour by Hour," *T Magazine*, April 22, 2018.

9 *even encouraged the students*: Martin Cooper, interview by author, March 21, 2022.

10 *reflected sound*: Daniel Abatemarco, interview by author, October 27, 2022.

10 *street-level noise to be heard*: Jon Ritter, interview by author, May 19, 2022.

10 *Sitting by the six-foot-tall window*: Timothy Jeffs, interview by author, August 18, 2022.

10 *Below, there were police cars*: Timothy Jeffs, interview by author, March 21, 2022.

10 *Seyster saw one officer*: Associated Press, "Witness: Cop Choked Stewart," *Newsday*, August 22, 1985.

10 *A poster*: Photo provided to the author by Timothy Jeffs.

10 *Robert Cummings*: RobZombieoffical, Instagram, June 1, 2020.

10 *"God, please help me!"*: Frank Faso and Stuart Marques, "'Man' Hit: Stewart Witness," *Daily News*, August 8, 1985.

11 *he assumed they'd caught a murderer*: John Gunderson, interview by author, May 4, 2022.

11 *out of the closet since the age of fifteen*: ActionLink, "Curtis Lipscomb on Leadership in the Black LGBT Community," ActionLink, n.d.

11 *"Look, look! Stop doing that!"*: Curtis Lipscomb, interview by author, September 12, 2022.

11 *Cooper poked his head*: Martin Cooper, interview by author, March 21, 2022.

11 *"Please don't kill me"*: Peter Noel, "'Please Don't Kill Me,'" *New York Amsterdam News*, September 7, 1985.

11 *calm the man down*: Daniel Baxter, interview by author, February 20, 2022.

12 *"What did I do?"*: M. A. Farber, "Student Recalls She Saw Police Beating Stewart," *New York Times*, July 23, 1985.

12 *Posner was clearheaded*: Heidi Posner, interview by author, August 8, 2022.

12 *"a cry of 'Help me'"*: Gerald McKelvey, "Stewart Screamed for Help, Witness Says," *Newsday*, August 28, 1985.

12 *She and some new friends*: Candice Leit, interview by author, February 20, 2022.

12 *the kicking, the nightsticks*: Don Flynn, "TA Defense Sez Witness Lied to Jury," *Daily News*, August 16, 1985.

13 *There was one pay phone*: Martin Cooper, interview by author, March 21, 2022.

13 *"We were babies"*: Candice Leit, interview by author, July 25, 2022.

13 *Some began closing their windows*: Timothy Jeffs, interview by author, March 21, 2022.

13 *"stood around"*: Alexander Epp, interview by author, August 19, 2022.

2: The Fab 500

15 *a gallerist estimated*: Patrick Fox, interview by author, March 4, 2023.

15 *"the conceptual movers"*: LaBouvier, *Basquiat's "Defacement,"* 114.

15 *"operated full tilt all night"*: Andy Warhol and Pat Hackett, *Andy Warhol's Party Book* (New York: Crown, 1988), 42.

15 *"He always gave gorgeous faces"*: Brill quoted in LaBouvier, *Basquiat's "Defacement,"* 107.

16 *anti-hierarchy*: Kestutis Nakas, interview by author, August 22, 2022.

16 *"glamorous gender-fuck"*: Tricia Romano, "Nightclubbing: New York City's Pyramid Club," Red Bull Music Academy Daily, 2014.

16 *"you can hear a rat"*: Jan Hodenfield, "Gentrification Comes to the Lower East Side," *Daily News*, December 4, 1980.

16 *lines around the block*: Jo Shane, interview by author, March 15, 2022.

16 *"keep it looking messed up"*: Brandon Stosuy, *Up Is Up But So Is Down* (New York: New York University Press, 2006), 125.

16 *Thurston Moore was among*: Julie Hair, interview by author, August 31, 2022.

16 *"the most significant spot"*: Thurston Moore, *Sonic Life: A Memoir* (New York: Doubleday, 2023), 208.

16 *"the right mix of lunatics"*: Brian Butterick, Susan Martin, and Kestutis Nakas, "'We Started a Nightclub': Building the Pyramid," *PAJ: A Journal of Performance and Art* 37, no. 3 (111) (2015): 22–45, https://www.jstor.org/stable/26935682.

17 *of Fort Greene, Brooklyn*: La Rosa, "The Death That Won't Die."

17 *a veteran of World War II and Korea*: "Obituaries," *Lexington Herald-Leader*, March 19, 2002.

17 *"He would write"*: LaBouvier, *Basquiat's "Defacement,"* 152.

17 *There, he further developed*: Leonard Levitt, "Graffiti Death: Cause Unknown," *Newsday*, September 30, 1983.

17 *his job at the phone company*: Greg Grinnell, interview by author, August 21, 2022.

17 *locs tucked*: Bisson, "The Murder of Michael Stewart."

17 *On an October night in 1981*: Mitchell Rosten, "Rosten's Review," *Canarsie Courier*, October 22, 1981.

17 *Its deejays were divided*: Stephanie Lanyon, interview by author, October 6, 2022.

18 *"were pretty reaching"*: Vaughn Martinian, interview by author, August 30, 2022.

18 *It didn't bother anyone*: Stephanie Lanyon, interview by author, October 6, 2022.

18 *He and Cheryl*: Cheryl Ricelyn Cassidy, interview by author, October 21, 2022.

18 *watch* Looney Tunes: Cheryl Ricelyn Cassidy, interview by author, January 19, 2024.

18 *creating murals*: Antonio Garcia, interview by author, August 19, 2022.

18 *drawing on Polaroids*: Greg Grinnell, interview by author, August 21, 2022.

18 *And he began entertaining*: Dianne Brill, interview by Franck Goldberg, 1983.

18 *On at least a dozen occasions*: Arthur Ludwig, interview by author, October 6, 2022.

19 *That afternoon he biked*: LaBouvier, *Basquiat's "Defacement,"* 116.

19 *in her oversize clothes*: Jennifer Clement, "Spirits of Place," *Harper's Bazaar*, January 28, 2024.

19 *Michael visited her*: Jennifer Clement, *Widow Basquiat: A Love Story* (New York: Broadway Books, 2000), 113.

20 *the summer before*: Suzanne Mallouk, interview by author, February 6, 2022.

20 *he kept her company*: Clement, *Widow Basquiat*, 112.

20 *"fully present"*: Suzanne Mallouk, email to author, October 7, 2022.

20 *"Yes, yes," Michael had said*: Clement, *Widow Basquiat*, 115.

20 *he'd swindled Haring*: Jeffrey Deitch, Suzanne Geiss, and Julia Gruen, *Keith Haring* (New York: Rizzoli, 2014), 352.

20 *When they arrived*: LaBouvier, *Basquiat's "Defacement,"* 112.

21 *glasses held high*: Susan Brown, interview by author, October 1, 2022.

21 *Michael had wept*: "The Death of Michael Stewart," YouTube video, https://www.youtube.com/watch?v=wekEsNqaUbw&t=21s.

21 *One coworker had brought him back*: Joan Marie Moossy, interview by author, May 13, 2022.

21 *She had vivid memories*: Peggy McKay, interview by Franck Goldberg, 1983.

21 *spray paint in hand*: Jana Marcus, interview by author, August 17, 2022.

21 *he'd spun records*: Maripol, interview by Franck Goldberg, 1983.

21 *was set to play at Lucky Strike*: La Rosa, "The Death That Won't Die."

21 *"He seemed to be all bubbling"*: Ann Craig, interview by Franck Goldberg, 1983.

21 *"fairly lucid"*: La Rosa, "The Death That Won't Die."

3: Glasgow

23 *Saul Bellow, Charles Mingus, and Lead Belly*: Emma Goldberg, *Life on the Line: Young Doctors Come of Age in a Pandemic* (New York: Harper, 2021), 85.

23 *sixteenth floor*: Ronald Sullivan, "AIDS: Bellevue Tries to Cope with Disease It Cannot Cure," *New York Times*, December 23, 1985.

23 *born in part of ignorance*: Mary Ann Giordano, "AIDS Fear Infects Docs, He Says," *Daily News*, June 15, 1983.

23 *sometimes they refused*: David Oshinsky, *Bellevue: Three Centuries of Medicine and Mayhem at America's Most Storied Hospital* (New York: Anchor Books, 2016), 267.

23 *A Bellevue policeman*: Carl Sharp, interview by author, January 29, 2024.

24 *"Obvious head trauma"*: This detail and others are taken from Arthur Liman and Max Gitter, "Special Counsel's Report to the Mayor on the Office of the Chief Medical Examiner of the City of New York," April 1985, in the collection of the Municipal Library and Archives at the New York City Department of Records and Information Services.

24 *swollen, and had blue splotches*: Isabel Wilkerson, "Nurse Says Stewart Was Bruised When He Arrived at the Hospital," *New York Times*, September 11, 1985.

24 *After some minutes*: Spencer Rumsey, "Murder + Lies," *East Village Eye*, October 1983.

24 *the Bellevue policeman*: Carl Sharp, interview by author, January 29, 2024.

24 *Patients that age*: Dana Pizzuti, interview by author, February 25, 2022.

24 *The environment was*: Dana Pizzuti, interview by author, September 13, 2022.

25 *he was placed on a ventilator*: United Press International, "MD: No Pulse in Stewart on Arrival at Hospital," *Newsday*, September 27, 1985.

25 *"People would get"*: Duncan McBride, interview by author, February 23, 2022.

25 *neither trauma to the brain itself*: United Press International, "MD: No Pulse in Stewart on Arrival at Hospital."

26 *"You moonlight a million hours"*: William Cole, interview by author, November 6, 2022.

4: Berserk

27 *the morning of*: Jennifer Clement, *Widow Basquiat*, 115–17.

27 *Mallouk asked*: Suzanne Mallouk, interview by author, February 6, 2022.

27 *two Transit Authority officers*: "In the Matter of Michael J. Stewart, Deceased: Petition for Appointment of a Special Prosecutor," in the collection of the New York State Archives.

27 *Two weeks later, his body was found*: "Info Sought in Drowning," *Daily News*, July 15, 1976.

27 *"unknown white male"*: LaBouvier, *Basquiat's "Defacement,"* 152.

28 *whom the Stewarts knew*: LaBouvier, *Basquiat's "Defacement,"* 145.

28 *an Associated Press dispatch*: Associated Press, "Man in Coma After Arrest in Subway," *Newsday*, September 16, 1983.

29 *"beaten ruthlessly"*: Murray Weiss and Arthur Browne, "Black Leaders Blast Koch on Brutality Probe," *Daily News*, September 16, 1983.

29 *Warhol, Calvin Klein*: Kristen Bateman, "Oral History: Remembering New York's Fiorucci Store," *New York Times Style Magazine*, September 19, 2017.

29 *she cut her own hair*: Clement, *Widow Basquiat*, 118–19.

29 *The prison ward apparently lacked*: "In the Matter of Michael J. Stewart, Deceased: Petition for Appointment of a Special Prosecutor."

29 *the same floor*: Sullivan, "AIDS: Bellevue Tries to Cope with Disease It Cannot Cure."

29 *fingerprinted and handcuffed*: Hospitalized Prisoner–Status Sheet, in the collection of the New York State Archives.

29 *He had been charged*: Criminal court complaint, in the collection of the New York State Archives.

30 *Leonard Pezzillo*: Unless otherwise noted, this account of the internal Transit Authority response is derived from Harold R. Tyler Jr.'s "Report of Special Counsel to the New York City Transit Authority," January 21, 1987, in the collection of the Municipal Library and Archives at the New York City Department of Records and Information Services.

30 *Dempsey interviewed*: Murray Kempton, "Report on Gross Shows How Cops Obstruct Justice," *Newsday*, April 24, 1985.

31 *pickpockets and "dicky-wavers"*: Carolyn Burke, interview by author, October 25, 2022.

31 *where women were s still ufficiently scarce*: Carolyn Burke, interview by author, January 20, 2024.

32 *"I'd put it off"*: Carolyn Burke, interview by author, October 25, 2022.

33 *unnerved the PBA's president*: William McKechnie, interview by author, January 16, 2023.

33 *One of the PBA representatives*: E. R. Shipp, "City Transit Officer Accused of Assault in Arrests of 5 Men," *New York Times*, July 8, 1983.

33 *A Queens man*: Neill S. Rosenfeld, "TA Cop Faces Beating Charges," *Newsday*, July 8, 1983.

33 *permanent brain damage*: Most of the details are taken from the sentencing portion of People of the State of New York v. Peter Marsala, May 16, 1984, Records V, Boxes 1838–1842, National Association for the Advancement of Colored People Records, Manuscript Division, Library of Congress, Washington, D.C.

33 *Marsala lost thirty days' pay*: Peter Marsala, interview by author, September 14, 2022.

34 *they had remained silent*: Depositions of Noreen Devine, Richard McCready, James McCarron, June 1986, Records V, Boxes 1838–1842, National Association for the Advancement of Colored People Records, Manuscript Division, Library of Congress, Washington, D.C.

34 *Marsala, however*: Peter Marsala, interview by author, November 29, 2022.

34 *a group of artists*: LaBouvier, *Basquiat's "Defacement,"* 122.

34 *In June*: *Hearings Before the Subcommittee on Criminal Justice of the Committee on the Judiciary, House of Representatives*, Ninety-Eighth Congress, 1st Sess. (on police misconduct), June 16, July 18, September 19, and November 28, 1983, Volume 4, Part 1 (hereafter *Hearings Before the Subcommittee on Criminal Justice*).

34 *nearly four hundred incidents*: Stuart Marques, "In Harlem, Seeds of Storm," *Daily News*, November 15, 1984.

34 *Just as Congressman Major Owens was*: *Hearings Before the Subcommittee on Criminal Justice*.

34 *"They killed my son!"*: United Press International, "A Woman Whose Screams Broke Up a Congressional Hearing . . . ," UPI, July 19, 1983.

34 *This was the voice*: "Date Is to Be Set Soon for Hearing on Police," *New York Times*, July 20, 1983.

35 *"could well have"*: Arthur Browne and Richard Sisk, "Panel Hears Charges of Police Brutality," *Daily News*, September 20, 1983.

35 *That April*: Shawn G. Kennedy, "A Black Churchman Says He Was Beaten by 2 Police Officers," *New York Times*, May 6, 1983.

35 *a catalyst*: Sam Roberts, "One Year After Hearings on Police Brutality, Critics Report Some Progress," *New York Times*, July 25, 1984.

36 *Randolph Evans*: Jimmy Breslin, "Questions Come to Mind in Wake of Boy's Death," *Daily News*, November 28, 1976.

36 *Arthur Miller*: Jon Sarlin, "A Father Was Choked to Death by the NYPD 42 Years Ago. His Family Has Never Recovered," CNN, June 21, 2020.

36 *allegedly lunged*: Joseph P. Fried, "Police Ruled Not Liable in Killing," *New York Times*, November 21, 1979.

36 *"When you are polarizing"*: Arthur Browne, "Ed: Glad to Testify at the Next Hearing," *Daily News*, September 21, 1983.

5: The Talk of the Day

37 *a "culture parent"*: Rene Ricard, "The Radiant Child," *Artforum*, December 1981.

37 *"If you were at the right party"*: Lili Anolik, "Once Upon a Time . . . at Bennington College," Podcast Addict, November 17, 2021.

37 *The two had met*: Brad Gooch, *Radiant: The Life and Line of Keith Haring* (New York: Harper, 2024), 204–5.

37 *Basquiat . . . approached Warhol*: Phoebe Hoban, *Basquiat: A Quick Killing in Art* (New York: Penguin Books, 1999), 200–201.

38 *hoping the pricey arrangement*: Andy Warhol and Pat Hackett, *The Andy Warhol Diaries* (New York: Twelve, 2014), 533.

38 *Basquiat would . . . stay*: Patrick Radden Keefe, "How Larry Gagosian Reshaped the Art World," *The New Yorker*, July 24, 2023.

38 *Gagosian took the pair*: Hoban, *Basquiat*, 164.

38 *the trio spent New Year's Eve*: Mary Gabriel, *Madonna: A Rebel Life* (New York: Little, Brown and Company, 2023), 116.

38 *"He piles up"*: William Wilson, "N.Y. Subway Graffiti: All Aboard for L.A.," *Los Angeles Times*, April 16, 1982.

38 *By summer*: Grace Glueck, "When Money Talks, What Does It Say About Art," *New York Times*, June 12, 1983.

38 *Deborah Harry . . . bought a painting*: Ekow Eshun, "Bowie, Bach and Bebop: How Music Powered Basquiat," *New York Times*, September 22, 2017.

39 *the* SoHo News *ran photos*: Hoban, *Basquiat*, 27.

39 *to the* Village Voice: Philip Faflick, "SAMO© Graffiti: BOOSH-WAH or CIA?" *Village Voice*, December 11, 1978.

39 *For the rest*: LaBouvier, *Basquiat's "Defacement,"* 20.

39 *art world luminaries*: Patrick Fox, interview by author, March 15, 2022.

39 *"have a sense"*: Janet Malcolm, "A Girl of the Zeitgeist," *The New Yorker*, October 20, 1986.

40 *the walls of which*: Peter McGough, *I've Seen the Future and I'm Not Going: The Art Scene and Downtown New York in the 1980s* (New York: Pantheon Books, 2019), 106.

40 *and Warhol protégé*: Donald Lee, "Obituary: Rene Ricard," *Art Newspaper*, February 28, 2014.

40 *He'd recently done a multicolored work*: Footage of the Stewart household filmed by Franck Goldberg.

40 *a word . . . meaning "bad art"*: S.v. "cacotechny (*n.*)," *Oxford English Dictionary*, September 2023, https://doi.org/10.1093/OED/7713072474.

40 *interest in numerology*: LaBouvier, *Basquiat's "Defacement,"* 114.

40 *He would often carry . . . as his friends well knew*: Bisson, "The Murder of Michael Stewart."

40 *"I don't remember"*: LaBouvier, *Basquiat's "Defacement,"* 19.

40 *"He was an artist"*: Deitch, Geiss, and Gruen, *Keith Haring*, 352.

40 *the famed long-nosed Kilroy*: "'Taki 183' Spawns Pen Pals," *New York Times*, July 21, 1971.

41 *spitting-mad Lindsay*: Thomas Poster, "Paint Mayor Red over Graffiti Problem," *Daily News*, July 24, 1972.

41 *installing razor wire*: Jeff Chang, *Can't Stop Won't Stop* (New York: St. Martin's Press, 2005), 181.

41 *wolves would be preferable*: Jen Chung, "Video: Ed Koch Wanted Wild Wolves to Stop Subway Graffiti Taggers," *Gothamist*, February 3, 2013.

41 *"It was a scream"*: LaBouvier, *Basquiat's "Defacement,"* 103.

41 *"Because graffiti art"*: Suzanne Mallouk, interview by author, February 6, 2022.

42 *Janis Joplin, Procol Harum*: Frank Mastropolo, "The Anderson Theater, Forgotten Forerunner of the Fillmore East," *Bedford + Bowery*, January 22, 2018.

42 *"an 1,800-seat theater"*: LaBouvier, *Basquiat's "Defacement,"* 114.

42 *Together they had raised*: LaBouvier, *Basquiat's "Defacement,"* 115.

42 *irritable mood*: Patrick Fox, interview by author, March 15, 2022.

42 *stay-at-home mother*: Carrie Goteiner, email to author, August 24, 2023.

42 *a union man*: Carrie Goteiner, interview by author, August 17, 2023.

43 *graduated in 1973*: Haoui Montaug résumé, provided to author by Carrie Goteiner.

43 *was briefly married*: Stephen Williams, "The Palladium's Main Man," *Newsday*, October 25, 1985.

43 *unemployable*: Jim Fouratt, interview by author, December 15, 2022.

43 *waving the Beastie Boys*: Michael Diamond and Adam Horovitz, *Beastie Boys Book* (New York: Penguin Random House, 2018), 132.

43 *managing the Lounge Lizards*: John Lurie, *The History of Bones* (New York: Penguin Random House, 2021), 108.

43 *strict rules of conduct*: Haoui Montaug, "Haoui's Rules of Conduct," *Newsday*, October 25, 1985.

43 *"He maintained order"*: "Haoui Montaug," *Daily Telegraph*, June 24, 1991.

43 *"He didn't take"*: Michael Musto, interview by author, November 18, 2022.

43 *October 13, 1982*: Denise Larson, interview by author, November 17, 2022.

43 *"Now, is everybody ready?"*: "Madonna—Everybody Live at Danceteria Haoui Montaug's No Entiendes (December 16, 1982)," YouTube video, n.d., https://www.youtube.com/watch?v=CORvtt6JTTA.

44 *"Madonna always the first to arrive"*: Andrew Morton, *Madonna* (London: Michael O'Mara Books, 2001), 112.

44 *familiarity with the demonstrations*: LaBouvier, *Basquiat's "Defacement,"* 124.

44 *chilly and overcast*: Weather for September 26, 1983, found at weatherspark.com.

44 *limestone pavilion*: Alex Mindlin, "For a Pavilion with a Past, Grumbling over the Future," *New York Times*, January 28, 2007.

44 *plastered on lampposts*: Lucy Sante, email to author, October 12, 2022.

44 *depicted skeleton policemen*: LaBouvier, *Basquiat's "Defacement,"* 135.

44 *Even Madonna*: Kenny Scharf, email to author, October 12, 2022.

44 *"Everyone from the neighborhood"*: LaBouvier, *Basquiat's "Defacement,"* 134.

45 *footage of him*: "Keith Haring: How a Furtive Artist Invaded the Art World," *CBS Evening News*, October 20, 1982.

45 *A large yellow banner*: Footage of the Union Square protest filmed by Franck Goldberg.

46 *Claude Reese*: Robert D. McFadden, "Officer Who Killed Youth, 14, Is Relieved of His Police Duties," *New York Times*, September 20, 1974.

46 *"art parade"*: Eleanor Blau, "Parade of 1,300 Artists Is 'Love Letter' to City," *New York Times*, September 28, 1983.

46 the *"Michael Stewart Friends Committee"*: Rumsey, "Murder + Lies."

47 *he'd been known to calm*: Sally Randall Brunger, interview by author, November 18, 2022.

6: 10-85

49 *But he failed a psychological exam*: James Peters, Murray Weiss, and Don Singleton, "Transit Cop in Stewart Case Failed City Police Psyche Test," *Daily News*, February 3, 1985.

49 *"We have in Mr. Kostick"*: Ellis Henican, "Dead Man Lives on in Ex-Cop, 31," *Newsday*, August 30, 1990.

49 *the equipment was inferior*: William McKechnie, interview by author, October 10, 2022.

49 *given batteries*: Peter Marsala, interview by author, November 29, 2022.

49 *in January 1982*: "One Death, 6 Defendants," *Daily News*, September 25, 1985.

49 *Three years before*: Sheryl Kornman, "Cop Battling Turnstile-Jumper Shot Dead with His Own Gun," *Newsday*, February 25, 1980.

50 *at the same subway station*: Daniel O'Grady, "Death Is Kin in a Cop Family," *Daily News*, June 20, 1980.

50 *The next year*: Barbara Basler, "A Disturbed Driver's Grim Path to Assault Charges," *New York Times*, May 12, 1981.

50 *seven years at Bellevue*: Larry Celona, Tina Moore, and Danika Fears, "NYPD Honoring 18 'Forgotten' Cops Who Died Serving the City," *New York Post*, November 28, 2017.

50 *"Those things, I think"*: William McKechnie, interview by author, October 10, 2022.

50 *three-foot-high*: Andrew Meier, *Morgenthau: Power, Privilege, and the Rise of an American Dynasty* (New York: Random House, 2022), 709.

50 *"1st Ave. on the 'LL' holding one"*: Transit Police radio communications transcript, in the collection of the New York State Archives.

51 *According to the token booth clerk*: Jane Gross, "Witness Says Stewart Was Calm After Arrest," *New York Times*, July 26, 1985.

51 *At 2:57 a.m.*: New York State Commission of Correction Memorandum, regarding the District 4 Blotter Entries, in the collection of the New York State Archives.

52 *a complaint*: Robert Rodriguez complaint, taken September 16, 1983, provided to author by Franck Goldberg.

54 *Nearly three years later*: Deposition of John W. Kostick, taken June 2, 1986, in the collection of the New York State Archives.

54 *"He just kept"*: William Cole, interview by author, November 6, 2022.

54 *Michael Stewart died*: Murray Weiss, "B'klyn Man Dies After Arrest," *Daily News*, September 29, 1983.

7: The Eyes of Michael Stewart

55 *"thankless"*: "Dr. Ira Pierce Is Medical Examiner and Coroner," *Knoxville News-Sentinel*, September 30, 1962.

55 *a six-thousand-dollar pay cut*: Joy Allen, "Elliot Gross," *Newsday*, August 10, 1979.

55 *born in Manhattan*: "New York, New York, U.S., Birth Index, 1910–1965," Lehi, Utah, Ancestry.com, 2017.

55 *He had aspirations*: Elliot Gross, interview by author, November 10, 2023.

56 *eight hundred homicides, suicides*: The State of New York v. Jose Antonio Reyes, Respondent's Brief, Google Books, July 20, 1967.

56 *he needed executive experience*: Colin Evans, *Blood on the Table: The Greatest Cases of New York City's Office of the Chief Medical Examiner* (New York: Berkley Books, 2008), 240.

56 *Connecticut's inaugural*: "Pathologist Named First Chief Examiner," *Hartford Courant*, August 23, 1970.

56 *Gross forgot*: Matthew L. Wald, "Columbia Student's Slayer Guilty of Manslaughter in Connecticut," *New York Times*, August 14, 1979.

56 *poor recordkeeping*: Richard Severo, "Koch Removes Baden as the City's Medical Examiner," *New York Times*, August 1, 1979.

56 *"a team player"*: Michael Baden, interview by author, February 14, 2022.

56 *oversaw . . . death of thousands*: David Median and Larry Sutton, "Elliot Gross to Succeed Baden," *Daily News*, August 7, 1979.

56 *the Bay Ridge family*: Associated Press, "Deaths Ruled Natural," *Mount Vernon Argus*, January 13, 1983.

56 *an M-80*: Associated Press, "Fireworks Accidents Mar Holiday Celebrations," *Ithaca Journal*, July 6, 1982.

56 *the hospital patients*: Ronald Sullivan, "Patient at a Struck Hospital Died of Causes Not Cited, Autopsy Finds," *New York Times*, March 20, 1981.

57 *"let them talk in public"*: Rachel Monroe, *Savage Appetites: Four True Stories of Women, Crime, and Obsession* (New York: Scribner Books, 2019), 28.

57 *had neither finished*: Elliot Gross, interview by author, February 7, 2024.

57 *"essentially pulseless"*: Joyce Wadler and Mike Sager, "'I Just Shot John Lennon,' He Said Coolly," *Washington Post*, December 10, 1980.

57 *under another name*: Michael Baden, *Unnatural Death: Confessions of a Medical Examiner* (New York: Random House, 1989), 73.

57 *peddle the falsehood*: United Press International, "Tennessee Williams Was Murdered, Brother Says," *South Florida Sun Sentinel*, March 10, 1983.

57 *several dozen*: Lindsey Gruson, "Second Opinions on Medical Examiners," *New York Times*, May 15, 1983.

58 *On the marble lobby wall*: M. A. Farber, "A Form of Death Without Honor," *New York Times*, February 25, 1974.

58 *In the basement*: Philip Shenon, "Family of Victim Levels Charges of Deceit in Autopsy Conclusion," *New York Times*, January 28, 1985.

58 *126 refrigerated*: Patrick W. McGinley, Victor E. Botnick, Dr. David J. Sencer, "Report to the Mayor: A Management Study of the Office of Chief Medical Examiner," February 1985.

58 *broken floor tiles*: David Axelrod, M.D., "Report to the Governor on the Office of the Chief Medical Examiner of the City of New York," February 1985.

59 *the Stewarts were concerned*: "Special Counsel's Report to the Mayor on the Office of the Chief Medical Examiner of the City of New York."

60 *nervous with regard to the weight*: William Cole, interview by author, November 6, 2022.

60 *"You answer my questions only"*: William Cole, interview by author, October 28, 2022.

61 *Cole believed*: William Cole, interview by author, December 5, 2022.

62 *an insurance policy*: Leonard Levitt: "Gross: A Personal Postmortem," *Newsday*, November 4, 1985.

62 *He'd performed such a procedure before*: Elliot Gross, interview by author, November 10, 2023.

8: Pressman

63 *covering everything from*: Robert D. McFadden, "Gabe Pressman, a Dean of New York TV Journalism, Dies at 93," *New York Times*, June 23, 2017.

63 *"On the rounds"*: Liz Trotta, *Fighting for Air: In the Trenches with Television News* (New York: Simon and Schuster, 1991), 24.

64 *"Here comes Gabe . . . Gabe had"*: Peter W. Kaplan, "Gabe!" *Daily News*, October 11, 1981.

64 *dozens of reports*: John F. Davis, "Keeping the Stewart Case Alive," *Village Voice*, November 22, 1983.

64 *his competition*: LaBouvier, *Basquiat's "Defacement,"* 147.

64 *guilty until proven innocent*: Barbara Rick, interview by author, April 10, 2023.

64 *"smelled"*: Vera Pressman, interview by author, November 3, 2022.

64 *"Why did Michael Stewart die?"*: WNBC-TV newscast provided by Franck Goldberg.

64 *accuse the chief*: Michael Armstrong, *They Wish They Were Honest* (New York: Columbia University Press, 2012), 38.

65 *"There was no way"*: Elliot Gross, interview by author, November 10, 2023.

66 *she and Dempsey hadn't seen . . . She was furious*: Carolyn Burke, interview by author, February 5, 2024.

66 *A photograph of Michael*: Footage of the Elliot Gross press conference filmed by Franck Goldberg.

67 *"The cause of death"*: Gross's press statement is drawn from both the version printed in the 1985 "Special Counsel's Report to the Mayor on the Office of the Chief Medical Examiner of the City of New York" and the slightly altered version delivered by Gross, shown in footage of his press conference filmed by Franck Goldberg.

69 *Levitt's lede*: Levitt, "Graffiti Death: Cause Unknown."

69 *he was blunt*: William Cole, interview by author, November 6, 2022.

9: Madonna

71 *approached*: Lew Powell, "I Asked Her Name. 'Madonna,' She Replied . . . ," *NC Miscellany*, November 14, 2012.

71 *"Her name is"*: Richard Maschal, "Do You Wanna Dance? They Do in Durham," *Charlotte Observer*, July 16, 1978.

71 *by autumn*: Morton, *Madonna*, 93.

71 *her nightgown went up in flames . . . "That's an important thing"*: Gabriel, *Madonna*, 82–83.

72 *over several weeks*: Morton, *Madonna*, 106.

72 *"Stay," "Don't You Know"*: Gabriel, *Madonna*, 96.

72 *"It was very sudden"*: Christopher Anderson, *Madonna: Unauthorized* (New York: Simon and Schuster, 1991), 95–101.

72 *"experimental melting pot"*: Peter Magennis, "Everything from Everybody," *Record Collector*, January 27, 2013.

72 *"I couldn't work out"*: Quoted in Ben Sisario, "Listening to Music's Quietest 'Record Man,'" *New York Times*, July 12, 2022.

73 *recovering from*: Seymour Stein, "How I Met Madonna, by Seymour Stein, the Man Who Signed Her," *Variety*, June 14, 2018.

73 *recently performed*: Jordan Levin, email to author, November 17, 2022.

73 *"She dropped us"*: Jordan Levin, "Michael Was Murdered. Discovering Police Brutality in the Death of Michael Stewart," Medium.com, November 19, 2019.

74 *received little direction*: Jordan Levin, interview by author, September 19, 2022.

74 *"after hanging out" . . . She was staying*: Sean Howe, "How Madonna Became Madonna: An Oral History," *Rolling Stone*, July 29, 2013.

74 *She'd dumped the artist*: Gabriel, *Madonna*, 117.

74 *"I like to stay"*: Wayne Robins, "Song for Happy Feet," *Newsday*, April 29, 1983.

75 *cracking the Top 200*: Keith Caulfield, "Four Decades of 'Madonna': A Look Back at the Queen of Pop's Debut Album on the Charts," *Billboard*, July 27, 2023.

75 *agreed to donate*: Rumsey, "Murder + Lies."

75 *"Keith was ranting"*: Warhol and Hackett, *The Andy Warhol Diaries*, 542.

75 *performance artist Kembra Pfahler*: Brian Butterick, Susan Martin, and Kestutis Nakas, *"We Started a Nightclub": The Birth of the Pyramid Cocktail Lounge as Told by Those Who Lived It* (Bologna, Italy: Damiani, 2024), 178.

75 *Cha Cha*: LaBouvier, *Basquiat's "Defacement,"* 125.

75 *joined the band*: Cynthia Carr, *Fire in the Belly: The Life and Times of David Wojnarowicz* (New York: Bloomsbury USA, 2012), 168.

76 *"Nobody was allowed"*: Doug Bressler, interview by author, November 22, 2022.

76 *"a stripped-down"*: Carlo McCormick, "Toy Soldiers," *Artforum*, Summer 2018.

76 *Her music had not been universally embraced*: Charlene Martinez, interview by author, February 9, 2024.

76 *who were, predictably*: Gooch, *Radiant*, 215.

76 *Madonna stopped by*: Julie Hair, interview by author, August 31, 2022.

76 *her makeup*: Jesse Hultberg, interview by author, November 28, 2022.

76 *When asked*: Michael Warren, interview by author, November 23, 2022.

76 *approximately ten thousand dollars*: Suzanne Mallouk, email to author, November 23, 2022.

76 *"I thought he was really cute"*: Madonna, interview by Franck Goldberg, 1983.

10: Stop Protecting Killer Cops

77 *"Devoted son"*: "Death Notices," *Daily News*, October 4, 1983.

77 *as newsmen waited*: Clement, *Widow Basquiat*, 124.

77 *and it closed with*: New Order set list, November 19, 1981, *setlist.fm*, https://www.setlist.fm/setlist/new-order/1981/ukrainian-national-home-new-york-ny-7bd7c678.html.

77 *the vocalist gripped the microphone*: "New Order-Temptation (Ukrainian National Home New York, 1981)," YouTube video, n.d.

77 *a cradle Catholic*: Greg Grinnell, interview by author, August 21, 2022.

77 *Friends, family*: Greg Grinnell, interview by author, December 1, 2022.

77 *favorite suit*: LaBouvier, *Basquiat's "Defacement,"* 107.

78 *unsettling*: Ted Parsons, interview by author, December 16, 2022.

78 *They were a gift*: Suzanne Mallouk, email to author, June 5, 2023.

78 *second service*: "Ex-Williamsburg Resident Dies in New York at 25," *Lexington Herald-Leader*, October 4, 1983.

78 *Briar Creek Cemetery*: https://www.findagrave.com/memorial/73965251/michael-jerome-stewart.

78 *Less than a week*: La Rosa, "The Death That Won't Die."

78 *"the galvanizing fact"*: Stuart Cox, interview by author, October 14, 2022.

78 *he complained*: Letter from Dr. Elliot Gross to Diane M. Coffey, October 14, 1983, LaGuardia and Wagner Archives, Long Island City, N.Y.

79 *A man*: Footage of the protest filmed by Franck Goldberg.

79 *encouraged Goldberg*: Franck Goldberg, email to the author, December 15, 2022.

79 *starting with Haoui Montaug's protest*: Franck Goldberg, interview by author, February 17, 2022.

79 *"an official cover-up"*: Leonard Levitt, "Dead Man's Family: Coverup," *Newsday*, September 29, 1983.

80 *"makes, or causes"*: New York Public Health Law, https://casetext.com/statute
/consolidated-laws-of-new-york/chapter-public-health/article-42-cadavers/title-2
-autopsy-and-dissection/section-4210-a-unlawful-dissection-of-the-body-of-a-human
-being#:~:text=A%20person%20who%20makes%2C%20or,of%20a%20class%20E%20
felony.

80 *petitioned Mayor Koch*: "Family Asks Koch to Oust Coroner," *New York Times*,
October 15, 1983.

80 *professional misconduct*: "Family Raps Examiner," *Daily News*, October 15, 1983.

80 *"callous disregard"*: Leonard Levitt, "Medical Examiner Firing Urged," *Newsday*,
October 15, 1983.

80 *approximately four thousand signatures . . . delivered by Mallouk*: Clement, *Widow
Basquiat*, 120–21.

80 *There was even*: Peter Noel, "Docs: Where Are Victim's Eyes?" *New York Amsterdam
News*, October 15, 1983.

81 *"totally within"*: Levitt, "Medical Examiner Firing Urged."

83 *"a large hemorrhage"*: "Ex-City M.E. Linked to Graffiti Death Prober," *New York Post*,
October 24, 1983.

83 *"a force like"*: "Artist Could Have Been Choked: Doc," *Daily News*, October 19, 1983.

11: Radiant Children

85 *Basquiat was shocked*: Anthony Haden-Guest, "Burning Out, *Vanity Fair*, November
1988.

85 *the D Train*: Faflick, "SAMO© Graffiti: BOOSH-WAH or CIA?"

85 *one summer morning*: Al Díaz, interview by author, December 26, 2022.

85 *"a coalition of punks"*: Glenn O'Brien, "1981: 'New York/New Wave,'" *Artforum*,
March 2003.

85 *"underground lair"*: Eleanor Nairne and Hans Werner Holzwarth, *Basquiat* (Cologne,
Germany: Taschen, 2020), 57.

86 *in October*: Dieter Buchhart, "When Keith Haring and Jean-Michel Basquiat Took
the 1980s NYC Art Scene by Storm," *Literary Hub*, March 7, 2022.

86 *she marveled*: Annina Nosei, interview by author, December 13, 2022.

86 *In the middle of the dance floor*: Paige Powell, interview by author, November 28, 2023.

86 *"80% anger"*: Henry Geldzahler, "From the Subways to Soho," *Interview*, January 1983.

86 *black skulls*: Hoban, *Basquiat*, 212.

86 *Haring, a student there*: Gooch, *Radiant*, 106.

86 *At the time*: Dieter Buchhart, *Keith Haring | Jean-Michel Basquiat: Crossing Lines*,
(Melbourne, Victoria: NGV, 2020), 8.

86 *"different beasts"*: Patrick Fox, interview by author, February 8, 2024.

86 *"manic draughtsmen"*: Buchhart, *Keith Haring | Jean-Michel Basquiat*, 12.

86 *left a finished painting*: LaBouvier, *Basquiat's "Defacement,"* 19.

87 *to commit suicide*: Warhol and Hackett, *The Andy Warhol Diaries*, 543.

87 *Basquiat traveled*: Buchhart, *Keith Haring | Jean-Michel Basquiat*, 323.

87 *the two talked*: Unpublished transcript of a conversation between Keith Haring and Rene Ricard, November 2, 1983, in the collection of the Keith Haring Foundation Archives.

87 *hands in his pockets*: Jane Maulfair, "Keith Haring: The City Is His Canvas," *Morning Call*, October 28, 1983.

87 *even the reporter . . . had been unaware*: Jane Maulfair, interview by author, March 22, 2024.

87 *painting on tarpaulin*: Anna Gurton-Wachter, email to author, May 2, 2023.

88 *as a child had loved*: Gooch, *Radiant*, 8.

88 *likely somewhat jealous*: Anna Gurton-Wachter, email to author, May 2, 2023.

89 *That day, in fact*: Footage of the meeting filmed by Franck Goldberg, November 2, 1983.

12: Mr. Morgenthau Declines to Meet

91 *Hogan was also pals*: Leonard Levitt, *NYPD Confidential: Power and Corruption in the Country's Greatest Police Force* (New York: Thomas Dunne Books, 2009), 81.

91 *two patrolmen*: "Black Panther Here Is Charged in the Shooting of 2 Policemen," *New York Times*, July 31, 1971.

91 *chose to overlook*: Martin Garbus, "The Case Against District Attorney Hogan," *New York*, December 6, 1971.

91 *he faked the hearing test*: Meier, *Morgenthau*, 294.

92 *"it wasn't macho"*: Andrew Meier, interview by author, September 26, 2023.

92 *"was merciless"*: Meier, *Morgenthau*, 599.

92 *"Mr. Morgenthau made it clear"*: John W. Fried, interview by author, February 9, 2022.

93 *Three weeks . . . several dozen residents*: "DA: Death Dispute to the Grand Jury," *Newsday*, October 20, 1983.

93 *"Are we being sequestered?"*: Footage of the day's events filmed by Franck Goldberg.

94 *Donald Wright*: Edward A. Gargan, "Officer in Killing of Bronx Youth Relieved of Duty," *New York Times*, January 1, 1981.

94 *outside a Harlem shoe store*: Peter McLaughlin, "Slain 'Cause He Was Black, Aunt Cries," *Daily News*, January 8, 1981.

94 *Morgenthau's office that very day*: "Grand Jury to Probe Suspect's Death," *Newsday*, October 20, 1983, https://www.newspapers.com/image/721076487/.

95 *"I thought everybody"*: Mary de Bourbon, interview by author, January 5, 2023.

95 *Henry Woodley Jr. shot to death . . . Larry Peoples kicked and hit around the head and neck*: Sam Roberts, "When Police Are Accused of Brutality," *New York Times*, October 27, 1983.

95 *refused to provide*: Leonard Levitt, "Mayor Skips Cop Hearing," *Newsday*, September 20, 1983.

95 *Larry Dawes*: Dawes v. Pellechia, 688 F. Supp. 842 (E.D.N.Y. 1988).

96 *Over two hours*: "Stewart's Attorneys Meet Manhattan DA," *Newsday*, October 21, 1983.

96 *they spoke of*: Letter from Louis Clayton Jones to Robert Morgenthau, October 24, 1983.

96 *couldn't even convince a grand jury*: Frank Faso and Paul Meskil, "Clear Four Officers of Police Brutality," *Daily News*, November 8, 1983.

13: The Gross Report

98 *"The final cause of death"*: Gross's press statement is drawn from both the version printed in the 1985 "Special Counsel's Report to the Mayor on the Office of the Chief Medical Examiner of the City of New York" and the slightly altered version delivered by Gross, shown in footage of his press conference filmed by Franck Goldberg.

98 *"cardiac arrest while under restraints"*: Liman and Gitter, "Special Counsel's Report to the Mayor on the Office of the Chief Medical Examiner of the City of New York."

98 *"Dr. Gross, what are"*: Footage of the press conference filmed by Franck Goldberg, 1983.

100 *The next day's*: Leonard Levitt, "Amended Report: Injury Lead [*sic*] to TA Graffiti Death," *Newsday*, November 3, 1983.

14: New York City Pigs

101 *fourth floor*: Elizabeth Lederer, email to author, August 24, 2023.

101 *A Connecticut woman*: Clint Roswell and Don Gentile, "Tests Could Free Death Driver," *Daily News*, September 22, 1983.

101 *"like a pancake"*: "Car Crushed; Mother, Tots Die," *Mount Vernon Argus*, September 25, 1983.

101 *The driver*: "Charges Reduced in Truck Crash," *New York Times*, September 22, 1983.

101 *He resented*: Ronald Fields, interview with author, January 13, 2023.

102 *"an independent body"*: Letter from H. Richard Uviller to Ronald P. Fields, October 21, 1983.

102 *In 1935*: "Dewey Gets Data on Union Rackets," *New York Times*, August 1, 1935.

102 *On October 24*: Gerald McKelvey, "Cops Indicted in Stewart Death," *Newsday*, June 2, 1984.

103 *famously suggested*: Marcia Kramer and Frank Lombardi, "New Top State Judge: Abolish Grand Juries and Let Us Decide," *Daily News*, January 31, 1985.

103 *"Every citizen"*: Solomon Wachtler, interview by author, January 24, 2023.

103 *The Stewart case had initially*: M. A. Farber, "As He Seeks a 4th Term, Morgenthau Confronts First Sustained Criticism," *New York Times*, June 17, 1985.

103 *ten days*: Details of the Manhattan district attorney's involvement in the case are drawn from "Special Counsel's Report to the Mayor on the Office of the Chief Medical Examiner of the City of New York," released in April 1985.

103 *"Nobody . . . was gonna trust the cops"*: Bridget Brennan, interview by author, July 20, 2022.

103 *trench-coated*: Timothy Jeffs, interview by author, January 18, 2023

103 *a single*: John W. Fried, interview by author, September 28, 2022.

104 *a woman in her sixties*: Don Flynn, "Cops Kicked 'Body': Witness," *Daily News*, August 29, 1985.

104 *a questionnaire*: Jane Gross, "Defense Attacks Another Student in Stewart Case," *New York Times*, August 16, 1985.

104 *who would whisper*: Lily Nazario, interview by author, January 11, 2023.

104 *"a fact-finding feel"*: Daniel Baxter, interview by author, January 19, 2023.

104 *That very month*: Salvatore Arena and Stuart Marques, "Order Graffiti Death Probe," *Daily News*, January 27, 1984.

105 *"Some members"*: Peter Noel, "Grand Jury Snoozing in Stewart's Probe?" *New York Amsterdam News*, November 26, 1983.

105 *their attorneys believed*: Barry Agulnick, interview by author, December 6, 2023.

106 *"The decision"*: LaBouvier, *Basquiat's "Defacement,"* 142.

106 *Fields was fairly sympathetic*: Ronald Fields, interview with author, January 13, 2023.

107 *two "blue-collar"*: Bryan Burrough, *Days of Rage: America's Radical Underground, the FBI, and the Forgotten Age of Revolutionary Violence* (New York: Penguin Press, 2015), 407–34.

107 *"When I came to"*: Curtis Wilkie, "Suffolk Courthouse Bomb Injures 19," *Boston Globe*, April 23, 1976.

108 *"The FBI"*: Ronald Kuby, interview by author, February 11, 2022.

108 *On May 12, 1983*: "2 N.Y. Bomb Blasts Hit Military Centers," United Press International, May 13, 1983.

108 *in August*: "Army Center Damaged by Explosions in Bronx," *New York Times*, August 22, 1983.

108 *At each scene*: Robert E. Kessler, "7 Are Charged in Area Bombings," *Newsday*, March 13, 1985.

108 *"These lies"*: *Build a Revolutionary Resistance Movement! Communiqués from the North American Clandestine Movement, 1982–1985* (New York: Committee to Fight Repression, 1985), 7.

108 *"Black and brown men"*: Barbara Curzi, interview by author, September 13, 2023.

109 *"Michael was strangled"*: Raymond Levasseur, interview by author, January 10, 2023.

109 *privately repudiated*: Letter from Louis Clayton Jones to Lee Stuart Cox, November 17, 1983.

109 *a political act and rebellion*: Patricia Rowbottom, interview by author, February 17, 2022.

109 *considerable damage*: Stewart Ain and Paul Meskil, "Bombs Hit Navy Center," *Daily News*, December 14, 1983.

109 *dedicated to Samuel Smith*: Kathy Sawyer and Joyce Wadler, "1 Killed, 1 Seized by Police Seeking Brink's Suspects," *Washington Post*, October 24, 1981.

15: Private Detective

113 *"I wasn't a Mata Hari"*: May Okon, "A Woman on the Bench," *Daily News*, April 26, 1970.

113 *she made history*: "Flash: History Is Made," *Daily News*, June 28, 1972.

113 *since 1974*: Ari L. Goldman, "Shirley Levittan, 73, Judge in New York and Legal Lecturer," *New York Times*, February 27, 1992.

113 *worked in financial services*: Patricia Kitchen, "If You're Out of a Permanent Job, Don't Sulk—Seize the Moment," *Newsday*, April 11, 1993.

117 *Back home in Ohio*: Patricia Rowbottom, interview by author, January 31, 2023.

117 *they saw themselves*: Burrough, *Days of Rage*, 526.

117 *who'd been getting frequent briefings*: Bridget Brennan, interview by author, October 25, 2023.

16: Absolute Secrecy

119 *"We had no basis"*: John W. Fried, interview by author, February 3, 2023.

119 *more than sixty*: McKelvey, "Cops Indicted in Stewart Death."

119 *five thousand pages*: Philip Shenon, "Police Brutality Case: Another Try by Prosecutors," *New York Times*, October 9, 1984.

119 *charged on six counts*: People of the State of New York v. John Kostick, Anthony Piscola and Henry Boerner, indictment, in the collection of the New York State Archives.

119 *Each officer faced*: "3 Transit Cops Indicted in Vandal's Death," Associated Press, June 1, 1984.

119 *hands clasped*: Illustration in the *New York Times* by Marilyn Church, June 2, 1984.

120 *"either directly"*: Philip Shenon, "Officers Indicted in Death of Man Held for Graffiti," *New York Times*, June 2, 1984.

120 *"If they didn't"*: Gerald McKelvey, "Cops Indicted in Stewart Death," *Newsday*, June 2, 1984.

120 *effectively worthless*: Peter Noel, "Attorneys Say Stewart Indictment Worthless," *New York Amsterdam News*, June 9, 1984.

120 *"the most serious case"*: Frank Faso and Richard Sisk, "Indict 3 Cops in Graffiti Death," *Daily News*, June 2, 1984.

120 *"In twenty-four of twenty-five cases"*: *Hearings Before the Subcommittee on Criminal Justice.*

121 *fault of journalists*: David Medina and Bella English, "Cops' Bitter Pals Say It Wasn't Fair," *Daily News*, June 2, 1984.

121 *at his behest*: Shenon, "Family of Victim Levels Charges of Deceit in Autopsy Conclusion."

121 *"we knew"*: Lily Nazario, interview by author, January 11, 2023.

121 *they were prosecuting*: "2 Landlords Among 22 Indicted in Terror Campaign," *Tarrytown Daily News*, May 2, 1984.

121 *the interns*: "DA Gets Dan's Son," *Daily News*, June 7, 1984.

122 *born in March*: "U.S., Index to Public Records, 1994–2019," online database, Ancestry.com.

122 *toted him around*: Meier, *Morgenthau*, 706.

123 *"tough cookie"*: Ronald Fields, interview by author, February 10, 2022.

124 *taught the subject*: Okon, "A Woman on the Bench."

125 *"Unseen by everyone"*: Joe Holley, "Ghostwriter to '40s Hollywood Stars," *Gazette*, August 4, 2009.

17: An Unsworn Witness

129 *Fields was informed*: Letter from David G. Duggan to Ronald Fields, April 24, 1984.

129 *Within weeks*: Jared McCallister and David Medina, "Coverup Charged in Graffiti Fatality," *Daily News*, November 15, 1983.

129 *"a systemic pattern"*: McCallister and Medina, "Coverup Charged in Graffiti Fatality."

129 *"It could have been him"*: LaBouvier, *Basquiat's "Defacement,"* 153.

130 *The governor had rebuffed her request*: "Graffiti Fatality: Gov Waits," *Daily News*, November 16, 1983.

130 *"We trust"*: Letter from Louis Clayton Jones to Mario Cuomo, June 4, 1984.

130 *Cuomo's first hire*: Michael Oreskes, "Criminal-Justice Chief," *New York Times*, November 24, 1982.

130 *"In general"*: Letter from Lawrence Kurlander to Louis Clayton Jones, September 7, 1984.

130 *"not one bit"*: Lawrence Kurlander, interview by author, March 15, 2024.

130 *overcrowded, poorly heated, and a "firetrap"*: Lawrence T. Kurlander, *Report to Governor Mario M. Cuomo: The Disturbance at Ossining Correctional Facility, Jan. 8–11, 1983*, September 1983.

130 *the hostages were released*: James Feron, "Ossining Convicts Free All Hostages After 2-Day Siege," *New York Times*, January 11, 1983.

131 *"In the case of Ossining, we were directly responsible"*: Lawrence Kurlander, interview by author, March 17, 2024.

131 *Pressman's commentary*: Gabe Pressman, "Mystery of the Stewart Indictment," *New York Amsterdam News*, June 12, 1984.

131 *on the eleventh floor*: Frank Faso and Frank Lombardi, "Hearing Disrupted," *Daily News*, June 20, 1984.

131 *Murray Kempton . . . watched*: Murray Kempton, "Transit Death Case Appears to Involve Lying by Officials," *Newsday*, January 20, 1984.

132 *informal, gratis legal advice*: Ronald Fields, interview by author, March 12, 2024.

132 *"detail his complaints"*: Letter from William Kunstler to Shirley Levittan, June 20, 1984.

133 *"I do not believe"*: Letter from Shirley Levittan to William Kunstler, June 25, 1984.

133 *On July 13*: Letter from John W. Fried to George F. Roberts, July 13, 1984.

133 *the result*: John W. Fried, interview by author, August 15, 2023.

133 *later that day*: Leonard Levitt, "Indicted Cops Claim Vendetta," *Newsday*, August 23, 1984.

133 *"kept the story alive"*: Davis, "Keeping the Stewart Case Alive."

133 *You do the story*: LaBouvier, *Basquiat's "Defacement,"* 143.

133 *a newspaper ad*: *Daily News*, November 12, 1984.

133 *a grand juror*: Lou Young, interview by author, February 16, 2022.

133 *Shenon's name*: Philip Shenon, "Juror Is Called Tainted in Transit Officers' Case," *New York Times*, August 23, 1984.

134 *the lawyer had been unaware*: Barry Agulnick, interview by author, August 17, 2023.

134 *"personal vendetta"*: Levitt, "Indicted Cops Claim Vendetta."

134 *The attorney asked*: Associated Press, "NYC Union Seeks Dismissal of Indictments in Beating Case," *Herald Statesman*, August 23, 1984.

134 *Roberts announced*: Pete Bowles, "Judge to Probe Jurors," *Newsday*, September 15, 1984.

134 *The judge*: Frank Faso and Stuart Marques, "'Stewart' Indictment Is Queried," *Daily News*, September 15, 1984.

134 *"vicious and sadistic"*: Frank Faso and Ruth Landa, "Ex-Cop Is Sentenced in 'Sadistic' Beatings of Three in Subway," *Daily News*, August 17, 1984.

134 *Over the last*: Murray Kempton, "A Question of Rights," *Newsday*, August 29, 1984

134 *"Cops Win Round"*: "Cops Win Round in Graffiti Death," *Daily News*, October 6, 1984.

135 *"an unsworn witness"*: Philip Shenon, "Charges Dismissed in Brutality Case," *New York Times*, October 6, 1984.

135 *"I wish"*: Ronald Fields, interview by author, May 3, 2023.

135 *declared that the indictments were insufficient*: Frank Faso and James Harney, "Charges Against Cops KO'd in Graffiti Death," *Daily News*, October 6, 1984.

135 *"We expected something like this"*: Mike Pearl and Philip Messing, "Judge Cans Indictments in Graffiti Artist Death," *New York Post*, October 6, 1984.

18: Eleanor Bumpurs

137 *Sixty-six*: Social Security Death Index, Master File, Social Security Administration, Washington, D.C.

137 *strike a match*: Jimmy Breslin, "Double-Barreled Double-Talk," *Daily News*, November 11, 1984.

137 *On at least two occasions*: "A Troubled History," *Daily News*, December 2, 1984.

137 *Elna Gray Williams*: L. Harris, "Beyond the Shooting: Eleanor Gray Bumpurs, Identity Erasure, and Family Activism Against Police Violence," *Souls* 20, no. 1 (2018): 86–109, doi:10.1080/10999949.2018.1520061.

138 *Bumpurs . . . was arrested in Brooklyn*: Suzanne Golubski, Murray Weiss, and Don Singleton, "She Need Not Have Died," *Daily News*, November 21, 1984.

138 *acute psychosis . . . Her hospital file notes*: Suzanne Golubski and David Medina, "Bumpurs' Past Was Violent One," *Daily News*, December 1, 1984.

138 *$80.85*: Victor Botnick, *Report to the Mayor on the Eleanor Bumpurs Case*, November 19, 1984.

139 *Through the door*: Records and Briefs, New York Court of Appeals, 68 N.Y.2d 495 (N.Y. 1986), Appellant's Brief, Part 1, People v. Sullivan, June 1986.

139 *"I'm going to get him"*: Opinion, People v. Sullivan, April 1, 1986.

141 *"It seems"*: "Day of Death, Days of Anger," *Daily News*, December 2, 1984.

142 *"remains a mystery"*: Mary Ann Giordano et al., "The Bumpurs Case: Did Cops Make a Rush to Judgment?" *Daily News*, December 2, 1984.

144 *"Bam, bam"*: Opinion, People v. Sullivan, April 1, 1986.

144 *Ruby Dee and Ossie Davis*: Ruben Rosario, "Peace, at Last," *Daily News*, November 4, 1984.

144 *"The tension"*: Murray Weiss, "Cops Can't Escape Bad Image," *Daily News*, November 18, 1984.

145 *"these confrontations"*: Sam Roberts, "Panel Sees Some Police Racism In New York," *New York Times*, November 15, 1984.

145 *At Sunday chapel service*: Aaron Short, "The Tucker Carlson Origin Story," *Insider*, May 5, 2022.

145 *At a town hall*: Michael Goodwin, "Koch, in Harlem, Discusses Shooting," *New York Times*, November 21, 1984.

19: Simultaneous Probes

147 *elected him*: Vincent Lee, Murray Weiss, and Stuart Marques, "Their Pockets Get Burned," *Daily News*, December 7, 1984.

147 *Just past midnight*: Sam Roberts, "Inquiries on Coroner: Concern over Coordination," *New York Times*, February 14, 1985.

147 *above-the-fold story*: Philip Shenon, "Chief Medical Examiner's Reports in Police-Custody Cases Disputed," *New York Times*, January 27, 1985.

148 *He couldn't ignore*: Sydney H. Schanberg, "Governing by Headline," *New York Times*, February 2, 1985.

148 *"There should not be a whiff"*: Roberts, "Inquiries on Coroner: Concern over Coordination."

148 *more than a dozen*: Philip Shenon, "14-Member Staff Is Named in Investigation of Coroner," *New York Times*, February 27, 1985.

149 *"Why, when"*: Sydney H. Schanberg, "The Protected Coroner," *New York Times*, January 29, 1985.

149 *no intention*: Ruth Landa, "Gross: Won't Quit," *Daily News*, January 28, 1985.

149 *a ten-million-dollar lawsuit*: Derrick Johnson, "Koch to Probe Medical Examiner," *Newsday*, January 28, 1985.

149 *"Dr. Gross has lied"*: Shenon, "Family of Victim Levels Charges of Deceit in Autopsy Conclusion."

149 *"important questions"*: Robert D. McFadden, "Investigations of Coroner Set by Koch and Cuomo," *New York Times*, January 29, 1985.

149 *would encompass*: Patrick Clark and Stuart Marques with David Medina, "Feds Join the Gross Probers," *Daily News*, February 1, 1985.

150 *who'd represented Gross*: "Two Docs for One Job," *Daily News*, August 4, 1980.

150 *got a call*: Don Singleton, "The Big Guns Boom for Gross," *Daily News*, February 8, 1985.

150 *presidents, mayors*: William Glaberson, "Howard M. Squadron, 75, Influential Lawyer, Dies," *New York Times*, December 28, 2001.

150 *"You would have thought"*: Singleton, "The Big Guns Boom for Gross."

151 *"Yes"*: Liz Smith, "Dinner Party with 2 Men of the Cloth," *Daily News*, February 3, 1985.

151 *acolyte of Lyndon LaRouche*: Paul Moses, "Inquiry Figure's Unusual Views," *Newsday*, February 3, 1985.

151 *an ideal venue*: Thomas Collins, "The Post Takes on the Times," *Newsday*, February 10, 1985.

151 *"What the* Times *Didn't Print"*: Guy Hawtin, Jeff Wells, and Ransdell Pierson, "What the Times Didn't Print," *New York Post*, February 1, 1985.

151 *rumored to have conducted*: Andrew Radolf, "Dogfight in New York," *Editor and Publisher*, February 9, 1985.

152 *"84 hours a week"*: Moses, "Inquiry Figure's Unusual Views."

152 *Kostick . . . failed*: Peters, Weiss, and Singleton, "Transit Cop in Stewart Case Failed City Psyche Test."

152 *Squadron remarked*: Ruth Landa, "Face-to-Face, Punctuated with Strain," *Daily News*, February 4, 1985.

152 *Gross read off*: Maureen Dowd, "Gross Responds to Allegations over Autopsies," *New York Times*, February 4, 1985.

152 *rebuttal*: Ruth Landa and Don Singleton, "Charges Made by the *Times* Untrue: Gross," *Daily News*, February 4, 1985.

153 *"There was evidence of injuries"*: Ruth Landa and Don Singleton, "Gross Counterattacks: No Truth to Accusations," *Daily News*, February 4, 1985.

153 *"For the first time"*: Dowd, "Gross Responds to Allegations over Autopsies."

153 *ninety minutes*: Ron Howell, "City Coroner on the Offensive," *Newsday*, February 4, 1985.

153 *120 misdemeanor cases a day . . . "Blacks kicking the shit out of him"*: Meier, *Morgenthau*, 708–10.

20: Here's Another

155 *He reminded a fellow passenger*: Leon Neyfakh, *Fiasco: Vigilante*, Audible Original Podcast, July 27, 2023.

155 *operating out of his apartment*: Richard Stengel, "A Troubled and Troubling Life," *Time*, April 8, 1985.

155 *more than $100,000*: Bernhard Goetz, interview by author, September 8, 2023.

155 *the median rent*: Josh Barbanel, "City Has Fewer Rental Apartments, Survey Finds," *New York Times*, March 6, 1985.

155 *Only months prior*: Ward Morehouse III, "New York Has Tough New Gun Law," *Christian Science Monitor*," June 19, 1980.

155 *"special need"*: "Record Number Ask Gun Permits in New York City," *New York Times*, March 16, 1981.

155 *People carrying guns*: Michael Brooks, "Stories and Verdicts: Bernhard Goetz and New York in Crisis," *College Literature* 25, No. 1 (Winter 1998): 77–93.

155 *In 1971, a real estate agent*: Eric Pace, "Passenger with a Licensed Gun Shoots 2 Assailants in Subway," *New York Times*, October 15, 1971.

155 *Eight years later*: Robert Mcg. Thomas Jr., "Harasser Shot by IRT Passenger," *New York Times*, November 1, 1979.

155 *In early 1984*: John Randazzo and Ruth Landa, "Puts Mug Suspect in Hospital," *Daily News*, February 14, 1984.

156 *There was a brief return . . . "I am the person"*: Suzanne Daley, "Goetz Drove Across New England For Several Days Before Surrender," *New York Times*, January 4, 1985.

156 *"I may be the biggest piece of bleep"*: "The Trial of Bernhard Goetz: Goetz's Videotaped Confession."

156 *"I wanted to maim those guys"*: Ibid.

157 *While he sat*: Ginia Bellafante, "Crime Is Down. So Why Don't New Yorkers Feel Safe?" *New York Times*, August 4, 2023.

157 *thousands of dollars*: Associated Press, "Subway 'Star,'" *Mount Vernon Argus*, January 20, 1985.

157 *Joan Rivers sent a telegram*: John Leo, "Behavior: Low Profile for a Legend Bernard Goetz," *Time*, January 21, 1985.

157 *the palpable consternation*: "The Vigilante," *New York Amsterdam News*, January 19, 1985.

157 *even after Jimmy Breslin*: Jonathan Markovitz, *Legacies of Lynching* (Minneapolis: University of Minnesota Press, 2004), 73.

157 *a near majority*: United Press International, "Poll Shows New Yorkers Stand Behind Subway Gunman," *Simi Valley Star*, January 7, 1985.

157 *"humorless law and order buff"*: Don Gentile and Brian Kates, "'A Little Strange,'" *Daily News*, January 1, 1985.

157 *"sad and frightened"*: Sydney H. Schanberg, "Support Your Local Shooter," *New York Times*, January 5, 1985.

158 *"was defending"*: Mary Ann Poust, "Public Support Mounts for Accused Vigilante," *Standard-Star*, January 6, 1985.

158 *Breslin threw up his hands*: Jimmy Breslin, "Goetz Should Take Mayoralty Shot," *Daily News*, January 17, 1985.

158 *Morgenthau . . . leaked*: Meier, *Morgenthau*, 709.

158 *"enlighten the public"*: Harvey Rosen, interview by author, February 16, 2024.

158 *The confession introduced New Yorkers*: United Press International, "Leaks from the Videotaped Confession of 'Death Wish' Gunman," January 18, 1985.

158 *"It was the view"*: Marcia Chambers, "Grand Jury Votes to Indict Goetz Only on Gun Possession Charges," *New York Times*, January 26, 1985.

158 *According to the film's producer*: Associated Press, "Goetz Shooting Sells Bronson on Another 'Death Wish,'" *San Francisco Examiner*, February 13, 1985.

159 *"Let's just say"*: Anthony Holden, "'Bronson Menaces Muggers, Reporters," *Pittsburgh Press*, November 5, 1985.

159 *even Ronald Reagan saw fit*: "Asked About Goetz, Reagan Cites the Law," *New York Times*, January 10, 1985.

159 *There was, however, at least one East Villager*: Leon Neyfakh, email to author, February 14, 2024.

159 *since the mid-1960s*: Joseph Lelyveld, "Lonelies Met Desperates in Little Black Book," *Cincinnati Enquirer*, January 19, 1972.

159 *"Peter Lorre's accent"*: John Godwin, *The Mating Trade* (Garden City, N.Y.: Doubleday and Company, 1973), 709.

159 *producing a few songs*: Mary Cross, *Madonna: A Biography* (Westport, Conn.: Greenwood, 2007), Kindle Edition, 417.

160 *self-styled troubadour*: Hank Gallo, "Ballad of Bernie," *Daily News*, April 19, 1985.

160 *"I didn't really have to shoot"*: J. Fitzsooth, Otto von Wernherr, Robert A. Brady, "The Saga of Bernhard Goetz."

160 *finding the piece somewhat exploitative*: Clive Smith, email to author, March 13, 2024.

160 *"at that time, it was just an opportunity"*: Clive Smith, interview by author, March 12, 2024.

160 *"A good electric boogie beat"*: John Leland, "Singles," *Spin*, September 1985.

160 *"appears to have fallen apart"*: Jimmy Breslin, "Letter Could Cost More than 22¢," *Daily News*, February 17, 1985.

21: Failure to Protect

161 *faced up to twenty-five years*: Frank Faso and Brian Kates, "6 TA Cops Indicted in Graffiti Death," *Daily News*, February 22, 1985.

161 *"the performance by a person"*: New York State Penal Law, Requirements for criminal liability in general and for offenses of strict liability and mental culpability, § 15.10, https://codes.findlaw.com/ny/penal-law/pen-sect-15-10/.

161 *The Manhattan District Attorney's Office had found*: John Fried, email to author, October 18, 2023.

161 *The county court*: *People v. Kazmarick*, June 19, 1979, 99 Misc.2d 1012,417 N.Y.S.2d 671.

162 *"What this indictment means"*: Marcia Chambers, "6 Transit Officers Indicted in Death in Graffiti Arrest," *New York Times*, February 22, 1985.

162 *"a novel theory"*: Frances A. McMorris and Gerald McKelvey, "6 Cops Indicted in Graffiti Death," *Newsday*, February 22, 1985.

163 *"by fists"*: Landa and Singleton, "Gross Counterattacks: No Truth to Accusations."

163 *wouldn't be clear*: John W. Fried, interview by author, September 11, 2023.

163 *the upshot*: Bridget Brennan: interview by author, July 20, 2022.

163 *"one of the most widely publicized"*: Chambers, "6 Transit Officers Indicted in Death in Graffiti Arrest."

163 *"a virtually unknown model"*: Faso and Kates, "6 TA Cops Indicted in Graffiti Death."

164 *a pair of women*: "2 Women Seen at Site of Blast," *New York Times*, February 24, 1985.

164 *Officers, alerted*: Ruben Rosario and Stuart Marques, "Cops Hunt 2 Fems in PBA Blast," *Daily News*, February 24, 1985.

164 *Within minutes*: Associated Press, "Police Union's Offices in Manhattan Bombed," *New York Times*, February 23, 1983.

164 *"This is Red Guerilla Defense"*: Associated Press, "Link of Bombing to Others Probed," *Newsday*, February 24, 1985.

164 *approximately half the NYPD*: Frank Spotnitz, "Police Rally Around One of Their Own," United Press International, February 7, 1985.

164 *"The ten thousand racists"*: Associated Press, "N.Y. Police Union Office Hit," *Olympian*, February 23, 1985.

165 *the first group of its kind*: Lila Thulin, "In the 1980s, a Far-Left, Female-Led Domestic Terrorism Group Bombed the U.S. Capitol," *Smithsonian Magazine*, January 6, 2020.

165 *"the frontline enforcers"*: William Rosenau, *Tonight We Bombed the U.S. Capitol* (New York: Atria Books, 2019), 216.

165 *"distorted and destroyed"*: *Build a Revolutionary Resistance Movement!*, 51.

165 *The PBA headquarters was chosen*: *Out: The Making of a Revolutionary*, documentary directed by Rhonda Collins and Sonja De Vries (2000).

165 *the FBI at first*: Associated Press, "Link of Bombing to Others Probed," *Newsday*, February 24, 1985.

165 *They had been*: Daniel Hays and Don Singleton, "7 Indicted in Bombings," *Daily News*, March 13, 1985.

166 *"I am guilty of no crime"*: Robert E. Kessler, "Arraignment Turns into Brawl," *Newsday*, March 26, 1985.

166 *"I want a guilty"*: Joseph P. Fried, "'Stun Guns' Used to Subdue 3 Men in Courtroom Brawl," *New York Times*, March 26, 1985.

166 *carried out by the elbows*: Barbara Curzi, interview by author, September 13, 2023.

166 *thirty days*: Letter to Mayor Edward Koch, March 1, 1985, LaGuardia and Wagner Archives.

167 *"understaffed, undertrained"*: Philip Shenon, "2 Investigations Sharply Critical of City Coroner," *New York Times*, March 5, 1985.

167 *"contribute credibly"*: Marianne Arneberg, "2 Probes Fault Coroner's Office," *Newsday*, March 5, 1985.

167 *"The first time"*: Richard Tofel, interview by author, May 13, 2022.

167 *"den of suspected intrigue"*: Leonard Levitt, "Mayor's Panel Clears Medical Examiner," *Newsday*, April 24, 1985.

168 *"All of our advisors are satisfied"*: Liman and Gitter, "Special Counsel's Report to the Mayor on the Office of the Chief Medical Examiner of the City of New York."

168 *In another instance*: Frederick T. Davis, interview by author, September 22, 2023.

169 *"I plan to stay"*: David Medina and Robert Carroll, "Mayor's Panel Clears Dr. Gross," *Daily News*, April 24, 1985.

169 *Weeks later*: United Press International, "Trial of 6 Transit Officers to Start," *Newsday*, July 18, 1985.

169 *jurors met with the defense*: Barry Agulnick, interview by author, March 20, 2024.

169 *was annoyed*: Farber, "As He Seeks a 4th Term, Morgenthau Confronts First Sustained Criticism."

22: Ricochet

171 *"There are fifty-three thousand people"*: Frank Lynn, "Morgenthau Announces Candidacy for 4th Term," *New York Times*, July 18, 1985.

171 *"You throw shit against the wall"*: Barry Agulnick, interview by author, March 20, 2024.

171 *one by one*: Jane Gross, "Six Officers Goon Trial in Stewart Slaying Case," *New York Times*, July 19, 1985.

171 *a pool of more than five hundred*: Don Flynn, "Beat-Death Trial Opens," *Daily News*, July 18, 1985.

171 *Morgenthau's announcement*: Associated Press, "Morgenthau Says He's a Candidate," *Newsday*, July 18, 1985.

171 *appointed to the bench by Koch*: "NY Mayor 'Outraged' at Conduct by Judge," *Tyler-Courier Times*, May 14, 1987.

171 *his first*: Jeffrey Atlas, interview by author, April 1, 2022.

172 *was probably drunk*: Don Flynn and Stuart Marques, "Stewart 'Woke Up Neighborhood,'" *Daily News*, July 19, 1985.

172 *his eye on*: John W. Fried, interview by author, October 10, 2023.

172 *Fried was compelled*: Murray Kempton, "Jury May Settle for the Possible in Stewart Case," *Newsday*, July 19, 1985.

172 *"I don't recall ever"*: John W. Fried, interview by author, October 10, 2023.

173 *an editor at* The New Yorker: Nancy Franklin, email to author, September 29, 2022.

173 *a practice he began in the wake*: Jan Hoffman, "Defending the Blue," *New York Times*, May 8, 1994.

173 *had won multiple acquittals*: Leonard Leavitt, "Defense Rests, but Restlessly," *Newsday*, November 21, 1985.

173 *"psycho"*: Associated Press, "Police Beating Death Trial Begins," *Mount Vernon Argus*, July 19, 1985.

173 *"frenzied"*: Farber, "Student Recalls She Saw Police Beating Stewart."

173 *"Michael Stewart is dead"*: Associated Press, "Officers' Defense Says Graffiti Artist Was 'Wildly Drunk,'" *Daily Record*, July 23, 1985.

174 *She told Fried*: Farber, "Student Recalls She Saw Police Beating Stewart."

174 *he jotted inconsistencies*: Index cards provided to author by Barry Agulnick.

175 *"He looks regular"*: Warhol and Hackett, *The Andy Warhol Diaries*, 540.

175 *"Why do you say that?"*: Associated Press, "Three Dispute Police Claim Artist Was Drunk When Arrested," *Jersey Journal*, July 24, 1985.

175 *"Did you see any bruises"*: M. A. Farber, "3 Witnesses Say Stewart Appeared Sober on the Night He Was Arrested," *New York Times*, July 24, 1985.

175 *sober and unbruised*: Don Flynn, "Calls Stewart Sober in Trial of Six Cops," *Daily News*, July 24, 1985.

176 *been in touch*: "Defense Impugns Stewart Witness," *New York Times*, July 25, 1985.

176 *When Eleanor Bumpurs*: LaBouvier, *Basquiat's "Defacement,"* 117.

176 *had advocated*: Associated Press, "Stewart Trial Witness Was at Protests," *Journal News*, July 25, 1985.

176 *The defense could not*: Don Flynn, "Protested Stewart 'Coverup': Witness," *Daily News*, July 25, 1985.

177 *at 2 a.m.*: Robert Rodriguez complaint

177 *"And suddenly"*: Marcia Chambers, "Witness Tells Stewart Jury He Saw Assaults by Police," *New York Times*, July 30, 1985.

177 *on two occasions*: Don Flynn, "New Michael Stewart Testimony," *Daily News*, July 30, 1985.

177 *diagnosed with schizophrenia*: Gerald McKelvey, "Stewart Witness Claims Coverup," *Newsday*, August 1, 1985.

178 *question decades later*: Jeffrey Atlas, interview by author, September 27, 2023.

178 *"I will not"*: United Press International, "Stewart Witness Admits Suicide Try," *Newsday*, July 31, 1985.

178 *"I expect"*: Associated Press, "Witness Admits Attempted Suicide to Stewart Trial," *Daily Record*, July 31, 1985.

178 *According to doctors' notes*: Don Flynn, "Bare Stewart Witness' Hosp Record," *Daily News*, July 31, 1985.

178 *elicited a smirk*: Peter Noel, "'I Am Not Crazy,'" *New York Amsterdam News*, August 3, 1985.

178 *a "mental patient"*: Don Flynn, "Stewart Witness Claims DA Coverup," *Daily News*, August 1, 1985.

178 *"Every aspect"*: Murray Kempton, "A Crime's Witness Who Lost a Prize by Being Honest," *Newsday*, July 31, 1985.

179 *"take a vacation until"*: Associated Press, "Stewart Case Witness Says He Suspected Cover-up," *Mount Vernon Argus*, August 1, 1985.

179 *"beat the hell"*: Don Flynn, "Defense Quiz of Stewart Case Witness," *Daily News*, August 2, 1985.

179 *"even at this early date"*: "Editorial" *City Sun*, August 7–13, 1985.

179 *"This is my courtroom, not yours!"*: United Press International, "Tempers Flare at Cops' Trial," *Newsday*, August 7, 1985.

23: The Students

181 *a black-and-white dress*: Jimmy Breslin, "'Twas Night to Remember," *Daily News*, August 16, 1985.

181 *"I was leaning on his back"*: Don Flynn and Alton Slagle, "Cop Gives Her Side," *Daily News*, August 15, 1985.

181 *"bucking, kicking"*: Jane Gross, "Officer Told Grand Jury Stewart Was Combative," *New York Times*, August 15, 1985.

182 *left to Breslin to report the truth*: Neyfakh, *Fiasco: Vigilante*.

182 *a single dereliction*: "One Death, Six Defendants," *Daily News*, November 25, 1985.

182 *civilian complaints*: 50-a.org, https://www.50-a.org/officer/BFLB.

182 *"stick or a club"*: Marcia Chambers, "Witness Says Officers Beat Stewart as Others Stood By," *New York Times*, August 8, 1985.

182 *"During the hitting"*: Associated Press, "More Students from Parsons Due to Testify in Stewart Death Case," *Citizen Register*, August 12, 1985.

182 *He'd testified*: United Press International, "Stewart-Case Testimony Questioned," *Newsday*, August 9, 1985.

183 *less than certain*: Jane Gross, "Witnesses Says He Saw Officers Strike Stewart," *New York Times*, August 13, 1985.

183 *the courtroom sketch artist*: Nancy Jo Haselbacher, interview by author, March 1, 2022.

183 *The tenth student*: Gross, "Defense Attacks Another Student in Stewart Case."

184 *walked past a glare*: Candice Leit, interview by author, February 20, 2022.

184 *"Was it like the Rockettes?"*: Flynn, "TA Defense Sez Witness Lied to Jury."

184 *appeared pained*: Jane Gross, "Team Is Defending 6 in Stewart Case," *New York Times*, September 2, 1985.

184 *Her uncle*: Candice Leit, interview by author, February 20, 2022.

184 *"idle conversation"*: "One Death, Six Defendants," *Daily News*, November 25, 1985.

185 *"acting in a violent manner"*: "Account Is Read of Officer's Bid to Curb Stewart," *New York Times*, August 20, 1985.

185 *"I observed"*: Associated Press, "Officer Denies He Kicked Suspect Who Later Died," *Journal News*, August 20, 1985.

185 *he had not seen*: Don Flynn, "Stewart Jury Hears Transcript," *Daily News*, August 20, 1985.

185 *Echoing Techky's and Barry's language*: "Arrest 'Routine,'" *Daily News*, August 21, 1985.

185 *"rolling from side to side"*: Jane Gross, "Stewart Jurors Hear Testimony on Choke Holds," *New York Times*, August 21, 1985.

186 *"John Fried deciding"*: Barry Agulnick, interview by author, August 17, 2023.

186 *This changed*: Jane Gross, "Witness Says Officer Used a Choke Hold on Stewart's Neck," *New York Times*, August 22, 1985.

186 *"I saw a police officer"*: Don Flynn, "Cop Used Club on Stewart, Student Says," *Daily News*, August 22, 1985.

186 *"The man with the club"*: Associated Press, "Witness: Cop Choked Stewart."

187 *"never observed physical abuse"*: Jane Gross, "A Transit Officer's Testimony Is Read to Stewart Trial Jury," *New York Times*, August 23, 1985.

187 *"In police jargon"*: Don Flynn, "Cop: Treated Stewart Like 'a Psycho,'" *Daily News*, August 23, 1985.

187 *a former marine*: "One Death, Six Defendants," *Daily News*, November 25, 1985.

187 *"I saw and did no violence"*: Gerald McKelvey, "Stewart Screamed for Help, Witness Says," *Newsday*, August 28, 1985.

187 *faculty appointments*: "Annemarie Feibes Crocetti," *Times Tribune*, August 7, 1996.

187 *She chain-smoked*: Richard Ayres, interview by author, October 24, 2023.

188 *"Will occur"*: Nathaniel Rich, "Losing Earth: The Decade We Almost Stopped Climate Change," *New York Times Magazine*, August 1, 2018.

188 *Two police officers*: Flynn, "Cops Kicked 'Body': Witness."

188 *"picked up the body"*: Isabel Wilkerson, "Doctor Testifies She Saw 2 Officers Kick Stewart," *New York Times*, August 29, 1985.

188 *an ambulance*: United Press International, "DA's Witness in Cops' Trial Admits Errors," *Newsday*, August 30, 1985.

188 *twenty-fourth*: Don Flynn, "For Stewart Jury, a Last Eyewitness," *Daily News*, September 4, 1985.

189 *sixth-floor window*: Associated Press, "Student Says Cops Kicked Stewart," *Newsday*, September 4, 1985.

189 *"a hectoring technique"*: Gross, "Team Is Defending 6 in Stewart Case."

189 *Decades later*: Curtis Lipscomb, interview by author, September 12, 2022.

24: Rested

191 *"Upon arrival at Dist. #4"*: Complaint provided to author by Franck Goldberg.

191 *walked toward him*: M. A. Farber, "Officer Swore Police Did Not Abuse Stewart," *New York Times,* September 7, 1985.

191 *detected no alcohol*: United Press International, "Transit Cop Says Stewart Struggled," *Newsday,* September 7, 1985.

191 *"took off like a shot"*: Don Flynn, "TA Cop: Stewart Fought and Yelled," *Daily News,* September 7, 1985.

192 *he was bruised*: Associated Press, "Nurse Describes Stewart's Injuries," *Newsday,* September 11, 1985.

192 *a red mark*: Don Flynn, "Stewart's Face 'Blue,'" *Daily News,* September 11, 1985.

192 *"I could tell"*: Wilkerson, "Nurse Says Stewart Was Bruised When He Arrived at the Hospital."

193 *interviewed twice*: United Press International, "Defense Takes Aim at Stewart Witness," *Newsday,* September 12, 1985.

193 *the Stewarts' attorney . . . had represented the nurse*: Isabel Wilkerson, "Defense Impugns Nurse's Claims in Stewart Case," *New York Times,* September 12, 1985.

193 *degrees from Swarthmore*: "Judith Walenta Obituary," September 24, 2017.

193 *swollen and bruised*: Associated Press, "Nurse in Trial of NYC Policemen Says Health Group Threatened Her," *Press and Sun-Bulletin,* September 19, 1985.

193 *So if you*: Jimmy Breslin, "Nurse's Aide Didn't Choke on the Stand," *Daily News,* September 24, 1985.

193 *"He was in"*: United Press International, "MD: No Pulse in Stewart on Arrival at Hospital."

194 *"severe impairment"*: Isabel Wilkerson, "Bellevue Doctor Says Stewart Lacked Heartbeat and Pulse," *New York Times,* September 27, 1985.

194 *the investigation*: Paul La Rosa and Marcia Kramer, "'New Cases' in Gross Probe," *Daily News,* August 2, 1985.

194 *Michael's case*: Marcia Kramer, "Stewart Case in Gross List," *Daily News,* August 2, 1985.

194 *the fourth probe*: "4th Probe of Office in 7 Months Again Finds Problems," *Daily News,* August 1, 1985.

194 *In a press conference*: Alan Finder, Albert Scardino and Walter Goodman, "Dr. Gross Faces Charges," *New York Times,* August 4, 1985.

194 *Gross took*: Sam Roberts, "Dr. Gross Accused of Incompetence by State Agency," *New York Times,* August 1, 1985.

194 *would probably sink*: Kathleen Kerr, "Misconduct Charges Baseless, Gross Says," *Newsday,* August 2, 1985.

194 *cleared the chief*: "U.S. Investigators Clear Dr. Gross," *New York Times,* September 13, 1985.

194 *Then, in October*: Adam Nagourney, "Gross Trial Ruled Out by Judge," *Daily News*, October 2, 1985.

194 *He blamed the doctors*: Leonard Levitt, "Brutality Lawyer Reverses on Gross," *Newsday*, October 4, 1985.

195 *the forty-second day*: Isabel Wilkerson, "Gross Testifies About Autopsy at Stewart Trial," *New York Times*, October 4, 1985.

195 *a gray-blue suit*: Leonard Levitt, "Stewart Lawyer 'Clears' ME," *Newsday*, October 4, 1985.

195 *The results, he explained*: "Gross Backs His Autopsy of Stewart," *Daily New*s, October 4, 1985.

195 *no longer stood by*: Isabel Wilkerson, "Dr. Gross, at Trial, Again Revises View on Cause of Stewart's Death," *New York Times*, October 5, 1985.

195 *after Stewart's arrival at Bellevue*: Associated Press, "Medical Examiner Recants Death Cause in N.Y.C. Cop Trial," *Central New Jersey Home News*, October 6, 1985.

196 *did not alter*: Leonard Levitt, "ME Gross Recants 'Impossible' 1st Finding in Death of Stewart," *Newsday*, October 12, 1985.

196 *Gross left the stand*: Don Flynn and David Medina, "Gross Flips Again on Stewart," *Daily News*, October 5, 1985.

196 *but he wouldn't say*: David Medina and Alton Slagle, "Gross Vague on Stewart," *Daily News*, October 8, 1985.

196 *"consistent with kicks"*: Leonard Levitt, "Gross Grilled on Stewart's Injuries," *Newsday*, October 9, 1985.

196 *"Can you now formulate"*: Isabel Wilkerson, "Gross Offers No Opinion on What Killed Stewart," *New York Times*, October 8, 1985.

197 *nearly twenty variables*: Alex Michelini and Marcia Kramer, "How Did Stewart Die?" *Daily News*, October 10, 1985.

197 *"assumptions," he called them*: Isabel Wilkerson, "Gross Offers Theory in Stewart's Death," *New York Times*, October 10, 1985.

197 *"acute intoxication"*: Leonard Levitt, "ME Switches on Stewart Death," *Newsday*, October 10, 1985.

197 *"impossible"*: Levitt, "ME Gross Recants 'Impossible' 1st Finding in Death of Stewart."

197 *annoyed and anxious*: "Gross Continues Stewart Testimony," *Newsday*, October 18, 1985.

197 *"He was"*: Peter Griffin, interview by author, September 28, 2022.

197 *"Gross has offered"*: Phil Makotsi, ""Combination of Factors" in Artist's Death," *City Sun*, October 16–22, 1985.

198 *Given the chance*: John W. Fried, interview by author, February 9, 2022.

198 *"We knew he'd get creamed"*: Bridget Brennan, interview by author, October 25, 2023.

198 *"the direct precipitant"*: Associated Press, "Expert: Body Blows Killed Stewart," *Journal News*, October 24, 1985.

198 *he explained*: Isabel Wilkerson, "Cardiologist Cites Blows to Back in Testimony at the Stewart Trial," *New York Times*, October 24, 1985.

198 *more than four thousand autopsies*: Elizabeth Karagianis, "Chief Medical Examiner Searches for Clues that Can Help the Living," *Boston Globe*, October 30, 1984.

198 *read through*: Associated Press, "Testimony: Stewart Died of Asphyxia," *Asbury Park Press*, October 29, 1985.

198 *He was unusually familiar*: Shenon, "14-Member Staff Is Named in Investigation of Coroner."

199 *brought on by a nightstick*: Isabel Wilkerson, "Expert Testifies Choking Caused Stewart's Death," *New York Times*, October 29, 1985.

199 *undercut on cross-examination*: Isabel Wilkerson, "Defense Challenges Witness on Stewart Choking Theory," *New York Times*, October 30, 1985.

199 *a person is perfectly capable of screaming*: Gary E. Weissman, interview by author, March 13, 2024.

199 *vomited in a courthouse*: Barry Agulnick, interview by author, February 16, 2022.

199 *approximately nine thousand pages*: Isabel Wilkerson, "Defense Lawyers in Stewart Trial Say They Will Call No Witnesses," *New York Times*, October 31, 1985.

199 *"Defense Shocker"*: Alex Michelini, "Defense Shocker," *Daily News*, October 31, 1985.

199 *discussing the idea for months*: Barry Agulnick, interview by author, October 23, 2023.

200 *Atlas allotted*: Alex Michelini, "Charges Dropped in Stewart Case," *Daily News*, November 2, 1985.

25: No Evidence of Racism

201 *"the multiple-choice"*: Isabel Wilkerson, "Defense Begins Its Summations in Stewart Trial," *New York Times*, November 13, 1985.

201 *"set pathology back one-hundred years"*: Alex Michelini, "Lawyer Labels Stewart Madman," *Daily News*, November 13, 1985.

201 *"living in a nightmare"*: Alex Michelini, "Graffiti Case Defense Rests," *Daily News*, November 14, 1985.

201 *"not arrested because"*: Associated Press, "Defense Sums Up in Transit Cops' Trial," *Journal News*, November 14, 1985.

201 *for seven hours*: Isabel Wilkerson, "Stewart Trial Prosecutor in Summation, Urges Jury to Focus on Testimony," *New York Times*, November 15, 1985.

201 *seats in the front row*: Leonard Levitt, "Silent Witnesses for Prosecution," *Newsday*, November 19, 1985.

201 *"evidence [neither] of racism"*: Alex Michelini, "Stewart Prosecutor Rips Cops," *Daily News*, November 15, 1985.

202 *"The issue is not"*: Leonard Levitt, "Stewart Prosecutor Assails Police," *Newsday*, November 15, 1985.

202 *four hours*: Isabel Wilkerson, "Jurors Told to Disregard Emotion in Reaching Stewart Case Verdict," *New York Times*, November 19, 1985.

203 *"Don't rush to judgment"*: Levitt, "Silent Witnesses for Prosecution."

203 *seven days*: Alex Michelini and Don Gentile, "6 Transit Cops Acquitted in Stewart Death," *Daily News*, November 25, 1985.

203 *"would not be dead"*: Peter Griffin, interview by author, September 28, 2022.

203 *But the jury could not*: Isabel Wilkerson, "Jury Acquits All Transit Officers in 1983 Death of Michael Stewart," *New York Times*, November 25, 1985.

203 *"In fact"*: Peter Griffin and Richard Essex, "2 Jurors in the Stewart Case Explain Their Vote," *New York Times*, January 4, 1986.

203 *court officers had*: Peter Noel, "Stewart Juror Pledges to Unveil 'Criminal Act,'" *New York Amsterdam News*, November 30, 1985.

26: Remember Michael Stewart

205 *The issue published*: *East Village Eye*, September 1983.

205 *"It was a brutal time"*: Al Díaz, interview by author, December 26, 2022.

205 *The October 1983 issue*: Rumsey, "Murder + Lies."

205 *March 1985*: Bisson, "The Murder of Michael Stewart."

205 *associated with the*: Margret Grebowicz, "Terry Bisson's History of the Future," *The New Yorker*, October 7, 2023.

206 *"it stepped on a lot of toes"*: Terry Bisson, interview by author, October 28, 2023.

206 *an editorial*: "The Man Nobody Killed," *East Village Eye*, December/January 1986.

206 *Approximately a third*: Jane Perlez and Selwyn Raab, "Rising Brutality Complaints Raise Questions About New York Police," *New York Times*, May 6, 1985.

206 *more than three thousand complaints*: "Brutality Cases Decline in 1986," *New York Times*, February 22, 1987.

207 *forced one man to swallow cocaine*: John Randazzo and Don Gentile, "Two Cops Yanked," *Daily News*, April 3, 1986.

207 *briefly dismissed*: "2 Dismissals Overruled by Ward," *New York Times*, September 18, 1986.

207 Soon enough: Eric Drooker, interview by author, November 1, 2023.

207 *through WBAI, the tabloids*: Eric Drooker, interview by author, October 28, 2022.

207 *in the style of German expressionism*: LaBouvier, *Basquiat's "Defacement,"* 132.

207 *sixty protestors*: Isabel Wilkerson, "City to Weigh New Actions Against Stewart Defendants," *New York Times*, November 26, 1985.

207 REMEMBER MICHAEL STEWART: David Holmberg, "Koch Orders City Review of Cops in Stewart Case," *Newsday*, November 26, 1985.

208 *still at Bellevue*: Siddhartha Mitter, "Behind Basquiat's 'Defacement': Reframing a Tragedy," *New York Times*, July 30, 2019.

208 *over-inked and smudged*: Peter Schjeldahl, "Basquiat's Memorial to a Young Artist Killed by Police," *The New Yorker*, July 1, 2019.

208 *holding a spray can*: Jimmy Breslin, "Walls of Sorrow on the Lower East Side," *Daily News*, November 28, 1985.

208 *lively Black child*: Associated Press, "Toni Morrison's First Play Opens in Albany," *Democrat and Chronicle*, January 4, 1986.

208 *who'd been the lyricist*: Carol Lawson, "Book and Lyrics of New Musical by Toni Morrison," *New York Times*, July 23, 1982.

208 *"Way it would have been"*: *Dreaming Emmett* draft, November 20, 1985, Toni Morrison Papers, 1908–2017, Princeton University, Princeton, N.J.

209 *more than a dozen drafts*: *Dreaming Emmett* draft, September 26, 1985, Toni Morrison Papers, 1908–2017, Princeton University, Princeton, N.J.

209 *and Michael Stewart*: United Press International, "Toni Morrison Premiere," *Newsday*, December 31, 1985.

209 *It's possible, too*: Namwali Serpell, email to author, November 16, 2023.

209 *Morrison had published*: Beenish Ahmed, "Henry Dumas Wrote About Black People Killed by Cops. Then He Was Killed by a Cop," NPR.org, October 1, 2015.

209 *"a multitude"*: Justine Tally, *The Cambridge Companion to Toni Morrison* (Cambridge, UK: Cambridge University Press, 2007), 106.

209 *What you did was*: *Dreaming Emmett* fragments, 1983–1985, Toni Morrison Papers, 1908–2017, Princeton University, Princeton, N.J.

210 *hoped to take the play*: William Kennedy, interview by author, March 24, 2022.

210 *The reviews were mixed*: Barbara Fischkin, "'Dreaming Emmett' Comes to Life," *Newsday*, January 8, 1986.

210 *never staged again*: Katie Cusack, "Toni Morrison's First Play 'Dreaming Emmett' Was Staged in Albany and Abandoned After Its First Run. What Happened?" *The Collaborative*, January 22, 2020.

210 *"I wasn't savvy enough"*: William Kennedy, interview by author, March 24, 2022.

210 *"He's been through"*: Joyce Purnick, "Mayor Restores Dr. Gross to Job, Citing Fairness," *New York Times*, December 19, 1985.

211 *his client wasn't*: Affidavit Index #1686/86, New York Times Company Records, General Files, Manuscripts and Archives Division, New York Public Library.

211 *members of the staff*: Alex Michelini and Joseph McNamara, "Gross to Sue N.Y. Times," *Daily News*, January 25, 1986.

211 *There was no proof*: "Criminal Inquiry Clears Gross," *New York Times*, May 9, 1986.

211 *The next year, however, Koch*: James Barron, "Koch Dismisses Gross, Faulting His Leadership," *New York Times*, October 30, 1987.

211 *was dismissed*: "Dismissal Is Upheld for Times Libel Suit," *New York Times*, June 17, 1992.

212 *Jeffrey Atlas*: Jeffrey Atlas, LinkedIn profile, https://www.linkedin.com/in/jeffrey-atlas-40787122.

212 *"Every time I hear" . . . "Today," he said*: Jeffrey Atlas, interview by author, April 1, 2022.

212 *"We should never"*: John Kostick, interview by author, November 18, 2022.

213 *an MTA committee*: Richard Levine, "M.T.A. Panel Urges Charge Against Officer in Stewart Death," *New York Times*, March 13, 1987.

213 *alone among the eleven*: Richard Levine, "M.T.A. Won't Charge 10 in Stewart Case," *New York Times*, March 28, 1987.

213 *eventually abandoned*: Richard Levine, "Charge Against Officer in Stewart Case Is Dropped," *New York Times*, October 28, 1987.

213 *"By the early morning"*: Tyler, "Report of Special Counsel to the New York City Transit Authority."

213 *Within days*: Dennis Hevesi, "Police Chief for Transit Resigns Post," *New York Times*, February 3, 1987.

213 *"The whole thing seems"*: Vincent Del Castillo, interview by author, November 16, 2023.

213 *Haring kept a newspaper clipping*: Gooch, *Radiant*, 219.

213 *"Continually dismissed"*: Keith Haring, *Keith Haring Journals* (New York: Penguin Books, 2010), 165–66.

214 *"He was"*: Haring, *Keith Haring Journals* (New York: Penguin Books, 2010), 165.

214 *"I'm always alone"*: Hoban, *Basquiat*, 24.

214 *"there was almost nothing left"*: Deitch, Geiss, and Gruen, *Keith Haring*, 454.

214 *he went to the East River*: Gooch, *Radiant*, 366.

215 *"I want the film"*: Spike Lee with Lisa Jones, *Do the Right Thing* (New York: Fireside, 1989), 24.

215 *He'd heard that*: Gavin Edwards, "Fight the Power: Spike Lee on 'Do the Right Thing,'" *Rolling Stone*, June 20, 2014.

215 *wrapped that fall*: Robert Fleming, "Back to Film Future in Bed-Stuy," *Daily News*, October 9, 1988.

216 *grossing nearly half its production budget*: Box Office Mojo, Domestic 1989 Weekend 26, June 30–July 2, 1989, https://www.boxofficemojo.com/weekend/1989W26/?ref_=bo_rl_table_1.

216 *A $45 million lawsuit*: Press release, September 10, 1986, Records V, Boxes 1838–1842, National Association for the Advancement of Colored People Records, Manuscript Division, Library of Congress, Washington, D.C.

216 *Unbeknownst to the attorneys*: James Meyerson, interview by author, November 27, 2023.

216 *"Since I have been overseeing requisitions"*: Letter from Joyce H. Knox to Herbert Henderson, Records V, Boxes 1838–1842, National Association for the Advancement of Colored People Records, Manuscript Division, Library of Congress, Washington, D.C.

216 *"We know that you are aware"*: Letter from James Meyerson to Spike Lee, Records V, Boxes 1838–1842, National Association for the Advancement of Colored People Records, Manuscript Division, Library of Congress, Washington, D.C.

216 *"I was a little bit cynical"*: James Meyerson, interview by author, November 27, 2023.

217 *In May 1990*: Letter from David Barrett to Jonathan Moore et al., Records V, Boxes 1838–1842, National Association for the Advancement of Colored People Records, Manuscript Division, Library of Congress, Washington, D.C.

217 *of $1.7 million*: William G. Blair, "Family Gets $1.7 Million for Stewart's Death," *New York Times*, August 29, 1990.

217 *He couldn't wash*: Sally Randall Brunger, interview by author, November 18, 2022.

217 *"We were going"*: Lisa Edelstein, interview by author, November 22, 2022.

217 *cast in a production*: Text message from Edelstein to the author, March 21, 2024.

217 *"a final fabulous send-off"*: David France, "This Doctor Wants to Help You Die," *New York*, June 13, 1997.

218 *"walked fast"*: Gross, "Witness Says Stewart Was Calm After Arrest."

218 *shot to death*: Kit R. Roane, "Gun Links Man Who Shot at Officers to '97 Killing of Token Clerk, Police Say," *New York Times*, April 3, 1998.

218 *"lived as a hero"*: Claire Serant, "Clerk 'Died a Hero,'" *Daily News*, March 29, 1997.

218 *"He was an ass"*: Bernhard Goetz, interview by author, September 8, 2023.

218 *Michael Stewart's father*: "Stewart, Millard," *New York Times*, March 17, 2002.

218 *He was buried*: Findagrave.com (https://www.findagrave.com/memorial/139647716 /millard-f-stewart)

218 *"to investigate"*: Governor Andrew Cuomo, Executive Order No. 147, July 8, 2015.

219 *Six years later*: Sarah Maslin Nir, Jonah E. Bromwich, and Benjamin Weiser, "A Special Unit to Prosecute Police Killings Has No Convictions," *New York Times*, February 26, 2021.

219 *"The owner of an old house"*: Isabel Wilkerson, *Caste: The Origins of Our Discontents* (New York: Random House, 2020), 15.

219 *the portrait of*: LaBouvier, Basquiat's *"Defacement,"* 20.

219 *bequeathed* Defacemento: Anna Gurton-Wachter, email to author, November 21, 2023.

219 *whose brother had been killed*: Helen Lewis, "The Guggenheim's Scapegoat," *The Atlantic*, November 2022.

219 *The artist's estate*: The Estate of Jean-Michel Basquiat, email to author, December 6, 2022.

219 *when it hung on the wall*: "Getting a Read on Basquiat," *Williams Magazine*, Fall 2016.

220 *"He was a child"*: Patrick Fox, interview by author, November 29, 2023.

INDEX

ABOUT THE AUTHOR

Founded in 2017, Celadon Books, a division of
Macmillan Publishers, publishes a highly curated list
of twenty to twenty-five new titles a year. The list of
both fiction and nonfiction is eclectic and focuses
on publishing commercial and literary books and
discovering and nurturing talent.